OUR WILL TO LIVE

TEREZIN MUSIC FOUNDATION

MARK LUDWIG

OUR WILL TO LIVE

The Terezín Music Critiques of Viktor Ullmann
Illustrated with original art from the
Heřman Collection at Památník Terezín

Steidl

For Kate, Sarah, and Asher

"We in no way merely sat around lamenting …
Our desire for culture was equal to our will to live."

—Viktor Ullmann, from "Goethe and Ghetto" (Terezín, 1944)

"There are three ascending levels of how one mourns:
With tears—that is the lowest.
With silence—that is higher.
And with a song—that is the highest."

—Chasidic teaching quoted by Rabbi Abraham Joshua Heschel

"The temple bell stops
but the sound keeps coming
out of the flowers."

—Matsuo Basho (1644–1694)

CONTENTS

PREFACE
Mark Ludwig

You may be familiar with *I Never Saw Another Butterfly*, the famous collection of touching poems and drawings child prisoners created in the Terezín concentration camp. But most people are startled to learn of a rich repertoire of music performed and composed in Terezín. A little more than thirty years ago, I had the same response.

In 1988, my career seemed pretty well charted. I was a violist in the Boston Symphony Orchestra and the Hawthorne String Quartet, and I directed a chamber music series in the Berkshires. But a book about Rabbi Leo Baeck—more specifically, pages 295 and 296 of *Days of Sorrow and Pain*—would dramatically shift the course of my professional career.[1] Baeck, a prominent leader in progressive Judaism during the first half of the twentieth century, had been a prisoner in the Theresienstadt concentration camp, where "Poets and musicians tried to capture the hunger, cold, and sadness in words and music." What's more, one of those musicians, Viktor Ullmann, composed an opera in the camp.

This immediately sparked my curiosity. How could this be possible in such an environment? Did this music express only "hunger, cold, and sadness"? What scores may have survived, and what were the quality, scale, scope, and styles of these compositions? Who were the other composers and musicians? These were only the first of many questions to come.

I was fortunate to grow up in a family of accomplished musicians and artists. My father was a violinist in the Philadelphia Orchestra during the Stokowski–Ormandy years, my brother was the associate concertmaster, and our cousin was principal cellist of the Boston Symphony Orchestra. And yet, none of us—nor any of our colleagues—had ever heard of Viktor Ullmann or any other Terezín composer.

My curiosity led me to reach out to the Český Hudební Fond (Czech Music Fund) in Prague, the central resource in Czechoslovakia for music by Czech composers, and to make my first visit to that historic city. At the time, the Fund's office was located on Pařížská Street, a beautiful boulevard lined with Art Nouveau buildings in what is known as both Staré Město (Old Town) and the Jewish Quarter, only paces from the famed Alte-Neue Schule and the Old Jewish Cemetery.[2] On that first visit, I had three profound experiences that changed my life.

First, Alena Jungerová of the Český Hudební Fond handed me scores to chamber works composed in the Terezín camp by prisoners Hans Krása, Gideon Klein, and Pavel Haas.[3] As I worked my way through them, hearing the interplay of voices in my mind's ear, I was thunderstruck by the beauty, sophistication, and power of these works, created by people who daily faced suffering and mortality. This was music beyond my expectations—I couldn't wait to play it!

Soon I was introduced to several Czech Jewish survivors who knew and in some cases performed with these composers. I learned the fascinating stories of the artists'

promising careers before the war—and of their suffering at the hands of the Nazis. Their courage and determination to continue creating in Terezín added a rich dimension to their musical legacy.

The last and most emotional experience was spending a day in Terezín and its archives with a survivor who had been imprisoned during his teen years. Almost half a century later, my guide shared personal stories of his internment, as we continued through the gray, deserted streets and the mostly abandoned barracks of the Great Fortress.[4] Every few paces we stopped, as another building or site evoked memories of unremitting hunger and fear. We stood at the railway tracks where he tearfully uttered the names of his family members who were placed on transports to the gas chambers of Auschwitz. The suppressed rage of many years was palpable as he pointed out memorial plaques extolling the valiant Soviet Red Army liberators—a reminder of the Soviet occupation of Czechoslovakia—while omitting any mention of Jewish prisoners.[5] It was as if the memory of those dearest to him was being revised, if not erased from history, and there was nothing he could do about it. To this day, the intensity of this moment infuses my commitment to champion the memory and legacy of Terezín.

We then made our way towards the Terezín archives in the Small Fortress. The raw, overcast weather further accentuated our chilling walk along solitary-confinement cells and brick walls topped with barbed wire. In the archives, the staff introduced me to a trove of artwork, manuscripts, and documents. The weight of the day lifted briefly when my guide saw artifacts that recalled a few cherished memories of attending children's programs—most notably Hans Krása's children's opera *Brundibár*. Yet, even this was a bittersweet reminder of friends and family lost in the Holocaust. The hardest part of this visit lay before us as we left the archives to visit the Terezín Crematorium. Standing by one of the four ovens, I lit several memorial candles and recited the Kaddish[6] for his family and the thousands cremated at this site. The flames from the candles cast our shadows along the wall next to a vitrine that displayed a paper urn containing the ashes of a prisoner.[7]

Hearing the stories of these imprisoned artists, viewing their little-known musical scores, and learning the history of Terezín amounted to one of the most emotionally and intellectually overwhelming experiences of my life—as an artist, a Jew, and a human being. It launched a thirty-year journey devoted to researching, performing, recording, writing, and teaching about the Terezín composers and artists. In 1990, I founded the nonprofit Terezín Music Foundation to support this work.[8]

Our Will to Live is part of this effort. Through text, visual art, and recordings, it journeys into Terezín's active cultural community. At its core are twenty-six concert programs given in Terezín, described in richly literary and learned critiques by composer Viktor Ullmann, along with stunning artwork created to promote and document these musical events and their artists. With his critiques, Ullmann chronicles much of the significant cultural life in the camp. Each critique is accompanied by a selection of color images

showing the hand-drawn, painted, and hand-lettered concert posters, programs, sketches, and other works secretly collected in the camp by a member of the Jewish leadership.

As you encounter the art and text, I invite you also to listen to the accompanying recordings of works by composers Ullmann mentions—much of it composed in Terezín. The audio tracks include performances by some of the world's great artists, including Yo-Yo Ma, members of the Boston Symphony Orcestra, and Terezín survivors.

In the past three decades, music from Terezín has made its way to the great concert stages of the world, and hearing it never ceases to impart the sense of awe I experienced on my first encounter with it. It is easy to be moved by its beauty, lyricism, and emotional range. And while the fates of these artists fill us with a deep sense of sadness, loss, and a desire to remember, there is also—as you will find in this book—an inspiring and transformative aspect of this creativity. In Terezín, music and art were precious sources of comfort and hope amidst horror and deprivation. They served as a powerful expression of life in the face of annihilation.

The history and art of Terezín transcends cultural and generational boundaries. One of my most memorable experiences was performing this repertoire with students and faculty of the Sarajevo Music Academy after the lifting of the horrific siege in the 1990s. We performed in the Academy's concert hall, where the bombardment had left a gaping hole in the wall.[9] The stories and music of Terezín resonated deeply with our audience, who had lost family and friends and braved sniper fire to attend lessons, rehearsals, and concerts. The arts helped sustain them through tremendous brutality. More recently, we have endured separation and loss during the Covid-19 pandemic. People sang from balcony windows. Instrumentalists and singers—professional and amateur—produced in-home concerts shared via the internet. And eighty-nine year-old Holocaust survivor Simon Gronowski moved his electric keyboard to his window and played jazz tunes to lift the spirits of his neighbors. Many inspiring acts reaffirmed the arts as a vital source of solace, connection, and hope. Surely, Terezín's story reaches across time and place in its power to inspire exchange and dialogue and remind us of our shared humanity.

In the pages ahead, the Terezín artists and their work challenge us to view our world through the lens of a heightened social consciousness. May you be enriched by the experience of *Our Will to Live*.

Annotations

1 Baker, Leonard. *Days of Sorrow and Pain: Leo Baeck and the Berlin Jews.* New York: Oxford University Press, 1978.

2 The Alte-Neue Schule (Old-New Synagogue) was completed in 1270. It is the oldest active synagogue in Europe.

3 Much of my exposure to Viktor Ullmann's music and writings would come shortly after this visit, during my research in the archives of the Goetheanum in Dornach, Switzerland.

4 Terezín consists of a *große und kleine Festung* (Large and Small Fortress). More information appears in the introductory essay.

5 Shortly after the Velvet Revolution of 1989, these plaques were changed to accurately record the victims and activities that took place. Under the directorships of the late Jan Munk and his successor Jan Roubínek, Památník Terezín is one of the world's major sites for Holocaust education and archival research.

6 Also referred to as the Mourner's Kaddish, it is a prayer traditionally recited in memory of a deceased loved one.

7 At the order of the SS commander, the prisoners began construction of a crematorium outside the walls of Terezín on May 7, 1942. It was operational on September 7, 1942. The ashes were placed in paper urns and stored in the camp columbarium. In an attempt to destroy evidence, a chain of two hundred prisoners were forced to dump over 22,000 urns into the Ohře River on October 31, 1944.

8 For more information on TMF's programs, please visit www.terezinmusic.org.

9 The siege of Sarajevo lasted from April 5, 1992 to February 29, 1996. The Sarajevo Music Academy building was damaged six times by mortar fire.

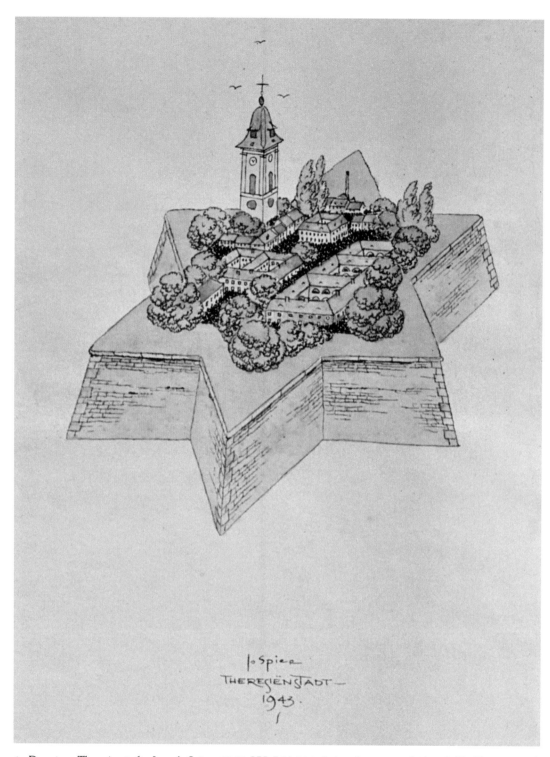

1. Drawing. *Theresienstadt.* Joseph Spier. 1943. LBI #84.511. *Spier places several identifiable Theresienstadt landmarks—the central square, barracks (Magdeburg and Hannover), and church—within the walls of the large fortress. In shaping the fortress walls into a Jewish star, Spier states the purpose of Theresienstadt as a Jewish ghetto/ concentration camp.*

16

INTRODUCTION
Mark Ludwig

In October of 1944, Viktor Ullmann and Karel Heřman received notices for transport from the Theresienstadt[1] concentration camp to Auschwitz. Both men made fateful decisions to leave their most valued possessions behind.

Ullmann, one of the most respected and gifted composers of his generation, entrusted his musical scores and personal writings—including a series of twenty-six detailed and learned critiques of musical performances in the camp along with two short, yet touching and inspiring personal reflections—to a friend and fellow prisoner. Heřman, a member of the Terezín Jewish administrative leadership, had collected hundreds of documents and works of art created by fellow prisoners. He hid them during the closing weeks of his incarceration in Terezín.

Heřman's trove miraculously survived and today offers a vibrant testament to the artistic determination and courage of the Terezín prisoners. It includes more than five hundred items—posters, programs, portraits, tickets, and administrative forms—documenting many of the cultural activities in the camp.

Our Will to Live weds Ullmann's Terezín texts with selections from the Heřman collection to create a journey into the unique and extraordinary cultural community that existed in the face of grave suffering, deprivation, trauma, and death. They are accompanied by recordings of works by composers noted in Ullmann's critiques—including music actually composed in Terezín—to further enrich the experience of this legacy.

Before entering this world, we begin with an overview of Terezín's history, the lives of these two prisoners, and the genesis and content of these collections.

THE HISTORY OF TEREZÍN

Terezín is situated at the confluence of the Ohře [Eger] and Labe [Elbe] Rivers approximately forty miles (sixty-two kilometers) northwest of Prague.

Terezín's origins reach back to the mid-eighteenth century, when the Hapsburgs began plans for the construction of fortifications between the Bohemian towns of Litoměřice and Bohušovice to discourage further Prussian incursions into the region. On October 10, 1780, two years after Prussian forces occupied Litoměřice, Emperor Franz Joseph II laid the cornerstone of what would be two fortresses on either side of the Ohře river. He officially decreed the fortifications Theresienstadt, in honor of his mother, the Empress Maria Theresa.[2]

Substantial manpower, materials, and money were channeled into building the *große und kleine Festung* (Large and Small Fortress). The construction of the Theresienstadt fortifications cost the Hapsburg treasury more than 12.5 million gold pieces and involved a workforce of 15,000 troops and 1,500 laborers, bricklayers, and masons.

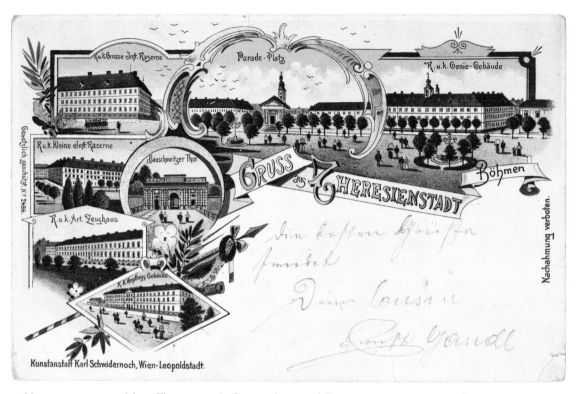

2. Vintage greeting card from Theresienstadt. Circa early 1900. ML.
Decorative postcard with drawings of central square and major barracks in Theresienstadt.

Just twelve years later, on December 9, 1792, Theresienstadt was granted status as an independent town. Despite its diminishing military role, it continued to serve as a garrison, now with the addition of shops, private homes, and barracks for the armies of the Hapsburg Austro-Hungarian Empire. By 1888, Theresienstadt had fully shed its official defensive military status, and it became a small garrison of three thousand troops and a small supporting civilian population. The purpose of the Small Fortress shifted to holding political and military prisoners.[3] During World War I, more than 2,000 prisoners of war from Tsarist Russia, Italy, Serbia, and Romania perished from hard labor and the harsh conditions of confinement there. The most notable prisoner of the time was Gavrilo Princip, the assassin of Archduke Franz Ferdinand, heir apparent to the Austro-Hungarian throne[4] [image 2].

With the end of World War I, the dissolution of the Austro-Hungarian Empire, and the establishment of the First Czech Republic, Theresienstadt officially reverted to its Czech name, "Terezín." Subsequent changes between its German and Czech names would reflect the country's fortunes, swinging between independence and occupation. With the Nazi occupation of Czechoslovakia on March 15, 1939, Terezín once again became Theresienstadt.

18

The Gestapo occupied both Terezín[5] fortifications on June 10, 1940 and set up a police prison and garrison within the Small Fortress. Its pre-existing barracks, solitary confinement cells, and gallows made the Small Fortress an ideal Gestapo prison for Czech and Slovak political prisoners, members of the resistance, Jews who defied the Nuremberg Racial Laws, and prisoners of war from the Soviet Union, Yugoslavia, Poland, France, Italy, and the United Kingdom. Until its liberation, thirty-two thousand men and women were incarcerated in the Small Fortress. More than 2,600 died from exhaustion, starvation, and disease, and at least 250 were executed by firing squad.[6]

In the fall of 1941, Reinhard Heydrich, the newly appointed *Reichsprotektor* of Bohemia and Moravia, selected the Large Fortress as a "ghetto-settlement" for Czech Jews [image 1].

The transformation began just before dawn on November 24, 1941, when 342 Jewish men were forcibly assembled at the Masaryk train station in Prague for transport to Terezín. Designated *Aufbaukommando 1* or AK 1 (construction commando), this transport was the first of two advance units sent to convert the garrison town into a concentration camp. This carefully selected team included one hundred laborers for "heavy work" and an array of skilled workers including cooks, carpenters, electricians, welders, sewage builders, municipal engineers, a hygienist, and a doctor.

After the Berlin Wannsee Conference in January 1942, Terezín's purpose expanded in scope and scale. Jews within the German Reich and occupied countries (Austria, Czechoslovakia, Holland, and Denmark) were to be sent to the camp and ultimately to the East for extermination (i.e. The Final Solution). The first transports to the East (*Osttransporte*) went to Treblinka. By October 26, 1942, all transports were directed to Auschwitz. More than 90,000 of the 141,000 people sent to Terezín were sent to the East.[7]

In addition to serving as a labor-transit camp, Terezín became a powerful propaganda vehicle for the Nazis, who labeled Terezín the "Preference Camp," "Theresien-spa," and even "Paradeis-ghetto." While the Nazis sought to create the illusion of luxury, especially for high-profile German and Austrian Jewish prisoners and the public at large, the daily reality was starvation, disease, lack of adequate medical care, and over-crowding.[8]

Edgar Krasa, a young professionally trained chef who was placed on the first transport to establish and supervise the kitchens, recalled the overall lack of quality and variety of meals served in the camp:

When I arrived, I had only a 300-liter pot to feed the first transports. I was always looking for food sources and solutions for the constant shortage of cooking supplies and equipment. Early on, with thousands coming on transports, we were fighting the fear of famine.

Food was not nutritional, but you had something to fill your stomach. You had potatoes, but the potatoes were detoured [came] from the pig sty because they were half rotten … There were ladies sitting cutting out the rotten part and you could use the rest.

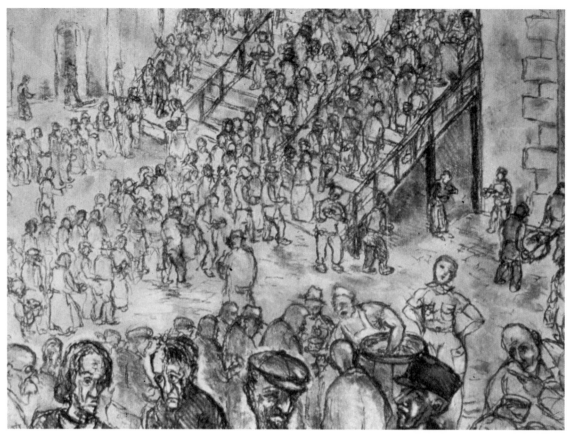

3. Drawing. "Distributing Food in a Barracks Yard." Ferdinand Bloch. Terezín, 1943. ZM #176.337.

There was some flour, a little sugar, once in a while you would receive a little pan of margarine and a teaspoon of marmalade.

Soups were made from powder. Nobody knows what was in the powder. There was one powder that would produce the gray—some would call the "thick soup"—they also called it the "lentil soup" because the color when cooked turned reddish. There was millet. We used it for the evening meal. But there was always soup. There were beets from which we made soup and sometimes enough potatoes [to have] with the soup.

Now it developed and it's not nice, but true—that it was not what you knew, it was who you knew in Terezín. If you know the guy in the kitchen who was ladling out the soup, he went a little deeper and got you some potatoes in your soup. If you didn't know him, he just gave you from the top … and this was everywhere, in Auschwitz and all the other camps."[9] [images 3–6].

Before its designation and function as a "ghetto-concentration camp," Terezín had a population of just over 7,500. By September 1942, with no additional expansion of infrastructure, the prisoner population swelled to a staggering 58,491.[10] Terezín was,

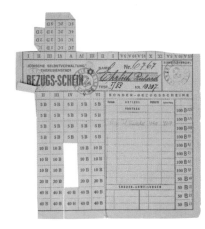

4. Theresienstadt ration sheets issued to Sophie and Richard Ehrlich. Photograph by Michael J. Lutch. TMF.

5. Blank monthly ration card with warning, "Abuse will be punished." Photograph by Michael J. Lutch. TMF.

in fact, a fortress-like ghetto of deprivation and death where more than 33,000 people died.

To attend to the daily logistical nightmare of running Terezín, the Nazis formed a Jewish Council of Elders (*Ältestenrat der Juden*). The Council was composed primarily of leaders from the major Czech, German, and Austrian Jewish communities that had been transported to the camp. It was faced with the impossible task of overseeing all aspects of prisoner life. The Nazi SS camp commandant dictated policy, punishments, and orders to be executed by the Council. The most sadistic aspect of this forced collaboration was enforcement of the Council's role in selecting individuals for transports to the East, an almost certain death sentence. The Council implemented all such orders and reported back on a daily basis to the SS command. They were in a hopeless struggle to follow the SS dictates while trying to find any means of improving the camp's horrendous conditions.[11]

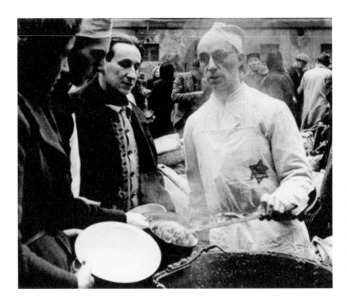

6. Photograph. Transport of Dutch Jews receiving their first meal in Terezin, January 20, 1944. United States Holocaust Memorial Museum, courtesy of Ivan Vojtěch Frič #20269. *The SS ordered Czech cameraman Ivan Vojtěch Frič to shoot this scene in preparation for the production of the 1944 Nazi propaganda film about Theresienstadt.*

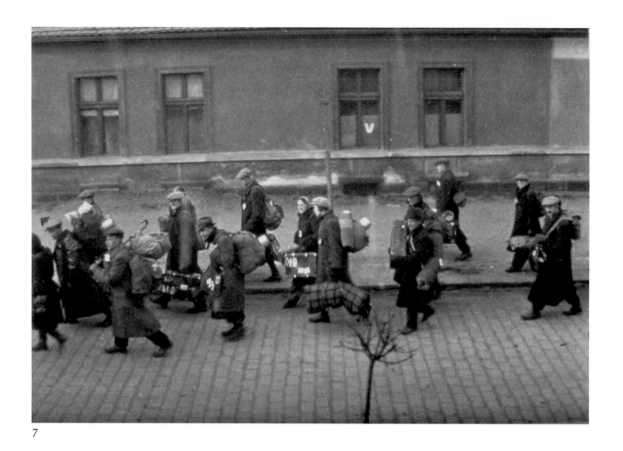

7

In a diary kept in Terezín, fifteen-year-old Petr Fischl recalled the hardships and brutality of life in Terezin:

We got used to standing in line at seven o'clock in the morning, at twelve noon, and again at seven o'clock in the evening. We stood in a long queue with a plate in hand, into which they ladled a little warmed-up water with a salty or a coffee flavor. Or else they gave us a few potatoes. We got used to sleeping without a bed, to saluting every uniform, not to walk on the sidewalks and then again to walk on the sidewalks. We got used to undeserved slaps, blows, and executions. We got accustomed to seeing people die in their own excrement, to seeing piled up corpses, to seeing the sick amid the dirt and filth and to seeing the helpless doctors. We got used to it that from time to time, one thousand unhappy souls would come here and another thousand unhappy souls would go away...

Petr[12] was one of more than fifteen thousand children transported from Terezín to Auschwitz.[13]

Prisoners arrived at Terezín carrying bundles and suitcases. Transport summons restricted luggage to a limit of fifty kilos (110 pounds), marked with the owner's name and transport numbers. Producing a false sense of hope for survival, the Nazis would order

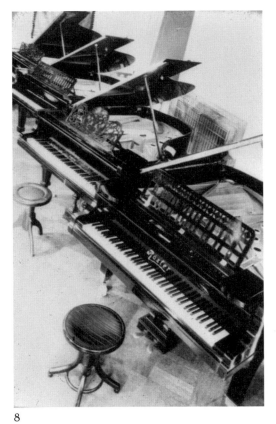

7. Photograph. Transport of Jewish deportees walking six kilometers from Bohušovice to Terezín. ZM #24.762. *Transports arrived in Bohušovice until June 1943, when a rail spur was completed into Terezín.*

8. Photograph. Stored pianos confiscated/looted by the Nazis. ZM #2.870.

8

many of the prisoners to pack clothing, bedding, food for five days, and cooking utensils for their journey.

The new arrivals were immediately registered and assigned to a barracks and work detail, while their parcels were searched and subject to the mercy of arbitrary confiscation at the whims of the guards.[14] The more fortunate received a space in the three- to four-tiered rows of bunks, usually with an under-bedding of matted straw. For many, this cramped, overcrowded, and degrading living space would be their last home, containing all that was left of their earthly possessions.

Remarkably, many amateur and professional musicians chose to smuggle in musical instruments and scores among their selected belongings. This was a perilous act, as the Nuremberg Racial Laws forbade the ownership of instruments by Jews throughout the Reich and occupied lands. Thousands of musical instruments, or *Contrabande*, were confiscated. In Prague, Jews were ordered by the *Reichsprotektor* to surrender all musical instruments by December 26, 1941. Those caught with such *Contrabande* were sent East. By February of 1944, the number of confiscated instruments in Prague alone had reached more than 23,000 [images 7–9].

Terezín prisoners went to remarkable and risky lengths to smuggle in their forbidden instruments. In one example, a prisoner cut his cello into pieces—an unimaginable act

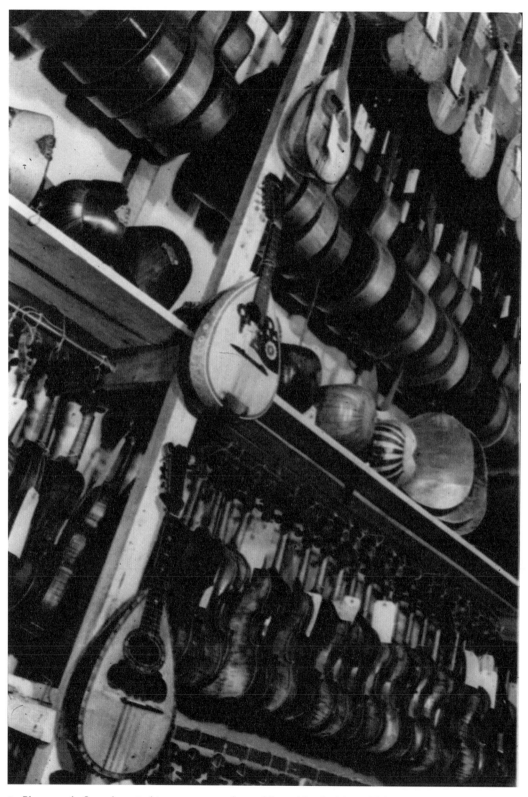

9. Photograph. Stored musical instruments confiscated/looted by the Nazis. ZM #2.878.

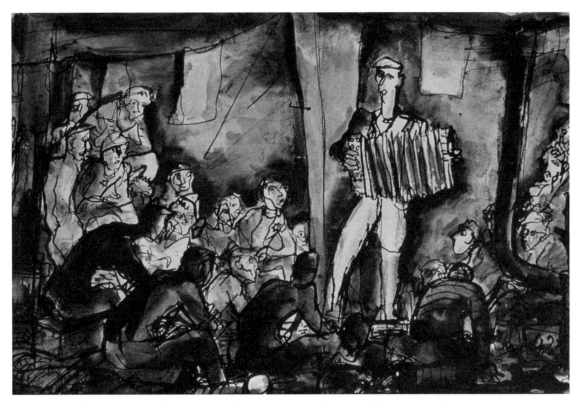

10. Drawing. "Entertainment." Bedřich Fritta. Terezín, 1943. Collection of Thomas Fritta Haas.

for any amateur or professional musician—and hid the fragments in the linings of the prisoners' coats.[15] In the camp, it was glued back together.

Prisoners secretly held informal evenings of song in the attics and basements of the barracks, the first documented in early December 1941. The number of performances increased with the growing number of amateur and professional artists arriving on the continuing transports [image 10].

Within weeks, the Nazis became aware of these cultural activities. For almost a year, they swung between periods of prohibition and indifference. In early 1942, the Council of Elders formed the *Freizeitgestaltung*[16] (Administration for Free-Time Activities). This department within the Department of Internal Administration served as the cultural command center for what would become an incredibly rich array of activities including classical, popular, and jazz concerts; cabaret and opera productions; theatre; and lectures. It also organized sports events that included chess, soccer, and ping-pong matches [images 11, 12, 31].

On the musical front alone, managing the logistics of producing diverse programs of a high standard on an almost daily basis in Terezín was impressive. The *Freizeitgestaltung* collected, maintained, and allocated instruments and music. They scheduled rehearsals and concerts; selection and preparation of venues; the distribution and maintenance of

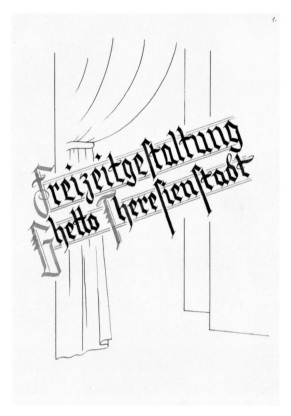

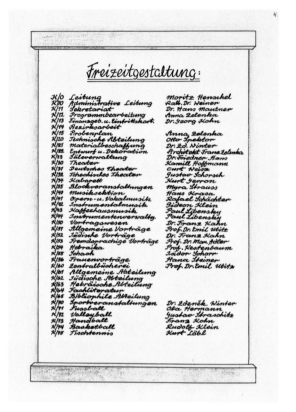

11. Poster. *Freizeitgestaltung Ghetto Theresienstadt.*
Heinrich Bähr. HCPT #3763.

12. Drawing. *Freizeitgestaltung.* HCPT #3863.
Listing of the subdivisions within the leisure activities.

musical instruments; and the circulation of tickets. The scale and scope of the *Freizeitge-staltung*'s responsibilities would be extraordinary for any comparably sized community in stable and prosperous times, let alone in a concentration camp. The collection of talent and diversity of offerings would rival that of any major city.

Amid this impressive array of ensembles and programming, there was the ever-present uncertainty and threat of transports to the East. Ensembles and productions were caught in a vicious cycle of formation, decimation, and reconstitution. As violinist Pavel Kling described it to me, "In Terezín there was little joy. Just darkness, hunger, and death. I felt I was playing music among the dead. Each day was about survival."[17]

In 1944, the cultural activity in Terezín would be co-opted for Nazi propaganda purposes. Beginning in February, the Nazis embarked on the *"Stadtverschönerung"* (project for urban improvement), a carefully orchestrated effort initiated to counter reports of the Final Solution and the horrific conditions in other concentration camps.

Beginning in February, Terezín was prepared for a staged visit by an International Red Cross Committee and the production of a propaganda film.[18] The film, titled *"Theresienstadt. Ein Dokumentarfilm aus dem Jüdischen Siedlungsgebiet"* ("Theresienstadt.

A Documentary from the Jewish Settlement Area"),[19] was designed to give the false impression of a "paradise ghetto" for the Jews.

A music pavilion, false shop facades, and cafés were erected, select buildings were superficially beautified, and tulips were even brought in from occupied Holland. A temporary nursery, playground, and makeshift school were constructed for the children, who were ordered to call the Commandant "Uncle Rahm" in front of the Red Cross delegation.[20] Street signs showed the way to a nonexistent post office, dental clinic, drugstore, bank, and various other shops. The SS Commandant ordered the shipment of musical instruments that had been confiscated in Prague. To relieve the appearance of over-crowding, 7,500 elderly people were sent directly to the gas chambers of Auschwitz. All these preparations were designed to dupe not only the International Red Cross Committee but future audiences of the film. Terezín would appear to be a paradise removed from the ongoing horrors of the war raging throughout Europe. Any mention of death camps or gas chambers was to be refuted by this Potemkin-like village. Furthermore, the film would perpetuate Nazi stereotypes of the "parasitic Jews"[21] luxuriating while pure Aryan Germans continued to sacrifice and suffer for the Fatherland [images 13–15].

On June 23, 1944, Dr. Maurice Rossel of the International Red Cross Committee (ICRC) and two Danish delegates were guided on a tightly scheduled tour by SS Theresienstadt Commandant Rahm and SS officers from Prague and Berlin. Rossel and the Danes were at all times accompanied by the SS. The eight- to ten-hour tour was meticulously planned with no opportunity for the visiting members to roam about the camp or mingle freely with prisoners.

Rossel's official report stated:

Immediately on entering the Ghetto, we were convinced that its population did not suffer from undernourishment...The children's homes are particularly well and sensibly furnished with murals whose decorative effect and educative value are remarkable ... There are several orchestras in the Ghetto ... We heard a rehearsal of Verdi's Requiem ... We must say we were astonished to find out that the Ghetto was a community leading an almost normal existence.[22]

Leo Baeck, a prisoner and esteemed Rabbi from Berlin, wrote:

They [the ICRC] appeared to be completely taken in by the false front put up for their benefit ... Perhaps they knew the real conditions—but it looked as if they did not want to know the truth. The effect on our morale was devastating. We felt forgotten and forsaken.[23]

Following the ICRC visit, both adults and children were forced to participate in the production of the propaganda film. Scenes included the performances of two works by composers imprisoned in Terezín, Pavel Haas and Hans Krása.

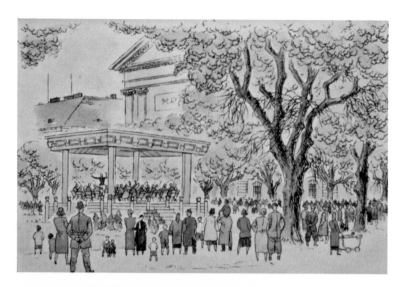

13. Drawing. From *Bilder aus Theresienstadt*. Joseph Spier. PT #2696. *Josef Spier was ordered to create a souvenir album titled "Images of Theresienstadt" for the visiting Red Cross Committee and Nazi SS members. The outdoor concert pavilion in the central square is one of the sites selected for the beautification project.*

14. Still from the Nazi propaganda film, *"Theresienstadt, A Documentary Film from the Jewish Settlement Area."* PT #1868. *This still shows a performance in the outdoor concert pavilion erected in the Central Square.*

15. Still from the Nazi propaganda film, *"Theresienstadt, A Documentary Film from the Jewish Settlement Area."* PT #1869. *This still shows The Ghetto Swingers performing with band leader Martin Roman.*

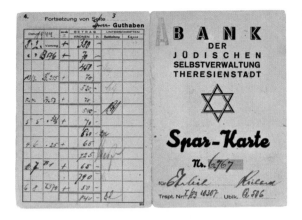

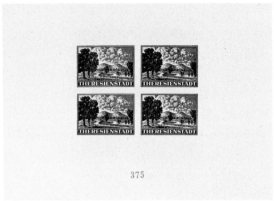

375

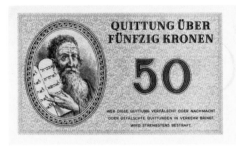

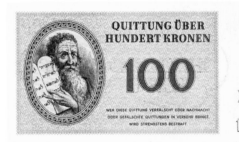

16. Cover and back page of savings book for Richard Ehrlich (Transport I/83, Transport No. 10307. Ehrlich was housed in Q506) issued by the Bank of the Jewish Self-Government in Theresienstadt. Photograph by Michael J. Lutch. TMF. *Entries occur only in the deposit columns. Withdrawals (far-right columns) were not permitted.*

17. Plate of Theresienstadt postage stamps. Photograph by Michael J. Lutch. ML. *The stamps give an idealized impression of Theresienstadt to the outside world receiving the censored mail from the prisoners. The currency and postage issued were another reminder of the exclusion of Jews from society at large. This is a promotional miniature sheet made for the Red Cross visit with a serial number printed below. The perforated sheets did not have a gum backing as they were not actually valid.*

18. Theresienstadt currency—Fünfzig Kronen. Photograph by Michael J. Lutch. ML. *The Reich bank official overseeing the production of Theresienstadt currency rejected the first design of the Moses figure on the grounds that it appeared too noble in character.*

19. Theresienstadt currency—Hundert Kronen. Photograph by Michael J. Lutch. ML.

Children once again performed Krása's children's opera *Brundibár*, which they had just staged for the ICRC. Now they did it for the cameras. The opera, composed in 1938, had been performed in Hagibor, the Prague Jewish orphanage, during the Nazi occupation. Many of the orphans subsequently sent to Terezín would perform it once again in this grand deception. In a rather clever twist unbeknownst to the Nazis, the text of the opera's finale was changed for the Terezín performances.[24]

Brundibár, the opera's mustachioed villain, was re-cast as an anti-fascist metaphor for Hitler. Ironically, the Nazis elected to film the finale of *Brundibár* with the children's chorus singing about his demise:

We've won a victory over the tyrant mean, sound trumpets, beat your drum, and show us your esteem! We've won a victory, since we were not fearful, since we were not tearful, because we marched along singing our happy song, bright, joyful, and cheerful. He who loves his dad, mother, and native land, who wants the tyrant's end, join us hand in hand and be our welcome friend![25]

Surviving fragments of the film also include scenes of *Freizeitgestaltung* activities—a lecture, the Ghetto Library, a soccer match, a sculptor at work, and an elderly man playing chess. One of the final scenes shows a performance given by a string chamber orchestra directed by the noted conductor Karel Ančerl. The narrator introduces the performance: "The music of a Jewish composer is being performed in Theresienstadt." The music is Pavel Haas's *Study for String Orchestra*, composed in Terezín in 1943. Haas, a prized pupil of Leoš Janáček, is shown taking a bow with the ensemble at the conclusion of the scene.

As part of the meticulous production planning for both the film and ICRC visit, Joseph Spier, a Dutch Jewish artist and children's book illustrator, was ordered to create a series of drawings depicting an official version of daily life in Terezín. These included scenes of prisoners in a bank being given fake Theresienstadt currency and bank books, patients in a dental clinic, and performances in a theatre and the outdoor concert pavilion in the central square [images 16–19].

The SS selected one of the prisoners, Kurt Gerron, to direct the "documentary." Gerron arrived[26] on a transport from the Westerbork transit camp in Holland on February 26, just months before filming began. Before the War, he was a well-known actor and director in Europe. Among his many film credits is an appearance alongside Marlene Dietrich in *Der Blaue Engel* (*The Blue Angel*). On stage, he performed the role of Jackie "Tiger" Brown in the 1928 world premiere of Kurt Weill's *Threepenny Opera* (*Die Dreigroschenoper*), a role that included singing "Mack the Knife," a popular song the Nazis would later vilify in 1938 as an example of *Entartete Musik* (Degenerate Music)[27] [image 20].

On September 28, less than three weeks after filming[28] was completed, the Nazis sent the first of eleven new transports from Terezín to Auschwitz. Gerron and most of the adults and children who participated in the film were among the 18,042 prisoners sent to the East. With the last transport on October 28, 1944, this extraordinary cultural community was decimated.

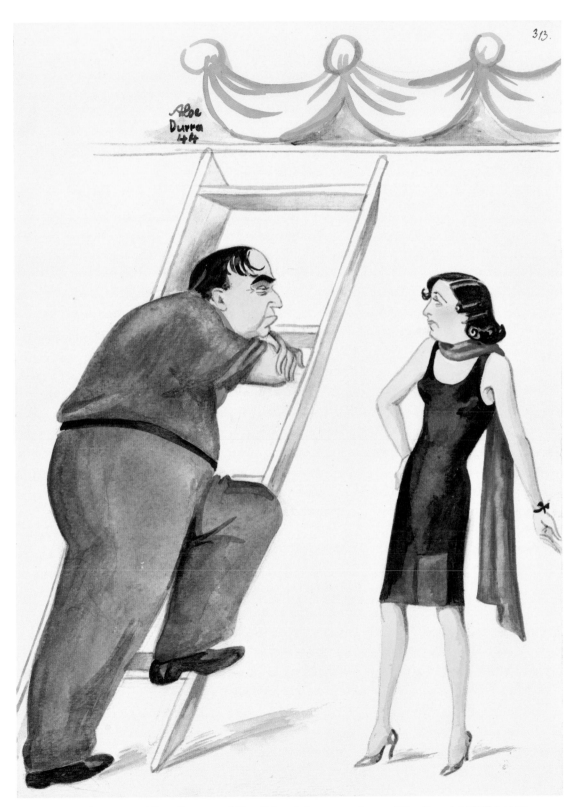

20. Drawing. Caricature of Kurt Gerron and Giza Wurzel. Annemarie Loewe (Aloe Durra). HCPT #4179.

THE COLLECTOR: KAREL HEŘMAN

Karel and Marie Herrmann[29] were among the 2,038 Jews placed on Transport Ev, the last transport from Terezín to Auschwitz. Almost three years earlier, on December 4, 1941, Heřman had arrived on the second of the two *Aufbaukommando* transports (AK II).[30] His pre-war business experience, especially as an arbitrator in Prague during the Nazi occupation and his connections within the Jewish community, made him an ideal candidate for a position on the Terezín Council of Elders [image 21].

Heřman lived and worked in Terezín's Hamburg Barracks leading the *Evidenzabteilung* (Evidence Department), whose primary functions were registering prisoners and tracking their activities and movements. A promotion to *Bezirksevidenzleiter* (Chief of the Evidence Office of District II) in July 1942 expanded his role and responsibilities. Because he was a member of one the first two transports and had elevated status within the Council of Elders, Heřman was afforded the rare and coveted privileges of greater movement within the camp, access to office supplies—paper, pencils, and typewriters were scarce commodities—and, most importantly, an extended period of protection from placement on transports to the East.

Like many of his colleagues within the Council of Elders, Heřman was interested in collaborating with the *Freizeitgestaltung*. This reflected his appreciation for intellectual and artistic culture and its potential to bolster morale. His freedom to move about the camp gave him access to artists and musicians in the various barracks, and his aforementioned access to office supplies and equipment was no doubt an added advantage. By the middle of 1943, Heřman became increasingly involved in organizing cultural activities, particularly in the Hamburg barracks.[31] In late September, he oversaw the construction of a stage and theatre for 260 in the barracks attic. The first performances there were Irena Dodalová's production of a program of poetry by François Villon with music by Viktor Ullmann.[32] Heřman helped oversee the scheduling of rehearsals and concerts in the Hamburg barracks and on occasion was also a participant.[33] Under his supervision, space for cultural activities later included Rooms 104 and 105 of the barracks, with renovations made in early 1944 to accommodate the increase in events. *Freizeitgestaltung* documents chronicle a busy calendar of rehearsals in the morning, followed by a steady stream of cabaret productions and lectures in the afternoon and evening. Kurt Gerron's cabaret, *Karussell*, was among the most popular offerings [images 22, 23, 30, 144].

In 1942, Heřman began chronicling and collecting materials documenting the overall activities in Terezín, especially those organized by the *Freizeitgestaltung*. This included the arts, chess matches, and sporting events (soccer and ping-pong) [images 24–29]. The collection from 1942 is small, due to the initial secrecy and precarious status of cultural activities. A number of performers feared punishment and possible transport to the East if their early activities were discovered. Once the Nazis fully instituted the *Freizeitgestaltung* in November of that year, the variety and number of activities increased, and with it Heřman's

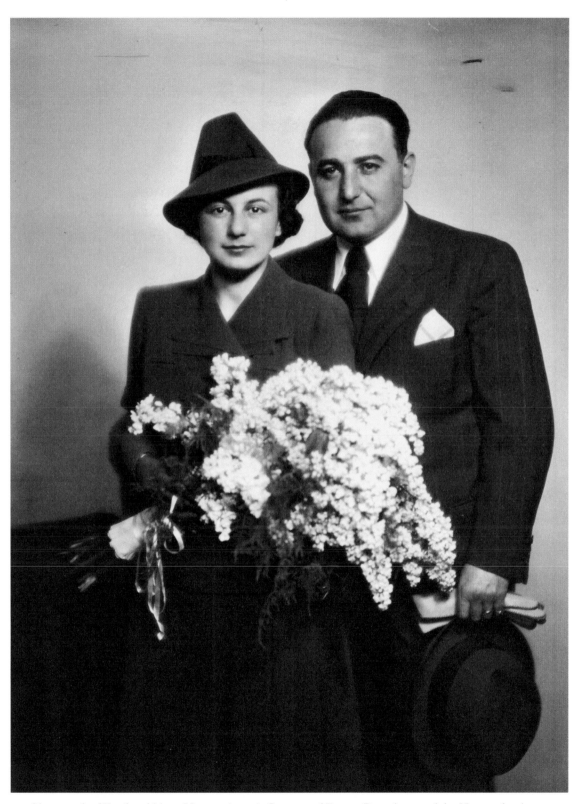

21. Photograph of Karel and Marie Heřman (1938). Courtesy of Zuzana Dvoraková and the Heřman family.

22. Poster. "Freizeitgestaltung—Lange Straße 5, Saal 105." Possibly Heinrich Bähr. HCPT #4227. *This poster marked Hall 105 in the Hamburg barracks where free-time activities were held in the spring and summer of 1944. The barracks was also home to the department of the Freizeitgestaltung and Karel Heřman's office.*

23. Poster. François Villon. Heinrich Bähr. HCPT #4301. *Poster for the dramatic production of François Villon with music composed by Viktor Ullmann.*

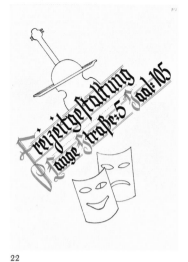

22

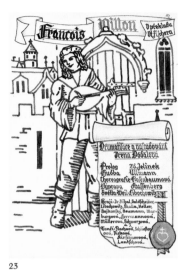

23

24

25

26

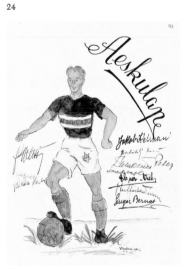

27

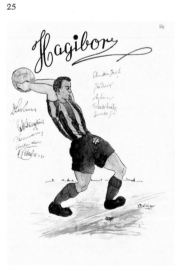

28

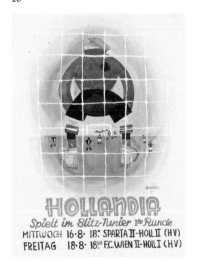

29

30. Drawing. "Theatre in the Hamburg Barracks." M. Frank. April, 1944. HCPT #4229.

24. Poster. "Table Tennis." Heinrich Bähr. HCPT #4260.

25. Poster. "Volleyball." Heinrich Bähr. HCPT #4280.

26. Poster. "Chess." Heinrich Bähr. HCPT #4268.

27. Poster. "Aeskulap Soccer Team." W. Thalheimer. HCPT #4252. *This is one in a series of posters listing teams in the 1944 Theresienstadt soccer league. Aeskulap was a team of doctors and nurses. The league teams were organized by nationality (e.g. Hollandia HCPT #4282, Vienna HCPT #4282), occupation (e.g. cooks, ghetto guards, medical, etc.), or clubs established before the war (e.g. Hagibor HCPT #4255). Matches were played mainly in the grand courtyard of the Dresden barracks.*

28. Poster. "Hagibor Soccer Team." W. Thalheimer. HCPT #4255. *Note the mandatory Star of David on the shorts of the soccer players. It was compulsory for prisoners to wear the Star of David on their jackets—or, when they were without jackets, to pin it to their pants.*

29. Poster. "Holland Plays." Frank Gobets. HCPT #4282. *This poster documents two matches: Sparta II vs. Holland on Wednesday, August 16, 1944 at 18:00, and F.C. Vienna vs. Hollandia I on Friday, August 18, 1944 at 18:50.*

collection, especially during the months leading up to and including the Red Cross visit and propaganda film production. Heřman's collection greatly expanded throughout 1943 and 1944—until September 1944, a month before his deportation to Auschwitz.

He accumulated over five hundred documents[34] that are astonishing for the artistic talent and devotion they display as well as for their content. The Heřman Collection contains concert programs and tickets; portraits; costume and set designs; and a wide array of graphic works announcing and commemorating[35] performances of a richly varied musical repertoire—classical, jazz, popular, and cabaret—as well as lectures, theatre (in Czech, German, and Yiddish), and sporting events. Heřman's status in the Council of Elders enabled him to enlist the leading artists in the camp including Bedřich Fritta, František Petr Kien, Felix Bloch, František Zelenka, Charlotta Burešová, Leo Haas, and Adolf Aussenberg, to create these works. Additional outstanding works were done by H. Alexander, Karl Bergel, Aloe Durra, M. Frank, Margareta Kleiner-Fröhlich, Heinrich Bähr, Frank Gobets, A. Goldmann, Herbert Graff, Bedřich Graus, Wilhelm Heimann, Pauli Schwarz, and Wilhelm Thalheimer.

Many of these artists were among the professional draftsmen, painters, sculptors, and architects assigned by the Council administration to the Technical Department in the Magdeburg barracks. Some were tasked with drafting construction plans, designing statistical charts, and illustrating official reports for the Nazi Command and the Camp Council. Many artists created decorative arts and paintings for the Terezín SS and their families. They were also ordered to decorate selected sites in preparation for the 1944 Red Cross visit and propaganda film production. This included painting the murals in the children's pavilion built specifically for these propaganda projects. These forced labor projects provided access to supplies—acrylic, oil, pastel, color and black ink, pencil, watercolor, crayon, and typewriters—for both their offical and secret commissions within the camp. The Heřman collection reflects the wide range of media that the artists employed [images 13, 31–32].

Visual artists took tremendous risks in order to document the harsh realities of Terezín. The most famous example is the dramatic story of Leo Haas, Bedřich Taussig (known as Fritta), Otto Ungar, and Felix Bloch, whose drawings and paintings powerfully detail grim scenes of starvation, executions, sickness, overcrowding, and other aspects of daily life in the camp.

Food and tobacco—among the key commodities for bartering within the camp—were smuggled in by members of the local Czech police. Through this pipeline, the artists managed to sneak works out to a Czech art collector, Leo Strass.[36] Several works found their way to Switzerland, encouraging the artists to intensify their efforts. Artists also hid a large portion of their remaining artwork inside the walls and under floorboards of their barracks. Friends buried some two hundred works by Fritta, and Leo Haas hid more than four hundred works within the walls of the Magdeburg barracks.[37]

Following the discovery of the smuggled artwork and shortly after the Red Cross visit, the four artists were rounded up and sent to the cellar of SS camp commandant Karl

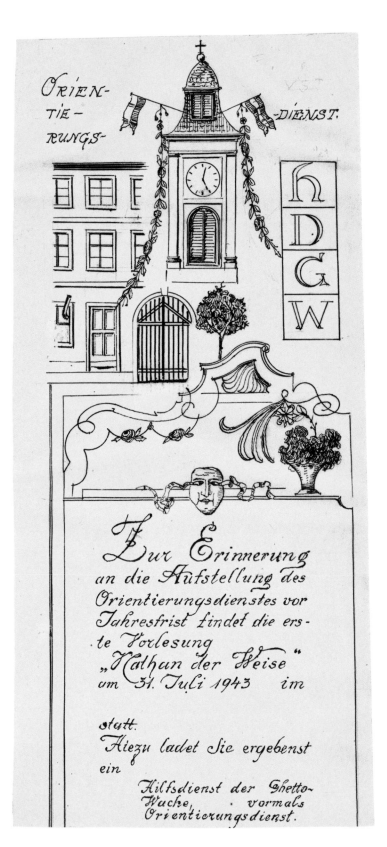

31. Poster. *Vorlesung* Nathan der Weise (*Orientierungsdienst*). J. Loeb (architect). HCPT #3774. *One of more than 2,500 lectures presented in Terezín. In University Over the Abyss, Elena Makarova, Sergei Makarov, and Victor Kuperman list 520 lecturers who gave 2,430 lectures in Terezín from 1942 to 1944. See makarovainit.com/list.htm.*

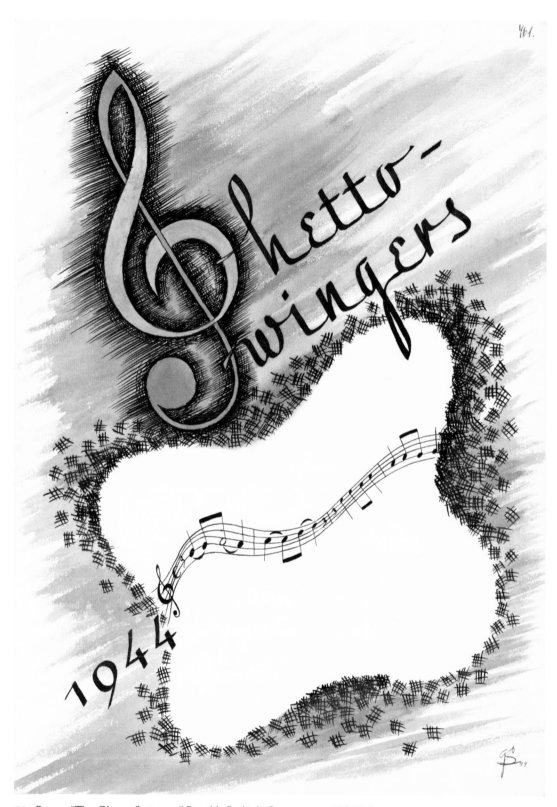

32. Poster. "The Ghetto Swingers." Possibly Bedřich Graus. 1944. HCPT #3967.

38

Rahm's headquarters, where Leo Strass, the Czech art collector, was already imprisoned. Rahm, camp inspector Karl Bergel, SS officers Ernst Möhs and Hans Günther, and Adolf Eichmann began the interrogation of the four artists on July 17, 1944. They sent them to the Small Fortress with their spouses and children (three-year-old Thomáš Taussig and seven-year-old Zuzana Ungarová) for further interrogation and torture. There they beat Felix Bloch to death and crushed Ungar's drawing hand. Haas, Fritta, and Ungar[38] were sent to Auschwitz. Fritta perished there, and Haas was ultimately liberated, the sole artist to survive.[39] In a parallel to the Heřman story that follows, Haas returned to Terezín after the war and recovered his and Fritta's hidden artwork.

As the production of the film came to a close in late August of 1944, Heřman became aware of the impending transports to Auschwitz and of his own vulnerability.[40] With the help of another prisoner, he began hiding his collection in the floorboards and woodwork of the barracks in late summer. He and Marie were placed on Transport Ev to Auschwitz on October 28. Marie was subsequently sent to Bergen-Belsen, then to Raguhn (a sub-camp of Buchenwald), and finally back to Terezín, where she remained until its liberation on May 8, 1945. Marie returned to Prague with the collection. Karel Heřman was liberated from Auschwitz on January 26, 1945. He made his way to Prague, where on June 1, 1945, he was miraculously reunited with both Marie and the collection.

Heřman had a history of being overweight coupled with high blood pressure. After suffering from a severe heart attack in late 1952, he died on October 20, 1953. Marie oversaw the collection until the early 1970s, when she sold most of it to Památník Terezín (the Terezín Memorial Ghetto Museum). In 1972, Památník Terezín designated it the Heřman Collection.

The collection is testament to Karel Heřman's vision and commitment to documenting the rich cultural community in this concentration camp for future generations. It also shows his dedication to facilitating and organizing many of these activities for his fellow prisoners in the face of great suffering and ultimate annihilation.

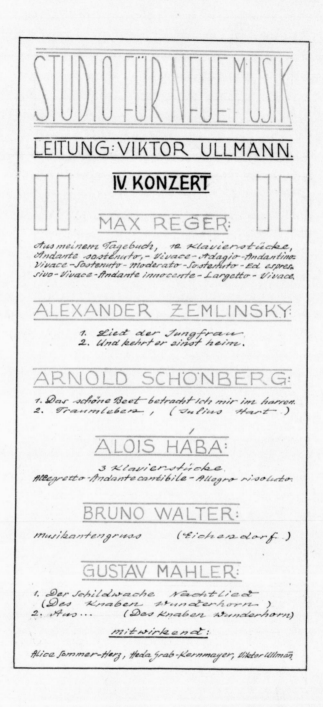

33. Poster. *Studio für neue Musik, Leitung: Viktor Ullmann. IV. Konzert.* HCPT #3951. *The fourth program featured works by three of Ullmann's mentors, Arnold Schönberg, Alexander Zemlinsky, and Alois Hába.*

THE COMPOSER AND CRITIC: VIKTOR ULLMANN

The Heřman Collection includes a poster announcing a concert directed by Viktor Ullmann [image 33]. This event was the fourth in a series of chamber music concerts titled *Studio für neue Musik* (Studio for New Music) which Ullmann started in Terezín. Its program featured works by Alexander Zemlinsky, Arnold Schönberg, Alois Hába, Bruno Walter, and Gustav Mahler.[41] All five composers were firmly established among the major forces in early twentieth-century classical music. Ullmann had deep musical and personal connections with Schönberg, Zemlinsky, and Hába dating back to his studies as a teenager in Vienna during the closing years of the Austro-Hungarian empire.

Ullmann was born in 1898 to Jewish parents who were married in the main synagogue in Vienna in 1896.[42] As newlyweds, they were baptized and remarried in a Catholic church, likely in order to further the career of Viktor's father, Maximillian Georg, as an officer in the Austro-Hungarian army. Ullmann and his parents spent almost ten years in the garrison town of Teschen[43] before Viktor moved with his mother, Malwine Marie née Bilitzer, to Vienna. His studies at the gynasium were coupled with lessons in piano with Eduard Steuermann and music theory and composition with Josef Polnauer, a student and teaching assistant of Arnold Schönberg. These two teachers would introduce him into the Schönberg circle (a.k.a. the Second Viennese School of classical music).

Ullmann's education was interrupted by the outbreak of World War I. He served in Italy and was awarded a Silver Medal for action during October 1917 on the Isonzo Front.[44] Near the end of the war, he was promoted to Lieutenant of the Reserves and, at his father's insistence, enrolled as a law student at the University of Vienna. But he soon abandoned law to resume studies in piano and composition. In 1918, he entered the Composition Seminar of Arnold Schönberg. That same year, Schönberg formed the *Verein für Musikalische Privataufführungen* (Society for Private Musical Performances) and invited Ullmann to serve on the excutive committee with his teachers Polnauer and Steuermann and composers Alban Berg and Anton Webern, both prominent disciples and figures in the Schönberg school.

From 1918 through much of the 1920s, Ullmann's professional and personal life was increasingly drawn into the Schönberg orbit. On May 24, 1919, he married Marta Koref, another student in the Seminar. The newly married couple moved to Prague, where, at Schönberg's recommendation, Ullmann assumed the responsibilites of *répétiteur* and choirmaster in the New German Theater under Zemlinksy's direction. Zemlinksy, a well-established conductor and composer, was closely bonded to Schönberg as both colleague and brother-in-law. Zemlinsky gave Ullmann a conducting position at the Theatre, which Ullmann held from 1922 to 1927. The mid-twenties were a period of great promise for Ullmann as a composer, conductor, and pianist. A photograph taken in 1924 shows him nonchalantly seated at Schönberg's fiftieth birthday party, smoking and exuding an air of confidence and comfort within this elite musical circle [image 34].

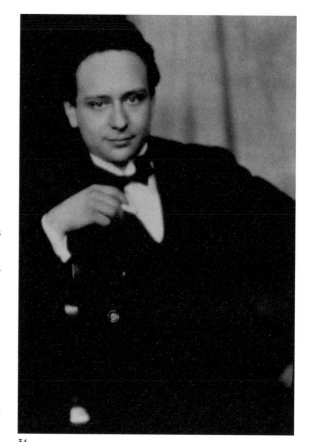

34. Photograph of Viktor Ullmann at Arnold Schönberg's fiftieth birthday party. Vienna. 1924. PT #4780

35. The *Kindertransport* form, and photograph of Viktor and Anna Ullmann's daughter, Felicia. ZM.

36. Photograph of Johannes and Felicia Ullmann in Bristol, United Kingdom following their arrival on the last of Nicholas Winton's *Kindertransports* from Prague. 1940–41. Courtesy of the collection of VUF.

37. Photograph of (left to right) Maximillian, Felicia, and Johannes Ullmann in Prague, 1939 before their separation on the August 2, 1939 *Kindertransport*. Courtesy of the collection of VUF.

34

Following his years in Prague, Ullmann held conducting posts in the opera-theatre house in Aussig[45] from 1927 to 1928, and at the Zürich Schauspielhaus from 1929 to 1931. Like Zemlinksy, he juggled composing with the demands of his conducting duties. Several of his works were well received on their premieres. Most notably, he earned critical acclaim for a performance of his Variations and Double-Fugue on a Theme by Schönberg for solo piano op. 3a at the 1929 International Society for Contemporary Music's (ISCM) World Music Days festival.[46] This paved the way for performances of the work in several major European cities, thereby elevating his profile on the classical music scene internationally. Despite these successes, Ullmann would soon enter a period of great professional and personal conflict.

As a composer, Ullmann struggled to find his voice beyond the confines of the Schönberg twelve-tone system. He envisioned a lyrical style blended with with tonality, an approach similar to that taken by his friend Alban Berg.[47] Amid this struggle, Ullmann would become an ardent follower of Rudolf Steiner's anthroposophical teachings. While at the 1929 ISCM festival in Geneva, he traveled to Dornach to see the recently completed Goetheanum.[48] The visit had a profound effect on him. Within two years, he became a member of Steiner's following.

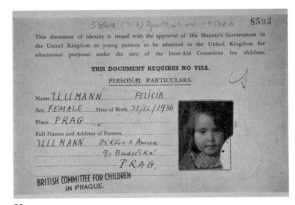

35

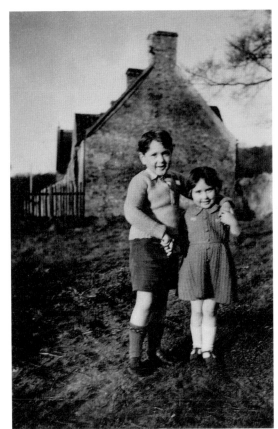

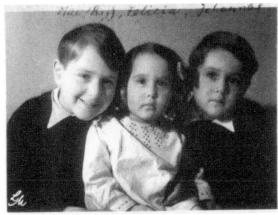

37

36

Five months after his divorce from Marta[49] in mid-April 1931, he married Anna (née Winternitz), whom he had met through the anthroposophical movement. From 1931 to 1933 the couple worked in and eventually took ownership of the anthroposophical book shop Novalis in Stuttgart. Ullmann devoted himself to studying Steiner's teachings. He would later declare that the Stuttgart experience "led [me] back to music."[50]

When the Nazis came into power in January 1933, the Ullmanns became double targets as both anthroposophists and residents of Jewish origin. Their bookstore had failed, deepening their already precarious financial situation. It is not difficult to see how the threatening political climate and their personal finances forced the Ullmanns to flee Germany for Prague in 1933.[51]

The return to Prague marked Ullmann's last years as a free man. He eked out a meager living as a freelance pianist and conductor, lecturer, part-time critic,[52] and composer. His final major successes were the 1936 Emil Hertzka Prize[53] for his opera *Der Sturz des Antichrist* (*The Anti-Christ*) and attending the 1938 performance of his String Quartet No. 2 op. 7, at the International Society for Contemporary Music's World Music Days festival[54] held in London. Once again, Ullmann continued on to visit the Goetheanum in Dornach following the festival. It would be his last travel abroad.

By 1938, with the impending threat of Nazi occupation of Czechoslovakia, Ullmann focused much of his energy on seeking emigration visas for his family, which now included two sons, Maximillian and Johannes, and a daughter, Felicia. On August 8, 1939, Viktor and Anna were able to place Felicia and Johannes on the last of the Kindertransports to England arranged by Sir Nicholas Winton.[55] The couple would have one more child, a son, Paul, born on November 21, 1940, in Prague [images 35–37].

By September 1941, music performed and composed by Jews was forbidden in the Protectorate. Ullmann, like other Jewish artists, circumvented the prohibition of public and radio appearances by performing under pseudonyms in secret salons. One such salon, which Ullmann frequented on Sunday afternoons, was hosted by acclaimed pianist and future Terezín survivor Alice Herz-Sommer and her husband, Leopold.[56] Ms. Herz-Sommer later recalled Ullmann as "a terribly polite man … almost to a fault. He was proper, yet elegant. I remember him kissing the hands of the women he met. Ullmann was shy, but an extremely engaging and knowledgeable man."[57]

In August 1941, Anna and Viktor divorced. Two months later, Ullmann married Elisabeth Frank-Meissl. This third marriage was likely an effort to forestall deportation to Terezín.[58] But the couple was deported on Transport Bf on September 8, 1942.[59] Anna, Maximillian, and Paul were already in Terezín.[60]

Ullmann's prominence as a composer and pianist, and his service in World War I, likely exempted him from labor details in the camp, a status and privilege that laid the groundwork for what would be his most productive period of composing. Survivor Eliska Kleinová recalled, "Ullmann seemed to thrive within the walls of Terezín. He demanded much of himself and the musicians."[61] As Ullmann himself wrote,

> Theresienstadt was and is for me a school of form… Earlier, when one did not feel the impact and burden of material life because comfort—this magic of civilization—suppressed it, it was easy to create beautiful forms. Yet, in Theresienstadt, where in daily life one has to overcome matter through form, where everything musical stands in direct contrast to the surroundings: here is a true school for masters.[62]

In Terezín, Ullmann was active as a pianist, conductor, music critic, and lecturer. As a prisoner, he was free of financial burdens and, ironically, could focus solely on music. It is no surprise that Ullmann emerged among the most active members of the *Freizeitgestaltung*. He was the founding director and on occassion the pianist for two concert series, the *Collegium musicum* and the *Studio für neue Musik*.

The *Collegium musicum* programmed a Baroque repertoire. The *Studio für neue Musik* focused on twentieth-century works, presenting an opportunity to hear music composed by fellow prisoners in the camp. Ullmann was a prolific composer in Terezín, writing vocal works (with piano or string trio accompaniment), choral arrangements, three piano sonatas, a string quartet (no. 3 op. 43), the chamber opera *Der Kaiser von Atlantis*,

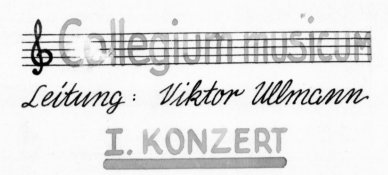

362

Collegium musicum

Leitung: Viktor Ullmann.

I. KONZERT

WILH. FRIEDMANN BACH — 1710 — 84
2 POLONAISEN IN DUR, IN E5 — MOLL

JOHANN MATTHESON — 1681 – 1764
VIOLINSONATE ADAGIO -ALLEGRO MODERATO·
ANDANTE-GIGA

Arien von:

Antonio Caldara — 1670 - 1716
Georg Friedrich Händel 1685 - 1759
Niccolo Piccini — 1728 - 1800
Giovanni Paisiello - 1741 - 1816

Joh. Christian Bach — 1735 - 82
2 Klavierstücke Adagio - Allegretto
Joh. Christian Bach:
Violinsonate Allegro - Rondo
Wilh. Friedemann Bach
Klaviersonate in C-Dur, Allegro -Grave-Vivace

Mitwirkend: Steiner-Kraus, Schwarz-Klein,
Fröhlich, Ferenz Weiss, Ullmann.

38. Poster. *Collegium musicum, Leitung: Viktor Ullmann, I. Konzert.* HCPT #3949.
A Baroque concert series organized by Ullmann.

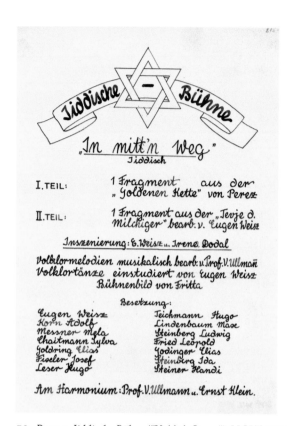

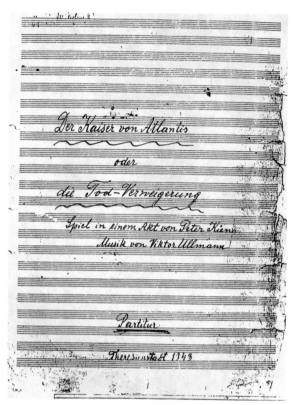

39. Poster. *Jiddische Bühne* ("Yiddish Stage"). HCPT #3918. *The poster announces a program of Yiddish theatre with folk melodies arranged by Viktor Ullmann. Ullmann and Ernst Klein each performed on the harmonium.*

40. The title page of the score for Viktor Ullmann's opera *Der Kaiser von Atlantis oder Die Todverweigerung* (*The Kaiser of Atlantis or Death Abdicates*). Original manuscript. ZM #319a. *The score was completed in Theresienstadt in 1943 with the libretto by František Petr Kien. Ullmann convincingly mixes jazz, cabaret, popular, and classical music with references to Bach, Mendelssohn, Mahler, and Suk. His scoring—reflecting the challenge the composer faced working with the instruments and instrumentalists at hand—imaginatively calls for the unusual combination of flute (doubling piccolo), oboe, B-flat clarinet, alto-saxophone, trumpet, tenor-banjo, cembalo (doubling piano), harmonium, percussion, two violins, viola, cello, and double bass. The Lautsprecher (Loudspeaker)—one of a cast of seven characters—describes the opening scene where Death and Harlequin "sit and watch the world go by, this world where the living have forgotten how to laugh and the dying how to die." Der Trommler (the drummer) interrupts Death's lamentation that "new Angels of death are here to replace me." She announces Emperor Überall's (Emperor Over All's) declaration of universal war with Death as his ally. Death is offended by the Emperor's cavalier assumption of an alliance and refuses to allow anyone to die. The Loudspeaker announces, "Thousands are wrestling with life… doing their best to die." A Young Lady shoots a Soldier from the opposing side. Unable to kill one another, they fall in love. To break the life-death stalemate, Death offers to return the universe to its original order in exchange for the Emperor's life. Ultimately, and with reservation, the Emperor agrees. The opera concludes with the cast singing a chorale: "Teach us to keep your holiest law: Thou shalt not use the name Death in vain now and forever!" There is a biblical air of what amounts to the declaration of an "Eleventh Commandment," only this commandment is authored by man, not God. Ullmann and his librettist, František Petr Kien, provided their fellow prisoners and future generations with a musical parable embracing death as "the greatest freedom." There is also no mistaking the reference to Hitler, as the Emperor's name, Überall, echoes the first line of the Third Reich's anthem, "Deutschland, Deutschland über alles." Although this opera was rehearsed, the Jewish Council of Elders did not permit its performance in the camp, fearing repercussions from the Nazis. In an interview (November 1991 in Prague) with Mark Ludwig, Terezín survivor Karel Berman, who sang the baritone role of Death, recalled that lookouts were posted during the rehearsals to warn of an unexpected visit by Nazi guards.*

incidental music, a *Don Quixote* overture, and the melodrama *Die Weise von Liebe and Tod des Cornets Christoph Rilke* (The Lay of the Love and Death of Cornet Christoph Rilke) [images 38–40].

Ullmann and other Terezín composers—Gideon Klein, Pavel Haas, Hans Krása, and Sigmund Schul—were all promising voices abruptly and brutally silenced. Their compositions, both before and during their time in Terezín, stand as significant contributions to twentieth-century classical music. With his surviving series of twenty-six *Kritiken* (critiques), Ullmann reaches beyond the confines of time and the walls of Terezín to share with us the world in which this legacy was created.

Ullmann had previous experience as a freelance critic in Prague during the mid-1930s. He was part of a tradition of well-known composers, including Hector Berlioz, E. T. A. Hoffmann, Robert Schumann, Richard Wagner, Paul Dukas, and Claude Debussy, who also wrote music criticism.

Surviving *Freizeitgestaltung* and Heřman collection documents and survivor testimonials help us answer several questions about the twenty-six Terezín music critiques. To start, for whom was Ullmann writing? Unlike his esteemed predecessors, he was not addressing the readership of a periodical. And we cannot be certain that the critiques were intended for his fellow prisoners. It is more probable that Ullmann—with the support of the *Freizeitgestaltung*[63]—wished to chronicle and in a sense tragically memorialize many of the doomed artists around him.

Yet the twenty-six critiques go far deeper than chronicling the performers, repertoire, and venues of the selected performances.[64] With great detail, Ullmann often describes the difficulty of producing these programs in such challenging circumstances. His critiques are tempered with touches of humor and juxtaposed with dark reminders of the context of uncertainty in the camp.

In the "Švenk Première" critique, for instance, Ullmann writes of an evening when:

"Shake well before use" isn't the medicine, but the patient. After one and a half hours of laughing, it is entirely impossible to raise any critical objections.

In a more ominous moment, he reminds us that:

The peculiar fate of our chamber music societies has the quality of a meteor: it briefly flashes promisingly and then disappears. In each new case, it is only to be desired that it may be different this time. And this time it would be particularly disappointing if there would be only a promise without a consequence.[65]

He also respectfully, and often with a tinge of admiration, shares insights into each performer's creative strengths, whether technical or interpretive. Generally, he was a

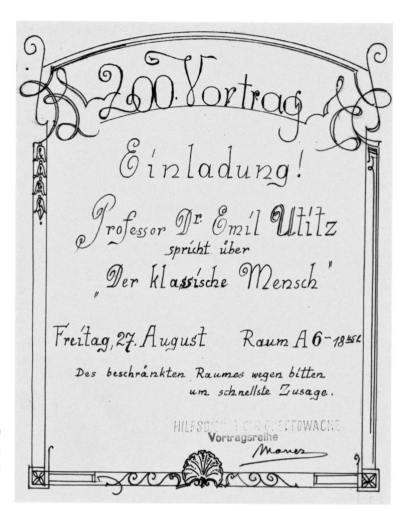

41. Poster. *200. Vortrag Einladung!*
HCPT #3772. *An invitation to
Professor Emil Utitz's lecture "The
Classical Man" presented in Room A6
at 18:45 on Friday, August 27, 1943.*

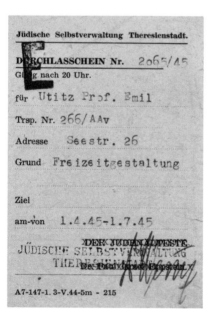

42. An official pass issued by the Theresienstadt Jewish Self-Administration permitting Professor Emil Utitz free access to move within the Large Fortress for *Freizeitgestaltung* activities from April 1 to July 1, 1945. ZM #450401. *Professor Emil Utitz was director of the Ghettozentralbucherei (Central Ghetto Library) from the opening on November 17, 1942, until its closure shortly following the liberation of Terezín. Utitz later wrote: "Now began the liquidation of the camp. We took charge of the proper packing of our stocks of books in many hundreds of boxes. The books with the stamp "Ghettobücherei" will however, recall this library again and again throughout decades or, perhaps, centuries." (Utitz's recollection in "The Central Ghetto Library in the Concentration Camp Terezín" from the book* Terezín, *published by the Council of Jewish Communities in the Czech Land, in 1965. Page 266.)*

48

gracious and appreciative critic, and even when critical he tended to offer suggestions in a supportive tone:

> *It is surprising that Fritz Königsgarten hasn't yet discovered his voice. It is like a gold ore in a mine shaft: Once he forgets his carefully studied mezza voce and allows a natural tone to resound—an uncontrolled, high tone such as in Schubert's "Doppelgänger" and its climax—then, to the astonishment of his listeners, Fritz Königsgarten's true voice emerges with violent pain. It is one of those rare, metallic voices of the Italian hero. After a couple of years of studying bel canto in Italy he would soon be heard singing Radames and Othello.[66]*
>
> *Bermann is also exceptionally talented as a conductor, although we would recommend him to have control over his movements—as multi-faceted as this charming artist is, we don't want to employ him as a dancer as well.[67]*

The critiques cover chamber music, solo piano and vocal recitals, and choral, opera, and cabaret programs. They reflect a highly sophisticated level of musical knowledge and appreciation, as well as the mind of a polymath deeply versed in history, music, literature, philosophy, religion, politics, and the arts. His critiques bring us into the company of a similarly gifted cultural community.

The majority of these extraordinary artists would perish in the final transports East. Hans Krása, whose symphony had been performed by Leopold Stokowski and the Philadelphia Orchestra, and with Serge Koussevitsky and the Boston Symphony Orchestra, in the mid 1920s; Pavel Haas, the prized pupil of Leoš Janáček; and Gideon Klein, whom survivors would remember as "our young Leonard Bernstein," were placed on Transport Er to Auschwitz with Viktor Ullmann on October 16, 1944.

In yet another surreal twist, Ullmann began and closed his life within the confines of two Austro-Hungarian garrisons. His final act as a composer and critic was to place his musical manuscripts and writings into the care of Dr. Emil Utitz, the head of the Terezín Ghetto central library.[68] Wearing a transport card around his neck and the Star of David on his coat, Viktor Ullmann, composer, pianist, conductor, critic, father, and husband, was now identified only as transport number 946. Upon their arrival in Auschwitz on October 18, he and his wife Elisabeth were sent directly to the gas chambers[69] [images 41–44].

> *I would only like to emphasize that my musical work was fostered and not inhibited by Theresienstadt, and that we in no way merely sat around lamenting by the banks of Babylon's rivers, and that our desire for culture was equal to our will to live.[70]*

This was Ullmann's credo. Its spirit courses through the critiques, artwork, and music you are about to experience.

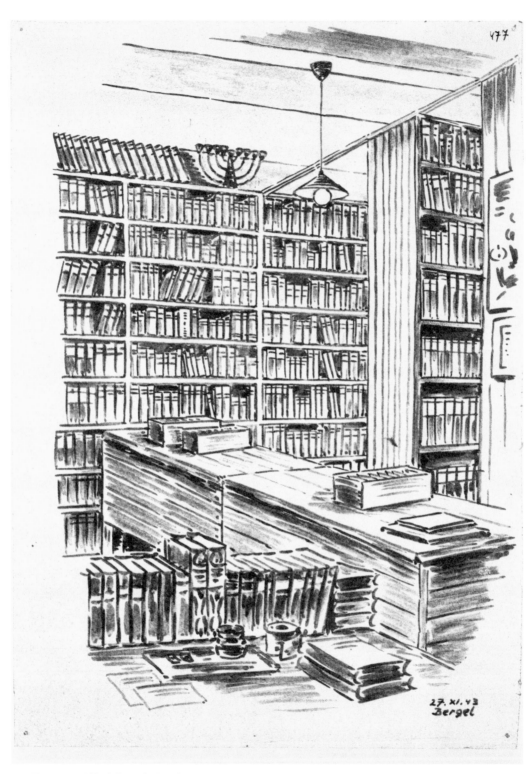

43. Drawing. Alfred Bergel. October 27, 1943. HCPT #4285. *Shown here is the Ghettozentralbucherei (Central Ghetto Library) in L304. The library was later moved, in 1944, to the L504 to accommodate both the growing number of volumes and the beautification efforts for the Red Cross visit and propaganda film production.*

Annotations

1 Theresienstadt in German, Terezín in Czech.

2 Maria Theresa was known for her religious intolerance, particularly towards the Jews. Terezín survivors Edgar Krasa and Karel Berman recalled one of the wry comments circulated within the camp: "If Maria Theresa knew that Theresienstadt was a concentration camp for the Jews, she would roll over in her grave in both delight and disgust." (From interviews with Mark Ludwig, November 1991).

3 Nineteenth-century Greek independence figures Alexander Ypsilantis and Georgios Lassanis were imprisoned in Terezín from 1820 to 1827.

4 The assassination of the Archduke and his wife, Countess Sophie, in Sarajevo on June 28, 1914 sparked World War I. Princip died of tuberculosis in the Small Fortress of Terezín on April 28, 1918.

5 For purposes of consistency and in consideration of the Czech people and Terezín survivors, this book uses Terezín, and Theresienstadt only when it appears in quotations, titles, or descriptions of images.

6 Statistics from Památník Terezín.

7 Terezín prisoner statistics provided by Památník Terezín.

8 These horrific conditions are borne out by the following statistics of incidences of disease in Terezín from December 1941 to 1945: between 50,000 to 60,000 cases of enteritis, 9,000 of epidemic conjunctivitis, 3,000 of hunger edema, 2,500 of spotted fever, 2,100 of tuberculosis, 2,000 of epidemic jaundice, 1,900 of scarlet fever, 1,300 of typhus, 1,100 of erysipelas, 1,100 of diphtheria, 1,100 of measles, 1,000 of encephalitis, 900 of phlegmon, and 25 of spinal polio. Further chilling statistics are the 273 suicides and 211 reported attempts during this period. (From *Theresienstadt 1941–1945*. H. G. Adler, 1960, 619.)

9 Excerpted from the many recorded talks Edgar Krasa gave when he presented Terezín Music Foundation (TMF) education programs in the United States. Edgar was one of TMF's most passionate and dedicated educators for close to twenty years. He was imprisoned in Auschwitz and Gleiwitz and was shot on a death march and taken for dead by a Nazi guard, which ultimately led to his liberation in January 1945.

10 Dr. Erich Springer, chief ghetto surgeon in Terezín, stated that the "population density was fifty times that of pre-war Berlin."

11 There was a succession of three men who led the Council as "Elder of the Jews": Jakob Edelstein (Czech), Paul Eppstein (German), and Rabbi Benjamin Murmelstein (Austrian), the only one to survive. On June 24, 1944, Edelstein was forced to witness the execution of his wife and twelve-year-old son before being shot in Crematorium III. Eppstein was arrested and executed in the Small Fortress on September 27, 1944. The Terezín SS sadistically quipped: "Edelstein, Eppstein, Murmelstein—stone [German: *stein*] by stone by stone, we will build a Jewish wailing wall." (Mark Ludwig interviews with Edgar Krasa and George Horner.)

12 **Petr Fischel** was assigned transport number 162 on **Transport Ev** to Auschwitz, where he died on October 28, 1944.

13 It is estimated that one percent survived.

14 The prisoners referred to it as the *Schleuse* [sluice]. Survivor Dagmar Lieblová recalled preparing for the transport to Terezín: "My parents had us wear many clothes. Everything was doubled—my stockings, underwear, blouses, dresses, and a coat. My parents thought that if you have many clothes on your body, so you will keep it. They thought someone could take your luggage or it could get lost, perhaps not what you have on your body." (From Mark Ludwig interview on December 8, 2017 in Prague.)

15 From Mark Ludwig interviews with Terezín survivor Eliska Kleinová from 1991 to 1994. Kleinová was the sister of Czech composer Gideon Klein, a leading musical figure in the Terezín musical

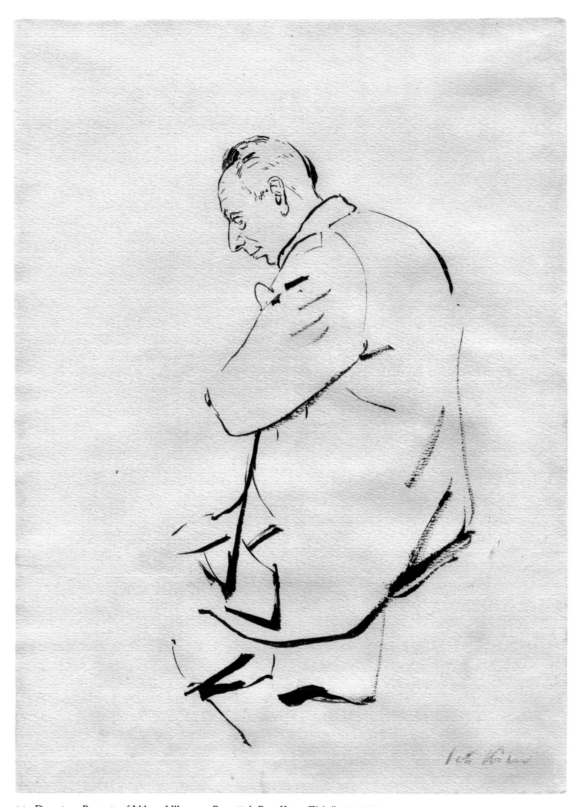

44. Drawing. Portrait of Viktor Ullmann. František Petr Kien. ZM #174.302.

community. She was an accomplished pianist and music teacher before and after the War. The story of the cello was further confirmed in conversations with Pavel Kling. He also noted that the Ghetto gendarmes, who sorted through the incoming bundles, would turn a sympathetic blind eye to smuggled items. Karel Berman (interviews with Mark Ludwig, November 1991 and May 1992 in Prague and Terezín) recalled that the Ghetto gendarmes were often bribed.

16 By November 1942, the Nazi SS command formally instituted the *Freizeitgestaltung*.

17 Violinist Pavel Kling in a conversation with Mark Ludwig on October 6, 2004.

18 Terezín already had a history of deception before the International Red Cross Committee and the propaganda film production in 1944. Many German Jews considered high-profile—those distinguished in the arts, sciences, and business as well as decorated World War I veterans—were transported there with the promise of luxury accommodations and health care. The Nazis stripped these people of their remaining assets by selling fraudulent "home purchase contracts" [German: *Heimeinkaufvertäge*] in *Theresienbad* [Eng: Terezín spa]. An earlier film titled *Ghetto Theresienstadt* was produced in the fall of 1942 for internal Nazi SS use. The plot line followed the journey of a fictional Jewish family, the Holländers, as they were transported and assimilated into Terezín.

19 Many Terezín survivors called the film "The Fuhrer Presents the Jews with a City."

20 From a Mark Ludwig interview with Edgar Krasa: "The children were coached to say, 'Chocolate again, Uncle Rahm?' for the coming Red Cross committee visit. Most of them didn't even know chocolate. They had never tasted chocolate. They said the same thing when given bread with butter and jam."

21 A term appearing in Hitler's anti-Semitic screed, *Mein Kampf* (*My Struggle*), and subsequently throughout Nazi propaganda.

22 From a Rossel report translated from French to English sent from Bern, Switzerland to John W. Pehle, Executive Director, War Refugee Board, Washington, D.C., dated October 26, 1944.

23 Dawidowicz, Lucy. "Bleaching the Black Lie: The Case of Theresienstadt." *Salmagundi* No. 29 (Spring 1975): 125–140. Skidmore College, 1975.

24 Including the filming and Red Cross visit, fifty-five performances of *Brundibár* were given in Terezín.

25 The Czech poet Emil A. Saudek (1876–1941) rewrote the finale. English translation by Joža Karas, Tempo Praha, 1993.

26 Gerron was placed on **Transport XXIV/4**, No. 247 from Westerbork to Terezín, February 26, 1944. He was on **Transport Ev**, No. 1284 on October 28, 1944 to Auschwitz, where he was murdered in the gas chambers.

27 This was part of a larger Nazi *Entartete* (Degenerate) policy that sought to purge German art and music of "decadent" elements. The policy was a sordid mix of pseudo-science, racial theories, anti-Semitism, and the NSDAP's ideology of Aryan supremacy. Two exhibitions were mounted to educate and indoctrinate the German public. The *Entartete Kunst* (Degenerate Art) exhibition opened in Berlin on July 19, 1937, followed by the Düsseldorf exhibition of *Entartete Musik* (Degenerate Music) on May 24, 1938. The NSDAP newspaper *Rheinische Landeszeitung* proclaimed that "just like the exhibition of Degenerate Art in the case of the visual arts, a clear decision in the field of music as to what is and was sick, unhealthy, and in the highest degree dangerous and hence to be stamped out." Atonal music, jazz, and all works by composers of Jewish origin were arranged in seven galleries with listening booths. Ironically, gallery four, which highlighted Weill's "Mack the Knife," was closed down by the Nazis due to its popularity.

28 The final editing and completion of the soundtrack to the film was completed in March 28, 1945. Four screenings took place the next month. Terezín Commandant Karl Rahm, Hans Günther, K. H. Frank, and several other high-ranking SS officers viewed the film in Prague on April 6, 1945. The film was then shown three more times in Terezín for delegations involved in talks seeking the possible release of prisoners. In 1964, surviving fragments of the film re-appeared in what was then still Czechoslovakia. [Karel Magry's article titled "Theresienstadt (1944–1945): The

Nazi Propaganda Film Depicting the Concentration Camp as Paradise," in *Historical Journal of Film, Radio and Television*, Vol. 12, No. 2 (1992): 154.]

29 Following the war, the Herrmanns changed their family name to Heřman.

30 Heřman was transport number 546 on **Transport J** on December 4, 1941.

31 During this period Heřman hosted a few lectures in his office, Room 92.

32 Jana Štefaniková's essay "Karel Hermann's Activities in Theresienstadt in the Years 1941–1944" notes the temporary suspension of performances in the attic due to the "great cold of December 1943."

33 The *Tagesbefehl* (Daily Orders) lists Heřman as presenting a lecture on hockey (Room 105) during the week of Feb 28–March 4, 1944 and as the organizer of a ping-pong tournament (Room 104) on May 3 and 4, 1944 [image 23].

34 Many of these documented programs were produced in the Hamburg barracks.

35 Karel Heřman commissioned several artists to create *Erinnerungsblatt* (English: dedication sheet) to chronicle recent events in the Hamburg barracks. A good number were rendered during the spring and summer months of 1944. Several bear signatures of participating artists with dedications, many to Heřman.

36 While overseeing the kitchens in the camp, Edgar Krasa provided artists and musicians with extra rations. In an interview with Mark Ludwig on May 24, 1996, Edgar recalled: "I gave Haas, Fritta, and several others food … some extra bread, margarine, jam, whatever I could to help record our misery. I gave food to Schächter, Berman, and people I sang with."

37 Leo Haas. *The Affair of The Painters of Terezín*. Terezín: Council of Jewish Communities in the Czech Lands, 1965, 158–60.

38 Until his death in Buchenwald, Ungar tried to draw with lumps of charcoal. (Ruth Bondy. *"Elder of the Jews" Jakob Edelstein of Theresienstadt*, 348). Ungar's wife, Frída, and their daughter, Zuzana, were liberated in Auschwitz.

45. Drawing. String quartet in Terezín. Ferdinand Bloch. ZM #174665.

39 From Auschwitz, Haas was sent to Sachsenhausen, where he was assigned to a unit counterfeiting English currency and Allied documents, and then to Mauthausen, and finally to Ebensee, where he was liberated. Haas's wife, Erna, and Fritta's wife, Hansi, and son, Thomáš, were held in solitary confinement in the Small Fortress for nearly a year. Hansi died there in February 1945. After the war, Leo and Erna Haas adopted Thomáš.

40 As Chief of the Evidence Office of District II, he was involved in the logistics of placing prisoners from the Hamburg barracks on transports to Auschwitz. He most certainly knew of the torture and interrogation of Haas, Ungar, Fritta, and Bloch.

41 All five composers in this program were among those targeted in the Nazi *Entartete Musik* (Degenerate Music) policy. In one of many surreal aspects of life in Terezín, far greater artistic freedom existed within the walls of this concentration camp than throughout Nazi Germany and occupied countries.

42 It was known as both the Seitenstettengasse Temple (the address was Seitenstettengasse 4, Vienna) and the Stadttempel (City Temple). The temple was consecrated on April 8, 1826 and was the only synagogue in Vienna to survive total destruction during Kristallnacht and World War II.

43 Now called Český Těšín.

44 Also known as the Battle of Caporetto, this was the final of twelve battles in World War I mounted between the Austro-Hungarian and Italian armies along the Isonzo River (in present-day Slovenia). The two armies suffered tremendous casualties: 728,754 soldiers died in the twelve offensives from June 23, 1915 to November 18, 1917. (1914–1918 Online International Encyclopedia of the First World War: www.1914-1918-online.net)

45 Now known as Ústí nad Labem in the Czech Republic.

46 The festival was hosted Geneva from April 6 to 10. The famous French Impressionist composer Maurice Ravel served on the festival's jury selection committee.

47 Max Bloch, who had studied with Ullmann in Prague from 1933 to 1938, refers to a "1938 note" written by Ullmann stating: "It seems that I was always striving for a twelve-tone system on a tonal basis, similar to the merging of major and minor keys. I am indebted to the Schönberg school for strict, i.e. logical structures and the Hába school for refinement of melodic sensitivity, the vision of new formal values, and the liberation from the canons of Beethoven and Brahms." (Max Bloch. "Viktor Ullmann: A Brief Biography and Appreciation." *Journal of the Arnold Schönberg Institute* Vol. III Number 2 (October 1979): 162–165).

48 Rudolf Steiner was the founder of the Anthroposophy Society. The Goetheanum is the international center of the Anthroposophical Society located in Dornach, Switzerland. Steiner was the architect for both the first and second Goetheanums. The first was destroyed by fire. Built in concrete, the second Goetheanum is regarded as an important example of early twentieth-century architectural engineering. The society was banned in Nazi Germany in 1935. "Anthroposophy is a philosophy founded by the nineteenth-century esotericist Rudolf Steiner that postulates the existence of an objective, intellectually comprehensible spiritual world, accessible to human experience. Followers of anthroposophy aim to develop mental faculties of spiritual discovery through a mode of thought independent of sensory experience." (From Robert McDermott, *The Essential Steiner*, Lindisfarne Books, 2007.)

49 Marta was sent to Terezín on the same transport as Viktor on September 8, 1942. She was sent to Treblinka on **Transport Bu**, where she died on October 8, 1942.

50 In a letter to Albert Steffen dated September 16, 1935, Ullmann wrote: "In 1931, I joined the society, resolving at the same time to lay aside music and dedicate myself to the dissemination of the philosophy of anthroposophy." (Ingo Schultz, *Wege und Irrwege der Ullmann-Forschung*, 1994, 22. The letter is in the Albert Steffen Foundation archives, Dornach, Switzerland). Following Steiner's death in 1925, Steffen (1884–1963) was the second president of the society until his passing in 1963.

51 Noted Ullmann scholar Ingo Schultz uncovered documents showing the financial failure of the Novalis bookstore. Schultz makes the case that finances and the potential ensuing legal issues were the main impetus for their departure.

52 Ullmann wrote essays and criticism mainly for the local German-language periodicals *Der Auftakt* (*The Upbeat*), *Das Montagsblatt* (*The Monday Sheet*), *Deutsche Zeitung Bohemia* (*German Newspaper Bohemia*), and *Musikblätter des Anbruch* (*Music Sheets of the Beginning*).

53 The prize was in memory of Emil Hertzka, former director of the prestigious music publishing house Universal-Edition and a noted champion of contemporary music.

54 The festival was held in London from June 17 to 24. The String Quartet No. 2 op. 7 was performed by the Prague String Quartet. The selection jury included conductors Ernest Ansermet and Sir Adrian Boult, composers Alois Hába and Darius Milhaud, and flutist Johan Bentzon.

55 Being quarantined with a case of the measles, Max was unable to join the Kindertransport. He and his mother, Anna, were sent from Prague to Terezín on **Transport At** on May 7, 1942. Johannes and Felicia were separated shortly after their arrival in the UK. These forced separations, followed by news of their family members' deaths in Auschwitz, would prove an enduring trauma for both children. In what may be a case of both bureaucratic and medical malpractice, Johannes was institutionalized in the Cheddleton Adult Mental Hospital in 1948, where he was heavily medicated and given insulin shock therapy. He was in several institutions until his death in 2010 in a hospital for homeless men. There is very little record of Felicia's fate, other than that she was adopted by a childless couple, the Gilpins, and died of cancer in 2004. Sadly, there was no next of kin to sign her death certificate. Felicia and her brother Johannes were not reunited until he attended her funeral. (From conversation with pianist Jacqueline Cole, director of the Viktor Ullmann Foundation.) Ullmann's Piano Sonata no. 7 (Terezín, August 22, 1944) was dedicated to Maximillian, Johannes, and Felicia.

56 Before their transport to Terezín, Ullmann dedicated his Piano Sonata No. 4 op. 38 to Herz-Sommer. He critiqued several of her performances in Terezín (see Critiques 5, 10 & 25).

57 From one of two conversations between Alice Herz-Sommer and Mark Ludwig.

58 Terezín survivor Eliska Kleinová, the sister of composer Gideon Klein, voiced this speculation in a June 26, 1996 interview with Mark Ludwig.

59 Ullmann was assigned transport number 142.

60 They were sent on **Transport At** from Prague on May 7, 1942. Paul died of tuberculosis in Terezín on January 14, 1943.

61 Interview with Eliska Kleinová (July 3, 1996) and Mark Ludwig.

62 From Ullmann's essay "Goethe and Ghetto," written in Terezín.

63 Since the *Freizeitgestaltung* had access to the scarce writing materials and typewriters Ullmann needed, it is likely he received its official support for this endeavor.

64 Although not in chronological order of their Terezín performance, the Critiques are presented in the order they are archived at the Instituut voor Oorlogs, Holocaust en Genocide Studies, Amsterdam, Netherlands.

65 "Gideon Klein, Paul Kling, Friedrich Mark Piano Trio" Critique.

66 "Fritz Königsgarten *Lieder* Evening" Critique.

67 "A Musical Panorama (II.)" Critique.

68 Should Ullmann not survive the war, Utitz was charged with giving these works to H. G. Adler. Before the Nazi occupation of Czechslovakia, Dr. Emil Utitz (1883–1956) was a professor of psychology and philosophy at Charles University in Prague. In 1947, he wrote *Psychologie života v terezínském koncentračním táboře* (*The Psychology of Life in the Terezín Concentration Camp*).

69 Five days later, Ullmann's second wife, Anna, and their son, Maximillian, were sent to Auschwitz on **Transport Et**, where they shared a similar fate.

70 From Ullmann's essay, "Goethe and Ghetto."

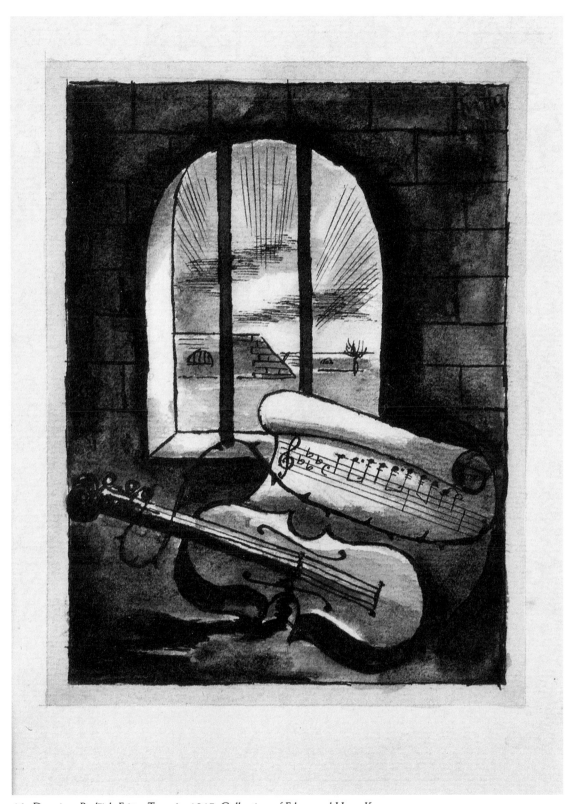

46. Drawing. Bedřich Fritta. Terezín, 1943. Collection of Edgar and Hana Krasa.

Viktor Ullmann

TEREZÍN MUSIC CRITIQUES AND WRITINGS

Annotations by Mark Ludwig

47. Poster. *Freizeitgestaltung*. Heinrich Bähr. 1943. HCPT #4214. *The poster is signed by Hedda Grab-Kernmayer.*

Critique 1
SONGS BY CZECH COMPOSERS

"… of the 20th century," one should add, since only Suk's[1] *"Wiegenlied"* ["Cradle Song"], a charming early work, was an exception (1891). Hence: an evening of songs without Schubert, Schumann, and Brahms.[2] We gratefully owe this to Mrs. Hedda Grab-Kernmayer,[3] the courageous and exceptional interpreter of contemporary music, and her accompanist Dr. Karl Reiner,[4] the well-known pianist and composer. Even though only recently composed music was performed, the audience nonetheless followed with sympathy and growing warmth.

The program began and ended with two of Vitězslav Novák's[5] songs composed thirty years apart: the *"Melancholischen Liebeslieder"* ["Melancholic Love Songs"] (1906) show the master still an epigone—here only *"O Liebe, endlos' Meer"* ["O Love, Thou Bottomless Ocean"] (Vrchlicky)[6] seems truly inspired; the *"Slovakischen Lieder"* ["Slovakian Songs"] (1936) reveal the mature, sculpting mastery of Novák's hand. However: if "spring sang to him" in the former, the *Volksgeist*[7] sang to him in the latter, and the folkloric part of the evening far outweighed the art song[8] in content and richness.

This became immediately clear when Leoš Janáček's[9] *"Mährische Volkspoesie in Liedern"* ["Moravian Folk Poetry in Songs"] was heard, a series of delightful bagatelles[10] elevated to high art by perfected mastery. Here, the singer and her accompanist found an appreciative subject for their interpretation, while the composer was given the expansive, big, yet supple voice, the heartfelt yet natural expression of Mrs. Grab-Kernmayer, and the crystal clear and solidly musical playing of Dr. Karl Reiner, who hopefully won't have us wait much longer for his first solo piano recital. The remaining program offered beautiful songs by Josef Suk—which did not, however indicate any hint of the later mastery of *Asrael*[11] and the other colossal symphonic paintings—and the cycle *"Vergängliches Glück"* ["Transitory Luck"] by K.B. Jirák,[12] which to me seems dispensable and in such surroundings probably should have been dropped. And yet: in every sense a successful and appreciatively welcomed evening [images 47–51].

V. I.

Lieder tschechischer Komponisten

....." des 20. Jahrhunderts" wäre zu ergänzen. denn
nur Suks "Wiegenlied" ein anmutiges Jugendwerk bildete
eine Ausnahme (1897) Also ein Liederabend ohne Schubert,
Schumann und Wolf Brahms. Dankbar quittieren wir dies Frau
Hedda Kab-Kernmayr, der mutigen und ausgezeich-
neten Interpretin zeitgenössischer Musik und ihrem
Begleiter, Dr. Karl Reiner, dem bedeutenden Pianisten
und Komponisten. und obwohl es nur neuere Musik
gab, folgte das Publikum dennoch mit Anteilnahme
und steigender Wärme.

Das Programm war eingerahmt von Liedern
Vitězslavs Nováks, die durch einen Zeitraum von 30 Jahren
getrennt sind: die "melancholischen Liebeslieder" (1906)
zeigen den Altmeister nicht als jugendlichen Epigonen (freilich)
— hier ist doch wohl nur "O Liebe, endlos Meer.. wirklich
inspiriert -; die "slovakischen Volkslieder" (1936) lassen
sie zu bildnerischer Meisterschaft gereifte Hand Nováks
erkennen. Allerdings: Was dort "der Lenz für ihn
sang" die das singt hier der Volksgeist für ihn; und
der folkloristische Teil des Abends überwog diesmal das Kunstlied an Wert und Fülle bei Weitem.

Dies war denn auch zugleich entschieden, als man
Leoš Janáček's „Mährische Volkspoesie in Liedern"
hörte, reizvolle Bagatellen, durch vollendete
Meisterschaft zum Range hoher Kunst erhoben.
Hier fanden auch Sängerin und Begleiter
in Glück ein dankbares Objekt ihrer Interpretation,
wie der Komponist umgekehrt die umfangreiche, große
und doch schmiegsame Stimme, die empfindene
und doch natürliche Expression der Frau Kab-
kenmayr und das Kristallene, urmusikalische
Spiel Dr. Karl Reiners, der uns nun hoffentlich
seinen ersten Klavierabend nicht länger schuldig
bleiben wird.
Der restliche Teil des Programms bot zwei
schöne Lieder Josef Suk's, die freilich keinen
Begriff vom Meister des „Asrael" und der
übrigen symphonischen Kolorialgemälde geben,
und den Zyklus „Vergängliches Glück" von K.B. Jiràk,
der mir entbehrlich scheint und in solcher Umgebung
wohl auch abfallen müsste. Dennoch: Ein in jeder
Beziehung gelungener und dankbar begrüßter Abend.

Viktor Ullmann

48. Viktor Ullmann's original manuscript of Critique 1. 2 pages. NIOD.

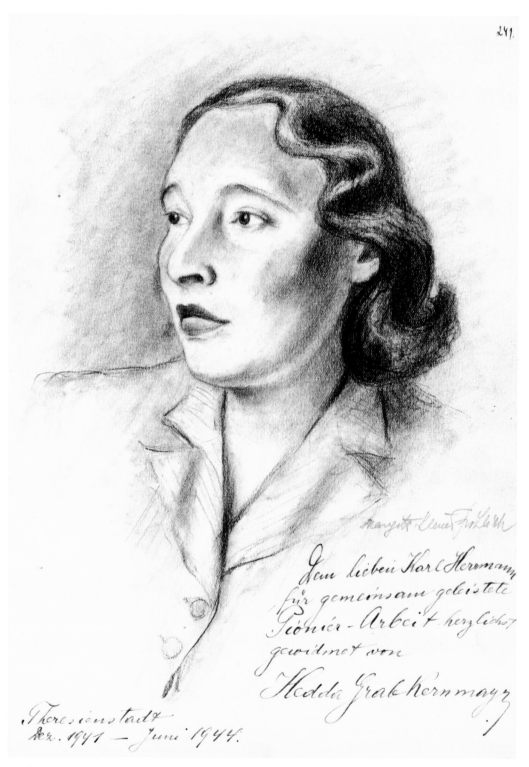

49. Drawing. Portrait of Hedda Grab-Kernmayer. Margareta Kleiner-Fröhlich. HCPT #4061. *The dedication reads, "Affectionately dedicated to dear Karl Herrmann for our pioneering work together by Hedda Grab-Kernmayer. Theresienstadt Dec. 1941–June 1944."*

C III/Saal 105 . 21.März 1942

I. Bunter Nachmittag .

Leitung : Hedda Grab-Kernmayer
Musik.Begleitung : Wolfgang Lederer
 Otto Fröhlieh

Von der Thorarolle bis zur Zeitung Marie Adler

 2 Biblische Lieder v.A.Dvořák H.Grab-Kernmayer

Rezitationen Trude Adler

Bewegungs-Studie /Tanz/ Hanka Meisel

2 Schubertlieder Emmy Zeekendorf

Tsehechische Polka getanzt von 6 Mädchen
der Zeekendorf-Gruppe

Dasselbe Programm wiederholt am 28.III.1942

50. Poster. *I. Bunter Nachmittag* ("A Colorful Afternoon") in C III Room 105 on March 21, 1942. HCPT #4215.

C III/ Saal 105 4.April 1942 .

Pürglitzer Abschiedsprogramm .
———————————————————————

Leitung : Hedda Grab-Kernmayer
Musik.Begleitung: Wolfi Lederer
 Otto Fröhlich

Parodien auf Maria Stuart Gertrude u.Marie Adler
/Marionetten/

Teče voda Gerta Harpmann
Jásej ptáčku aus d.Oper
Hubička v.B.Smetana

Humoristische Chansons Erna Salten

Arien aus "Studně" und "Carmen" Hedda Grab-Kernmayer

Ungar.Tanz v.Brahms Hanka Meisel

Dieses Programm wiederholte man immer in 3 Schichten
am 11.April 1942 .

51. Poster. *Pürglitzer Abschiedsprogramm* ("Pürglitzer Farewell Program") in C III Room 105 on April 4, 1942. HCPT #4216.

Annotations

1 **Josef Suk** (1874–1935). Czech composer, violinist and pedagogue; student of Antonín Dvořák (1891–1892), whose daughter, Otilie, he later married. Suk was a professor of composition at the Prague Conservatory, his alma mater, and second violinist of the Czech String Quartet [Critiques 1, 7, 14, 24].

2 **Franz Peter Schubert** (1797–1828) [Critiques 1, 4, 8, 14, 15, 19, 23]; **Robert Schumann** (1810–1856) [Critiques 1, 6, 9, 11, 25]; and **Johannes Brahms** (1833–1897) [Critiques 1, 5–9, 21]. The large repertoire of works by these composers represents the pinnacle of German Romantic *lieder* (song) and was a staple of vocal recitals in Ullmann's time.

3 **Hedda Grab-Kernmayer** (Hedvika Kernmayerová) (1899–1990) (**Transport N** from Prague on December 17, 1941). Czech opera singer (alto) who participated in the *Kameradschaftsabende* (Comradeship Evenings) and later the *Freizeitgestaltung* (Free Time Activities Organization, also known as the Recreation Office [H. G. Adler]) during her incarceration in Terezín. She was among the few artists to remain in Terezín until its liberation on May 8, 1945 [Critiques 1, 26].

4 **Karl (Karel) Reiner** (1910–1979) (**Transport De** from Prague on July 5, 1943) (**Transport Ek** to Auschwitz on September 28, 1944). Czech composer and pianist. Reiner studied law at the German University in Prague and musicology at the University of Prague. At Prague Conservatory, he attended Suk's master classes in 1931 and Alois Hába's courses in microtonal music from 1934 to 1935. After his liberation in Dachau, Reiner became a composer and pianist in Prague [Critiques 1, 9, 10, 13].

5 **Vitězslav Novák** (1870–1949). Czech composer. Novák's music is generally noted for its connection to German Romanticism and Czech patriotic themes [Critiques 1, 6, 9].

6 **Jaroslav Vrchlický**, a pseudonym of **Emil Bohuslav Frida** (1853–1912), a Czech writer, poet, and translator, and author of the text for "O Love, Thou Bottomless Ocean" [Critiques 1].

7 *Volksgeist* (national character) is a German Romantic term connoting the idea that each nation has its own particular "special genius" (J. G. Herder) expressed through language, folklore, mores, and legal order.

8 **Art Song** is a genre of classical settings of poems, generally for voice and piano, and displays the symbiotic relationship between music and language.

9 **Leoš Janáček** (1854–1928). Czech composer, music educator and theorist, and folklorist. At the time Ullmann was writing, Janáček, Dvořák, Smetana, and Suk were the towering figures in Czech music [Critiques 1, 7, 8, 15].

10 **Bagatelles** are generally short solo works expressing a mood, setting, or idea.

11 *Asrael* **Symphony** in C Minor op. 27 was inspired by the loss within fourteen months of the two dearest people in Suk's life, his mentor and father-in-law Antonín Dvořák, and his wife, Otilie. During the First Czech Republic (1918–1938), this symphony was often performed at times of national mourning. During his incarceration in Terezín, Ullmann would use the death motif from *Asrael* in his opera *Der Kaiser von Atlantis* [Critiques 1, 7].

12 **Karel Boleslav Jirák** (1891–1972). Czech composer and conductor [Critique 1].

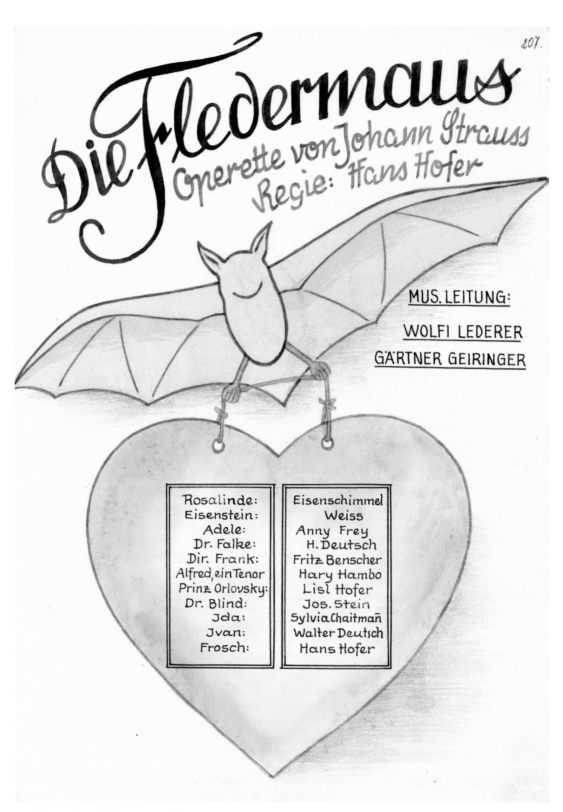

52. Poster. *Die Fledermaus.* Possibly A. Aussenberg. HCPT #4045. *Poster for the operetta directed by Hans Hofer.*

Critique 2
DIE FLEDERMAUS[1]

It was Adele, Johann Strauss's second wife, who convinced the skeptical and recalcitrant king of waltzes to try his—and therefore our—luck at writing operettas for the stage. For this we are grateful to her, because we have *Zigeunerbaron* [*The Gypsy Baron*], *Eine Nacht in Venedig* [*A Night in Venice*], and *Die Fledermaus* [*The Bat*]. In this and all of Johann's other operettas, the waltz is certainly the unacknowledged central motif around which everything else revolves; and rarely—except for the indestructible and ingeniously inspired waltzes—are there passages that couldn't have been written by another talented composer. From a formal point of view, Johann Strauss was and remains imperfect and unscrupulous. The blessed and blissful 3/4 meter carries him above all the unevenness of his scarcely developed formal instinct (even the canon *"Brüderlein und Schwesterlein"* ["Brother and Sister"]—with its lovely melody—and the unfortunately much too brief tercet *"Hier steh' ich voll Zagen"* ["Here I Stand Full of Doubting"] in the third act of *Die Fledermaus,* cannot disguise this). Johann Strauss: that's the *Fledermaus* waltz, the "Tête-à-Tête" waltz, and the appealing notice of *"Mein Herr Marquis…"* of the "Emperor's Waltz," the *Rosen aus dem Süden* [*Roses from the South*], the "Patzman Waltz," and so forth.

We in Theresienstadt look with a certain amount of disillusionment at this world, at this society, whose main supporters often sway disturbingly back and forth and who are perpetually more or less tipsy. We have long understood that the motto of the world is no longer "amusement" as it was during our grandfathers' time; beyond these last descendants of Harlequin and Columbine[2] we see as the historical and cultural future that we have experienced in our past. Much too much euphoria and wine, women, and song it was—dancing on the tombs of the future and at our expense. We take a sip of this champagne—but we remain sober.

The Theresienstadt performance, for which we owe gratitude to the initiative of the young, talented, and ambitious Wolfgang Lederer,[3] is a performance worthy of being seen and heard. To be seen: because of the delightfully improvised stage sets created by Adolf Aussenberg[4] and the colorful and humorous costumes by Eva Kohner;[5] to be heard: because we have a "cast" that would be equally successful at any other good theater as it was with our audience. Annie Frey,[6] the experienced and charming *soubrette,*[7] whose brilliant voice has lost none of its appeal; Nelly Eisenschimmel,[8] who gave the part of Rosalinde the advantage of her beautiful, well balanced voice; Kurt Weisz,[9] our excellent *bon vivant,* who took upon himself the sacrifice of singing just a little something for us—and very musically too; Liesl Hofer[10] as Orlofsky, discreet and yet effective. They were joined by Dr. Georg Běhal,[11] Fritz Benscher,[12] H. Hambo[13] and, as the prison guard, "Frog" Hans Hofer,[14] whose father I had seen previously in that same role—I believe his son looked even deeper into his drinking glass. The text was revised by Wilhelm

U. Z # Die Fledermaus

I Es war Adele, Johann Strauß' zweite Gattin, die den
zweifelnden und widerstrebenden Walzerkönig überredete, sein
und damit unser Glück auf der Bühne zu versuchen und Operetten
zu schreiben. Wir sind ihr heute dafür dankbar, denn wir haben
den „Zigeunerbaron", die „Nacht in Venedig" und „die Fledermaus".
Freilich ist in allen diesen und allen anderen Operetten
Johanns der Walzer das unerschöpfliche Motiv, um das oder nach dem sich alles dreht; und
selten finden sich neben den unverwüstlichen und
genial inspirierten Walzer Stellen, die wohl auch
von einem anderen begabten Komponisten sein
könnten. Formal betrachtet ist Johann Strauß stets
unvollkommen und skrupellos geblieben. Der
selige und seligmachende 3/4 - Takt trägt ihn über
alle Unebenheiten seines wenig entwickelten
Formengefühls hinweg. Worüber auch der Kanon
„Brüderlein und Schwesterlein" (mit seiner wunder-
schönen Melodie) und auch das leider so kurze
Terzett, Hier steht ist voll Fugen des II. Fledermaus- Aktes
nicht hinwegtäuschen kann. Johann Strauß: das ist
der Fledermaus- Walzer, der Tête-a-tête-Walzer und der

53. Viktor Ullmann's original manuscript of Critique 2. 5 pages. NIOD.

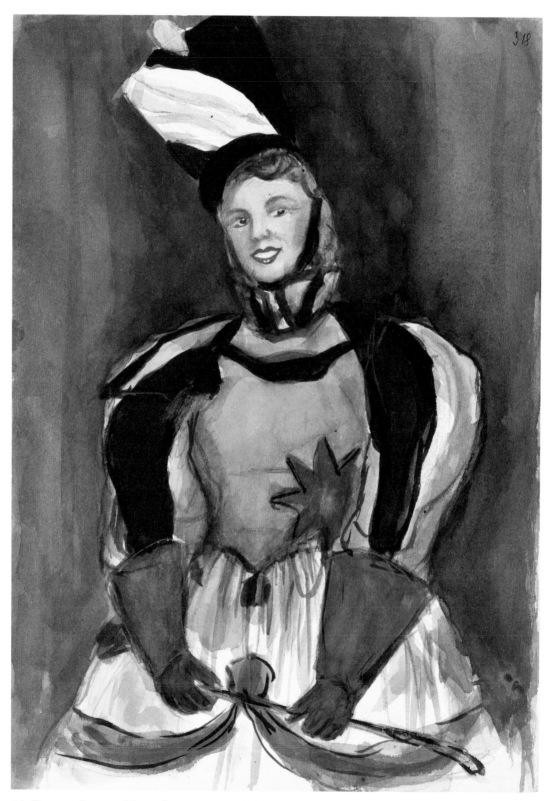

54. Drawing. Portrait of Annie Frey in costume. HCPT #4184.

Sterk[15] and enriched with satyr games, improvisations, motivations, of which the old text by Haffner and Genée[16] was in dire need!

The accompaniment was, naturally, the most serious problem given the circumstances of our theatre; after all, if our various salon orchestras had been combined, they would have formed a nearly complete theater orchestra, which would have been the better solution. The piano—played by none less than Renée Gärtner-Geiringer[17]—certainly performed its function impeccably; but the combination with the harmonium remains problematic, even if Wolfgang Lederer's great skill tempted woodwind sounds from it. The Overture—or more accurately the introductory potpourri—can't really resonate if performed this way. The production was musically clean and flawlessly rehearsed, and staged by Hofer with humor and tempo.

There remains the question whether *Die Fledermaus* was suited to our needs; I know: two hours of Johann Strauss, "immortal waltzes" etc. But there is a rather well-known Jewish operetta composer, who consistently was shortchanged outside of Theresienstadt as well, even though he gave the world *Hoffmann's Erzählung* [*The Tales of Hoffmann*]: Jacques Offenbach. We don't want *Beautiful Hélène*; but it is precisely the lesser known operettas that contain musical gems: *Madame l'archiduc*, *Perichole*, *The Brigands*, even the *Marriage by the Lanterns*[18]—a charming little one-act operetta. Our operetta company, brought into being by Wolfgang Lederer, has a fertile field to explore here [images 52–57].

Annotations

1 *Die Fledermaus* is a lighthearted operetta by Johann Strauss (1825–1899), the famous Viennese conductor, violinist, and composer known as the Waltz King [Critique 2].

2 **Harlequin** and **Columbine** are traditional characters in *commedia dell'arte*, "artistic comedy." Harlequin was a boisterous response to classic Italian theatre of the second half of the sixteenth century, often a clown in a mask and colorful costume. Columbine was usually a wife, companion, or maid to Pantaloon, an elderly Venetian merchant; her wit and charm contrasted with Pantaloon's unscrupulousness, foolishness, and vanity. Harlequin reappears as one of the central characters in Ullmann's Terezín opera, *Der Kaiser von Atlantis* [Critiques 2, 16].

3 **Petr Wolfgang (Wolfi) Lederer** (1918–1997) (**Transport J** from Prague on December 4, 1941) (**Transport Ek** to Auschwitz on September 28, 1944). Accordionist and pianist. A versatile keyboard musician, Lederer played piano, harmonium, and accordion in jazz, classical, and light music productions in Terezín. He played accordion in one of the earliest noted Terezín performances, a variety show in the Sudeten barracks in December 1941. He was a member of Jazz Quintet Weiss, an ensemble formed in Nazi-occupied Prague and again in Terezín. The quintet included Bedřich Weiss (clarinet), Koko Schumann (guitar, percussion), Paul Libenský (double bass), and Franta Goldschmidt (guitar). Lederer organized and directed a production of the operetta *Die Fledermaus*. He was also the pianist in performances of Beethoven's "Ghost" Trio in D Major and Novák's Piano Trio in G Minor op. 1 with violinist Heinrich Taussig and cellist Paul Kohn. With soloist Karel Fröhlich, he performed in unusual arrangements: on accordion in

the Mozart Violin Concerto in D Major, and on harmonium in the Tartini Violin Concerto in D Minor, the Dvořák Violin Concerto in A Minor op. 53, and Pablo Sarasate's *Zigeunerweisen*. Liberated in Auschwitz [Critiques 2, 6].

4 **Adolf Aussenberg** (1914–1944, Auschwitz) (**No. 476 on Transport X** from Prague to Terezín on February 12, 1942) (**Transport Eq** to Auschwitz on October 12, 1944). Set designer in the film industry in Prague and an amateur painter. Like most graphic and visual artists in Terezín, Aussenberg was assigned to the Technical Department that worked in the drafting room of the Magdeburg barracks. Artists there were largely responsible for designs of construction programs, ghetto graphics, and other projects handed down from the Nazi command through the Council of the Elders. Aussenberg also created sketches for *Freizeitgestaltung* theater productions, cartoons, and depictions of life in the Terezín ghetto. He designed the sets for the production of *Die Fledermaus* [Critique 2].

5 **Eva Kohner** (dates unknown) [Critique 2].

6 **Annie Frey(ová)** (1906–unknown) (**Transport AAp** from Prague to Terezín on July 9, 1942). Actress and singer in Vienna. In Terezín she performed in *Die Fledermaus* and several cabaret productions including Kurt Gerron's *Karussell*. Liberated in Terezín [Critique 2].

7 A *soubrette* is a light-hearted soprano role in comic opera [Critiques 2, 16].

8 **Helena (Nelly) Eisenschimmel(ová)** (1905–1944, Auschwitz) (**No. 100 on Transport De** from Prague to Terezín on July 5, 1943) (**No. 504 on Transport Er** from Terezín to Auschwitz on October 16, 1944). Soprano [Critique 2].

9 **Kurt Weisz** (1894–1944, Auschwitz) (**Transport Cc** from Prague to Terezín on November 20, 1942) (**Transport Er** to Auschwitz on October 16, 1944). Singer [Critiques 2, 4].

10 **Liesl Hofer** (stage name of Alžběta Schulhofová) (1912–1991) (**Transport AAu** from Prague to Terezín on July 27, 1942) (**Transport En** from Terezín to Auschwitz on October 4, 1944). Actress and cabaret singer. She and her husband, Hanuš Schulhof (stage name: Hans Hofer), performed in Terezín cabaret productions. Liberated from Mauthausen [Critique 2].

11 **Dr. Jiří Běhal** (1912–1945, Kaufering, a subcamp of Dachau) (**No. 957 on Transport J** from Prague to Terezín on December 4, 1941) (**No. 48 on Transport El** to Auschwitz on September 29, 1944). Lawyer and amateur actor in Prague. Běhal participated in one of the first documented Terezín performances. He also acted in Viktor Ullmann's incidental music to ballads of French poet François Villon [Critique 2].

12 **Fritz Benscher** (1904–1970) (**No. 7 on Transport VI/8** from Hamburg to Terezín on June 25, 1943) (**No. 1212 on Transport Ek** from Terezín to Auschwitz on September 28, 1944). Liberated in Dachau. Cabaret singer and actor [Critique 2].

13 **H. Hambo** (Harry Hambo, stage name of Harry Hambo Heymann) (1907–1983) (Placed on one of the 1943 transports from Denmark to Terezín). Danish-German clown, cabaret actor, and female impersonator. Tenor. Hambo performed the role of Alfred in the Terezín production

55. Concert ticket.
Die Fledermaus. PT #A13131.

56. Concert ticket. "Opera Evening."
ZM #A7691. *Standing-room-only seating.*

of *Die Fledermaus*. Professor Anna Hájková noted him among the few openly gay prisoners in the camp [Critique 2].

14 **Hans Hofer** (stage name of Hanuš Schulhof, also known as Bedřich Schulhof) (1907–1988) (**Transport AAu** from Prague to Terezín on December 27, 1942) (**Transport Ek** from Terezín to Auschwitz on September 28, 1944). Cabaret actor and singer. Hofer performed in *Die Fledermaus* and directed and produced Hofer cabaret productions with predominantly German casts. He directed one-act plays of Hugo von Hofmannsthal and Arthur Schnitzler in the attic of barracks Q307. In 1944, he worked as an assistant to Kurt Gerron in the production of the Nazi propaganda film. Liberated from Allach [Critique 2].

15 **Wilhelm Sterk** (1880–1944, Auschwitz) (**No. 67 on Transport IV-14** from Vienna to Terezín on January 6, 1943) (**No. 1422 on Transport Ep** from Terezín to Auschwitz on October 9, 1944). Lyricist of Viennese songs and operettas in the early twentieth century [Critique 2].

16 **Karl Haffner** and **Richard Genée**. Librettists for the Johann Strauss operetta *Die Fledermaus* [Critique 2].

17 **Renée Gärtner-Geiringer** (1908–1944, Auschwitz) (**No. 12 on Transport IV-12** from Vienna to Terezín on October 2, 1942) (**No. 660 on Transport Eq** from Terezín to Auschwitz on October 12, 1944). Pianist. Gärtner-Geiringer was an active recitalist, performing more than thirty programs in Terezín. Her recitals included rich and diverse solo repertoire by Bach, Beethoven, Brahms, Chopin, Franck, Haydn, Liszt, Schubert, and Schumann. She performed selections of vocal works by Brahms, Donizetti, Händel, Puccini, Schubert, and Verdi with tenor Machiel Gobets. In *Die Fledermaus*, she performed a piano/reed organ reduction of the orchestral score. Gärtner-Geiringer also provided the piano reduction for performances of Haydn's oratorio *The Creation* [Critiques 2, 19, 22].

18 *Beautiful Hélène, Madame l'archiduc, Perichole, The Brigands,* and *Le mariage aux lanternes* are operettas by French composer **Jacques Offenbach** (1819–1880) [Critiques 2, 17].

57. Drawing. "Singing Male Choir." Charlotte Burešová. HCPT #5520.
Edgar Krasa is the singer in the center.

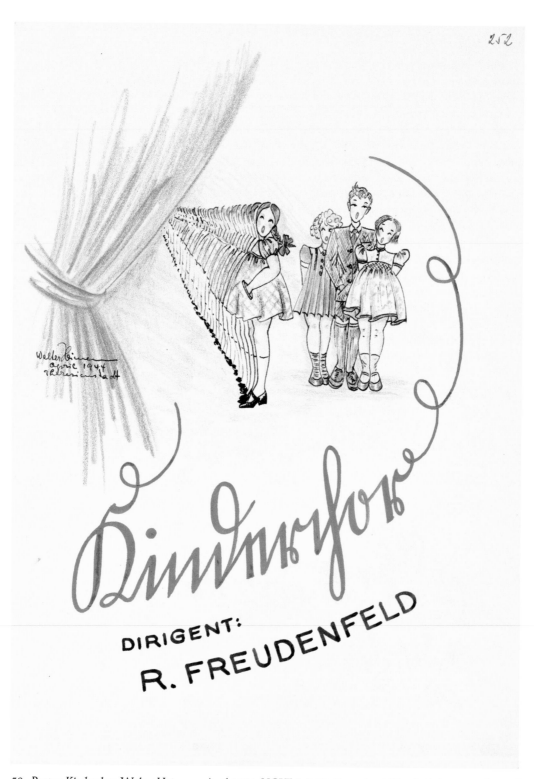

58. Poster. *Kinderchor*. Walter Heimann. April 1944. HCPT #4069. *Poster for children's choir concert directed by Rudolf Freudenfeld. Freudenfeld collaborated on Hans Krása's children's opera* Brundibár *in the Prague Jewish orphanage, Hagibor, and subsequently in Terezín.*

Critique 3
CHILDREN'S CHOIR CONCERT

R. Freudenfeld[1] and his choir, whose achievements with Krása's[2] *Brundibar*[3] will not be forgotten, this time offered us different arrangements (Gideon Klein,[4] Adolf Schächter,[5] Otakar Šín,[6] J.B. Foerster,[7] and so forth) of Czech and Hebrew folksongs. Freudenfeld is a true teacher and a good musician; we are thankful to him, not only for the mostly not-at-all-easy, cleanly rehearsed, and bravely sung three- to four-part chorales, during which the littlest as well as the biggest singers held their own, but also in general for his loving work with the children of Theresienstadt.[8]

On the whole it must be said that those arrangements that ranged within the middle register, which is most suited to children's voices, sounded the best. The falsetto notes in the soprano should generally be avoided. In contrast, the little ones can carry a straight, linear polyphony very well—as evidenced by the many children's songs from different cultural traditions that are composed in the canonical form. A piece arranged for a *Liedertafel*[9] easily causes the children to sing in a way that is physiologically wrong, not only in the case of our own children's choir, but also, for example, in the case of the Wiener Sängerknaben[10] to whom I naturally cannot yet compare our promising children's choir.

The best praise of the critic is probably that he heard his own arrangements of Hebrew melodies[11] performed impeccably [images 58–64].

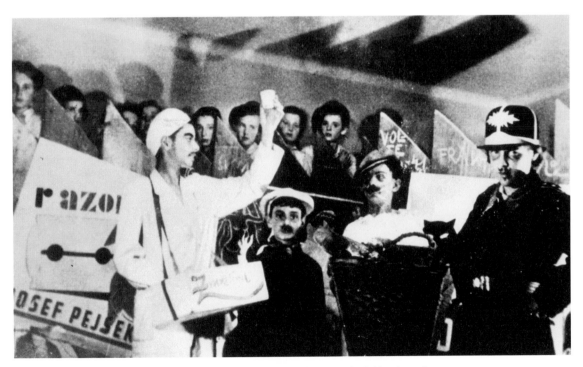

59. Photograph of a performance of *Brundibár* in Hagibor, the Jewish children's orphanage. Prague 1940. ZM #41.443.

Kinderchor-Konzert

R. Freudenfeld und sein Chor, dessen Leistung in Krása's „Brundibar" nicht vergessen wird, bot uns diesmal tschechische und hebräische Volkslieder in verschiedenen Bearbeitungen (Gideon Klein, Adolf Schächter, Otakar Sín, J. B. Förster u.s.f.) Freudenfeld ist ein echter Pädagoge und ein guter Musiker; wir sind ihm dankbar, nicht nur für die zum großen Teile gar nicht so leichten, sauber studierten und tapfer gesungenen 3-4stimmigen Chöre, in denen sich die Kleinen wie die größeren Sänger wacker hielten, sondern auch für seine liebevolle Beschäftigung mit den Theresienstädter Kindern überhaupt.

Im Ganzen muss gesagt werden, dass jene Bearbeitungen, die sich in der den Kinderstimmen angemessenen Mittellage bewegen, am besten klangen. Die Kopfregister-Töne des Soprans sind grundsätzlich zu vermeiden. Dagegen vertragen die Kleinen sehr wohl eine gradlinige Polyphonie, wie denn viele Kinderlieder der Völker im Kanon erfunden sind. Ein Liedertafel-Satz bringt die

60. Viktor Ullmann's original manuscript of Critique 3. 2 pages. NIOD.

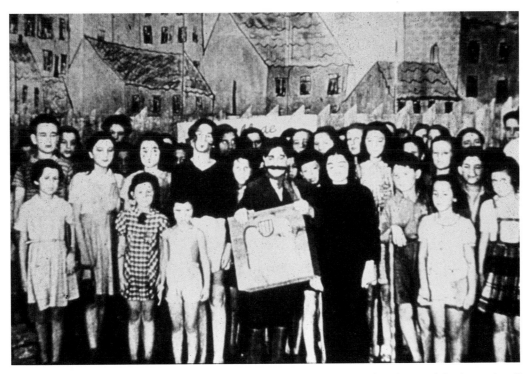

61. Still from the Nazi propaganda film, *"Theresienstadt, A Documentary Film from the Jewish Settlement Area."* Collection of Ela Weissberger and ZM #24750. *This still shows a performance of Hans Krása's children's opera* Brundibár *in the Sokol Hall, Terezín.*

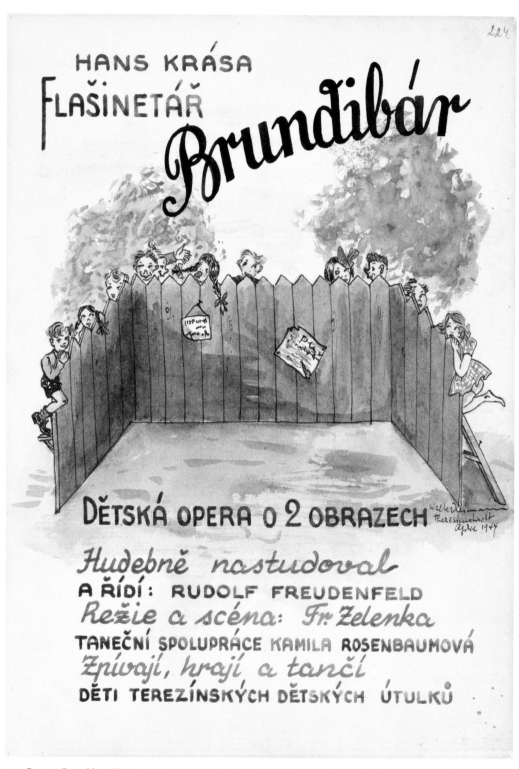

62. Poster. *Brundibár*. Walter Heimann. April 1944. HCPT #4010. *Poster for the production of the children's opera Brundibár by Hans Krása. Heimann incorporates the fence from František Zelenka's set designs for the Hagibor orphanage and Terezín productions.*

63. Poster. Invitation to *Feierabend der Hausältesten* ("End of the House Elders' Workday"). Joseph Eduard Adolf Spier. HCPT #4235. *There were two programs — by invitation only — celebrating the second anniversary of the house for the elders. They took place on the evening of July 15, 1944 in Westgasse 3 (the Sokol House) beginning with the Krása opera* Brundibár *at 19:15 and followed by a performance by the Kurt Gerron Swing Orchestra at 20:30.* Eintritt nur Gegen Karte *in English: Entry only with a card.*

64. Drawing. Illustration showing "The Yard" stage set from Hans Krása's *Brundibár*. HCPT #3921. *Set designed by František Zelenka.*

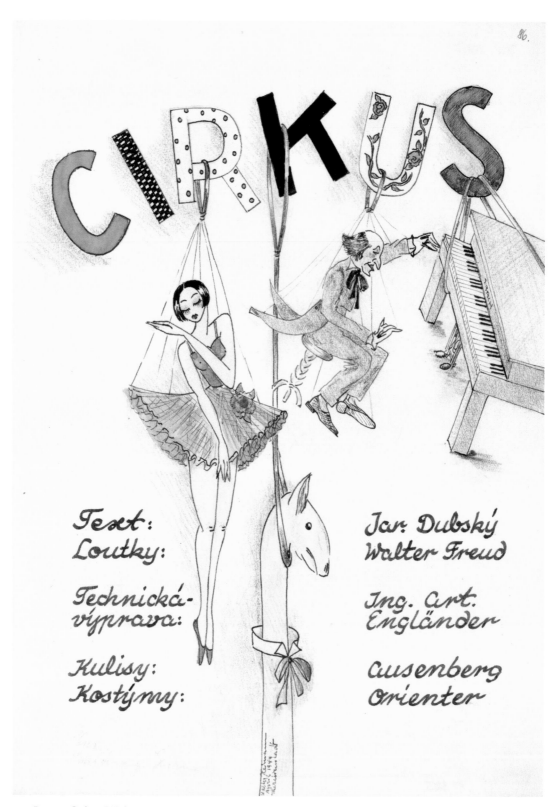

65. Poster. *Cirkus*. Walter Heimann. April 1944. HCPT #3885. *Poster for children's puppet show, Cirkus.*

CHILDREN'S PRODUCTIONS IN TEREZÍN

Productions of music, dance, and text—such as *Brundibár, Cirkus, and Broučci*—were part of a larger effort to entertain and educate the children in Terezín. Formal instruction was largely forbidden by the Nazis. Friedl Dicker-Brandeisová,[12] Fredy Hirsch,[13] Ilse Weber,[14] Valtr Eisinger,[15] and Gonda Redlich[16] were among the many dedicated teachers, counselors and nurses who selflessly risked their lives to care for children who had been thrust into a world of loss, deprivation, and uncertainty.

Within the fortress walls of Terezín, they miraculously constructed programs and projects that served as arts therapy, thereby providing purpose and direction for the incarcerated children [images 65–76].

66. Poster. *Ein Mädchen reist ins gelobte Land—Kinderrevue.* ("A Girl Travels to the Promised Land—Children's Revue") on September 1943. HCPT #4014.

67. Poster. *Simchas Torah, Walter Freud, Wava Schön (a.k.a. Vlasta Schönová).* October 1943. HCPT #3912. *Simchas Torah is a Jewish holiday celebrating the annual completion of reading the Torah and the beginning of a new cycle.*

68. Poster design for Jean Cocteau's monodrama *The Human Voice* (*La Voix Humaine*) with a signed dedication to Karel Heřman by actress Vlasta Schönová. A. Goldman. 1942. HCPT #3794. *Schönová performed the role of Elle, a despairing woman who talks to her lover on the telephone after finding out he is leaving the next day to marry another woman. Before the war, Schönová performed this role in Prague. In Terezín, Schönová acted in and directed several theatrical productions and was involved in children's puppet plays and theatre productions, most notably "Broučci" ("The Fireflies"). Schönová was liberated in Terezín and resumed her career as an actress and director primarily in Israel under the name Nava Shan-Herrmann.*

84

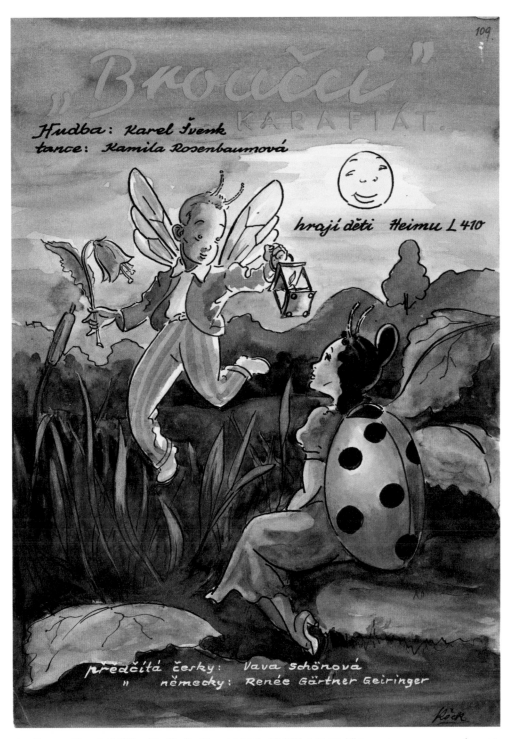

69. Poster. *"Broučci"* (*"The Fireflies"*). Oswald Pöck. HCPT #4299. *This poster announces a dramatic reading in German by Renée Gärtner-Geiringer and in Czech by Vava Vlasta Schönová, with choreography by Kamilla Rosenbaum and music by Karel Švenk. The program was produced in the children's home L410. The production was adapted from the 1876 Czech children's classic Broučci pro malé i velké děti (Fireflies for Small and Big Children) by Jan Karafiát.*

70. Poster. *Wie war Mordechai?* ("How was Mordechai?"). HCPT #3852. *A revue written in German and directed by Walter Freud. It was performed in the adolescents' home Q710 and L410. It was inspired by the biblical story Mordechai and Esther that is traditionally recited on the Jewish holiday Purim.*

71. Poster. "Queen Esther." Children's play written and directed by Michael Flach. HCPT #4040. *The children of Hohenelber barracks gave five performances in March 1942.*

72. Poster. "Hanukkah Game." December 1942. HCPT #4050. *A Hanukkah program written by Walter Freud, directed by J. Goldstein, and performed by the children in the Boys Home L417 and Girls Home L410 with choreography by Greta Wurmová.*

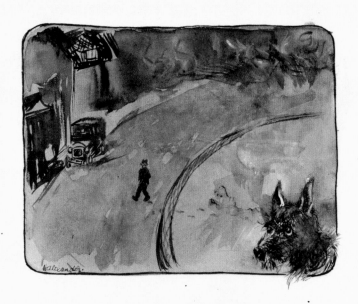

Erich Kästner:
EMIL UND DIE DETEKTIVE

Bearbeitet von Hardy Plaut
Regie: Hardy Plaut

Ausstattung und künstl. Beratung:
 WALTER FREUD

MUSIK: LEO SCHLEIM

Darsteller: Jugendliche d. Heimes L-414

73. Poster for theatrical production of Erich Kästner's children's novel *Emil and the Detectives*. H. Alexander. HCPT #3848. *The event took place in the children's home L414. Musical score by Leo Schleim.*

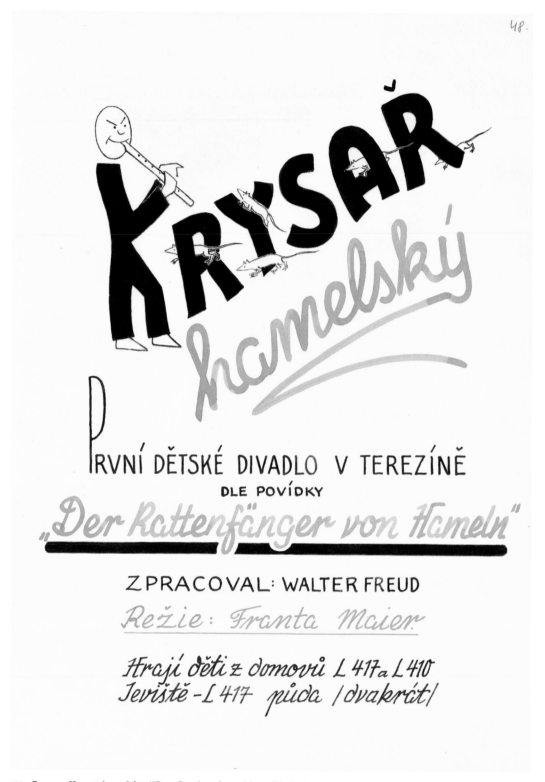

74. Poster. *Krzsař hamelský* ("Rat Catcher from Hamel"). HCPT #4310. *This was the first children's theatre production in children's home L410 and L417. Possibly late 1942.*

Annotations

1 **Rudolf Freudenfeld, Jr.** (1921–1985) (**Transport De** from Prague to Terezín on July 5, 1943) (**Transport Ek** to Auschwitz on September 28, 1944). Amateur conductor and teacher. Freudenfeld conducted the first performance of Hans Krása's children's opera, *Brundibár*, in Hagibor, a Jewish orphanage in Prague. He would later bring Krása's score on the transport to Terezín, where he conducted fifty-five performances of *Brundibár*. Freudenfeld directed the Terezín Children's Choir. Liberated in Gleiwitz. Following the war he changed his name to Rudolf Franěk [Critique 3].

2 **Hans Krása** (1899–1944, Auschwitz) (**No. 67 on Transport Ba** from Prague to Terezín on August 10, 1942) (**No. 940 on Transport Er** from Terezín to Auschwitz on October 16, 1944). Czech composer. In the 1920s his works were largely influenced by two forces in modern classical music: the avant garde and the surrealism of Les Six and the Second Viennese School. Alexander Zemlinsky (Schönberg's brother-in law) was Krása's mentor during and after his studies at the German Music Academy in Prague. Krása served as a vocal coach and assistant conductor at the New German Theatre in Prague, where Zemlinsky was the music director. Despite Krása's limited compositional output, Zemlinsky, Stokowski, Koussevitzky, and Szell conducted performances of his works in the 1920s and 1930s. In 1933, Krása received the Czechoslovak State Prize in Composition for his opera *Betrothal in a Dream*. In Terezín, he was head of the music department of *Freizeitgestaltung*. According to a poster in the Heřman collection, he played Cembalo in Pergolesi's *La serva padrona*. Karel Berman, in his September 2, 1989 testimony recorded by Mark Ludwig, recalled that Rafael Schächter conducted and played the continuo at the rehearsals [Critiques 3, 16, 17].

3 *Brundibár* is a children's opera composed in 1938 by Hans Krása, with a libretto by Adolf Hoffmeister. It was originally intended for submission to a competition sponsored by the Czech Ministry of Education and Culture. After the enforcement of the Nuremberg Racial Laws, the premiere was given secretly in Hagibor, Prague's Jewish orphanage. Krása was already in Terezín, where he rescored the opera for the available instrumentalists. The Terezín premiere took place on September 23, 1943 in the Magdeburg barracks, and the opera was subsequently performed fifty-four times in the camp. In the summer of 1944, a staged performance was given for the International Red Cross Committee's visit, and the opera's finale appears in the Nazi propaganda film *Theresienstadt. Ein Dokumentarfilm aus dem jüdischen Siedlungsgebiet* (referred to by survivors as *The Fuhrer Gives the Jews a City*) [Critiques 3, 17].

4 **Gideon Klein** (1919–1945, Auschwitz-Fürstengrube) (**No. 76 on Transport J** from Prague to Terezín on December 4, 1941) (**No. 944 on Transport Er** from Terezín to Auschwitz on October 16, 1944). Composer, conductor, and pianist. Klein showed extraordinary talent at a young age and studied piano with Vilém Kurz at the Master School of the Prague Conservatory. His studies of musicology and philosophy at Charles University were cut short by the Nazi occupation of Czechoslovakia. During the occupation, he performed in Prague under the name Karel Vránek and studied secretly with Alois Hába, the father of microtonal music. The Nuremberg Racial Laws prevented him from accepting an invitation to study at the Royal Academy of Music in London. He was a major force in the cultural life in Terezín as a composer, pianist, conductor, teacher, and educator, performing solo recitals, chamber concerts, and piano accompaniments to operas, and, most notably, piano reduction in the Verdi *Requiem*. He also performed Brahms and Dvořák piano quartets with Fröhlich, Süssmann, and Friedřich Mark, as well as the Beethoven Piano Trio op. 70 no. 2 and Brahms Piano Trio op. 8 with Mark and Paul Kling. Klein arranged more than a dozen Czech-Slovak and Hebrew folk songs for choirs led by Rafael Schächter, among them *"Bachuri leantisa"* for women's chorus, which marked the beginning of his compositional output in Terezín. Other songs were Madrigal for Two Sopranos, Alto, Tenor and

JUGENDHEIM
L 414

EINLADUNG

An .

Am 4., 5. und 6. September 1943 feiert das Jugend=
heim L 414 ein Fest und bringt verschiedene Darbie=
tungen aller seiner Insassen. Wir laden Sie zu
diesem Feste herzlichst ein und ersuchen Sie, nach Be-
lieben und Interesse wenigstens einige der im beige=
fügten Programm genannten Veranstaltungen zu besu=
chen und einige Feststunden im Kreise unserer Kinder
zu verbringen.

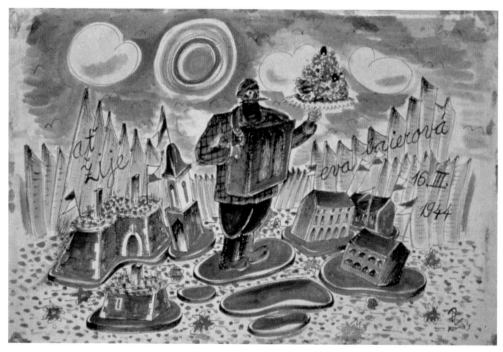

75. Invitation card. *Einladung Jugendheim L414. ZM #430904. An invitation to programs in the Jugend-heim (Children's Home) L414 on September 4, 5, and 6, 1943.*

76. Drawing, dedicated. "To Eva Baierová for her birthday." František Zelenka. 1944. ZM #101370/72. *Zelenka includes the walls and barracks of Terezín within the set designed for Hans Krása's children's opera Brundibár. Eva sang the role of Anika. In the center is Brundibár, the opera's villain. Dated March 16, 1944.*

Bass (1942, text by Villon); "The First Sin" for male chorus (1942); Madrigal for two Sopranos, Alto, Tenor, and Bass (1943, text by Hölderlin); "*Wiegenlied*" for Soprano and Piano (1942); "Fantasie and Fugue" for String Quartet (1943); Piano Sonata (1943); and String Trio (1944). Klein and Hans Krása were assigned to the October 16, 1944 transport to Auschwitz. They entrusted their Terezín manuscripts to Klein's girlfriend, Irma Semecká, prior to their deportation. Following her liberation in Terezín, Ms. Semecká gave these compositions to Klein's sister, Eliska Kleinová. A survivor of Terezín and Auschwitz, Eliska dedicated her life to championing her brother's music. The circumstances and place of Klein's death are unclear, but it is presumed that he died in the Fürstengrube camp in late January 1945 [Critiques 3, 7, 18, 21].

5 **Adolf Schächter** (1900–1944, Auschwitz) (**No. 196 on Transport Bg** from Prague to Terezín on September 12, 1942) (**No. 1968 on Transport Ek** from Terezín to Auschwitz on September 28, 1944). Violinist who performed chamber music and recitals in Terezín; the brother of Rafael Schächter [Critiques 3, 5].

6 **Otakar Šín** (1881–1943). Czech composer who studied with Víteslav Novák at the Prague Conservatory of Music, where he later became a professor of music theory [Critique 3].

7 **J. B. Foerster** (1859–1951). Czech composer and pedagogue. Taught composition at the Prague conservatory (1919–1922) and University of Prague (1920–1936). Named National Artist of the Czech Government in 1945 [Critique 3].

8 Terezín survivor Ela Weissberger recalled, "**Rudy (Freudenfeld)** was God for me. He was very special for all us children in Terezín. You know, I was Rudy's little pet—he always called me 'Kitty' [Ela sang the role of the cat in Hans Krása's opera *Brundibár*]. With music he gave us moments of freedom from the darkness. The songs made us strong. We forgot our troubles, we forgot our hunger and our fear. When we performed *Brundibár* we didn't have to wear the Jewish star. It was a moment of freedom that meant so much for everyone." (From Mark Ludwig interview on January 22, 2005 in Boston.)

9 *Liedertafel* were German and Austrian men's societies for performing four-part vocal music; they started in the early nineteenth century.

10 *Wiener Sängerknaben* (Vienna Boys' Choir) was founded in 1498 by Emperor Maximilian. Gluck, Mozart, Salieri, and Bruckner worked with the choir. Many notable composers and performing artists were members, including Haydn and Schubert [Critique 3].

11 Ullmann's **Hebrew melodies** for children's chorus were "*A'mcha Yisrael,*" "*Halleluja! bezilzele schama,*" and "*Hedad gina ktana*" for boys' chorus (a cappella), completed in Terezín in 1944.

12 **Friedl Dicker-Brandeisová** (1898–1944, Auschwitz) studied and worked in Bauhaus Berlin in early 1920s. She is remembered for her secret programs employing the arts as a means of therapy and education. The surviving works are part of the Jewish Museum in Prague collections.

13 **Fredy Hirsch** (1916–1944, Auschwitz) was a Zionist youth leader and athletics teacher in Terezín and later in the children's block of the segregated Theresienstadt Family camp in Auschwitz II-Birkenau.

14 **Ilse Weber** (1900–1944, Auschwitz) was a nurse in Terezín who wrote poems and songs for the children.

15 **Valtr Eisinger** (1913–1945, death march) inspired the boys in Barracks L417 or Home One (ages 12–15) to create **Vedem** (*In the Lead*), a Czech literary magazine of poems, articles, and drawings. Petr Ginz (1928–1944, Auschwitz) was a contributor and editor-in-chief of *Vedem*. His Terezín drawing of the earth seen from the moon was with Israeli astronaut Ilan Ramon on the ill-fated Shuttle Columbia voyage.

16 **Gonda Redlich** (1916–1944, Auschwitz) was director of the Terezín "Youth Welfare Office." Under the Nazi occupation, Redlich and Hirsch worked together in the Zionist Youth Aliyah school in Prague.

77. Dedication sheet. *Juliette Arányi. Heinrich Bähr. HCPT #4197. The inscription reads, "Dedicated to the genial Karl Herrmann with the warmest affection. Juliette Arányi. Theresienstadt, 17.VI.1944 (June 17, 1944)."*

Critique 4
A MOZART EVENING

Is Mozart[1] popular? Was he in his time? Many masterworks which only later gained popularity owe it to a process of intellectual inflation through which a style that seems strange or even offensive to contemporaries is gradually aligned to suit the aesthetic needs of a great number of people. "The beauty of a work of art begins at that moment when those who are unproductive begin to miss its beauty." (Arnold Schönberg[2]) Thus, Rafael's *Sistine Madonna*[3] hangs in every peasant's parlor; thus, the *Mona Lisa* smiles from countless postcards and poor quality prints; thus, Schubert's noble wealth of melodies is turned into the *"Dreimäderlhaus;"*[4] thus, the hurdy-gurdy man croaks out Verdi's[5] cantilenas—just to give a few examples. In every case—as in the common sentimental misunderstanding of the Romantics—content wins over form, even though form has already eradicated content in the master's process of creation. How much we misunderstand Mozart today—moving in the direction of an anemic, saccharine sweet "Mozärtian"[6] Rococo—is proved by E. T. A. Hoffmann's[7] ingenious *Don Juan* novella, for example, or by the traces of the Mahlerian Mozart tradition, which could be observed under Zemlinsky[8] and Bruno Walter.[9] Or by Lert's book *Mozart auf dem Theater* (*Mozart in the Theater*), where it is quite correctly recognized that hidden under the delicate, gallant wig stands a Shakespeare-like figure, and a demonism controlled by the powers of genius that spark like lightning in almost all his works; they often flash in his letters, and is finally revealed in its entirety in the finale of the second act of *Don Giovanni*.[10] The gallant style is Mozart's mask, as are his knee-breeches and braid, which he wears as a creature of his time—persona means mask—but not as the genius and creator of times to come. How well that is confirmed—for Gustav Mahler[11] and Ernst Lert[12] it was self-evident—by Goethe's[13] remarks to Eckermann:[14] "Mozart should have composed the *Faust*," and by his comments about *Don Giovanni*, in which Goethe rejects the applicability of the term "composing" to Mozart since "nothing seems baked together." How well the fiasco of *Don Giovanni* in Vienna—indeed Mozart's entire biographical image—confirms that we admire Mozart's surface, but not his totality. "Too beautiful for our ears!" was Joseph II's[15] judgement, who considered Mozart a mediocre talent and preferred Dittersdorf.[16]

The G-Minor Piano Quartet (July 1785) is one of those works that have been bestowed with eternal youth. Mozart himself judged: "It's the best I've written in my life."[17] The performance was worth listening to. It was performed harmoniously, clean, distinguished, and from memory by Mrs. Juliette Aranyi,[18] Paul Kling[19] and the gentlemen Süssmann,[20] and Mark,[21] the latter two are well-established presences in our chamber music. Kling was a little timid, but worthy. It was difficult for the Clarinet Trio[22] to assert itself against this standard work, but it was superbly successful. Fritz Weiss[23] is a very good clarinetist; it is astonishing that all his jazz blowing hasn't ruined his tone and embouchure.

Mozart-Abend

Ist Mozart populär?War er es zu seiner Zeit?Viele
Meisterwerke verdanken ihre spätere Beliebtheit einem geistigen
Inflationsprozesse,durch den ein den Zeitgenossen fremder oder
sogar anstössiger Stil allmählich dem Kunstbedürfnis einer grossen
Zahl von Menschen angeglichen wird."Die Schönheit eines Kunstwer-
kes beginnt in dem Augenblick,wo die Unproduktiven sie zu ver-
missen beginnen."(Arnold Schönberg)So hängt Rafaels sixtinische
Madonna in jeder Bauernstube,so lächelt Mona Lisa von unzähligen
Ansichtskarten und schlechten Drucken,so wird Schuberts edler
Melodienreichtum zum "Dreimäderlhaus",so krächzt der Leiermann
Verdis Cantilenen--um nur wenige Beispiele zu nennen.Überall
hier siegt,wie in dem gebräuchlichen sentimentalen Missverstehen
der Romantiker,der Stoff über die Form,die doch jenen im Schaffen
des Meisters schon vertilgt hat.Wie sehr wir heute Mozart miss-
verstehen -nach der Seite des mozärtlichen,blutarmen Rokoko hin-
beweist etwa E.Th.A.Hoffmanns geniale Don Juan Novelle,beweisen
die Spuren der Mahlerschen Mozart-Tradition,die unter Zemlinsky
und Bruno Walter zu erhaschen waren,beweist Lerts Buch "Mozart
auf dem Theater",wo ganz richtig erkannt wird,dass hinter dem
zierlich-galanten Zopfträger eine Gestalt ähnlich der Sheak-
speares steht,eine mit der Kraft des Genies beherrschte Dämo-
nie,die fast durch alle Werke wetterleuchtet,die in seinen
Briefen häufig aufblitzt,die sich endlich ganz in Stücken wie
dem Finale des II.Aktes des Don Giovanni enthüllt.Der galante
Stil ist Mozarts Maske,wie die Beinkleider oder der Zopf,den
er als Geschöpf seiner Zeit trägt-persona heisst Maske- nicht
aber als Genius und Schöpfer künftiger Zeiten.Wie sehr wird
diese-auch Gustav Mahler und Ernst Lert selbstverständliche-
Auffassung bestätigt durch den Ausspruch Goethes zu

94

78. Viktor Ullmann's original manuscript of Critique 4. 3 pages. NIOD.

In the middle was Juliette Arányi's F-Major Sonata. The artist plays—as evidenced in this piece as well as in the care she took with the piano parts of the pieces mentioned above—with a rare rhythmic precision worthy of imitation, as well as an absolute homogeneity in the structure of the passages. Calmly and with a stylistic purity, she stood above her material, perhaps too high above it. An almost ascetic elimination of personality is pushed to the point where it becomes problematic. Thereby, the technical side of her Leimer-method[24] not only invites discussion, but it also raises the question of subjective interpretation in general, from which, after all, the living pulse of performance flows. "The tempo must have undergone a change in the third or fourth bar!" Gustav Mahler once wrote. The agogics[25] must not become mechanical—the metronome is an insinuation of the basic time unit, not a factor of performance.

Juliette Arányi transformed the modern grand piano into a clavichord—very naturally, because we have adapted the "normal" piano technique from the harpsichord, which wouldn't have responded to the Leimer-Gieseking method at all. Thus, the question remains of whether Mozart might not have composed for a different instrument, hence requiring a more robust tone [images 77–84].

UNTERHALTUNGS-MUSIK

CERINI	V.KOHN
BRAMMER	WEISS-QUINTETT
SWING-CLUB	

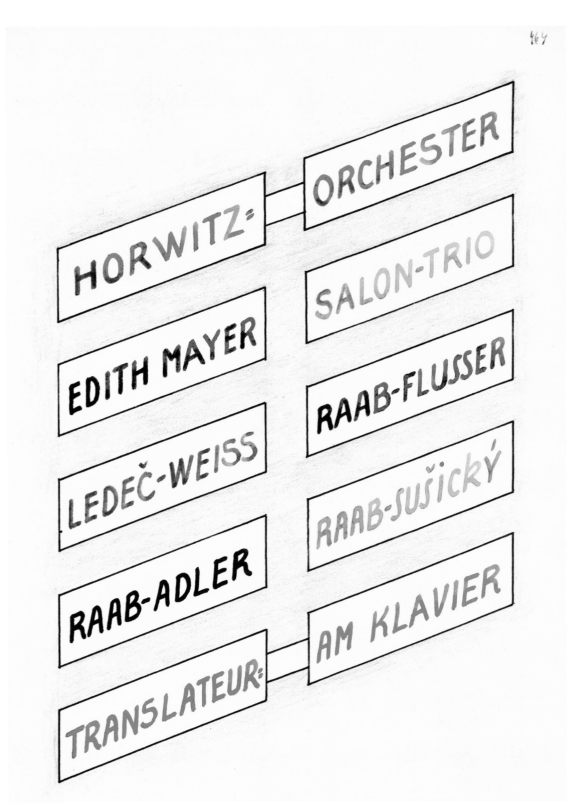

79. Poster (in two sections). *Unterhaltungs–Musik* ("Entertaining Music") with the Weiss Quintet. HCPT #3969.

80. Drawing. Portrait of the clarinetist Bedřich Weiss. Margareta Kleiner-Fröhlich. HCPT #3965.

Annotations

1 **Wolfgang Amadeus Mozart** (1756–1791) [Critiques 4, 9, 10, 14, 16, 17, 21, 22, 25].

2 **Arnold Schönberg (Schoenberg)** (1874–1951). Father of twelve-tone music, which he preferred to call "pan-tonality." His dodecaphonic system became the bedrock for the Second Viennese school which included composers Berg, Ullmann, Egon Wellesz, and Ernst Krenek. In 1925, he was appointed to the faculty of the Prussian Academy of Arts in Berlin. He was dismissed from this position at the beginning of the Nazi regime for his "racial origins (Jewish)." He fled Europe and arrived in New York on October 31, 1933. Schönberg became a U.S. citizen in 1941 and resided in Los Angeles until his death in 1951 [Critiques 4, 8, 11].

3 *Sistine Madonna*: Painting created in 1513 by the master Italian Renaissance artist Raffaello Sanzio da Urbino, or Rafael (1483–1520). The *Sistine Madonna* is the most celebrated of his madonnas; it has been reproduced for generations and appears in homes and churches of the faithful. A portion of the painting showing two *putti* (angels) leaning on the balustrade has become a popular image on postcards, posters, and T-shirts [Critique 4].

4 *Dreimäderlhaus* was a popular Viennese operetta adapted by Heinrich Berté comprising a selection of famous works by Schubert. The operetta in its various formats was a simplistic and superficial attempt to portray Schubert through a medley of his music [Critiques 1, 4, 8, 14, 15, 20, 23].

5 **Giuseppe Verdi** (1813–1901) was one of the masters of nineteenth-century Italian opera [Critiques 4, 18].

6 *"Mozärtian" ("mozärtlichen")*. Ullmann's play on Mozart's name, blending it with the German word *zärtlich*, meaning saccharine.

7 **E. T. A. Hoffmann** (Ernest Theodor Amadeus Hoffmann) (1776–1822) was a famous German writer known primarily for his fairy tales. He was also a composer and opera conductor [Critique 4].

8 **Alexander Zemlinsky** (1871–1942). Austrian conductor and composer. Zemlinsky's sister, Mathilde, was married to Arnold Schönberg, who, along with Mahler, greatly respected Zemlinsky's work. Mahler conducted the premiere of Zemlinsky's opera *Es war einmal* at the Vienna State Opera in 1900. In 1910, Zemlinsky and Schönberg founded the Union for Creative Musicians in Vienna. Dissatisfied with his career in Vienna, Zemlinsky moved to Prague in 1911. Until his move to Berlin in 1927, he was director of the New German Theatre, where both Ullmann and Krása served as his assistants. He fled Austria for New York following the *Anschluss* (annexation of Austria in 1938) [Critiques 4, 17].

9 **Bruno Walter** (1876–1962). German-born pianist, composer, and conductor. He was conducting assistant to Mahler in 1894 and most notably at the Vienna Court opera from 1901 until Mahler's death in 1913. A champion of Mahler's music, he conducted the premieres of Mahler's Symphony no. 9 and *Das Lied von der Erde*. During his illustrious career, he conducted the Bruno Walter Concert Series with the Berlin Philharmonic (1921–1933), the Salzburg Summer Festival, Berlin's Städtische Oper, the New York Philharmonic, The Metropolitan Opera in New York, and the NBC Symphony Orchestra. In 1929, he succeeded Wilhelm Furtwängler as music director of the Leipzig Gewandhaus Orchestra until the Nazi regime dismissed him from the post and barred him from performances in Germany. He was then appointed music director of the Vienna State Opera but relieved from this post upon the *Anschluss* [Critiques 4, 17].

10 *Don Giovanni*. W. A. Mozart conducted the premiere of his opera *Don Giovanni*, K. 527 in Prague on October 29, 1787 at the Estates Theatre [Critique 4].

11 **Gustav Mahler** (1860–1911). Austrian conductor and composer whose work is of monumental influence on classical music, specifically on early twentieth-century works of Second Viennese School figures including Schönberg, Berg, Webern, and Ullmann. Upon his conversion from

SWING ORCHESTER

LEADER: MARTIN ROMAN

Brass:	Reed:	Rhytm:
Kohn,	Weiss,	Libenský,
Gokkes,	Vodňanský,	Nettl,
Vogel,	Donde,	Goldschmidt,
Taussig,		Schumann,

81. Poster. *Swing Orchestra. Leader: Martin Roman.* HCPT #3979.

M O Z A R T - Abend
17.4.1944

Trio: /Violine, Viola, Klavier/

 Sonate F Dur /Klaviersolo/

Quartett G Moll
 /Violine, Viola, Cello, Klavier/

 Klavier : Juliette Aranyi
 Violine : Karl Fröhlich
 Viola : Prof. M.Smyders
 Cello : Dr. Svab

Juliette A r a n y i

Klavierabend 22. September 1943

J.S. Bach: Französische Suite E Dur

W.A.Mozart: Sonate C Dur

C. Debussy: Children's Corner

 ,, Arabesque

 ,, Doktor Gradus

 ,, Le general lavine exentric

F. Chopin: Nocturno Fis Dur

 ,, Fantasie F Moll

82. Program. "Mozart evening" with Juliette Arányi.
April 17, 1944. HCPT #4198.

83. Program. "Piano evening" with Juliette Arányi on
September 22, 1943. HCPT #3935.

Judaism to Roman Catholicism in 1897, Mahler received the imperial appointment of Director of the Vienna Court Opera. From 1898 to 1901 he also directed the Vienna Philharmonic. In 1907, he resigned his post from the Vienna Court Opera and became Principal Conductor of The Metropolitan Opera in New York. Two years later, he became its Music Director. Mahler was married to Alma Schindler. Alma studied composition with Zemlinsky, Schönberg's brother-in-law [Critiques 4, 7, 10, 17, 20, 26].

12 **Ernst Lert** (1883–1955). Librettist and author. Ullmann is referring to Lert's book *Mozart auf dem Theater* [Critique 4].

13 **Johann Wolfgang von Goethe** (1749–1832). German poet, novelist, playwright, and natural philosopher [Critiques 4, 13, 15, 20, 24].

14 **Johann Peter Eckermann** (1792–1854). German scholar and writer who worked with Goethe. Ullmann's quote is taken from Eckermann's *Conversations with Goethe* [Critique 4].

15 **Joseph II** (1741–1790). The Holy Roman Emperor Joseph II was the eldest son of Empress Maria Theresa of the Austro-Hungarian monarchy. On October 10, 1780, he placed the cornerstone of the Terezín fortress, named in honor of his mother. He commissioned Mozart's first opera, *La Finta Semplice*. Ullmann's quote from Joseph II refers to a supposed encounter between the monarch and Mozart after a performance of Mozart's opera *Die Entführung aus dem Serail* (*The Abduction from the Seraglio*), K. 384. Joseph II is said to have given the back-handed compliment: "Too beautiful for our ears, and an awful lot of notes, dear Mozart." Mozart's retort: "No more notes than necessary, Your Majesty!" [Critique 4].

16 **Karl Ditters von Dittersdorf** (1739–1799). Composer of the Viennese classical period. He was granted the Order of the Golden Spur by the Pope in 1770, and in 1773 the Holy Roman Emperor Franz Joseph II ennobled him *von Dittersdorf* [Critique 4].

17 Ullmann mistakenly attributes Mozart's quote to the wrong composition. In a letter to his father Leopold dated April 10, 1784, Mozart wrote: "I have written two grand concertos, and also a quintet [...] which was received with extraordinary applause. I consider it myself to be the best thing I ever wrote in my life. How I wish you could have heard it; and how beautifully it was executed!" Mozart is referring to his Quintet for Fortepiano, Oboe, Clarinet, Horn, and Bassoon in E-Flat Major, K. 452.

18 **Juliette Arányi** (1912–1944, Auschwitz). (Transport information uncertain). Slovak concert pianist. Arányi began her concert career as an acclaimed child prodigy. The special musical bond between Ullmann and Arányi predated Terezín. Ullmann composed two works for her, the Piano Concerto op. 25 (1939) with the dedication, "A Dionysiac work to the revered virtuoso of Apollonian piano playing," and the Third Piano Sonata op. 26 (1940). The Piano Sonata closes with a variation movement based on a Mozart theme—a tip of the hat to Arányi, who was known for her interpretations of the master. Arányi's concert piano career was cut short by her deportation to Terezín [Critique 4].

19 **Pavel Kling** (1928–2005) (**Transport Cy** from Prague to Terezín on April 9, 1943) (**Transport Ek** from Terezín to Auschwitz on September 28, 1944). Violinist. Kling studied in Vienna and Prague and performed chamber music and recitals. He performed in a string quartet reduction of Mozart's *Bastien and Bastienne*. His chamber music performances included the Brahms Sextet in G Major op. 36, Schubert Quintet in C Major op. 163, Beethoven Piano Trio op. 70 no. 2, and Brahms Piano Trio op. 8. His musical studies in Terezín included composition with Pavel Haas, theory with Bernard Kaff, and violin with Karel Fröhlich. Following his liberation in Auschwitz, Kling performed and taught in Japan, Canada, and the U.S. He also served as concertmaster of the Louisville and NHK Symphony Orchestras [Critiques 4, 8, 21].

20 **Romouald Süssmann** (1914–1996) (**Transport N** from Prague to Terezín on December 17, 1941). Czech violinist. A member of Theresienstadt String Quartet, Süssmann performed Brahms and Dvořák Piano Quartets with Gideon Klein, Fröhlich, and Mark. In addition to the Mozart Piano Quartet, he performed the Brahms Sextet in G Major op. 36 and Schubert C-Major Quintet op. 163 with Taussig, Kling, Ančerl (second viola), Mark, and Kohn. He also performed in the Terezín premiere of Krása's Theme and Variations for String Quartet and *"Tanec"* ("Dance") for String Trio. Süssmann lectured on botany and agriculture in Terezín. Liberated in Terezín [Critiques 4, 8].

21 **Friedřich (Bedřich) Mark** (1918–1945, Dachau) (**No. 275 on Transport Ao** from Prague to Terezín on April 28, 1942) (**No. 257 on Transport Em** from Terezín to Auschwitz on October 1, 1944). Cellist. Member of Theresienstadt String Quartet with Fröhlich, Taussig (violins), and Süssmann (viola). Mark performed Krása's string trio *"Tanec"* with Fröhlich and Süssmann. Krása also composed Passacaglia and Fugue for this string trio, but unfortunately it was never performed in Terezín. He also performed Beethoven and Brahms piano trios with Gideon Klein and Paul Kling, as well as the Brahms Sextet in G Major op. 36 and the Schubert Quintet in G op. 163 with Ančerl, Kling, Kohn, Süssmann, and Taussig. Mark also performed in *Brundibár* [Critiques 4, 8, 21].

22 Referring to Trio for Clarinet, (or Violin), Viola, and Piano in E-Flat Major, K. 498 known as the "Kegelstatt."

23 **Bedřich (Fritz) Weiss** (1919–1944, Auschwitz) (**No. 89 on Transport J** from Prague to Terezín on December 4, 1941) (**No. 2186 on Transport Ek** from Terezín to Auschwitz on September 28, 1944). Czech jazz arranger, clarinetist, and saxophonist. Weiss played clarinet in *Brundibár* performances and performed in Krása's "Three Songs" for baritone, clarinet, viola,

and cello. As a jazz clarinetist, he led the Jazz Quintet Weiss with bassist Paul Libeský, guitarist and percussionist Koko Schumann, pianist Wolfgang Lederer, and guitarist Franta Goldschmidt [Critique 4].

24 **Karl Leimer** (1858–1944). Pianist and piano pedagogue. Leimer and his pupil Walter Gieseking co-wrote *The Shortest Way to Piano Perfection*, a methodology book. Heinrich Neuhaus, famous piano pedagogue of the Moscow Conservatory, distilled the Leimer approach to: "practice with your head, not fingers; develop your inner hearing; study your scores mentally, not at the piano; cultivate your imagination of the sound-picture; visualize the physical act of playing, complementing the mental picture with a full-blooded image of the sound." Liberated from Blechhammer [Critique 4].

25 **Agogics.** A musical accentuation produced through the lengthening or pacing of one or more notes or rests, rather than through the use of dynamics, articulations, or pitch. Agogics are achieved by means of rubato, tempo accelerations and retards, rests, and the fermata. Rubato (from the Italian *tempo rubato*, to steal time) is a way of taking rhythmic liberty with music; the performer may vary the speed within the structure of the musical phrase. A fermata can be a holding of pitch or a pause; it is notated as ⌢.

84. Drawing. "Coffeehouse." Bedřich Fritta. Terezin, 1943. Thomas Fritta-Haas, permanent loan to the Jewish Museum Berlin.

85. Poster. *Maier-Sattler—Das beliebteste Musikduo*. Pauli Schwarz. HCPT #3964.
Poster for the popular Maier-Sattler Duo (accordion and violin).

Critique 5
TWO VIOLIN EVENINGS

It is a deplorable fact that our art endeavors are not spared from conflicts of a purely personal nature, which have paralyzed entire branches of our chamber music. Thus we haven't heard—for how long?—any string quartets, which were once an essential and pleasurable part of our musical life. The inability to differentiate and separate artistic issues from uninteresting personal ones has already caused repeated disturbing interferences. What has so often jeopardized and even exploded the existence of high-ranking quartets in normal life and in the artistic world—I recall Rosé[1] and Kolisch[2]—becomes a catastrophe for us here, where every trained instrument of sound is irreplaceable. Not to mention the well-known *Quod licet Jovi*[3]...

Thus, every performance of currently scarce chamber music is a welcome feast for every musician and music lover's ear. Adolf Schächter[4] rested his program on two beautiful concertos—Vivaldi[5] and Mozart—and played Beethoven's A-Minor Sonata[6] as an encore, which, by the way, would have been better placed between the two concertos. Adolf Schächter is an accomplished violinist, to whom one will always enjoy listening. The high points of his performance were in the slow movements of both concertos; attention should be brought especially to the melodically and harmonically highly prophetic magnificent movement in the Vivaldi. The cadenzas in both concertos succeeded exceptionally, especially the Mozart cadenzas composed by Ferdinand David,[7] which are marvelously inventive. I imagine Schächter as the concertmaster of an excellent orchestra. At the piano, Alice Herz-Sommer[8]—about whom almost everything that needs saying has been said—this time was not quite so unrestrained, since one can create better poetry alone than in company, and she is a true poet.

"How different is the power of this sign"[9]—specifically that of the "three great B's"—to whom von Bülow,[10] the master conductor who referred to them that way, wanted to dedicate his life—Bach,[11] Beethoven, Brahms.[12] After all it's a game such as we played as children—famous men starting with B—since there is no apparent reason why Buxtehude,[13] Berlioz,[14] and Bruckner[15] shouldn't be included. Nevertheless, Karl Fröhlich's[16] beautiful and well selected program presented Bach's light and playful A-Major Sonata alongside two first-rate stars of the violin literature: Brahms's G-Major Sonata and Beethoven no. 7 Sonata in C Minor. Fröhlich is an accomplished violinist, without any doubt an exceptional talent and on the best path towards developing it further. Where this path will lead him or what will be withheld is, of course, impossible to predict. At any rate, he has a strong, beautiful gift and is already capable of shaping his material. He is still a bit cool, but his tone is warm, his technique well-balanced. He was accompanied by Ferencz Weiss,[17] a truly excellent pianist, whose technique, however, is the only thing deserving of exceptional praise. The most successful piece was the Beethoven. The Brahms was definitely too slow in the first movement, and also, due to the performers'

U.I5

Zwei Violinabende

Es ist betrüblich, dass unser Kunstbetrieb nicht verschont
bleibt von Reibungen rein persönlicher Art,die ganze Zweige der Kammer-
musik lahm gelegt haben.So haben wir-seit wie lange?-keine Streichquar-
tette mehr gehört,die einst ein wesentlicher und erfreulicher Teil un-
seres Musiklebens waren.Die Unfähigkeit,sachlich-künstlerische von un-
interessanten persönlichen Belangen zu unterscheiden und zu trennen,hat
schon wiederholt störend eingegriffen und was im normalen Leben und Kunst-
Treiben so oft ~~und gefährlich~~ den Bestand von Quartetten höchsten Ranges
gefährdet und oft auch gesprengt hat..ich erinnere an Rosé und Kolisch-,
das kommt für uns,da jeder geschulte Klangkörper unersetzlich ist,einer
Katastrophe gleich.Ganz abgesehen von dem bekannten quod licet Jovi...
So ist denn jede Art der jetzt raren Kammermusik ein für Musiker
wie alle Musikfreunde erwünschter Ohrenschmaus.Adolf Schächter hat sein
Programm auf zwei schöne Konzerte gestellt-Vivaldi und Mozart- und spielt
als Zugabe die amoll-Sonate Beethovens,-die übrigens ihren Platz besser
inmitte der zwei Konzerte gefunden hätte.Adolf Schächter ist ein tüchtige
Geiger,den man immer gerne hören wird.Seine Höhepunkte hat er in den
langsamen Sätzen der beiden Konzerte,von denen besonders auf den in Melos
und Harmonik zukunftweisenden,prachtvollen Satz Vivaldis hingewiesen sei.
Die Cadenzen gelangen in beiden Konzerten vorzüglich,insbesondere die
Ferdinand Davidschen Mozartkadenzen,die ganz herrlich erfunden sind.
Ich stelle mir Schächter als Konzertmeister eines vorzüglichen Orchesters
vor.Am Klavier Alice Herz-Sommer,womit eigentlich alles gesagt ist,nicht
ganz ungehemmt,weil man eben allein besser dichten kann,als in Compagnie..
und sie ist nun einmal eine echte Poetin.
Anders wirkt dies Zeichen auf mich ein--das der "drei grossen
B",denen -von ihm stammt ja der Ausdruck-Bülow,der Meisterdirigent, sein
Leben weihen wollte,Bach,Beethoven,Brahms.-Es ist schliesslich eine
Spielerei,wie wir sie als Kinder trieben-berühmte Männer auf B-,da nicht
einzusehen ist,warum etwa Buxtehude,Berlioz und Bruckner nicht darunter
sein sollten.Allerdings brachte Karl Fröhlichs schönes und gut gewähltes
Programm neben Bachs lichter und verspielter A-dur-Sonate zwei Sterne
erster Grösse der Violinliteratur:Brahms' G-Dur-Sonate und Beethovens
7.in C-moll.Fröhlich ist ein Geiger von Format,ohne Zweifel eine hervor-
ragende Begabung und auf dem besten Wege der Entwicklung.Wohin ihn diese
noch führen oder was sie ihm vorenthalten wird,ist natürlich mit bestem
Willen nicht zu prophezeien.Jedenfalls hat er starke und schöne Anlagen
und ist heute schon fähig,zu gestalten.Er ist noch etwas kühl,aber der
Ton ist warm,die Technik ausgeglichen.Am Klavier accompagnierte Ferencz
Weiss,ein wirklich ausgezeichneter Pianist,dem allerdings nur das Techni-
sche nachzurühmen ist.Am besten gelang Beethoven.Brahms war im ersten
Satze entschieden zu langsam,ausserdem-bei der Kühle beider Interpreten-
wer es eben kein Brahms..Kalbeck erzählt,dass er -ich glaube- in Ischl
einst einen Wahnsinnigen auf den Feldern erblickt habe.Der rannte wie
besessen,schleifte seine Joppe hinter sich auf der Erde,brüllte wie ein
getroffener Stier,..und Kalbeck erkannte Meister Johannes,mit blutunter-
laufenen Augen,der Schweiss rann stromweise über sein erschöpftes Antlitz-
"Glaubt Er,dass ich an seine elende Geige denke,wenn der Geist zu mir
spricht?"schrie einst Beethoven dem Schuppanzigh zu.Ja,so muss man aber-
auch spielen,so,wie der Geist zu den Meistern gesprochen hat.Sonst bleibt
nur die Fassade,vergleichbar der photographischen,grauen Wiedergabe eines
in blühenden,herrlich leuchtenden und leidenschaftlich hingeworfen'n *Farben*
Gemäldes.....

86. Viktor Ullmann's original manuscript of Critique 5. 1 page. NIOD.

coolness it wasn't even Brahms. Kalbeck[18] recounts how he once saw a madman in the fields of—I think it was in Ischl.[19] He ran as if possessed, dragging his jacket behind him on the ground, screaming like a wounded bull—and Kalbeck recognized Maestro Johannes (Brahms), with bloodshot eyes and sweat pouring down his exhausted face. "Does he believe that I think about his wretched fiddle when the spirit speaks to me?" Beethoven once screamed at Schuppanzigh.[20] Yes, that is exactly how one has to play, just as the spirit spoke to the masters. Otherwise only a façade remains, comparable to the gray photographic reproduction of a blooming, luminous, and passionately created painting in glowing colors … [images 85–93].

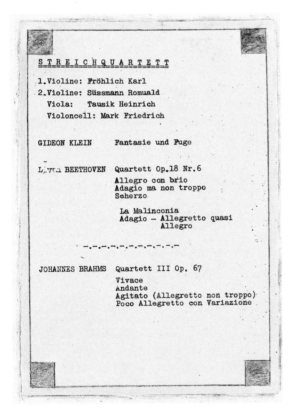

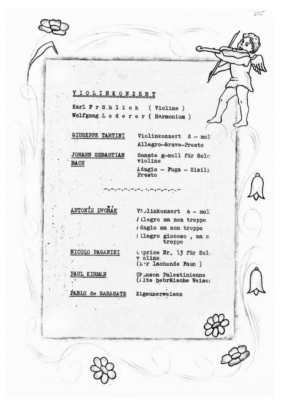

87. Program. String Quartets. HCPT #3943. *Announcement for a program of string quartets beginning with a new work by Terezín composer Gideon Klein followed by two masterpieces from the standard classical repertoire by Beethoven and Brahms. Before their transport to Terezín, Fröhlich, Süssmann, Tausik (Taussig), and Mark performed secretly in Nazi-occupied Prague.*

88. Drawing. Violin Concert. HCPT #3944. *Two programs of concerts by Karl Fröhlich (violin) and Wolfgang Lederer (harmonium) performing works by Tartini and Bach (first concert); and Dvořák, Paganini, Kirman, and Sarasate (second concert).*

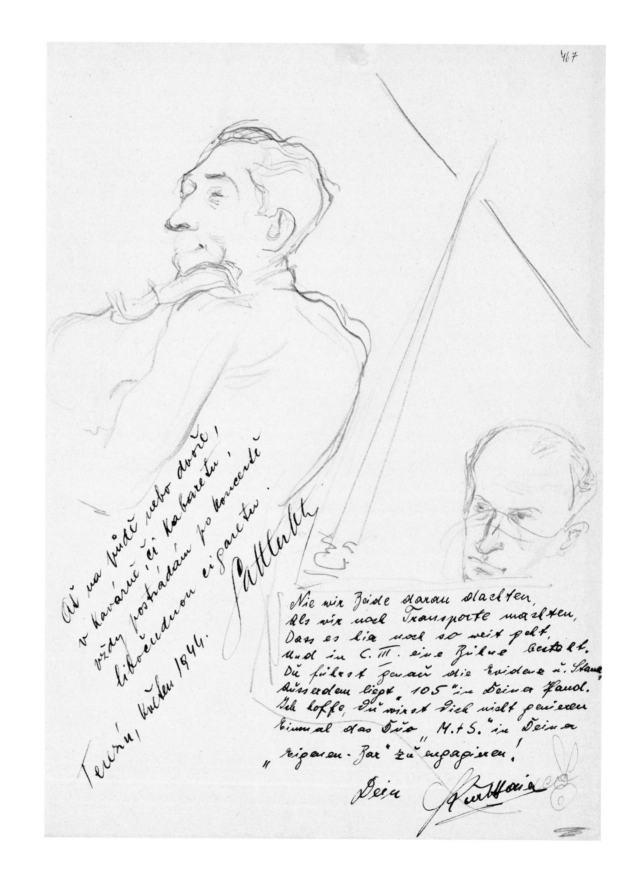

89. Drawing, dedicated. Sketches of Kurt Maier and Otto Sattler with dedications to Karel Heřman. Leo Haas. May 1944. HCPT #3971. *The drawing of the rabbit in the lower-righthand corner is Leo Haas' cartoon signature (German: Hase; English: rabbit).*

Kurt Maier's dedication reads:

"Never would we two have thought,
when we still did transports
that it would go on so far here,
And that a stage would be created in C. III.

You carefully run Evidence and Status
And "105" is also in your hands.
I hope you will not be too embarrassed
to one day hire the duo "M + S" in your "own" bar!"

The German "Evidenz" and "Stand" in the fifth line refers to Heřman's position within the Ghetto Administration.

Otto Sattler's dedication reads:

"At attic or courtyard
At cafe or cabaret
Always after the concert
I miss the delightful taste of a cigarette."

90. Poster. *Taube Orchestra.* HCPT #3976. *Egon Ledeč and Karel Fröhlich are noted as the concertmasters in the Carlo Taube Orchestra.*

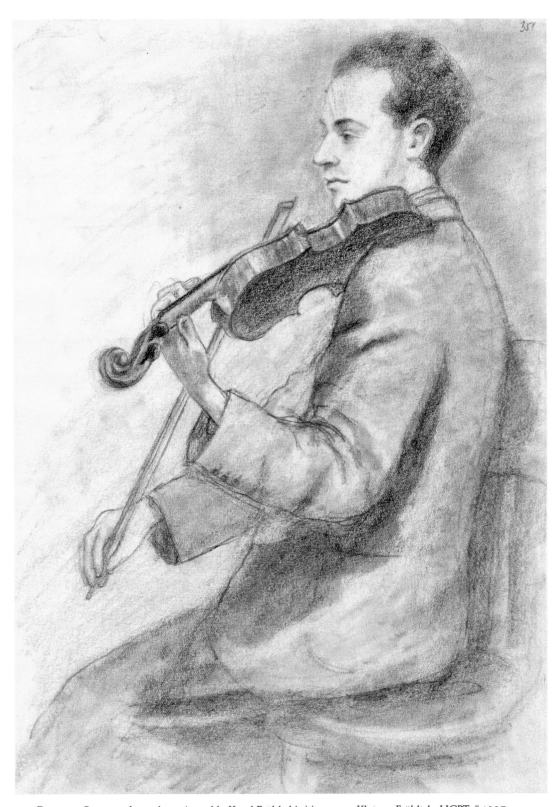

91. Drawing. Portrait of a violinist (possibly Karel Fröhlich). Margareta Kleiner-Fröhlich. HCPT #4207.

Annotations

1 **Arnold Rosé** (1863–1946) was married to Gustav Mahler's sister, Justine. Rosé was appointed concertmaster of the Vienna Philharmonic and Opera in 1881, a post he held until the *Anschluss*. He founded the Rosé String Quartet in 1882. His brother, Eduard, was a cellist in the quartet and later played in the Boston Symphony Orchestra from 1891 to 1899. Eduard died in Terezín in 1942. As a member of the quartet and a soloist, Arnold Rosé premiered important works of Schönberg and Berg. He fled the Nazis in 1938 and remained in exile in London until his death. His daughter, Alma, was a violin soloist who led the women's orchestra in Auschwitz, where she died in April of 1944 [Critique 5].

2 **Rudolf Kolisch** (1896–1978). Like Arnold Rosé, Kolisch was a noted violinist and chamber musician. At the Vienna Academy of Music, he studied violin with Otakar Ševčik and composition with Franz Schreker and Arnold Schönberg. Amazingly, after an injury, he learned to play the violin in reverse, bowing with his left hand and holding the violin with the right. In 1922, he founded the New Vienna String Quartet (later changed to the Kolisch String Quartet), distinguished for championing the works of contemporary composers Schönberg, Berg, Webern, and Bartók. Kolisch chaired the Chamber Music department at the New England Conservatory of Music in Boston from 1967 until his death [Critique 5].

3 *Quod licet Jovi non licet bovi* is an anonymous Latin adage: "What is permitted to Jupiter is not permitted to the ox."

4 **Adolf Schächter** [Critiques 3, 5].

5 **Antonio Vivaldi** (1678–1741). Italian composer of the baroque period. In addition to sacred works and operas, he is noted for composing over 500 concertos [Critique 5].

6 **Ludwig von Beethoven** (1770–1827). German composer of the Classical and early Romantic periods whose master works extend well beyond the symphonic form. The A-Minor op. 23 Violin and Piano Sonata—one of ten sonatas—is among his vast canon of chamber compositions [Critiques 5, 6, 10, 11, 18, 20–22, 25, 26].

7 **Ferdinand David** (1810–1873). German pedagogue, violin virtuoso, and composer. A friend and colleague of the composer Felix Mendelssohn, David gave the premiere of Mendelssohn's Violin Concerto. A cadenza is a solo section that highlights the virtuosity of the performer, and it generally appears near the close of a movement in a concerto. Traditionally improvisatory in nature, many cadenzas are written by performers [Critique 5].

8 **Alice Herz-Sommer** (1903–2014) (**Transport De** from Prague to Terezín on July 5, 1943). Pianist. She studied piano with Eduard Steuermann, a student of Arnold Schönberg and Václav Štěpán at the German Music Academy in Prague. Her musical association with Viktor Ullmann predated their incarceration in Terezín; she performed his Piano Sonata no. 2 op. 19 in Prague. In Terezín, she gave recitals of Beethoven, Brahms, Chopin, Debussy, Schumann, Smetana, and Ullmann. Her son Rafael sang the role of the sparrow in Krása's opera *Brundibár*. Herz-Sommer resumed her career as a pianist in Czechoslovakia after her liberation in Terezín. Four years later, she emigrated to Israel and joined the faculty of the Academy of Music of Tel Aviv University. In some Terezín documents she is referred to as Sommer-Herz [Critiques 5, 10, 11, 25].

9 **Quote** from Goethe's *Faust* Part I, "Night" (translation by Walter Kaufmann) [Critique 5].

10 **Hans von Bülow** (1830–1894). German pianist and conductor. In addition to crowning Brahms as the third of the "big B's," von Bülow championed the works of Richard Wagner. He conducted the premieres of Wagner's operas *Tristan and Isolde* and *Die Meistersinger von Nürnberg* [Critique 2].

11 **Johann Sebastian Bach** (1685–1750). German composer and organist of the late Baroque period [Critiques 5, 7, 10, 14, 18, 20, 22].

12 **Johannes Brahms** (1833–1897) [Critiques 1, 5–9, 21].

13 **Dietrich Buxtehude** (1637–1707). Baroque German composer and organist. He was a musical influence on J. S. Bach [Critique 5].

14 **Hector Berlioz** (1803–1869). French Romantic composer. A number of his masterpieces are programmatic, deriving their inspiration from literary sources, for example, *Harold en Italie* (Byron), *La Damnation du Faust* (Goethe), and *Roméo et Juliette* (Shakespeare) [Critique 5].

15 **Anton Bruckner** (1824–1896). Austrian composer and organist noted for his sacred and symphonic works [Critiques 5, 20].

16 **Karel Fröhlich** (1917–1994) (**Transport J** from Prague to Terezín on December 4, 1941) (**Transport Em** from Terezín to Auschwitz on October 1, 1944). Violinist. Fröhlich performed in one of the first programs in Terezín, in December 1941. He was a member of the Theresienstadt String Quartet (Heinrich Taussig, violin; Romauld Süssmann, viola; and Friedrich Mark cello). The ensemble performed string quartets of Beethoven, Brahms, Mozart, Tchaikovsky, Klein, and Krása. Frölich performed piano quartets of Brahms, Dvořák, and Mozart with pianists Juliette Arányi and Gideon Klein, as well as Bach solo sonatas. He also performed a recital with pianist Bernard Kaff; the program included Beethoven's *Kreutzer* Sonata and Franck's A-Major Sonata. Liberated in Auschwitz, he returned to Prague briefly before resuming his studies in Paris. In 1948, he and his wife emigrated to the United States [Critique 5].

17 **Ferencz Weiss** (1893–1944, Auschwitz) (**No. 797 on Transport XXIV/2** from Westerbork to Terezín on January 20, 1944) (**No. 1486 on Transport Ek** from Terezín to Auschwitz on September 28, 1944). Pianist who served on the faculty of the Liszt Academy in Budapest and later moved to Holland [Critique 5].

18 **Max Kalbeck** (1850–1921). Music critic for the *Neue Freie Presse* and *Neues Wiener Tagblatt*. Kalbeck was a friend and biographer of Johannes Brahms [Critique 5].

19 **Ischl.** Austrian spa town east of Salzburg where Brahms spent his summers from 1889 to 1896.

20 **Ignaz Schuppanzigh** (1776–1830). Austrian violinist who was a friend and colleague of Beethoven. He championed and premiered works of Beethoven and Schubert [Critique 5].

92. Concert ticket. Mayer-Sattler. ZM #A317003.

93. Concert tickets. *Kaffeehaus.* Photograph by Michael J. Lutch. TMF. *The ticket is to a concert on October 15, 1943 at 12:00 to 4:00 P.M. Maier, Sattler, and George Horner (who played accordion and piano) were among the many musicians performing popular and light classical music in the Kaffeehaus.*

Musikinstrument-Reparatur
oder:
Das klagende Lied!

Das Instrument hat seine Tück'
Und wenn es nicht spielt, ruft man den Pick.
Bis jetzt war er ein Pharmazeute,
Allhier jedoch ward er 'ne Beute
Seiner Musikleidenschaft,
Weshalb er für die Freizeit schafft.

Ward ein Instrument zu Trümmern
Muss Dich das nicht sehr bekümmern,
Scheint es Dir auch ganz kaputt;
Wirf es noch nicht auf den Schutt,
Musst auch deshalb noch nicht weinen
Denn Du weisst, es gibt ja einen,
Der ein Ganzes macht aus Teilen,
Und Harmonien stimmt mit Feilen,
Saiten knüpft in den Klavieren,
Hammerspiele flickt mit Schnüren,
Bringt in Gang den Leierkasten,
Darf nicht ruhen, darf nicht rasten,
Denn man holt ihn ohne Schonung
Aus der sogenannten Wohnung,
Aus dem sogenannten Bett:
„Lieber Pick, komm! Sei so nett!
Mein Konzert hab ich doch heute,
Sicher kommen 1000 Leute.
Ganz verstimmt doch ist der Kasten
Hängen bleiben ein paar Tasten
Das Pedal quietscht wie ein Lurch
a vübec – bitte, sieh ihn durch!"

Apotheker war er zwar
Hat studiert so manches Jahr.
Hier ergriff er Hammer, Zange,
Dass mit neuem, frohen Klänge
Jedes Instrument erklinge.
Dann treibt er noch andre Dinge:
Spielt Akkordeon im Café,
Fährt gern wütend in die Höh',
Ist ein Crok mit einem Worte,
Doch nicht von der schlimmsten Sorte.
In der Stadtkapelle spielt er
Gern in Mollakkorden wühlt er,
Liebt sein Weib und die Musik,
Heisst Magister Rudi Pick.

Dem lieben Freunde und unermüdlichen
Kämpfer für die Ermöglichung von
Freizeitveranstaltungen Herrn Karl
Herrmann zur Erinnerung an ein
Stück gemeinsamer Arbeit gewidmet.
Theresienstadt, im Juni 1944. Rudolf Pick.

Heinr. Bähr 44

Critique 6

PIANO TRIO

Our new trio: Heinrich Taussig,[1] violin; Paul Kohn,[2] cello; and Wolfgang Lederer,[3] piano, has introduced itself to the satisfaction of all friends of good chamber music with Beethoven's[4] "Ghost" Trio, and Novak's op. 1. The young artists have stylistic feeling, technical maturity, and musical instinct; they play together well and with discipline. They even slightly exaggerate the "chamber music tone" and are too careful in their concern not to break it. Therefore, we recommend that they follow their own healthy instincts and play more daringly. Beethoven can definitely take a stronger grip on accents, tone, agogics, and dynamics[5]—indeed, his musical personality often demands it. Therefore, no coddling and no pale, cautious playing!

Style—in music the manner of composing—is the entire person, and Beethoven composed what Napoleon did and Fichte[6] philosophized ...

Although Beethoven's op. 70 no. 1 was happily received, the performance of Novák's op. 1 seemed superfluous. It wasn't that the performance wasn't flawless—it was well sculpted and full of temperament. But today, the old Czech master could rightfully disown this sin of his youth. This early work, a graduation piece, dangles in the air somewhere between Brahms[7] and Dvořák.[8] With the exception of the well-crafted *scherzo*, all the movements betray the beginner and that particularly adolescent style in which everyone composed, at one point or another, between the '80s and the World War ...

But Brahms burned two large boxes of his early works, which Robert Schumann had warmly recommended to his publisher ...

We hope to hear our piano trio soon again [images 94–96, 130].

94. Poster. *Musikinstrument-Reparatur* oder *Das klagendes Lied!* ("Musical Instrument Repair or The Mournful Song"). Heinrich Bähr. 1944. HCPT #3766. *The poem (author unknown) is a tribute to Rudolf (Rudi) Pick's repair of instruments in Terezín. In an April 2010 interview with Mark Ludwig, Dr. George Horner, who played piano and accordion in Terezín, recalled attending a concert by Bernard Kaff and Gideon Klein, where, between performances, Dr. Pick worked on a piano resting on wooden crates. Dr. Pick's dedication reads, "Dedicated to the dear friend and tireless fighter for enabling leisure events, Herrn Karl Herrmann, in memory of a piece of joint work. Yours, Rudolf Pick. Theresienstadt, June 1944." Though he was a pharmacist before the war, music was Dr. Pick's true passion. In addition to repairing instruments in Terezín, he gave lectures titled "Variety Hour" and "Proper Use of Musical Instruments."*

Klavier-Trio

Unser neues Trio:Heinrich Taussig,Violine,Paul Kohn,Cello und
Wolfgang Lederer,Klavier hat sich zur Befriedigung aller Freunde guter
Kammermusik mit Beethovens Geister-Trio und Nováks op.I vorgestellt.
Die jugendlichen Künstler verfügen über Stilgefühl,technische Reife
und musikalisches *INSTINKT* ~~Gefühl~~;sie sind gut eingespielt und diszipliniert,
ja sie übertreiben ein wenig den "Kammerton" und sind allzu diskret
in der Besorgnis,ihn zu durchbrechen.Also empfehlen wir ihnen,ihrem
gesunden Instinkt zu folgen und unbekümmert zu musizieren.Beethoven
verträgt in Akzenten,Tongebung,Agogik und Dynamik durchaus ein kräfti-
ges Zugreifen,ja seine musikalische Persönlichkeit fordert es oft.
Also keine Verzärtelung und kein blasses,vorsichtiges Musizieren!
Der Stil,in der Musik die Satzweise,ist der ganze Mensch und Beetho-
ven musizierte das,was Napoleon tat und Fichte philosophierte...

So freudig man Beethovens op.70 Nr.I begrüsste,so überflüssig
dürfte die Aufführung von Nováks op.I sein.Nicht,dass die Auffüh-
rung nicht einwandfrei gewesen wäre,sie war plastisch und temperament-
voll.Aber der čechische Altmeister dürfte mit Recht heute diese
Jugendsünde verleugnen.Denn irgendwo hängt dieser Erstling,eine
Absolventen-Arbeit,zwischen Brahms und Dvořak in der Luft und mit
Ausnahme des sehr gekonnten Scherzos verraten alle Sätze den
Anfänger und jenen Pubertäts-Stil,in dem alle einmal zwischen den
Achtzigerjahren und dem Weltkriege ~~einmal~~ komponiert haben..
Aber Brahms verbrannte zwei grosse Kisten mit Jugendwerken,die ein
Robert Schumann seinem Verleger in warmer Weise empfohlen hatte..
Wir hoffen,unser Klaviertrio bald wieder zu hören.

Viktor Ullmann

95. Viktor Ullmann's original manuscript of Critique 6. 2 pages. NIOD.

96. Drawing. Piano in the attic theatre. František Zelenka. 1943. NGP.

Annotations

1 **Heinrich (Jindřich) Taussig** (1923–1944, Auschwitz) (**No. 986 on Transport J** from Prague to Terezín on December 4, 1941) (**No. 251 on Transport Ek** from Terezín to Auschwitz on September 28, 1944). Violinist. Member of Theresienstadt String Quartet with Fröhlich, Süssmann, and Mark [Critiques 6, 8].

2 **Pavel (Paul) Kohn** (1902–1944, Auschwitz) (**No. 395 on Transport H** from Prague to Terezín on November 30, 1941) (**No. 114 on Transport Ek** from Terezín to Auschwitz on September 28, 1944). Violist and trumpeter. Kohn performed in one of first Terezín performances in the Sudeten barracks. He performed the second cello part in performance of the Brahms Sextet in G Major op. 36 and the Schubert Quintet in C Major op. 163. He also performed in the Terezín pit orchestra for *Brundibár* productions. Kohn was a member of the Ledeč String Quartet with his brother Viktor, a violist [Critiques 6, 8].

3 **Wolfgang Lederer** [Critiques 2, 6].

4 **Ludwig von Beethoven** [Critiques 5, 6, 10, 11, 18, 20–22, 25, 26].

5 **Dynamics**. In music, dynamics are the notated levels of performance volume.

6 **Johann Gottlieb Fichte** (1762–1814). German philosopher who developed the *Wissenschafts-lehre*, a system of transcendental idealism. He declared that "he created God every day."

7 **Johannes Brahms** (1833–1897) [Critiques 1, 5–9, 21].

8 **Antonín Dvořák** (1841–1904). Nineteenth-century Czech Romantic composer famous for his operas, overtures, symphonies, and chamber works. Deeply influenced by Brahms, Wagner, and particularly Smetana, he blended folk music elements from his native Czech homeland into the symphonic tradition. Dvořák lived in the United States from 1892 to 1895, serving as director of the New York National Conservatory of Music. As he joined composers like Smetana in forging a Czech national school of music, he also encouraged the development of an American style of composition. During his American visit, he composed several of his most notable and popular works: Symphony No. 9 in E Minor op. 95 (*"From the New World"*), the "American" String Quartet op. 96 in F, and the B-Minor Cello Concerto [Critiques 6, 14, 15].

97. Poster. *Klavier-Konzert Gideon Klein.* HCPT #4200. *The pianist is stylized as the letter "K" with "lavier" arching above the piano (German: Klavier; English: piano). The "K" in "konzert" (concert) is the supporting back leg of the piano.*

Critique 7
GIDEON KLEIN PIANO EVENING

The program deliberately excludes the sonata form and places the emphasis on two 20th-century Czech masters at the start—a remarkable attempt to utilize the listener's freshness at the beginning of a concert instead of letting loose the "modern" when nerves are already exhausted. Furthermore, by placing Bach's grandiose organ *toccata*[1] at the end of the program, Gideon Klein shows that the pianist can refrain from displaying a cheap yet brilliant apotheosis of his virtuosity and still achieve a well-deserved success.

Bach and Suk[2] are mystics. If genius means fighting the battle of existence against oneself instead of against others—the battle of the genius against the demon—then to be a mystic is to have fought this battle and won. In his book *Die Kunst der Fugue* [*The Art of the Fugue*], Dr. Erich Schwebsch[3] shows that Bach's last work is the key to the creations of this greatest master of music. Busoni's[4] arrangement transforms our grand piano into an organ. Gideon Klein proved himself very capable of this challenge and was at the peak of his ability. Josef Suk, the modern mystic, was represented by his "*Erträumtes und Erlebtes* II" ["Things Lived and Dreamed II op. 30"]. This great composer climbs step by step in his four symphonic works from the "*Trauer des Stoffes*" ["Mourning of Matter"] in *Asrael*[5] to the plant-like, blossoming splendor of the sweet *Sommermärchens* [*A Summer Fairy Tale*][6] to the tart, masculine passion of his biographical *Lebensreife* [*The Ripening*],[7] and finally up to his captivating *Epilog* [*Epilogue*].[8] The piano works similarly carry the unmistakable signature of this *homo religiosus*, one of the last after Gustav Mahler,[9] especially in his harmony, these idiosyncratic and incomparably graceful sonorities.

While Brahms,[10] who was represented by three *intermezzi*, is the great preserver of classical form, Janáček[11] belongs to that small group of masters who consciously abandon it—Debussy,[12] Webern,[13] Haba.[14] The future will tell where this path that rejects thematic development, metamorphosis, intensification, and development will lead. Thus, there are no movements of the classical type in Leoš Janáček's Sonata "I.X.1905."[15] Here too, the later master of the Moravian peasant's opera does not disown his idiosyncrasy. He is always powerful and personal, even when he does not charm. The first movement—"*Die Ahnung*" ["The Premonition"]—is perhaps stronger than the second—"*Der Tod*" ["Death"]—with its halting rhythms.

Gideon Klein is without doubt a very important talent. His style is that of the new youth—cool and objective; one may wonder at this precocious stylistically confident interpretation. The pioneers of 1770, the avant-garde of the *Ars Nova* of their time, were "*Stürmer und Dränger*."[16] Our youth has strong intelligent brains; hopefully they can lift the heart up into the head [images 97–101].

Klavierabend Gideon Klein

Das Programm verzichtet bewusst auf die Sonatenform und
stellt zwei čechische Meister des XX.Jahrhunderts an die Spitze-ein
bemerkenswerter Versuch, zu Beginn des Konzertes die Frische des Zuhörers
zu benützen, statt auf dessen ermüdete Nerven die "Modernen" loszulassen.
Weiter zeigt Gideon Klein, indem er Bachs grossartige Orgel-Toccata an
den Schluss des Programms stellt, dass der Pianist auf billige, dafur aber
brillante Apotheosen seiner Fingerfertigkeit verzichten und doch den
verdienten Erfolg haben kann.

Bach und Suk sind Mystiker.Wenn Genie heisst,den Kampf ums
Dasein gegen sich selbst zu führen statt gegen die andern,den Kampf
des Genius gegen den Dämon,so heisst Mystiker sein:diesen Kampf sieg-
reich bestanden zu haben.In seinem Buche "die Kunst der Fuge" zeigt
Dr.Erich Schwebsch,dass das letzte Werk Bachs der Schlüssel zum Schaffen
dieses grössten Meisters der Musik ist.Busonis Nachdichtung verwandelt
unseren Konzertflügel in eine Orgel.Gideon Klein zeigte sich der Aufgabe
durchaus gewachsen und auf der Höhe seines Könnens.Josef Suk,der moderne
Mystiker,war durch "Erlebtes und Erträumtes"II vertreten.Dieser grosse
Komponist steigt in seinen vier symphonischen Werken von Stufe zu Stufe,
von der "Trauer des Stoffes" im "Asrael" über die pflanzenhaft blühende
Pracht des süssen "Sommermärchens" zur herben,männlichen Leidenschaft
seiner Biographie "Lebensreife" und von hier zu seinem ergreifenden
"Epilog" empor.Auch die Klavierwerke tragen die unverkennbare Signatur
dieses homo religiosus,eines der letzten nach Gustav Mahler,insbesondere
seiner Harmonik,dieser eigenartigen und unvergleichlich anmutigen Klänge.

Ist Brahms,der durch drei Intermezzi vertreten war,der grosse
Bewahrer der klassischen Formgestalt,so gehört Janáček zu jener kleinen
Gruppe von Meistern,die sie bewusst preisgibt –Debussy,Webern,Hába.Die
Zukunft wird lehren,wohin dieser Weg führt,der auf thematische Entwick-

120

lung,auf Metamorphose,Steigerung,Durchführung u.s.w.Verzicht leistet.So gibt es auch in Leoš Janačeks Sonate "I.X.1905" keine klassischen Satztypen.Der spätere Meister der mährischen Bauernoper verleugnet auch hier seine Eigenart nicht.Stark und persönlich ist er immer,auch dort,wo er nicht erwärmt.Der erste Satz-"die Ahnung"-ist vielleicht doch stärker als der zweite-"der Tod"-mit seinen stockenden Rhythmen.

Gideon Klein ist zweifellos ein sehr bedeutendes Talent. Sein Stil ist der kühle,sachliche der neuen Jugend;man darf sich über diese merkwürdig frühe,stilsichere Abklärung wundern.Die Pioniere von 1770,Vorkämpfer der damaligen ars nova,waren "Stürmer und Dränger". Unsere Jugend hat starke,intelligente Gehirne;hoffentlich vermag sie auch das Herz in den Kopf zu heben.

Viktor Ullmann

98. Viktor Ullmann's original manuscript of Critique 7. 2 pages. NIOD.

Klavierkonzerte

GIDEON KLEIN

Veranstaltung	Programm	Reprisen	Mitwirkende
I. Klavierkonzert	Mozart: Adagio h-moll Beethoven: Sonate Op.11o Schumann: Phantasie Op.17	6 x	-
Klavier-Trio	Beethoven: B-dur Op.97 Schubert: B-dur Op.99	1o x	Friedrich Mark Karl Fröhlich
Klavier-Quartett	Brahms: C-moll Op.6o Dvořák: Es-Dur Op.84	11 x	Karl Fröhlich Romuald Süssmann Friedrich Mark
II. Klavierkonzert	Janáček: 1.X.19o5 Suk: Op.3o Brahms: 3 Intermezzi Bach-Busoni: Toccato und Fuge C-dur	9 x	-

99. Program of four concert programs, two solo piano recitals and two chamber concerts, performed by Gideon Klein. HCPT #3938.

100. Drawing. Portrait of Gideon Klein conducting Bach in Teplice-Šanov. March 1, 1936.
ZM—Eliska Kleinová collection.

101. Drawing. Portrait of Gideon Klein. Charlotte Buresová. PT #5522.

Annotations

1 **Organ** *toccata*. A *toccata* is generally a virtuoso show piece for harpsichord or organ. It was a popular format for keyboard works of the Baroque period [Critiques 5, 7, 10, 14, 18, 20, 22].

2 **Josef Suk.** [Critiques 1, 7, 14, 24].

3 **Dr. Erich Schwebsch** (1889–1953). A musicologist, writer, and member of the anthroposophic movement.

4 **Ferruccio Busoni** (1866–1924). Italian-German pianist and composer. Among his composition students were Sibelius and Weill [Critique 7].

5 Suk's *Asrael* Symphony op. 27 and "Meditation on an Old Czech Chorale, 'St. Wenceslas'" op. 35 are among his most notable compositions. They served as inspiration for Ullman and another composer incarcerated in Terezín, Pavel Haas [Critiques 1, 7].

6 *A Summer Fairy Tale*, Symphonic Poem op. 29 [Critique 7].

7 *The Ripening*, Symphonic Poem op. 34 [Critique 7].

8 *Epilogue* for Soprano, Baritone, Bass, Two Choirs and Orchestra op. 37. Although composed from 1907 to 1929, *A Summer Fairy Tale*, *The Ripening*, and *Epilogue* are meant to be performed as a complete symphonic trilogy [Critique 7].

9 **Gustav Mahler.** [Critiques 4, 7, 10, 17, 20, 26].

10 **Johannes Brahms** [Critiques 1, 5–9, 21].

11 *Intermezzi*. (Italian: interludes). An *intermezzo* was originally a comic musical scene sandwiched between acts of serious operas in the eighteenth century. By the nineteenth century, Brahms and other composers wrote "*intermezzi*" as short pieces for piano.

12 **Claude Debussy** (1862–1918). French composer considered father of the Impressionist movement in music [Critiques 7, 8, 24–26].

13 **Anton Webern** (1883–1945). Austrian composer. Webern was a student and disciple of Arnold Schönberg's twelve-tone system. Webern, Berg, and Schönberg established the Second Viennese School of music composition [Critique 7].

14 **Alois Hába** (1893–1973). Czech composer and pedagogue. He studied with Novák at the Prague Conservatory (1914–1915) and Schreker in Berlin (1918–1922). His interest in Asian music led to his exploration of composing in quarter tones. He is considered the father of microtonal music (quarter-tone music). He conducted a seminar in composition at the Prague Conservatory from 1922 to 1951. Among his many pupils were Erwin Schulhoff, Viktor Ullmann, Gideon Klein, and Karel Reiner. His classes were twice closed down; first by the Nazis and then in 1951 by the Czech Communist government [Critique 7].

15 **Leoš Janáček's piano sonata "1.X.1905 Z Ulice"** ("From the Street"), 1905. Ullmann is referring to Janáček's break from the traditional sonata form in composition [Critique 7].

16 *Ars Nova* (Latin: New Art). **Sturm und Drang** (Storm and Stress) was a German literary movement propelled by the works of Goethe and Schiller in the latter part of the eighteenth century. The Ars Nova of its time, *Sturm und Drang* marked a revolt from the rationalism and conventions of the Enlightment and would pave the way to the Romantic era in Europe. Goethe's 1774 novel, *The Sorrows of Young Werther*, became a manifesto for the movement. *Werther* explored the heroic struggles of an emotional young man raging against society's mores.

102. Poster. *Kammermusik-Abend.* Possibly Heinrich Bähr. HCPT #4212. *Poster for an evening of chamber music. The concert featured the Schubert String Quintet in C op. 163 and the Brahms String Sextet in G op. 36.*

Critique 8
A MUSICAL PANORAMA (I.)

"Eastern Jewish Tunes," liturgical chants, Chasidic art songs,[1] and folk tunes were performed skillfully and artfully with beautiful vocal technique by Ada Schwarz-Klein[2] and the gentlemen Goldring[3] and Hermann.[4] Among the rhapsodic-recitative religious chants was an especially remarkable melancholic duet, moving in parallel thirds. While the arrhythmic, vocalizing Eastern element prevailed in this first genre, the world-famous hymns by the eminent Levi Yitzhak of Berdytshew[5] showed the influence of a rhythmic, dance-like style, in particular in the well-known "Dudale,"[6] which was part of Vittorio Weinberg's[7] repertoire. Especially in music akin to folk songs, Western rhythmic symmetry is the rule.

All these serious and lighthearted moods—even in the latter, the minor key dominates, presumably because of the pre-tonal keys—were well received by a sympathetic audience. The arrangements often showed Western influence, yet without violating the characteristics of their folkloric substance.

The first chamber music concert in the community house united the gentlemen Taussig,[8] Kling,[9] Süssman,[10] Mark,[11] and Paul Kohn[12] in a musically joyful ensemble, joined by Karl Ančerl[13] for the Brahms[14] Sextet. While Ančerl modestly concealed himself in the second violist's seat, his mark as a conductor was imprinted on the performance, whose quality far surpassed the preceding Schubert Quintet.[15] The sextet's precision, clarity, beauty of tone, and stylistic purity were all praiseworthy. The Schubert Quintet was less successful, but it seemed to improve from movement to movement.

Bernhard Kaff[16] courageously played a modern program. Actually, modern music is feared only because of its harmonies, since, leaving a few exceptions aside, classical form is not relinquished. The abandonment of the tonal system, thus the natural overtones, corresponds to the departure from the faithful imitation of nature in painting. However, Paul Haas[17] does not continue this process; rather he does the opposite by introducing new sounds into the tonal system—one could describe it as a tonal twelve-tone music.[18] The *"Partita im alten Stil"* ["Partita in the Old Style"][19] preserves the forms, or at least the original archetype phenomena of suite movements. In this aspect as well, Haas's music is certainly praiseworthy—it is playfully powerful, effortlessly polyphonic, transparent in the piano part, interesting and graceful. I would give the prize to the little air without meaning to diminish the other suite movements. Whether the term "partita" should still be applied to tonally ambiguous and heterogeneous parts within the movements is a different question. Originally, all of a partita's movements were connected by the same key. Therefore, I would have preferred the title "Second Suite."

Kaff played the partita with élan and mastery. This time he actually chose an ascetic program. Janáček's[20] *"Im Nebel"* ["In the Mists"][21] remains an ungrateful work for a pianist. Janáček is one of a small group of composers without precedence, who proudly

Die erste Kammermusik im Gemeinschaftshause vereinte zu
musizierfreudigem Ensemble die Herren Teussig, Kling, Süssmann, Mark und
Paul Kohn, zu denen dann im Sextett von Brahms noch Karl Ančerl stiess,
der zwar bescheiden am 2.Bratschenpulte sich verbarg, dessen Dirigenten-
Signatur aber dennoch der Reproduktion aufgedrückt war,die das vorange-
gangene Schubert-Quintet um ein beträchtliches überragte.Präzision,Deut-
lichkeit,Klangschönheit und Stilreinheit sind dem Sextett nachzurühmen.
Das Schubert-Quintet gelang weniger,doch besserte sich der Eindruck von
Satz zu Satz.

Bernhard Kaff spielte mutig ein modernes Programm.Eigentlich
wird die neuere Musik nur um ihrer Harmonik willen gefürchtet,denn mit
ganz geringen Ausnahmen ist ja die klassische Form nicht preisgegeben
worden.Das Aufgeben des tonalen Systems, also der naturgegebenen Obertöne,
entsprach dem Verlassen der getreuen Naturnachahmung in der Malerei.
Paul Haas setzt aber diesen Prozess nicht fort, er führt eigentlich um-
gekehrt die neuen Klänge in die Tonalität ein;man könnte von einer tonalen
Zwölftonmusik sprechen.Die "Partita im alten Stil"wahrt die Formen oder
wenigstens die Urphänomene der Suitensätze.Haas Musik ist auch hier
durchaus zu bejahen, sie ist spielend-kraftvoll, ungezwungen mehrstimmig,
durchsichtig im Klaviersatz, interessant und graziös.Ich gebe der kleinen
Air den Preis, ohne darum die anderen Suitensätze herabsetzen zu wollen.
Ob der Ausdruck "Partita" für tonal-schwebende und in den einzelnen Sätzen
verschiedene Stücke noch angewendet werden soll,ist eine Frage für sich.
In der Partita sind ursprünglich alle Sätze durch die gleiche Tonart ver-
bunden.Ich hätte daher die Bezeichnung als 2.Suite vorgezogen.

Kaff spielte die Partita mit Elan und meisterlich.Er hatte
diesmal eigentlich ein asketisches Programm gewählt.Janačeks "Im Nebel"
bleibt jedenfalls für den Pianisten ein undenkbares Werk.Janaček gehört zur
kleinen Gruppe jener Voraussetzungslosen, die es stolz verschmähen, die
Tradition der musikalischen Form anzunehmen."V o r mir die Sintflut-"
und sie machen Musik wie zum ersten Mal, als sie aus der Arche stiegen.
Hierher gehört auch Mussorgsky.Es sind meist geniale Autodidakten und
manche von ihnen-Schönberg, Debussy-gehen in reiferen Jahren den Weg nach
Canossa und kehren zur geschlossenen klassischen Formidee zurück."Im Nebel"
-wer denkt hier nicht an den Sprechton der mährischen Bauern in Janačeks
Opern?Mit unerhörter Kühnheit wird er aufs Klavier übertragen.

Mussorgsky, Stammvater des Impressionismus,ist der zweite Opern-
Komponist, den Kaff als Klaviermeister vorführte, sinnvoll dem ersten gegen-
übergestellt.Und man vermisst Ravels Instrumentation der "Bilder einer Aus-

103. Viktor Ullmann's original manuscript of Critique 8. 2 pages. NIOD.

refuse to adopt the tradition of musical forms. *"Before me, the deluge"*[22]—and they make music as if for the first time, just as they emerged from the ark.

Mussorgsky[23] belongs in this group as well. They are mostly ingenious autodidacts, some of whom—like Schönberg or Debussy—take the road to Canossa[24] in their more mature years and return to the idea of the closed classical form. "In the Mists"—who isn't reminded of the spoken tone of Moravian peasants in Janáček's operas? With incredible audacity, it is transposed to the piano.

Mussorgsky, the progenitor of impressionism, is the second opera composer to be performed by the piano virtuoso Kaff, in a meaningful contrast to the first [Janáček]. When Kaff plays, one doesn't miss Ravel's[25] orchestration of the "Pictures of an Exhibition;"[26] he is in control of technique, colorful, fantastical, and always expresses the essential, never the arbitrary. Art emerges from skill and commitment. Kaff has no need of personal idiosyncrasies; he plays in the spirit of the composer, and yet soulfully and personally.

The lack of any form of polyphony in Mussorgsky's cycle is striking. Despite its length, it is never tiring—indeed it intensifies all the way to the "Hut of Baba Yaga"[27] and the glorification of Kiev. The question could be raised, however, if the titles might be dispensable; since who would guess—if the "program" happened to maliciously refrain from mentioning it—that the delicate rhythm of the dance piece is of all things a "Ballet of Chicks in their Eggshells"...?[28] [images 102–104].

Annotations

1 The Chasidic movement started in Eastern Europe in the eighteenth century. The founder of Chasidism, Rabbi Israel Baal Shem Tov (referred to as "The Besht," an acronym of his name) was a great scholar and mystic. In contrast to the somewhat intellectual style of the mainstream Jewish leaders of his day and their emphasis on Torah study, Chasidism emphasizes attachment to God and Torah in all daily activities. Chasidic songs (in Hebrew, *nigunim*) were composed to express joy (*simcha*) and as a means of connecting to the sacred and divine. [Critique 8].

2 **Ada Schwarz-Klein** (1895–unknown) (**Transport Dh** from Prague to Terezín on August 7, 1943). Alto. In Terezín, she performed the role of Carmen in Bizet's *Carmen* and sang the arias of Paisiello and Pergolesi in the "Music of the Rococo" program. Liberated in Terezín. [Critique 8].

3 **Jakub Goldring** (1916–1959) (**Transport AAl** from Prague to Terezín on July 2, 1942) (**Transport Er** from Terezín to Auschwitz on October 16, 1944). Tenor. In Terezín, Goldring sang in vocal programs of Yiddish songs and performed classical works of Bizet, Dvořák, Meyerbeer, Puccini, and Smetana. He sang the role of Vašek in Smetana's *The Bartered Bride,* the role of Uriel in Haydn's *The Creation,* and Remendado in *Carmen.* Liberated in Friedland. [Critique 8].

4 **Josef Hermann**: Tenor. Sang a program of Eastern Jewish tunes, liturgical chants, Chasidic art songs, and folk tunes with Ada Schwarz-Klein and Jakub Goldring in Terezín. [Critique 8].

5 **Reb Levi Yitzchak ben Meir of Berdichev** (a.k.a. The Berdichever Rabbi) (1740–1810) was a leading spiritual figure in the early years of the Chasidic movement. He is revered as a great

tzaddik (righteous one) and was renowned throughout eastern Europe for his challenge to the *misnagdim* (Jewish mainstream) in public debates. He often addressed God directly in his famous prayers, such as the well-known and often-recorded "Kaddish," in which he pleads with the Lord to have *"rachhmones"* (pity or mercy) on his people. According to one tradition, Levi Yitzhak, overwhelmed by the suffering—both physical and spiritual—of his brethren, approached God during the Jewish High Holidays. Mixed with humility before God and his deep love for his people, he raised the question of His accountability for permitting their suffering. Popular tradition has preserved prayer songs (*nigunim*) in Yiddish attributed to Levi Yitzhak. The Berdichever Rabbi taught, "A *nigun* opens windows in the soul." [Critique 8].

6 **"Dudale"** is a song of the Lubavitcher Chasidim [Critique 8].

7 **Vittorio Weinberg** (born Chaim Weinberg in Jerusalem) (1895–unknown). Baritone. After studies in the Milan Conservatory of Music, Weinberg sang and recorded major operatic roles throughout Europe in the 1920s. He sang and taught primarily in what is now Israel from 1932 to 1939, when he left for the United States to assume a cantorial position at Congregation Beth Shalom in San Francisco. It is possible that Ullmann either attended a recital by Weinberg in the 1920s or heard his 78 rpm shellac recordings of music from the operatic and cantorial repertoires [Critique 8].

8 **Heinrich Taussig** [Critiques 6, 8].

9 **Pavel (Paul) Kling** [Critiques 4, 8, 21].

10 **Romuald Süssmann** [Critiques 4, 8].

11 **Friedrich (Freddie) Mark** [Critiques 4, 8, 21].

12 **Pavel (Paul) Kohn** [Critique 6, 8].

13 **Karl Ančerl** (in Czech, Karel Ančerl. This book uses the Czech version of his name everywhere except within Ullmann's Critiques.) (1908–1973) (**Transport Cb** from Tábor on November 16, 1942) (**Transport Er** to Auschwitz on October 16, 1944). Conductor and violist. Before World War II Ančerl studied conducting with Václav Talich and was a vocal coach at the Munich Opera House under Hermann Scherchen. In Terezín, he was in the center of musical activities primarily as a conductor and on occasion as a violist performing chamber music. He worked in Terezín's kitchens. Ančerl gave a series of lectures on musical topics, and he organized a string orchestra consisting of eight stands of first violins, six stands of second violins, four stands of violas, three stands cellos, and one double bass. This orchestra performed Bach's Piano Concerto in D Minor, Bach's Violin Concerto in E Major, Dvořák's String Serenade in E Major op. 22, Haas's Study for String Orchestra, Händel's Concerto Grosso in F Major, Mozart's *Eine Kleine Nachtmusik*, Suk's "Meditation on an Ancient Old Czech Chorale, 'St. Wenceslas'" op. 35a. Ančerl also performed as second violist in Brahms's Sextet in G Major op. 36. Following his liberation in Auschwitz, he was director of the Czech Philharmonic (1950–1968) and the Toronto Symphony (1969–1973) [Critiques 8 & 14].

14 **Johannes Brahms** (1833–1897) [Critiques 1, 5–9, 21].

15 **Quintet in C Major, D. 956** was Schubert's last complete chamber work. He completed it in 1828, the year he died in Vienna [Critiques 1, 4, 8, 14, 15, 20, 23].

16 **Bernhard Kaff** (1905–1944, Auschwitz) (**No. 420 on Transport K** from Brno to Terezín on December 5, 1941) (**No. 1404 on Transport Er** from Terezín to Auschwitz on October 16, 1944). Concert pianist noted for championing contemporary repertoire. In Terezín, he performed solo recitals of Beethoven, Chopin, Janáček, Mussorgsky, Liszt, and Haas. Kaff performed a violin and piano recital featuring Beethoven's Sonata no. 9 in A op. 47 (*Kreutzer*) and Franck's Sonata no. 1 in A Major op. 13 with Karel Fröhlich. Kaff premiered Haas's Partita in the Old Style on June 28, 1944. He also gave piano lessons and coached chamber music ensembles [Critiques 8, 20].

17 **Pavel Haas** (1899–1944, Auschwitz) (**No. 731 on Transport G** from Brno to Terezín on December 2, 1941) (**No. 1231 on Transport Er** from Terezín to Auschwitz on October 16, 1944).

104. Poster. *Haydn—Die Schöpfung.* Emo Groag. April 1944. HCPT #4063. *Poster showing programs in which Jakob Goldring performed. Clockwise from the top: Haydn's* The Creation, *Mozart's* The Marriage of Figaro, *Yiddish Folk Songs, Hebrew Songs, and Smetana's* The Bartered Bride. *The inscription reads, "Affectionately dedicated as a remembrance of my work in Theresienstadt by Jakob Goldring."*

132

Composer of film scores, operas, and vocal, symphonic, and chamber music. Haas's style was greatly influenced by studies with his mentor Leos Janáček at the State Conservatory of Brno. Haas was considered to be the major voice among the next generation of composers connected to the Czech traditions of Smetana, Dvořák, and Janáček. His surviving compositions from Terezín are "Al S'fod" ("Do Not Lament") for male chorus (1942), Study for String Orchestra (1943), and Four Songs to the Text of Chinese Poetry for Bass and Piano (1944) [Critiques 8, 14, 15].

18 **Twelve-tone music,** or serial music, was a new system of composition introduced in the early half of the twentieth century. The basis of twelve-tone technique is the tone row or series, an ordered arrangement of the twelve notes of the chromatic scale (the twelve equal tempered pitches: A, A-sharp, B, C, C-sharp, D, D-sharp, E, F, F-sharp, G, G-sharp). A tone row becomes the unifying element for the melodic and harmonic structures of the composition. Serial music makes a departure from anchoring tonal music to the home key of a major or minor triad chord. Arnold Schönberg, the father of serial music, describes it best in a letter to his pupil Alban Berg: "Just as the church modes disappeared and made way for major and minor, so these two have disappeared and made way for a single series, the chromatic scale. Relation to a keynote, tonality, has been lost … Earlier, when one wrote in C-major, one also felt 'tied' to it; otherwise the result was a mess. One was obliged to return to the tonic, one was tied to the nature of this scale. Now we base our invention on a scale that has not seven notes but twelve."

19 **Partita.** Ullmann draws attention to the confusion over historic and new use of the musical term "partita." Originally it was a set of variations; contemporary use designated a suite.

20 **Leoš Janáček** [Critiques 1, 7, 8, 15].

21 **"In the Mists"** ("Im Nebel-V mlhách") for solo piano, 1921 [Critique 8].

22 **"Before me, the deluge."** Ullmann facetiously alludes to the famous quote "Après moi, le déluge" ("After me, the flood"), attributed to Louis XV in cavalier anticipation of the French Revolution.

23 **Modest Mussorgsky** (1839–1881). Famous nineteenth-century Russian composer. Mussorgsky was one of the principal nationalist composers of late nineteenth-century Russia, a group dubbed the "Mighty Five" or "Handful" by Russian critic and librarian Vladimir Stasov. The five included Balakirev, Borodin, Cui, and Rimsky-Korsakov [Critique 8].

24 **Canossa** is a ruined castle in Emilia, Italy, where in 1077 the "excommunicated" Holy Roman emperor Henry IV gave penance before Pope Gregory VII. The term "going to Canossa" signifies the power of the Pope and the Roman Catholic Church's monopoly on granting royal legitimacy. Napoleon would break from this tradition when he crowned himself emperor.

25 **Maurice Ravel** (1875–1937) and Claude Debussy were the outstanding composers of French impressionist music. In addition to his orchestral arrangement of Mussorgsky's *Pictures at an Exhibition*, Ravel's best-known ballet and orchestral works include *La Valse, Bolero, Daphnis et Chloé,* and Suites One and Two [Critique 8].

26 **Mussorgsky-Ravel's** *Pictures at an Exhibition*. French impressionist composer Maurice Ravel orchestrated Mussorgsky's solo piano suite, *Pictures at an Exhibition* (1874). The composition was inspired by a group of paintings by Mussorgsky's friend, artist Victor Hartmann [Critique 8].

27 **"Hut of Baba Yaga"** is a movement (tableau) in Mussorgsky's *Pictures at an Exhibition* [Critique 8].

28 **"Ballet of Chicks in their Eggshells"** is a tableau in *Pictures at an Exhibition* [Critique 8].

105. Poster. *Stadt-Kapelle, Kapellmeister: Carlo Taube, Peter Deutsch.* HCPT #3975.

Critique 9
A MUSICAL PANORAMA (II.)

Carlo Taube[1] played a Romantic program. Even though for us here this means carrying owls to Athens[2] it should be noted that Taube chose rarely played and yet—or therefore—especially beautiful works: Schumann's wonderful *Phantasiestücke*,[3] one of the first declarations of his young genius, and unfortunately as neglected as the *Davidsbündler* or the Novelettes; then, two *intermezzi* and the grand B-Minor Rhapsody of Brahms[4] dedicated to his friend [Elisabet] Herzogenberg;[5] and, to finish with an "all's well that ends well"—there was, of course, a bouquet of Chopin.[6] Carlo Taube would doubtlessly be one of the best pianists if he had devoted himself from the beginning and exclusively to the piano and the study of art music. He was born, so to speak, with the hands of a pianist and has temperament enough for two (sometimes a little too much). But naturally: the piano is like a beloved who will not tolerate a rival, and let us add: One has to dedicate oneself to the study of the old and new masters with the perseverance and self-sacrifice usually found only in scientific research; with that Brahmsian self-discipline which is simply the be-all and end-all of morality of art. Like Heracles, Taube stands at a crossroads—he has to decide.

Dr. Karl Reiner[7] and Karl Bermann[8] offered a charming and interesting experiment with a program of spoken and sung choirs. One has to admit that the voice band[9] was actually more impressive. The school of the young Czech avant-garde is unmistakable, even if it is—as was the case here—interpreted by children. The melodramatic effects of the dear and—why deny it?—even to us grown-up children still interesting fairy tales of Božena Němcová[10] among others were remarkable. The children, who spoke their ensemble and solo parts in correct counterpoint, were most lovable. The performances by Bermann's new girls' chorus—even if limited for the time being to one and two-part folk songs or arrangements—were excellent and promise beautiful things to come in the future. The arrangements were done by the masterful hands of Dvořák and Novák (as well as a few others). Bermann is also exceptionally talented as a conductor, although we would recommend him to have control over his movements—as multi-faceted as this charming artist is, we don't want to employ him as a dancer as well.

We also have to thank him for the excellent and impeccable production under his direction of Mozart's *Bastien and Bastienne*,[11] the first scenic operatic performance in Theresienstadt. This pretty pastoral play has always been a playground for young singers and conductors. It is, however, more than lightweight and light fare: In the second half, we can anticipate the later Mozart, the other is in the gallant style of the time. Among the singers we discovered a true talent for both acting and singing: R. Fuchs.[12] One should keep an eye out for her.

Miss Tomková[13] also stood her ground and after she overcame her timidity, displayed a very pretty voice. Pollak[14] needs a competent voice teacher: he sings into himself, so to speak, which is really a pity given his sonorous voice.

Musikalische Rundschau

Carlo Taube spielte sein romantisches Programm. Wenn dies bei uns auch Eulen nach Athen tragen heisst, so muss doch gerühmt werden, dass Taube sich selten gespielte und dennoch -oder deswegen- besonders schöne Werke gewählt hat: Schumanns -wundervolle Fantasiestücke, eine der Kundgebungen des jugendlichen Genius und leider so vernachlässigt wie etwa die Davidsbündler oder die Novelletten-, neben zwei Intermezzi die der Freundin Herzogenberg gewidmete herrliche h-moll-Rhapsodie von Brahms -zum Teil sowell all's well natürlich ein Bouquet Chopin. Carlo Taube wäre zweifellos einer der besten Pianisten, wenn er sich von Anfang an und ausschliesslich dem Klavier und dem Studium der Kunstmusik gewidmet hätte. Die Klavierhände sind ihm sozusagen angeboren und Temperament hat er für zwei (manchmal etwas zuviel). Aber freilich: Das Klavier ist wie eine Geliebte, die keine Nebenbuhlerin duldet und fügen wir hinzu: dem Studium der alten und neueren Meister muss man sich mit jener sonst nur wissenschaftlicher Forschung eigenen Zähigkeit und Selbstlosigkeit hingeben, mit jener Brahmsschen Selbstdisziplin, die eben das Um und Auf künstlerischer Moral ist. Taube steht heute am Scheidewege wie einst Herakles -er hat zu entscheiden.

Einen reizvollen und interessanten Versuch boten Dr. Karl Reiner und d. Karl Hermann mit einem Programm von Sprech- und Gesangschören. Man muss gestehen, dass die voice band eigentlich noch eindrucksvoller war. Die Schule der jungtschechischen Avantgarde ist unverkennbar auch dann, wenn die in diesem Falle Kinder- die Interpreten sind. Die -sozusagen melodramatischen- Wirkungen in den lieben und -warum es leugnen- uns noch interessanten Märchen der Dozena Nemcova u.a. sind erstaunlich. Die Kinder, die in richtigem Contrapunkt ihre chorischen und solistischen Ensemblesätze sprachen, waren ganz allerliebst. Auch die Darbietungen des neuen Hermannschen Mädchenchors -wiewohl vorläufig noch auf ein- und zweistimmige Volkslieder bezw. Bearbeitungen eingeschränkt, waren ausgezeichnet und versprechen für die Zukunft mancher Schöne. Die Bearbeitungen stammen aus den Meisterhänden Dvoraks und Novaks (sowie einiger anderer). Hermann ist auch als Dirigent ausgesprochen begabt, doch empfehlen wir ihm Beherrschung seiner Bewegungen. So vielseitig dieser sympathische Künstler ist- als Tänzer möchten wir ihn doch nicht auch noch beschäftigen.

Ihm danken wir auch die vorzügliche, einwandfreie Instudierung von Mozarts "Bastien und Bastienne", der ersten scenischen Opernaufführung in Theresienstadt, nebst der Regie. Das höische Schäferspiel ist seit jeher der Tummelplatz junger Sänger und -ware: erst in der zweiten Hälfte ahnen wir den späteren Mozart, das Andere ist galanter Stil der Zeit. Unter den Sängern entdeckten wir ein echtes Theater- und Gesangstalent: H. Fuchs. Man habe ein Auge auf sie. Auch Frl. Tomkova hielt sich sehr wacker und zeigte nach Ueberwindung einiger Befangenheit eine sehr hübsche Stimme. Pollak braucht einen guten Gesangspädagogen: er singt sozusagen in sich hinein und es ist wirklich schade um seine sonore Stimme. Das Streichquartett, von Jochowitz noch etwas schwerfällig geleitet, wäre unbedingt durch einen Kontrabass zu ergänzen -denn wie kann man basslos spielen?- und womöglich durch eine zweite I. Violine.

106. Viktor Ullmann's original manuscript of Critique 9. 2 pages. NIOD.

The String Quartet, led a little too ponderously by Jochowitz,[15] should definitely be supplemented by a double bass—how can one play without a bass?—and perhaps by a second first violin as well [images 105–111].

Annotations

1 **Karel Zikmund Taube** (Carlo S. Taube) (1897–1944, Auschwitz) (**No. 261 on Transport L** from Prague to Terezín on December 10, 1941) (**No. 125 on Transport Em** from Terezín to Auschwitz on October 1, 1944). Composer, conductor, and pianist. Taube studied with Ferruccio Busoni in Vienna. During the Nazi occupation, he performed secretly under the name Holubovský (which means pigeon in Czech; his name, Taube, is pigeon in German). In Terezín, he was a pianist and conductor of popular light classical concerts, and he performed solo piano recitals of works by Beethoven, Brahms, Chopin, Liszt, and Schumann. He composed a suite of three miniatures for violin and piano titled *Poem, Caprice, and Meditation,* and on a larger scale he composed the *Terezín* Symphony. He collaborated with his wife, Erika, in *"Ein jüdisches Kind,"* ("A Jewish Child") a lullaby for soprano and piano. **Erika Taubeová** (1913–1944, Auschwitz) (**No. 262 on Transport L** from Prague to Terezín on December 10, 1941) (**No. 96 on Transport En** from Terezín to Auschwitz on October 4, 1944) and their child were sent directly to the gas chambers. Karel Taube also performed in Terezín's *Kaffeehaus* [Critiques 9].

2 **"Carrying (or bringing) the owls to Athens"** is an ancient Greek adage referring to a pointless or unnecessary endeavor. An English example is "bringing coals to Newcastle," or in Dutch "bringing water to the sea."

3 **Schumann's** *Phantasiestücke (Fantasy Pieces)* **op. 12** is among the major works of his early piano period. These eight solo piano pieces dedicated to the Scottish pianist Robena Laidlaw are musical sketches poetically reflecting Schumann's alter egos, Eusebius and Florestan [Critiques 1, 6, 9, 11, 25].

4 **Johannes Brahms** (1833–1897) [Critiques 1, 5–9, 21].

5 **Elisabet von Herzogenberg** née **Elisabet von Stockhausen** (1847–1892) was a pianist, soprano, and composer. She and her husband, Heinrich (1843–1900), were close friends and supporters of Johannes Brahms. Heinrich was a cofounder and director of the Bach-Verein in Leipzig and professor of composition at the Berlin Hochschule für Musik [Critique 9].

6 **Frédéric Chopin** (born Fryderyk Franciszek Chopin) (1810–1849). Virtuoso pianist and classical Romantic composer famous for his great contributions to the solo piano repertoire [Critiques 9, 11, 25].

7 **Karl Reiner** [Critiques 1, 9, 10, 13].

8 **Karl Bermann** (in Czech, Karel Berman. This book uses the Czech version of his name everywhere except within Ullmann's Critiques and in captions directly quoting text that appears in artwork). (1919–1995) (**Transport Cv** from Prague to Terezín on March 6, 1943) (**Transport Ek** to Auschwitz on September 28, 1944). Basso. During the Nazi occupation of Czechoslovakia, Berman assumed the name František Havlas in order to circumvent the Nuremberg prohibitions. In Terezín he performed in several opera productions: the roles of Kecal (twenty-five times) in Smetana's *The Bartered Bride*; Smetana's *The Kiss* (the first of fifteen performances took place in the Dresden Barracks on July 20, 1943); the roles of Speaker of the Temple and Sarastro in Mozart's *The Magic Flute*; Bastien in Mozart's *Bastien and Bastienne*; Zuniga in *Carmen*; and Todt (Death) in Ullmann's

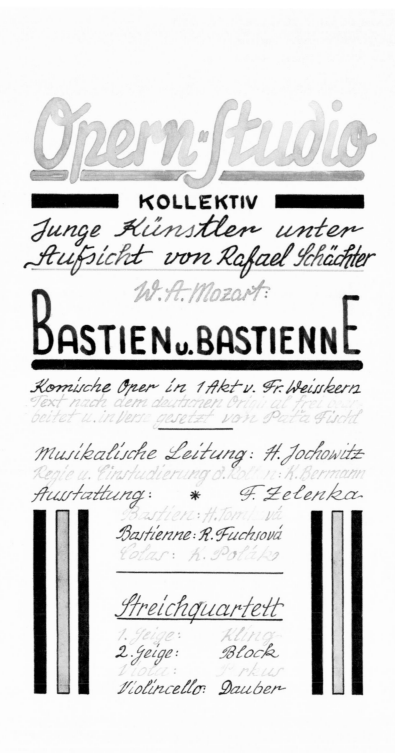

107. Poster. Opern-Studio. HCPT #3930. *Poster for the young artists performing Mozart's opera* Bastien *and* Bastienne *under the direction of Rafael Schächter.*

349

KONZERTE Prof. Carlo T A U B E .

I.

L. v. Beethoven	:	Sonate As Dur mit Treuermarsch
Brahms-Paganini	:	Variationen 2 Bände
F . Liszt	:	Waldesrauschen
"	:	Gnomentanz
F. Chopin	:	Nocturno G Dur
"	:	2 Etuden Ges Dur

II.

F. Chopin	:	Sonate B Moll
		Prelude
		Ballade G Moll
		Improptu Fis Dur
		Valse brilante
		3 Etuden E Dur, As Dur, A Moll

III.

R. Schuhmann	:	Fantasiestücke
J. Brahms	:	Intermezzo
"	:	Rhapsodie H Moll
"	:	Ballade G Moll
F. Chopin	:	Scherzo Cis Moll
"	:	Nocturno Des Dur
"	:	Polonaise As Dur

108. Program of three concert programs directed by Carlo Taube. HCPT #3942.

109. Drawing. Carlo Taube at the piano. Margita Kleiner-Fröhlich. HCPT #4206.

Der Kaiser von Atlantis. He was the bass soloist in the Terezín Verdi *Requiem* performances and sang and acted in Karel Švenk's cabaret production, *Long Live Life.* Berman performed vocal recitals of Beethoven, Dvořák, Wolf, Haas (the premiere of "Four Songs to the Text of Chinese Poetry"), Mahler, and Schul, as well as Schubert lieder with Edith Steiner-Kraus. He also prepared vocalists for opera productions and served as piano accompanist with other vocalists, including Windholz in Smetana's *The Evening Songs.* Berman also composed a cycle of three songs titled *"Poupata"* ("The Rosebuds") for basso and piano, and he lectured on the music of Smetana. Berman was liberated from Allach, the largest subcamp of Dachau. Following the war, he was a leading operatic figure in the National Theatre in Prague from 1953 to 1990 [Critiques 9, 10, 15, 16, 18].

9 In his original German text, Ullmann types the English "**voice band.**" His immediate connection to the "school of the young Czech avant-garde" make it reasonable to assume he is referring to Voiceband, a group formed in 1927 by the Czech avante-garde artist, playwright, and director Emil František Burian (1904–1959). A politically far-left theatre ensemble, Voiceband mixed music—primarily jazz—with "collective" or group recitations. From 1934 until the Nazi occupation, Voiceband performed in Studio 34, an avante-garde theatre formed and directed by Burian in Prague. Ullmann would have attended and perhaps covered their productions as a critic in the mid 1930s. In late 1941, Burian was arrested by the Nazis as a political dissident and sent to the Small Fortress in Terezín, where he would not have had any contact with Ullmann or the *Freizeitgestaultung* in the Large Fortress of Terezín. Burian was later transported to Dachau and liberated in Neuengamme.

10 **Božena Němcová** (1820–1862) was a major literary figure in the Czech national revival of the nineteenth century. She is famous for her fairy tales and the novel *Babička* (*The Grandmother*). Czech novelist Milan Kundera considered Němcová "the mother of Czech prose" [Critique 9].

11 **Mozart's *Bastien and Bastienne*, K. 50/46b**. Mozart composed the one-act *singspiel* at the age of twelve. *Singspiel* is a light German folk opera with spoken dialogue between sections of music, much like its French counterpart, *opéra comique*. An interesting note of music trivia: *Bastien and Bastienne* was commissioned by Dr. Anton Mesmer, the Viennese doctor who practiced a form of hypnotism later called mesmerism. This *singspiel* is a lighthearted story of young love and reconciliation based on *Les amours de Bastien et Bastienne* (*The Loves of Bastien and Bastienne*) by Marie-Justine-Benoîte Favart and Harny de Guerville, which in turn was a parody adaptation of Jean-Jacques Rousseau's operatic *intermezzo Le devin du village* (*The Village Soothsayer*) [Critiques (Mozart) 4, 9, 10, 14, 16, 17, 22, 25].

12 **Rita Fuchs (Fuchsová)** (1923–1945, Bergen-Belsen) (**No. 502 on Transport Di** from Prague to Terezín on July 13, 1943) (**No. 934 on Transport Eo** from Terezín to Auschwitz on October 6, 1944). Soprano. In Terezín, she sang in *Bastien and Bastienne* (role of Bastienne) and the role of one of the Three Ladies in *The Magic Flute* [Critiques 9, 17].

110. Document. Lectures in Terezín. ZM #A1260. *The dates, times, lecturers, titles of lectures, and locations are listed on this fragment. Dr. Jiřina Irma Fischerová lecture: "How Does a Woman View a Man in Terezín." Karel Ančerl lecture: "Modern Czech Music." Dr. Max Popper lecture: "The Origins and Development of Prague."*

13 **Hana Tomková** (1916–unknown) (**Transport AAl** from Prague to Terezín on July 2, 1942). She performed the role of Bastien in *Bastien and Bastienne*. Tomková was liberated in Terezín [Critique 9].

14 **Karel Polák (Pollak)** (1918–1945, Dachau-Kaufering) (**No. 432 on Transport G** from Brunn to Terezín on December 2, 1941) (**No. 86 on Transport Ek** from Terezín to Auschwitz on September 28, 1944) (**Transport** from Auschwitz to Dachau-Kaufering on October 10, 1944). Amateur singer. Polák sang the operatic roles of Matouš in Smetana's *The Kiss* (*Hubička*), Colas in *Bastien and Bastienne*, and Le Dancaïre, The Smuggler, in Bizet's *Carmen* [Critiques 9, 17, 26].

15 **Jindřich (Hanuš) Jochowitz** (1920–1944, Dachau-Kaufering) (**No. 731 on Transport Ck** from Prague to Terezín on December 22, 1942) (**No. 2073 on Transport Ek** from Terezín to Auschwitz on September 28, 1944) (**Transport** from Auschwitz to Dachau-Kaufering on October 10, 1944). Pianist and conductor. Jochowitz conducted thirty performances of *Bastien and Bastienne* and performances of the folk play *Esther* with incidental music by Karel Reiner. In addition to performing, he gave lectures on the music of Smetana and taught in the Boys' Home Q 609 [Critique 9].

111. Poster. *Die Stadtkapelle, Leitung: Carlo Taube.* Walter Heimann. August 1944. HCPT #3973. *Taube formed Die Stadtkapelle (Town Orchestra), an ensemble that performed semi-classical and light popular music. This poster shows the open-air concert pavilion in the central square where* Die Stadtkapelle *and* The Ghetto Swingers *performed. One of the performances was staged for the International Red Cross Committee visit.*

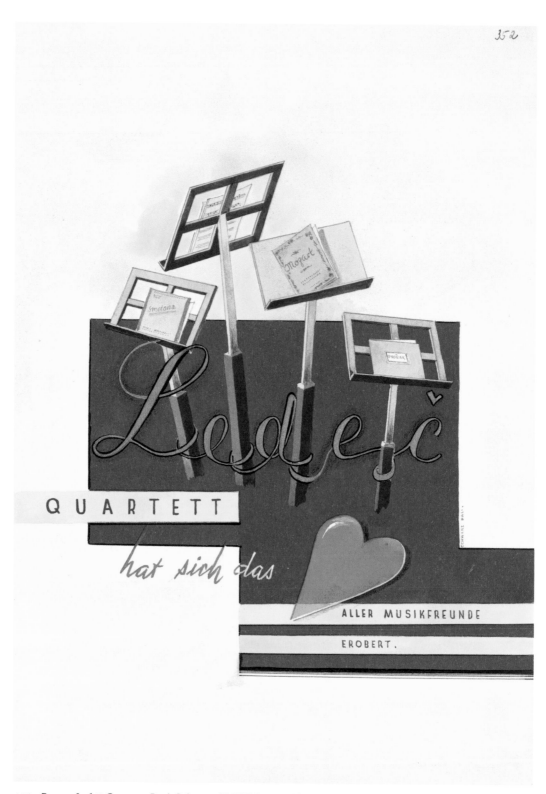

112. Poster. *Ledeč Quartett*. Pauli Schwarz. HCPT #4208. *The Ledeč String Quartet* "has conquered the heart of all music lovers."

144

Critique 10
A MUSICAL PANORAMA (III.)
Mid-August 1944

The summer months have seen an increase rather than a decrease of interest in musical productions and therefore we have more performances once again.

The Smetana[1] Evening with Rafael Schächter's[2] choir delighted everyone through the familiarity of the cheerful enthusiastic cantata "The Czech Song,"[3] which displays all of the master's merits: the powers rooted in the folkloric tradition, which consistently impart his melodic inventions with youthful freshness and fullness, as well as the stylistic signature influenced by Mozart (as Hanslick[4] already pointed out) and symbiotically combined with neo-Romantic elements. Rafael Schächter offers us a vivacious, lively, dynamic, rhythmically pleasing, and well sculpted performance of the lovable piece. The sonorous arrangement for two pianos was done by Heinz Alt.[5] It goes without saying that not all of the women's and men's choirs sounded as good as the mixed choir; but even they performed at an impressive level. Walter Windholz[6] sang Smetana's "Evening Songs" with a noble voice and stylistic sensitivity.

A second, more challenging choir evening was presented by Karl Fischer:[7] Mendelssohn's *Elias*.[8] Mass, opera, and oratorio are the three streams of European vocal music; the secular child lies in the middle between the Catholic and Protestant art forms. Here, Mendelssohn competes for the crown of laurels with Schütz,[9] Händel,[10] Bach[11]—whom he, so to speak, discovered—and with Beethoven, Haydn,[12] and other great and greatest masters; he passes with flying colors. There are more ingenious, but not more talented works by Felix Mendelssohn.[13] The choruses are not always easy, comfortably, and effectively set, and are often full of glorious polyphonic density and dramatic momentum. The phases of Elias's life—drought, awakening of the dead, conflict with the clerics of Baal, persecution, wilderness, and ascension to heaven—pass by us in often gripping musical tones. Karl Fischer's performance is at a high level; the richness of the sound produced by the approximately eighty-member choir is astonishing. It would have been recommended to use an abridged version of the lengthy piece, but without damaging its noble parts. Windholz was impressive as he supported the performance in the starring role. At his side, Mrs. Borger's[14] bell-clear voice distinguished itself along with Mrs. Lindt's[15] marvelous alto and Gobets's[16] beaming, metallic tenor. Mrs. Kohn-Schlesskow[17] stood out as choir soloist. Dr. Karl Reiner[18]—who also accompanied the Schächter choir and Bermann[19]—and Mrs. Bach-Fischer[20] worked commendably on the two pianinos[21] that replaced the orchestra.

Ledeč[22] and Alice Herz-Sommer[23] played three of the most beautiful Beethoven violin sonatas. How Beethoven frees himself in op. 12 from any prototype is shown in the most charming way in the Mannheim-style[24] first movement. The second [movement] with its daring melodies and harmonies leads directly into Beethoven's phase as master,

Musikalische Rundschau

Mitte August 1944

Die Sommermonate haben das Interesse an musikalischen
Veranstaltungen eher gesteigert als vermindert und so sind auch
die Darbietungen wieder häufiger geworden.
Der Smetana-Abend des Rafael Schächter-Chores
erfreute durch die Bekanntschaft mit der frohgemut-begeisterten
Kantate "das böhmische Lied", die alle Vorzüge des Meisters zeigt:
die im Volkshaften wurzelnden Kräfte, die seiner
melodischen Invention stets neue Jugendfrische und Fülle zuführen,
wie die an Mozart gebildete stilistische Signatur-die schon
Hanslick aufgefallen ist- in ihrer Symbiose mit neuromantischen
Elementen.Rafael Schächter bietet uns eine schwungvolle,lebendige,
dynamisch und rhythmisch befriedigende und plastische Aufführung
des liebenswürdigen Werkes.Die gut klingende Bearbeitung für
zwei Klaviere stammt von Heinz Alt.Dass nicht alle Frauen -und
Männerchöre so gut klangen wie der gemischte Chor,ist selbst-
verständlich;aber auch sie hielten sich auf beachtlicher Höhe.
Walter Windholz sang mit edler Stimme und Stilgefühl Smetanas
"Abendlieder".
Einen zweiten,anspruchsvolleren Chorabend liess Karl Fischer
hören:Mendelssohns "Elias".Missa,Oper und Oratorium sind die
3 Strömungen der europäischen Vokalmusik,das Weltkind in der Mitte
zwischen der katholischen und der protestantischen Kunstform.
Mendelssohn ringt hier um die Palme mit Schütz,Händel,Bach--den
er ja sozusagen entdeckt hat- und mit Beethoven,Haydn und anderen
grossen und grössten Meistern;er besteht in Ehren.Es gibt genia-
lere,aber nicht talentiertere Werke Felix Mendelssohns.Die Chöre
sind nicht immer leicht,immer dankbar und gut gesetzt,oft von
herrlicher polyphoner Verdichtung und dramatischem Schwunge.
Die Phasen des Eliaslebens -Dürre,Totenerweckung,Streit mit
den Baals-Pfaffen,Verfolgung,Wüste und Himmelfahrt -ziehen in
oft ergreifenden Tönen an uns vorüber.Die Aufführung Karl Fischers
ist von hohem Niveau,die Klangfülle des ungefähr 80 Personen
zählenden Chores ist überraschend.Eine Kürzung des überlangen
Werkes wäre zu empfehlen gewesen,ohne Verletzung edler Teile.
Imponierend ist Windholz als Träger der Hauptpartie.Ihm zur
Seite zeichnen sich aus Frau Borgers glockenhelle Stimme neben
dem prächtigen Alt der Frau Lind und Gobec' strahlendem,metalli-
schem Tenor.Als Chorsolistin fiel angenehm auf Frau Kohn-Schless-
kov.An den zwei Pianinos,die das Orchester ersetzten,wirkten
verdienstvoll Dr.Karl Reiner -der auch den Schächterchor beglei-
tet-,und Frau Bach-Fischer.
Ledeč und Alice Herz-Sommer spielten drei der schönsten
Beethoven-Violinsonaten.Wie sich Beethoven in op.12 vom Vorbilde
löst,zeigt aufs Anmutigste der Mannheimerische erste Satz,der
zweite führt mit seiner kühnen Melodik und Harmonik mitten in
die Meisterzeit,als deren Blüte uns die Frühlingsonate entgegen
tritt,während op.96 die Schatten der Spätperiode über das blen-
dende Licht der jugendfrischen Inspiration breitet-nicht mehr
vegetativ,sondern meditativ komponiert der ertaubende Beethoven.
(Klingt da nicht Mahlers Fischpredigt mit im Trio des Scherzos?)
Egon Ledeč ist mehr als ein ausgezeichneter "böhmischer Musikant"
der mit seinem Instrument verwachsen ist,er ist ein bewusst und
mit feinem Stilgefühl gestaltender Künstler,der auch um die

Geheimnisse der Geige weiss,um Phrasierung,Stricharten,Bo-
genführung,Griffbrettspiel u.s.w.Sein schöner Ton,der nun von-
Schlaken gereinigt ist,sein beseelter Vortrag und sein musikan-
tischer Instinkt sind zu rühmen.Ihm zur Seite Alice Herz-Sommer
am Klavier bot echten,unverfälschten Beethoven mit ihrem schönen,
edlen Klaviergesange und ihrer plastischen thematischen Gestaltung
mit der wohlproportionierten Gliederung der Form,in Agogik und
Dynamik vollendet.
 Zuletzt sei des neuen Ledec-Quartettes (Ledec,Cohn,~~Kraus~~, *Kraus*
Dauber)gedacht,das uns mit einem zauberhaft schönen und vortreffl:
lich musizierten Haydn aufwartete,dem Sigmund Schuls interessan-
tes,gut gearbeitetes (und schon bekanntes)Divertimento ebraico
folgte,zuletzt Borodins schwungvolles,aber nicht immer voll-
wertiges Quartett,das manchmal mehr nach Boulevard als nach Stepp
klingt.Das neue Quartett spielt gepflegt,präzise und mit schöner
Tongebung.Es ist unbedingt ein Gewinn für unsere Kammermusik.
 Viktor Ullmann

113. Viktor Ullmann's original manuscript of Critique 10. 2 pages. NIOD.

FISCHER CHOR

SYNAGOGALE - MUSIK

GEISTLICHE ORATORIEN:

DIE SCHÖPFUNG

VON J. HAYDN

ELIAS

VON F. MENDELSSOHN.

OPERN - KONZERT:

CAVALLERIA-RUSTICANA

AIDA

DIRIGENT: KARL FISCHER.

114. Poster. *Fischer Chor — Synagogale-Musik.* HCPT #4042. *The first program performed by the Fischer Choir offers synagogue music titled "spiritual oratorios" and the other presents selections from the operas* Cavalleria rusticana *and* Aida.

115. Drawing. Sketches of musicians. František Petr Kien. *Egon Ledeč is the violinist in the upper-lefthand corner.* PT #9841.

which blossomed in his Spring Sonata. In op. 96, however, the shadows of his late period spread over the blinding light of his youthful inspiration—Beethoven, slowly turning deaf, no longer composes in a vegetative state but rather meditatively (Doesn't Mahler's "*Fischpredigt*"[25] resonate in the Trio of the Scherzo?). Egon Ledeč is more than just an exceptional "Bohemian musician," who has become one with his instrument. He is an artist who sculpts his material consciously and with a fine stylistic sensibility, and who knows the secrets of the violin; about phrasing, bowing, *sul tasto* playing,[26] etc. ... His beautiful tone, now cleared of all waste, his soulful presentation, and his musical instinct deserve praise. At his side, Alice Herz-Sommer offered authentic unadulterated Beethoven with the beautiful, noble song of her piano and her sculptural thematic structure with its well-proportioned organization of form, agogically and dynamically perfected.

Lastly the new Ledeč quartet[27] should be mentioned, which presented us with an enchantingly beautiful and excellently performed Haydn. It was followed by Sigmund Schul's[28] interesting, well-crafted (and already familiar) *Divertimento ebraico* and finally by Borodin's[29] vivacious, but not always fully worthy quartet, which occasionally sounds more like boulevard than steppe.[30] The new quartet plays with cultivation, precision, and beautiful tone. It is doubtless a gain for our chamber music [images 112–117].

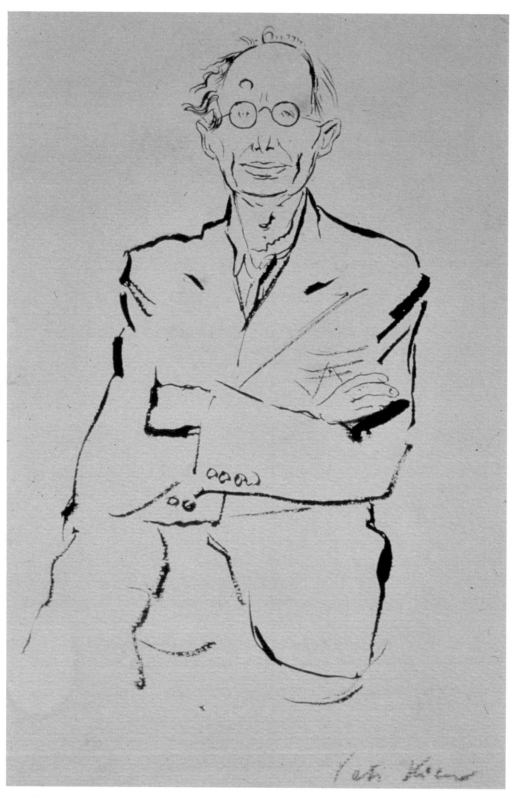

116. Drawing. Portrait of Egon Ledeč. František Petr Kien. ZM #174.303.

Studio für neue Musik

Leitung: Viktor Ullmann

2. Konzert

Junge Autoren in Theresienstadt

1. **Gideon Klein:**
Die Pest, 4 Lieder für Altstïe
u. Klavier, Dichtung: Peter Kien

2. **Heinz Alt:**
6 Miniaturen für Klavier

3. **Siegmund Schul:**
2 Chassidische Tänze für Violine u. Cello

4. **Karl Bermann:**
Ponpata

5. **Siegmund Schul:**
Diverti-Mento Ebraico für Streichquartett

Mitwirkende:
aronson-Lind, Kling, Ledeč-Quartett
Dr. Reiner, R.-Schächter, Weissenstein

117. Poster. *Studio für neue Musik* ("Studio for New Music"). HCPT #3950. *In this second concert, Ullmann served the dual role of artistic director and critic. He selected Sigmund Schul's "Divertimento Ebraico" for a concert titled "Young Composers in Theresienstadt" as part of his Studio for New Music chamber series.*

151

118. Poster. *Tempel-Chor* ("Temple Choir"). HCPT #4070.

CHORAL ENSEMBLES IN TEREZÍN

Rafael Schächter, Karl Fischer, Rudolf Freudenfeld, Siegmund Subak, and Karel Berman were the major forces in organizing and directing children and adult choirs in Terezín. An impressive canon of arrangements and original compositions were composed for these ensembles by Karel Berman, Rafael Schächter, Gideon Klein, Pavel Haas, Viktor Ullmann, Karel Švenk, Sigmund Schul, Bernard Pollak, František Domažlický, and Karel Vrba.[31] The repertoire spanned secular, liturgical, folk, and cabaret music. In addition to choral programs, the choirs performed in oratorios, operas, and cabaret productions—most notably in Hans Krása's children's opera *Brundibár*, the Verdi *Requiem*, *The Creation* by Franz Joseph Haydn, and Felix Mendelssohn's *Elijah* [images 118–124].

119. Poster. *Subak Chor*. Possibly Alfred Bergel. HCPT #4067. *Announced here is a program by the Subak Choir of synagogue, Jewish folk, and "new Palestinian" music directed by Siegmund Subak.*

120. Poster. *Abend der Psalmen* ("Evening of Psalms"). HCPT #3903. *Announced here is a program by the [Wilhelm] Durra Choir, with an introduction by Rabbi L. Neuhaus and biblical recitations by Ernst Östreicher.*

Annotations

1 **Bedřich Smetana** (1824–1884). Considered the father of the Czech nationalist school of music, inspiring major Czech composers including Dvořàk, Suk, Janáček, Haas, and Martinů. One of his eight operas, *The Bartered Bride*, is among the most frequently performed Czech operas worldwide. It is joined in popularity by his cycle of six symphonic poems titled *Má Vlast* (*My Country*). Smetana suffered from tinnitus, and he highlighted his suffering in the autobiographical String Quartet no. 1 in E Minor with a high screeching E in the last movement [Critiques 10, 11, 17].

2 **Rafael Schächter** (1905–1944, death march) (**No. 128 on Transport H** from Prague to Terezín on November 30, 1941) (**No. 943 on Transport Er** from Terezín to Auschwitz on October 16, 1944). Pianist and conductor. In early 1942 in Terezín, Schächter established the first female and male choirs and gave the first choral performances. He worked with Švenk on cabaret productions, and Gideon Klein arranged folk songs for his choirs. He conducted operas: Smetana's *The Bartered Bride* and *The Kiss*, Mozart's *The Marriage of Figaro* and *The Magic Flute*, and Pergolesi's *La Serva Padrona*, and he conducted rehearsals for the aborted production of Ullmann's opera *Der Kaiser von Atlantis*. He also conducted performances of Verdi's *Requiem* and a performance of Smetana's "The Czech Song," and he began rehearsing Krása's *Brundibár*. Schächter also accompanied bass Karel Berman and tenor Machiel Gobets in *lieder* recitals [Critiques 10, 15–18].

3 **Smetana's "The Czech Song."** A cantata for mixed choir and orchestra (1878).

4 **Eduard Hanslick** (1825–1904). Nineteenth-century music critic for the *Neue Freie Presse* and *Neues Wiener Tagblatt*. He was a noted champion of Brahms and detractor of Wagner and his genre of music drama. In response, Wagner caricatured Hanslick through the role of Beckmesser in his opera *Die Meistersinger von Nürnberg* [Critiques 10, 21].

5 **Jindřich (Heinz) Alt** (1922–1945, Dachau-Kaufering) (**No. 8 on Transport Df** from Ostrava to Terezín on June 30, 1943) (**No. 2396 on Transport Ek** to Auschwitz on September 28, 1944). Singer and composer. Alt performed on Ullmann's *Studio für neue Musik* concert series in Terezín, where he composed *Six Miniatures* for solo piano and several arrangements for chorus, the only surviving works of his incarceration period. He died in Dachau-Kaufering on June 1, 1945 [Critique 10].

6 **Walter Windholz** (1907–1944, Auschwitz) (**No. 21 on Transport Cd** from Prague on November 26, 1942) (**No. 952 on Transport Er** to Auschwitz on October 16, 1944). Opera basso. Windholz sang in several Terezín vocal productions; he appeared in Smetana's *The Bartered Bride*; performed the roles of Escamillo in Bizet's *Carmen*, Scarpia in Puccini's *Tosca*, Papageno in Mozart's *The Magic Flute*, and Elijah in Mendelssohn's *Elijah*; and performed selections of Mahler's *Des Knaben Wunderhorn*, *Kindertotenlieder*, and *Lieder eines fahrenden Gesellen* (with Dr. Otto König, piano) and Smetana's *Evening Songs*. Windholz also sang the role of the Kaiser in the Terezín rehearsals for Ullmann's *Der Kaiser von Atlantis* [Critiques 10, 17, 26].

7 **Karl Fischer** (1893–1944, Auschwitz) (**No. 250 on Transport G** from Brno on December 2, 1941) (**No. 942 on Transport Er** to Auschwitz on October 15, 1944). Conductor and vocalist. During his incarceration in Terezín, Karl Fischer performed more frequently as a conductor than as a vocal soloist. He sang the role of Le Dancaïre, The Smuggler, in *Carmen*. He formed and directed the Fischer Choir. Focusing mainly on the production of oratorios, he directed Haydn's *The Creation* (1943–1944) and Mendelssohn's *Elijah* (1944). He also conducted concert versions—without sets or costumes—of Verdi's *Aida* and Mascagni's *Cavelleria rusticana* [Critiques 10, 19, 26].

8 *Elias, or Elija* (1846) is one of two substantial oratorios, along with *St. Paul*, composed by Mendelssohn. *Elijah* op. 70 tells a story of transgression and redemption: When the children of Israel turn to idolatry, worshipping the pagan god Baal, the prophet Elijah proclaims a curse of

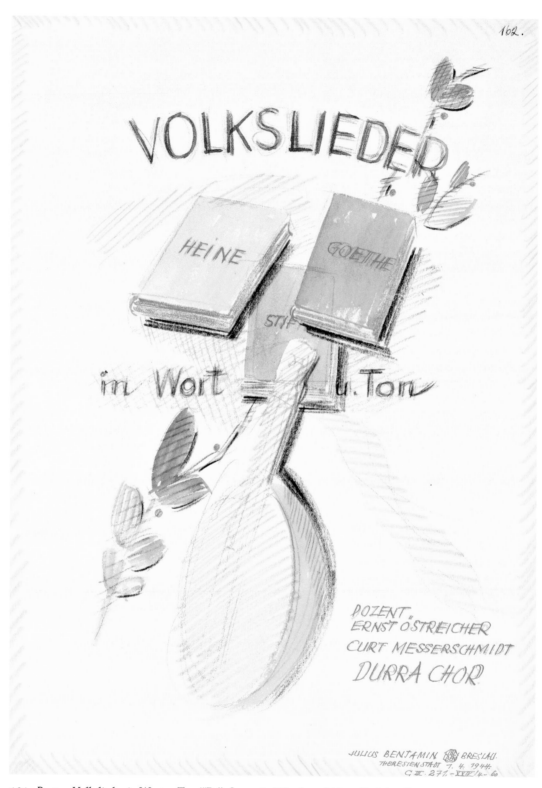

121. Poster. *Volkslieder in Wort u. Ton* ("Folk Songs in Words and Music"). Julius Benjamin.
April 1, 1944. HCPT #3905.

drought and famine. The priests of Baal are purged from the land, the Israelites return to God, and Elijah is carried off to heaven in a fiery chariot. An oratorio is a large composition for orchestra, vocal soloists, and chorus, usually based on themes from the Old or New Testaments (Händel's oratorios are based on Greek and Roman mythologies).

9 **Heinrich Schütz** (1585–1672) was a major force in introducing the Italian baroque style into German music. A good portion of his surviving compositions are sacred vocal works for the liturgy of the Lutheran Church [Critique 10].

10 **Georg Friedrich Händel** (1685–1759). Baroque composer. Although born in Germany, he later became a subject of the English crown and is buried in Westminster Abbey. One of his best-known works is the oratorio *The Messiah*, often performed during the Christmas season. Noted scholar and musician Christopher Hogwood aptly sums up Händel as "a man of the theatre. When thwarted in opera…he turned to a form he largely shaped—the oratorio … The first truly cosmopolitan composer, with a staunch independence and a pragmatic approach to composition that enabled him to excel in every chosen field, sacred or secular" [Critiques 10, 17].

11 **Johann Sebastian Bach** [Critiques 5, 7, 10, 14, 18, 20, 22].

12 **Felix Mendelssohn-Bartholdy** (1809–1847). German composer, conductor, and pianist of the early Romantic period. His grandfather Moses Mendelssohn was a noted Jewish philosopher and theologian. In 1816, his immediate family converted to Christianity, but this did not prevent the Nazis from designating Mendelssohn's music as *entartung* (degenerate) and banning performances because of his "racial origins." Like Mozart, he was a child prodigy as a pianist and composer; he composed his famous Octet for Strings at the age of sixteen. Goethe would request of the young Mendelssohn: "When I am sad, come and cheer me with your playing." Zelter and Goethe introduced Mendelssohn to the works of J. S. Bach. As a conductor, Mendelssohn would champion the revival of Bach's music and look to him as a source of inspiration. [Critiques 10, 11, 23, 24]

13 **Franz Joseph Haydn** (1732–1809) is acknowledged as the father of the symphony and string quartet. His prolific output and further development of these forms established their place in classical music. He composed a large body of sacred and secular compositions: symphonies, masses, oratorios, dramatic works, works for keyboard (sonatas and chamber pieces), and *divertimenti* [Critiques 10, 19].

14 **Gertrude (Truda) Borger** (1903–unknown) (**Transport Bl** from Ostrava to Terezín on September 26, 1942) (**Transport Em** to Auschwitz on October 1, 1944). Soprano. Borger sang in several Terezín productions: she was one of the Three Ladies in *The Magic Flute*, Micaëla in *Carmen*, and Eve in Haydn's *The Creation*. She was Mařenka in Smetana's *The Bartered Bride* and the soprano soloist in Mendelssohn's *Elijah* and Verdi's *Requiem*. In the Terezín rehearsals for Ullmann's *Der Kaiser von Atlantis*, she sang the role of der Lautsprecher (the Loud Speaker). Liberated in Mauthausen [Critiques 10, 17, 26].

15 **Mrs. Hilde Aronson-Lindt** (1899–unknown) (**Transport XII/7** from Frankfurt/M. to Terezín on March 16, 1944). Alto/mezzo soprano. Aronson-Lindt was flexible in singing mezzo soprano and alto roles in Terezín. She performed the role of Mercedes in *Carmen*, one of the Three Ladies in *The Magic Flute*, and the Shepard Boy in *Tosca*. On July 9, 1943, she sang in a Mahler evening that included excerpts from *Kindertotenlieder*, *Des Knaben Wunderhorn*, and *Lieder eines fahrenden Gesellen* with pianist Dr. Otto König and baritone Walter Windholz. Aronson-Lindt performed a lost song cycle composed in Terezín by Gideon Klein titled *Die Pest* (The Plague) on the second program of Ullmann's *Studio für neue Musik* series. She was the Drummer Girl in Ullmann's *Der Kaiser von Atlantis*, as well as alto soloist in 1944 performances of the Mendelssohn's *Elijah* led by Karl Fischer, and soloist in the Verdi *Requiem* performances led by Rafael Schächter. Liberated in Terezín [Critiques 10, 17, 18, 26].

16 **Machiel (Michael) Gobets** (1905–1945, Dachau) (**No. 241 on Transport XXIV/2** from Westerbork to Terezín on January 20, 1944) (**No. 1407 on Transport Ek** to Auschwitz on

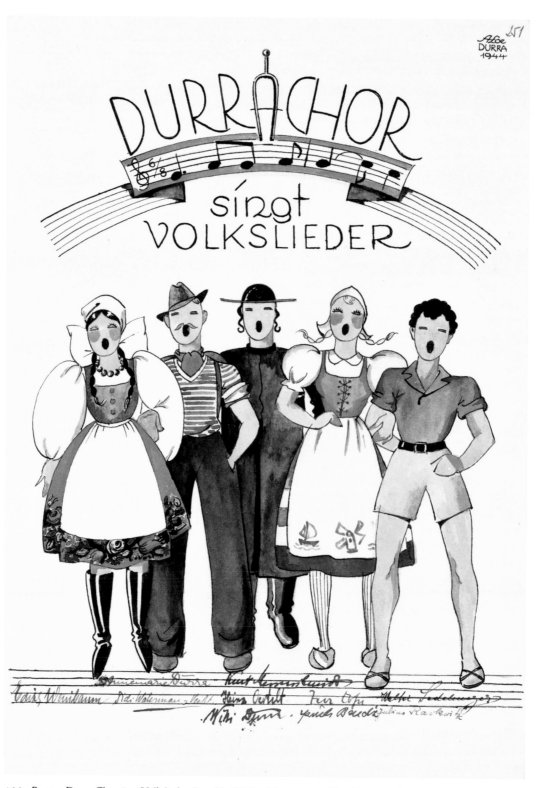

122. Poster. *Durra Chor singt Volkslieder*. Possibly Walter Heimann or Aloe Durra. HCPT #4068. *Announcement for a concert of folk songs sung by The [Wilhelm] Durra Choir. The poster is signed by the choir members.*

September 28, 1944). Lyric tenor in the Netherlands Royal Opera. In Terezín, Gobets performed vocal recitals of Brahms, Donizetti, Händel, Puccini, Schubert, and Verdi with pianists Renée Gärtner-Geiringer and Rafael Schächter. He sang the role of Don José in *Carmen*; he performed in *The Marriage of Figaro*, *The Magic Flute*, and Haydn's *The Creation* (performing the role of Uriel) directed by Karl Fischer on February 15, 1944; and he was the tenor soloist in Mendelssohn's *Elijah*. Gobets also sang and acted in Gerron's cabaret *Karussell* [Critiques 10, 26].

17 **Mrs. Lotte Kohn-Schlesskow** (unknown). Soprano coloratura. In Terezín, she sang in Haydn's *The Creation*, and she was a member of the chorus in Mendelssohn's *Elijah* [Critiques 10, 19].

18 **Dr. Karl Reiner** [Critiques 1, 9, 10, 13].

19 **Karel Berman** [Critiques 9, 10, 15, 16, 18].

20 **Mrs. Bach-Fischer** (unknown). Pianist. In the summer of 1944 in Terezín, she and Dr. Karel Reiner performed the orchestral score of Mendelssohn's *Elijah* on two upright pianos. Approximately eighty people were in the chorus [Critique 10].

21 **Pianinos:** upright pianos.

22 **Egon Ledeč** (1899–1944, Auschwitz) (**No. 178 on Transport L** from Prague to Terezín December 10, 1941) (**No. 953 on Transport Er** from Terezín to Auschwitz on October 16, 1944). Violinist who studied with Otakar Ševčík at the Prague Conservatory (1926–1939). Ledeč was associate concertmaster of the Czech Philharmonic. He smuggled a violin into Terezín and gave impromptu performances in the barracks. He participated in *Kameradschaftsabende* until the formation of the *Freizeitgetsaltung*. In 1942, he formed the Doctor's String Quartet (Dr. Ilona Král, violin; Viktor Kohn, viola; and Dr. Klapp, cello) and soon established the Ledeč String Quartet. Ledeč also performed recitals with Alice Herz-Sommer. He was concertmaster of Ančerl's string chamber orchestra, and he composed short concert pieces for small ensembles, mainly light fare. One surviving work is the Gavotte for String Quartet (December 1942) [Critiques 10].

23 **Alice Herz-Sommer** [Critiques 5, 10, 11, 25].

24 **Mannheim school.** In the second half of the eighteenth century, the court orchestra of Mannheim developed revolutionary approaches to orchestral performance and composition, including an expanded orchestra, more independent scoring of wind voices, greater variety and scale of dynamics, and the use of tremolo (rapid bowing of one pitch) in the strings. Johann Stamitz, composer and director of the court orchestra in Mannheim, is considered the founder of the Mannheim style, a precursor to the classical style of Haydn and Mozart [Critique 10].

25 **Gustav Mahler's *"Fischpredigt"*** ("Fish Sermon"). The third movement (scherzo) of Mahler's Second Symphony in C Minor (*The Resurrection*) is based on the song *"Des Antonius von Padua Fischpredigt"* ("The Fish Sermon of Anthony") from his *Des Knaben Wunderhorn* (*The Youth's Magic Horn*). "The Fish Sermon" is one of St. Anthony's great miracles: When his sermon fell on deaf ears in Rimini, he went to the sea to preach to fish. As they witnessed the miracle of fish listening with rapt attention, the Rimini parishioners were inspired to return to their faith. In Mahler's version, his song deviates from the parable with the fish returning to their old ways "like rational creatures," once the Franciscan priest had finished preaching. Mahler satirizes the story in the scherzo of his *Resurrection* Symphony using burlesque melodies [Critiques 4, 7, 10, 17, 20, 26].

26 *Sul tasto* (Italian: on the fingerboard) is an instruction to perform a musical passage by bowing the strings over the fingerboard of the instrument producing a breathy, almost flute-like tone.

27 **Ledeč String Quartet members.** Established by first violinist Egon Ledeč. The quartet had several personnel changes involving amateur violinist Schneider (first name unknown), violinist; Viktor Kohn, viola; Paul Kohn, cello; Julius Stwertka, violin (formerly of the Rosé String Quartet); Adolf Kraus, violin; Robert Dauber, cello; and Arnost Weiss, second violin [Critique 10].

28 **Sigmund Schul** (1916–1944, Terezín) (**No. 738 on Transport H** from Prague to Terezín on November 30, 1941). Composer who had studied with Hindemith and Hába. His music was

heavily influenced by Hebrew melodies from the medieval to contemporary periods. Schul transcribed Hebrew chants from Prague Jewish community collections. In Terezín, there was a special bond between Schul and his mentor, Ullmann. Schul composed the *"Divertimento Ebraico"* ("Hebrew Divertimento") for string quartet and *"Zwei Chassidische Tänze"* ("Two Chasidic Dances") for viola and cello, featured with works by Terezín composers in Ullmann's Studio for New Music concert series. Other Terezín works include *"Ki tavoa al-haeretz"* ("When We Shall Come into the Land"), *"Uv'tzeil K'nofecho"* ("In the Shadow of Your Wings"), *"Cantata Judaica,"* and *"Schicksal"* ("Fate"). Included in this volume is a translation of Ullmann's touching elegiac essay "Sigmund Schul." It reflects the deep respect and connection between these two artists [Critique 10].

29 **Alexander Borodin** (1833–1887). Composer and professor of chemistry at the Academy of Medicine in St. Petersburg. A member of the "Mighty Five," he is best known for his orchestral work *In the Steppes of Central Asia* and "The Polovtsian Dances" from the opera *Prince Igor*. Composing was a laborious process for him, and he left a number of his works incomplete. The composers Glazunov and Rimsky-Korsakov edited and completed several of his unfinished manuscripts [Critique 10].

30 **"More like boulevard than steppe."** Borodin's music was known for its Russian oriental flavor. Ullmann playfully notes Borodin's uncharacteristic departure in musical style.

31 From testimonies from Terezín survivors Karel Berman and Eliska Kleinová (sister of composer Gideon Klein) given to Mark Ludwig (January 19–22, 1991, and November 18–27, 1991 in Prague). They estimated that more than 300 of these works were written and performed by the Terezín choirs.

123. Drawing. "Cabaret in a Yard." František Petr Kien. HCPT #9910.

124. Poster. Lieder-Arien. HCPT #4219. Poster announcing a program of lieder and arias with Machiel Gobets.

125. Poster. *Klavier Konzerte* ("Piano Concerts"). Possibly Pauli Schwarz. HCPT #4196.

Critique 11
ALICE HERZ-SOMMER[1] PIANO EVENING

She is a friend of Beethoven, Schumann, and Chopin;[2] for years now, we are grateful to her for many an exquisite hour both before and in Theresienstadt. Alice Herz-Sommer at the piano means unadorned, clear, intense playing: moments—often entire movements—of true greatness and genuine congeniality with the master. To her, reproduction means real recreation and identification with the work and its creator. Hence her eminent technique, her whole vast ability serves the musical work; she is not one of those piano devils whose virtuosity is both egotistical and a purpose unto itself; she has more warmth than brilliance, more intimacy than *brio*. Her playing has significantly clarified and developed over the past years; once, even this highly talented artist was a temperamental virtuoso.

After all that has been said above, one would think she would be the perfect interpreter of Romantic music, and she is. The way she plays the indescribably beautiful final movement of Schumann's C-Major Fantasia op. 17[3] brings sheer joy; transfiguring and soaring, this piece fabricated in the high Romantic style of Jean Paul[4] transfixes the deeply moved listener, and he forgets that the rhythm of the preceding march-scherzo slipped away from the artist; speed alone won't help to grab hold of this movement, whose problematic and rhythmic monotony will not have escaped the notice of such a thoroughly musical interpreter. Alice Herz-Sommer has an affinity for the simplicity of the "ineffective" Beethoven; in this Sonata, op. 10, no. 3, the closeness to Schubert in the D-Minor Largo is always an experience, and it probably was also the pinnacle of our artist's performance. At the end, Mrs. Herz-Sommer gave us the appealingly harmless "Czech Dances" by Smetana, among them the famous "Furiant."[5] Here the Czech soul has a rendezvous with Franz Liszt.[6] We recommend not emphasizing the late-Romantic middle voices quite as much. It has largely become a habit, especially among modern composers, to strictly separate the main and middle voices, even by labeling them [in the score].

Lastly, a word to our pianists: we absolutely respect the commendable competitive fervor with which they present to us the Romantic composers. However, there are a large number of composers who deserve our interest, not only because they are Jews, but also because they have talent and genius and are still not performed in the surrounding world. I will name Mendelssohn, Karl Goldmark,[7] Paul Dukas,[8] Arnold Schönberg,[9] Ernest Bloch,[10] E.W. Korngold,[11] Wilhelm Grosz,[12] Erwin Schulhoff,[13] Kurt Weill,[14] Hans Eisler,[15] Carol (Karol) Rathaus,[16] Egon Wellesz,[17] Ernst Toch,[18] Paul Pisk[19]—I could name many more, and I haven't even mentioned Theresienstadt composers. And I think that all of them have written interesting works for piano [images 125–131].

Klavierabend Alice Sommer-Herz

Sie ist die Freundin Beethovens, Schumanns und Chopins; wir denken ihr
seit Jahren vor und in Theresienstadt so manche köstliche Stunde. Alice
Sommer-Herz am Klavier bedeutet schlichtes, klares, intensives Spiel,
Augenblicke - oft ganze Sätze - wahrer Grösse und echten Kongenialität
mit dem Meister. Für sie heisst Reproduzieren wirklich Nachschaffen,
Identifikation mit dem Werke und seinem Schöpfer. Folgerichtig stellt
sie ihre eminente Technik, ihr ganzes grosses Können in den Dienst des
Werkes; sie gehört nicht zu den Klaviertafeln, deren Virtuosität
Selbstzweck und Selbstsucht ist; sie hat mehr Wärme als Glanz, mehr
Innigkeit als Brio. Ihr Spiel hat sich in den letzten Jahren merklich
abgeklärt und entwickelt; denn auch diese hochbegabte Künstlerin war
einstmals eine Temperaments-Virtuosin.

Nach dem Gesagten müsste sie die berufene Interpretin der Romantiker
sein und sie ist es. Wahrhaft beglückend spielt sie z.B. den unbeschreib-
lich schönen Schlusssatz der C-Dur-Phantasie Schumanns Op. 17; ent-
rückt und schwebend gleitet diese Jean Paulisch fabulierende Hochromantik
an dem ergriffenen Hörer vorüber und er vergisst, dass das vorangehen-
de Marsch-Scherzo der Künstlerin im Zeitmass entglitten war; mit
Schnelligkeit kommt man diesem Satz, dessen Problematik und rhythmische
Monotonie einer so durch und durch musikalischen Interpretin natürlich
aufgefallen ist, nicht bei. Der Schlichtheit des "wirkungslosen" Beetho-
ven steht Alice Sommer-Herz sehr nahe; in dieser Sonate Op. 10 Nr. 3
ist immer wieder die Schubert-Nähe des d-moll-Largos ein Erlebnis und
bedeutete wohl auch den Höhepunkt unserer Künstlerin. Zum Schlusse
schenkte uns Frau Sommer-Herz die reizvoll-harmlosen /tschechischen
Tänze/ von Smetana mit dem berühmten "Furiant". Hier gibt sich die
tschechische Volks-Seele ein Rendezvous mit Franz Liszt. Wir raten,
die spätromantischen Mittelstimmen weniger hervortreten zu lassen. Es
ist in der neuesten Zeit grade bei modernen Komponisten Gepflogenheit
geworden, Haupt- und Mittelstimmen streng zu sondern, auch durch die
Bezeichnung.

Zuletzt ein Wort an unsere Pianisten: der löbliche Wetteifer, mit dem
sie uns die Romantiker vorführen, sei durchaus respektiert. Aber es
gibt eine grosse Zahl von Komponisten, die unser Interesse nicht nur
dadurch verdienen, dass sie Juden sind, sondern auch dadurch, dass
sie Talent und Genie haben und trotzdem in der umgebenden Welt nicht
gespielt werden. Ich nenne Mendelssohn, Carl Goldmark, Paul Dukas,
Arnold Schönberg, Ernest Bloch, E.W.Korngold, Wilhelm Grosz, Erwin
Schulhoff, Kurt Weill, Hans Eisler, Carol Rathaus, Egon Wellesz, Ernst
Toch, Paul Pisk - ich könnte noch viele nennen, wobei ich von There-
sienstädter Komponisten absehe. Und ich finde, dass diese alle interes-
sante Klavierwerke geschrieben haben.

126. Viktor Ullmann's original manuscript of Critique 11. 1 page. NIOD.

Annotations

1 **Alice Herz-Sommer** [Critiques 5, 10, 11, 25].

2 **Frédéric Chopin** (1810–1849) [Critiques 9, 11, 25].

3 **Schumann's C-Major Fantasia op. 17** was dedicated to Franz Liszt [Critiques 1, 6, 9, 11, 25].

4 **Jean Paul** is the pseudonym of Johann Paul Friedrich Richter (1763-1825), a German Romantic novelist. He was a literary icon for Romantic composers like Schumann and Brahms.

5 **Furiant** is a Bohemian/Slavic dance filled with rapid changes in meter (usually 2/4 and 3/4 time) and accents.

6 **Franz Liszt** (1811–1886). Great nineteenth-century virtuoso pianist and Romantic composer [Critiques 11, 24].

7 **Karl Goldmark** (1830–1915) was a Hungarian composer and the son of a cantor. He studied violin and composition at the Vienna Conservatory. Goldmark's works were successfully performed by the Vienna Philharmonic and Vienna Court Opera in the mid-nineteenth century. His most performed works are his overtures and the Violin Concerto in A Minor op. 28 [Critique 11].

8 **Paul Abraham Dukas** (1865–1935). French composer, critic, scholar, and teacher.

9 **Arnold Schönberg** [Critiques 4, 8, 11].

10 **Ernest Bloch** (1880–1959). Composer. Born in Switzerland, Bloch later obtained American citizenship in 1924. Several of Bloch's most noted works drew inspiration from Jewish themes and culture. He was a mentor to Leon Kirchner, Roger Sessions, Quincy Porter, and other composers [Critique 11].

11 **Eric Wolfgang Korngold** (1897–1957). Born and trained in Vienna, Korngold was considered one of the great rising stars of his generation of classical composers. Mahler, Strauss, and Puccini declared the young prodigy another Mozart. A Jew, he fled the Nazis in 1934 and lived in exile in Hollywood until becoming a naturalized American citizen in 1943. The Nazis banned his music in 1938, labeling it *entartung* (degenerate). In Hollywood, Korngold became a great film composer, winning Academy Awards for his scores to *Anthony Adverse* (1936) and *The Adventures of Robin Hood* (1938) [Critique 11].

12 **Wilhelm Grosz** (1894–1939). Composer, pianist, and conductor. Grosz studied at the Hochschule für Musik in Berlin with Franz Schreker. The Nazis banned his works as *entartung*. In exile in England, he switched from classical music to popular songs and film scores. Several of his works were hits, including "Red Sails in the Sunset" with Louis Armstrong [Critique 11].

13 **Erwin Schulhoff** (1894–1942, Wülzberg). Czech composer and pianist. Before serving in World War I, Schulhoff studied with Reger and Debussy and later with Hába. He twice won the prestigious Mendelssohn Prize in piano (1913) and composition (1918). Beyond the established

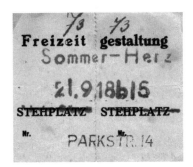

127. Concert ticket. *Sommer-Herz.* PT #A13131-2. *Ticket for a concert performed by Alice Herz-Sommer.*

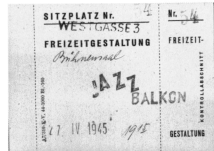

128. Concert ticket. "Jazz." ZM #A317003. *Balcony seating.*

KONZERTE Alice SOMMER-HERZ

I.

L. v. Beethoven : Apasionata
Bach-Patita : B Dur
Chopin : Etuden

II.

L. v. Beethoven : Sonate Op. 81
V. Ullmann : Sonate
C. Debussy : Refec dans l´eau
 " : Ministrels
R. Schuhmann : Karneval

III.

J. Brahms : Intermezzi
 " : Rhapsodie G moll
R. Schuhmann : Symph. Etuden

IV.

L.v. Beethoven : Sonate D Dur Op 10
R. Schuhmann : Fantasie
B. Smetana : Tänze

V.

Fr. Chopin 24 Etuden

129. Program for concert with Alice Herz-Sommer. ZM #317b.

repertoire, Schulhoff was a dedicated champion of contemporary music; he performed works by Alois Hába and Ivan Wyschnegradsky on the quarter-tone piano and was among the first to master a performance technique for this complex double keyboard. Ideology was at times a potent element in Schulhoff's compositions; two examples are his 1921 Dada piece, *Symphonia Germanica*, and his 1932 *The Communist Manifesto*, a cantata setting of the text by Marx and Engels. Many of his works reflect musical trends of the 1920s and 1930s; jazz was a particularly strong influence. A Jew carrying a Soviet passport, whose music and ideology were "degenerate and subversive" in the eyes of the Nazis, Schulhoff was a triple target. He took pseudonyms—Eman Balzar, Jirí Hanell, Hanuš Petr, and Franta Michálek—so that he could continue writing and performing in public. He was arrested and transported to the Wülzburg concentration camp, where he died on August 18, 1942. Schulhoff's father, Gustav (1860–1942, Treblinka), was deported to Terezín a month before (**No. 659 on Transport AAq** from Prague to Terezín on July 13, 1942) (**No. 1556 on Transport Bw** from Terezín to Treblinka on October 19, 1942). It is unknown whether Gustav attended an Ullmann performance or met him in Terezín [Critique 11].

14 **Kurt Weill** (1900–1950). Great composer of musical theatre. Weill studied at the Berlin Hochschule für Musik with Humperdinck and at the Prussian Academy of Arts with Busoni. He left Germany in 1933 for the U.S., where he became a U.S. citizen in 1943. Throughout Weill's career, he partnered with leading playwrights and lyricists to create a rich musical theater repertoire. He collaborated with playwright Bertolt Brecht on several important and popular works including *The Rise and Fall of the City of Mahagonny*, *The Threepenny Opera*, *Happy End*, and *The Seven Deadly Sins*. Weill also stretched the boundaries of conventional vocal formats with the radio cantatas *Das Berliner Requiem* and *Der Lindberghflug*. In the U.S., he composed for Broadway and Hollywood, working with Ira Gershwin in *Lady in the Dark* and Alan Jay Lerner in *Love Life* [Critique 11].

15 **Hans Eisler** (1898–1962). Composer who studied with Weill, Schönberg and Webern. The Second Viennese school of music left an imprint on Eisler, as did jazz and cabaret of the 1920s. Like Schulhoff, he was deeply committed to Marxism and used music as a means of expressing his social conscience. For close to thirty years, Eisler and Brecht collaborated on plays and films. Both fled Germany in 1933 and spent much of their time working as "anti-Nazis" in the U.S. Eisler composed Hollywood film scores and worked with Charlie Chaplin from 1942 to 1947. In 1947, he was a target of the House Un-American Activities Committee, which investigated "subversive" figures in the entertainment industry. Labeled "the Karl Marx of music," he was among the first blacklisted Hollywood artists. Bernstein, Copland, Stravinsky, and Chaplin gave benefit concerts for his defense, but Eisler and Brecht were deported in 1948. Eisler returned to East Berlin, where he composed the East German national anthem, *"Auferstanden aus Ruinen"* ("Rising from the Ruins") [Critique 11].

16 **Karol Rathaus** (1895–1954). Composer and pedagogue. In the early 1920s Rathaus was a student in Franz Schreker's composition master class at the Hochschule für Musik in Berlin, along with Alois Hába, Berthold Goldschmidt, and Ernst Krenek. He immigrated to the U.S. in 1938 and obtained citizenship in 1946 [Critique 11].

17 **Egon Wellesz** (1885–1974). A distinguished Austrian composer, musicologist, and scholar of both Byzantine music and the Second Viennese school. Wellesz studied composition with Schönberg and musicology with Guido Adler at the University of Vienna. He wrote the first biography of his mentor (*Arnold Schönberg*, Vienna, 1921). He fled his native Vienna in 1938 for exile in London. He taught music history at Oxford University. Among his many accomplishments was the deciphering of Byzantine musical notation. His nine symphonies and chamber, vocal, and solo works bear the influence of the late German Romantics and Second Viennese School [Critique 11].

18 **Ernst Toch** (1887–1964). Noted composer, pianist, and pedagogue. He received much of his training in his native Vienna, as well as in Mannheim and Heidelberg. He was a teenager when the esteemed Rosé Quartet performed his Sixth String Quartet op. 12 in 1906. Toch fled

Germany in 1933 and set roots in the U.S., where he became a citizen in 1940. In addition to works in the classical genre, he composed scores for film, stage, and radio. He was awarded the Pulitzer Prize in 1956 for his Third Symphony [Critique 11].

19 **Paul Amadeus Pisk** (1893–1990). Noted Austrian musicologist, writer, pedagogue, and composer associated with the Second Viennese School. He studied composition with Schreker and Schönberg. Fleeing Nazi tyranny, he emigrated from Vienna to the United States in 1936 [Critique 11].

```
                    K l a v i e r  -  T r i o .
                    ─────────────────────────────

         Klavier   :     Wolfgang Lederer
         Violine   :     Heinrich Taussig
         Violincello :   Paul Kohn

   L.v. Beethoven  :         Trio D-Dur Op.70 No.1
                             / Geistertrio/

   Vítězslav Novák :         Trio G-Moll Op. 1

   Premiere März 1944
   10 Repriesen
```

130. Program for a piano trio concert with Wolfgang Lederer, Heinrich Taussig, and Paul Kohn. 1944. HCPT #3941.

131. Drawing. Erwin Schulhoff on his death bed. Petr Schulhoff. August 18, 1942. Photograph by Michael J. Lutch.
ML. *Schulhoff's son, Petr, drew this portrait as his father was dying from tuberculosis in the Wülzburg concentration camp,
near Weissenburg in Bavaria. After his father died in his arms, Petr was reportedly forced to dig his grave. After liberation,
Petr gave this sketch and several pencil drawings to Jacob Mincer, who had been a fellow prisoner. (Dr. Mincer [1922–2006]
became Joseph L. Buttenweiser Professor of Economics and Social Relations at Columbia University. He is regarded as a
father of modern labor economics and was nominated several times for a Nobel Prize.) Dr. Mincer gave Petr's collection to
Mark Ludwig in the late 1990s, after the two met at a 1993 New York performance by the Hawthorne String Quartet; the
Quartet had just released its recording "Silenced Voices," featuring chamber works by Erwin Schulhoff.*

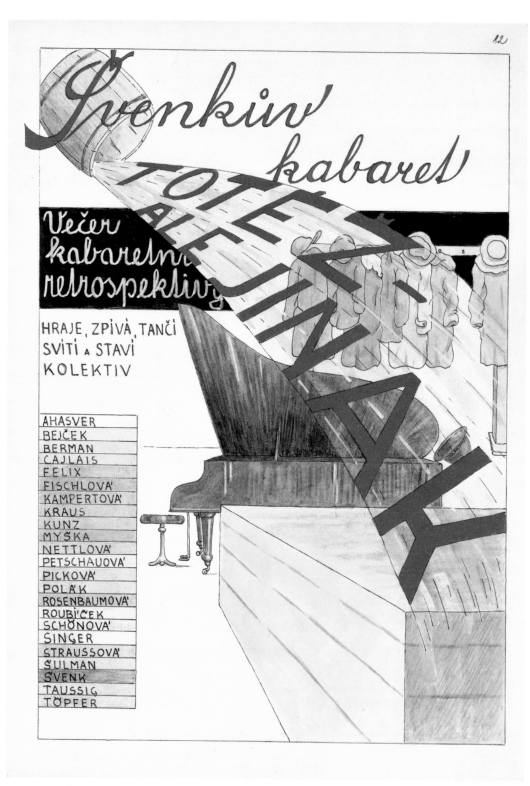

132. Poster. *Švenkův kabaret: Totéž—ale jinak* ("The Same Thing—but in a Different Way"). HCPT #4303. *Poster for Karel Švenk's cabaret.*

Critique 12
THE ŠVENK[1] PREMIÈRE

Our Aristophanes[2] of Theresienstadt unfortunately only rarely appears, even though he would have enough material, talent, and inventiveness to transform his annual contributions into a monthly revue. "Shake well before use" doesn't refer to the medicine this time around, but to the patient. After one and a half hours of laughing, it is entirely impossible to raise any critical objections. Hence it should merely be ascertained that the new revue "*Dasselbe in Grün*" ("The Same in Green")—or is it called "*Alles geht nun mal nicht*" ("Not Everything Works After All"), which would be the analogous translation of the Czech title—from a literary and satirical point of view decidedly surpasses the previous one—while "*Es lebe das Leben*" ("Long Live Life")[3] was more musically powerful. It was therefore only natural that Švenk inserted some of those original musical numbers.

Švenk has the ability—like Wedekind[4] in *King Nicolo*—to perform for us "the ancient acrobat's feat of standing on one's own head." This can be achieved in two ways: ironically or reverentially. Here, the former succeeded masterfully. The ironic self-knowledge of man generates either comedy or satire, whose child is parody. Certainly: Švenk's revue is predominately a parody. But isn't that true for Nestroy's[5] *Tannhäuser* and *Judith*? In some of the essential scenes Švenk unequivocally achieves the level of satire and thus true art, as for example in the—also musically exceptional—choral parodies, the weekly newsreels, or the parody of events in the Theresienstadt theater. The same goes for Camilla Rosenbaum's[6] splendid dance parody. But one shouldn't mention any names, since it's a "collective" that performs, dances, and sings—and so each and every one of them should receive our thanks in the form of a symbolic golden tiepin, which Wagner[7] once actually gave as a present to the composer of Nestroy's *Tannhäuser* parody, which had so brilliantly satirized the Venusberg motifs. "Of all the spirits that negate, the rogue bothers me the least ..."[8] [images 132–136, 138, 154].

Die Svenk-Premiére

Unser Theresienstädter Aristophanes stellt sich leider nur selten ein,wiewohl er Stoff und Talent und Erfindungsgabe genug hätte,seine Jahresbeiträge in Monats-Revuen umzuwandeln. "Vor Gebrauch zu schütteln"ist nun diesmal nicht die Medizin, sondern der Patient und es ist nach einundhalbstündigem Lachen ganz unmöglich,etwaige kritische Einwände zu erheben.Und so sei nur festgestellt,dass die neue Revue "Dasselbe in Grün"- oder heisst sie "Alles geht nun mal nicht",was die sinngemässe Überset- tzung des dechischen Titels wäre?- literarisch bezw.satirisch der vorigen entschieden überlegen ist;dafür war "Es lebe das Leben" musikalisch stärker.Es war daher nur natürlich,dass Svenk einige der originellen Musiknummern als Einlagen brachte.

Svenk vermag,wie Wedekind in "König Nicolo",uns das "uralte Akrobaten-Kunststück zu zeigen,sich selber auf den Kopf zu steigen".Das kann man nämlich auf zweierlei Art,in Ironie oder Ehrfurcht.Hier ist das Erste meisterlich geglückt.Die ironische Selbsterkenntnis des Menschen bringt entweder die Komödie hervor oder die Satire,deren Kind die Parodie ist.Gewiss,Svenks Revue ist vorwiegend parodistisch.Aber sind dies Nestroy's "Tannhäuser" und "Judith" nicht auch?In wesentlichen Scenen erreicht Svenk unbedingt das Niveau der Satire und damit echter Kunst,so in den auch musikalisch ausgezeichneten- Chorparodien,in der Tonfilm- Wochenschau,in der Parodie Theresienstädter Theaterereignisse; das Gleiche gilt von Camilla Rosenbaums prächtiger Tanz-Parodie. Doch man soll keine Namen nennen,da ja ein "Kollektiv"spielt, tanzt und singt -und so sei jedem von ihnen unser Dank in Form einer symbolischen goldenen Kravattennadel dargebracht,die einst Wagner tatsächlich dem Komponisten der Nestroyschen Tannhäuser- parodie zum Geschenk gemacht hat,der die Venusbergmotive so glän- zend verulkt hatte."Von allen Geistern,die verneinen,ist mir der Schalk am wenigsten zur Last..."

Viktor Ullmann

133. Viktor Ullmann's original manuscript of Critique 12. 1 page. NIOD.

172

CABARET PRODUCTIONS IN TEREZÍN

Cabaret productions in Terezín were presented in German and Czech.

Hans Hofer, Ernst Morgan, Bobby John, Leo Strauss, Manfred Greiffenhagen, Walter Steiner, and Walter Lindemann directed and performed cabaret productions in German. Their shows tended toward the nostalgic, incorporating songs popular in Vienna and Berlin in the 1930s.

The Czech productions focused more on the satirical aspects of life in Terezín. Karel Švenk was among the most popular of the cabaret artists, composing several productions in the camp. The first cabaret performed in Terezín, Švenk's *The Lost Food Card*, included the hailed *"Theresienstädter Marsch"* ("Terezin March"). Adopted by the prisoners as the camp anthem, it declared:

> *"Everything goes if there is a will—tomorrow a new life starts, we'll pack up our bundles and go home, and laugh on the ruins of the ghetto."*

Gallows humor courses through Švenk's 1944 cabaret *The Last Cyclist*, where insane patients escape from a mental asylum to take over the world. They are led by a dictator named Rat who orders the hunting down of cyclists and anyone having connections to bicycles—clearly an absurdist allegory to Hitler and the Nazis. A moment—among many—in the production raises the issue of intolerance:

> *"The Jews and the cyclists are responsible for all our misfortunes!"*
> *"Why the cyclists?"*
> *"Why the Jews?"*

The Last Cyclist shared the same performance fate as Ullmann's opera *Der Kaiser von Atlantis*. Fearing reprisals from the Nazi command, the Jewish Council of Elders forbade its public performance in Terezín [images 137, 139–155].

KABARET!

EI SÁL VII A V – LEDEN ÚNOR 1942

CONFERENCIER: EGON KRAUS

POŘAD:

1. Pochod „Castaldo": Dolfi Reich
2. Písně a chansony: Erwin Jellinek
3. Harmonika: Strauss
4. Písně : Nathan
5. Kouzelník: Lewin
6. Písně : Fuchsová
7. Židovské písně: Kestenbaum
8. Houslista : Brahmer
9. České písně : Ambrož
10. Recitace: „Když" „Všechno" „Imitace"
 (Egon Kraus)
11. Chansony: Páté poschodí } Švenk
 Všechno jde:
12. Chansony a písně: Josef Löwy
 a) Misisipi, b) Pistole,
 c) Pasol Janko tri voly.

134. Poster. *Kabaret!* HCPT #3786. *Poster for a cabaret program produced twelve times between January and February of 1942.*

174

Annotations

1 **Karel Švenk** (1907–1944, death march) (**No. 171 on Transport Ak** from Prague to Terezín on November 24, 1941) (**No. 191 on Transport Em** from Terezín to Auschwitz on January 10, 1944). A composer active in Prague's cabaret and avant-garde theatre community. Švenk and Schächter were leading figures in establishing Terezín's cultural activities. Shortly after their arrival, they collaborated on the production of the first Terezín cabaret, *The Lost Food Card*, one of several cabaret productions Švenk created in Terezín. Švenk performed as Vespone in the Terezín production of Pergolesi's opera *La serva padrona* [Critiques 12, 16].

2 **Aristophanes** (ca. 446–385 B.C.E.). Famed Athenian comic playwright and poet whose plays satirize Athenian politics and society [Critique 12].

3 *At' žije život!* in Czech.

4 **Benjamin Franklin Wedekind** (1864–1918). German playwright [Critique 12].

5 **Johann Nestroy** (1801–1862). Great Austrian comic dramatist and actor in the nineteenth century. Nestroy began his career singing in the Vienna Court Opera, but found success as an actor and playwright. The "Austrian Shakespeare," he was affiliated with the Theater an der Wien from 1831 to 1862. He was known for his parodies of popular operas, including Wagner's *Tannhäuser* and *Lohengrin* [Critique 12].

6 **Camilla Rosenbaum** (Kamilla Rosenbaumová, married name Ronová) (1908–1988) (**Transport Y** from Kladno to Terezín on February 22, 1942) (**Transport Et** from Terezín to Auschwitz on October 23, 1944). Choreographer and dancer in Prague Liberated Theatre. In Terezín she was a *Mädchenheim* (Girls' Home, a department of the *Jugendfürsorge*, or Youth) counselor and a teacher of Room 15 in Home L410. She choreographed productions of *The Fireflies, Esther,* Švenk's cabaret *Long Live Life,* and Krása's *Brundibár.* Rosenbaum was placed on an evacuation transport from Auschwitz to Terezín, where she was liberated on May 8, 1945 [Critiques 12, 13].

7 **Richard Wagner** (1813–1883). Composer known as the giant of German opera. Wagner enlarged the scale and scope of both dramatic staging and orchestral accompaniment. His melodic structure and harmonies were groundbreaking, and his operas created a fantasy world of epic proportions. Wagner's greatest undertaking was *Der Ring des Nibelungen* (*The Ring*), a sequence of four mythological operas: *Das Rheingold, Die Walküre, Siegfried,* and *Götterdämmerung.* To house the scale and ambitions of his works, Wagner designed and built the Bayreuth Festival Theatre, the embodiment of his concept *Gesamtkunstwerk* ("total art work"), a blending of all art forms [Critiques 12, 17, 26].

8 **"Of all the spirits … "** God speaking to Mephistopheles in Goethe's *Faust,* Part I: "The Prologue in Heaven."

135. Poster. *Revue — At' žije život!* ("Long Live Life!"). Adolf Aussenberg. HCPT #3893. *A cabaret by Karel Švenk.*

136. Poster. *Karel Švenk: Všechno Jde.* ("Everything is Possible") HCPT #4308. *Švenk's cabaret is commemorating the half-year anniversary of the first transport AK I to Terezín in 1942.*

138.

139

140.

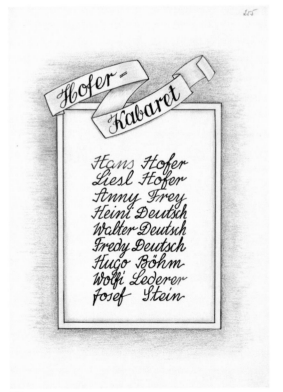

141

179

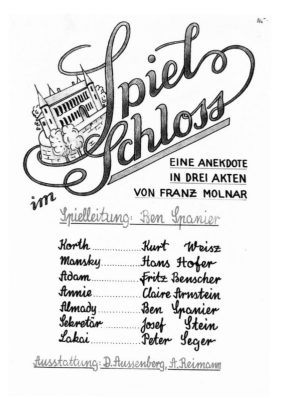

142.

143.

137. Poster. *Ein Tag in H.V* ("A day in H.V."). HCPT #3910. *Revue by Selma Amstein and Siegfried Grünfeld, Hans Hofer is among the actors. The artist frames the poster with characters in the cabaret.*

138. Poster. *Švenkur cabaret*. HCPT #4309. *Announcement for Švenk's cabaret.*

139. Title sheet for *Kabaretts*. Heinrich Bähr. HCPT #4071. *Artists made such images for Heřman at his request; he used them to separate his collection into sections by artist, sport, musical genre, and the like. This one is for the section of documents relating to cabaret productions.*

140. Poster. *Alles mit Musik* ("Everything with Music"). Possibly Heinrich Bähr. HCPT #4073. *Announcement for Hans Hofer's music revue.*

141. Poster. *Hofer Kabaret*. Heinrich Bähr. HCPT #4072.

142. Poster. *Spiel im Schloss* ("Play in the Castle"). HCPT #3908. *An anecdote in three acts by Franz (Ferenc) Molnár.*

143. Poster. *K.G. Carousell Holland*. František Zelenka. HCPT #4293. *Poster for Kurt Gerron's production "Karussell Holland." The cursive "Holland" at the base of the karussell is a reference to Gerron's imprisonment in Westerbork, in Holland, before he was transported to Terezín.*

144. Poster. *Kurt Gerron's Karussell*. Pauli Schwarz. HCPT #3933.

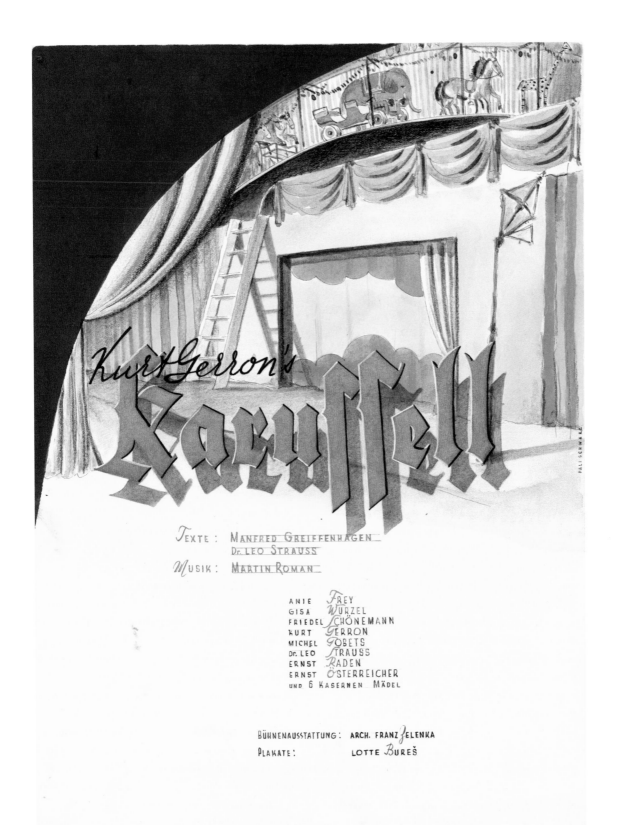

Kurt Gerron's
Karussell

Texte : Manfred Greiffenhagen
 Dr. Leo Strauss
Musik : Martin Roman

Anie Frey
Gisa Wurzel
Friedel Schönemann
Kurt Gerron
Michel Gobets
Dr. Leo Strauss
Ernst Raden
Ernst Österreicher
und 6 Kasernen Mädel

Bühnenausstattung : Arch. Franz Jelenka
Plakate : Lotte Bureš

144.

MORGAN-REVUE
MORGANREVUE
„Es ist serviert"
EINE LUSTIGE BILDERFOLGE
IN SCENE GESETZT VON ERNST MORGAN
Musik.Ltg. Kapellmeister Adolf Strauss
DER VERFASSER DES REVUE SCHLAGER
„ES IST SERVIERT" Dr. LUDWIG HIFT
MUSIK, DR. RALPH BENATZKY
Es wirken mit:

Die Damen:	Die Herren:
CHAITMANN, SYLVA	FISCHER, NAZI
HARBURGER, TRUDE	HAMBO,
MEYER, URSULA	JELLINEK, ERWIN
NEUMANN, GERTI	JOHN, BOBBY
PAGENER, RUTH	MORGAN, ERNST
	STREETA ???

145.

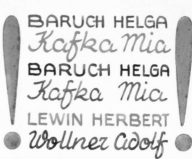

BUNTE - GRUPPE
Conferance:
Richard Goldschmidt-Goldek
BARUCH HELGA
Kafka Mia
BARUCH HELGA
Kafka Mia
LEWIN HERBERT
Wollner Adolf
MUSIK.LEITG.
DR. KURT BRAMMER

146.

John-Kabarett
Conferance
Ernst Morgan
GERTI NEUMANN
Harry Hambo
ERWIN JELLINEK
Bobby John
KURT MESSERSCHMITT
Ernst Morgan
ADOLF STRAUSS
Musik.Leitung: Ad. Strauss.

147.

WALTER STEINER-Kabarett
WALTER ✡ STEINER
MIA ✡ KAFKA LOTTE ✡ MAY
EMILIE ✡ BECHMANN
HELGA ✡ BARUCH DR. KURT ✡ BRAMMER
WALTER ✡ NEUMANN

148.

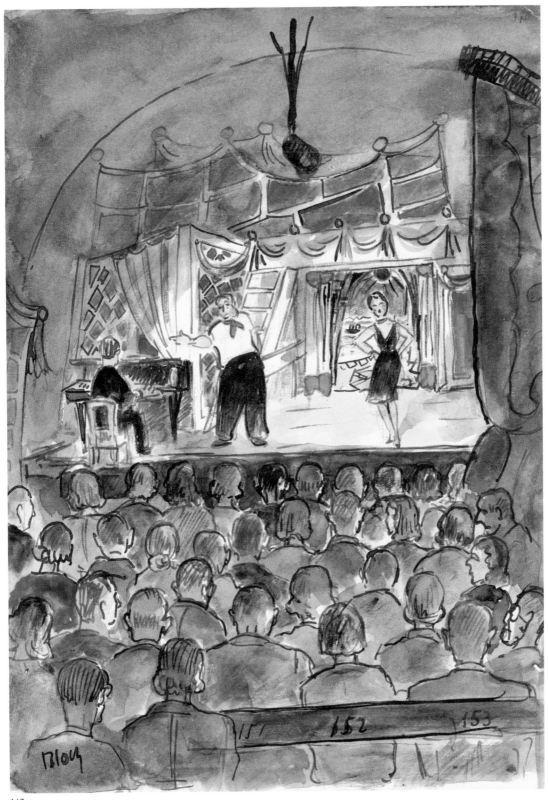

149.

183

„PRINZ BETTLIEGEND"

AUTOR : JOSEF LUSTIG
TEXTY : FRANT. KOVANIC
VÝPRAVA, KOSTÝMY: OTA NEUMANN
HUDBA : JAROSLAV JEŽEK

KOUZELNÍK	OTA NEUMANN
BUBENÍK	MILAN KLINGER
DÁMA	GERTA WEINBERGOVÁ
KRÁL	EVŽEN FEURSTEIN
PRINCEZNA DIENSTFREI	TRUDA POPPEROVÁ
MINISTR FINANCÍ	FRICEK GROSS
MINISTR ZDRAVOTNICTVÍ	EGON KRAUS
ORDONANC	OTA BAUER
MENAGE - DIENST	OSKAR SOBOTA
PRINC „BETTLIEGEND"	JIRKA REICH
PLAČÍCÍ SLEČNA	ZDENKA FANTLOVÁ
HOKUS	JIŘÍ SPITZ
POKUS	JOSEF LUSTIG

DOPROVÁZÍ: JIRKA HORNER
REŽIE: JOSEF LUSTIG
SVĚTLA: JINDRA WEIL

150

184

151

152

145. Poster. *Morgan Revue—Es ist serviert* ("It Is Served"). Possibly Heinrich Bähr. HCPT #4094.

146. Poster. *Bunte Gruppe.* HCPT #4165.

147. Poster. *John Kabarett.* Possibly Heinrich Bähr. HCPT #4098

148. Poster. *Walter Steiner Kabarett.* HCPT #4171.

149. Painting. *The "Karussell"* performance in the Hamburg barracks. Ferdinand Bloch. HCPT #3958.

150. Poster. *Prinz Bettliegend* ("Prince Laying-in-Bed"). HCPT #4305.

151. Poster. *Lindenbaum-Gruppe.* H. Alexander. HCPT #4164.

152. Poster. *Dilettanten Ensemble—Die Welt von oben* ("The World from Above"). HCPT #4037.

153. Poster. *Torn Kabarett—Dreierlei Humor.* HCPT #4100.

154. Photograph. Karel Švenk (right). PT #1294.

155. Still from the Nazi propaganda film "Theresienstadt, A Documentary Film from the Jewish Settlement Area." PT #1893. *Hans Hofer (left) singing with Austrian actor Behr.*

156. Poster. *Esther*. Possibly Heinrich Bähr. HCPT #4298. *Announcement for the biblical folk play* Esther.

Critique 13
ESTHER

The old Czech peasant's play is merely one sibling of a very numerous family. The *Esther*[1] material must have been staged at every fair or *pout,*[2] because it can't be a co-incidence that Goethe includes it in his *"Jahrmarkt von Plundersweilern"* ("The Town Fair of Plundersweilern")[3] in German doggerel. *Esther* belongs in the category of peasant plays that adapt biblical material of an earthy nature and have become genuine folk art. Especially during the last years of the nineteenth century, these plays were discovered and collected; for example, K. J. Schröer[4] and the peasant plays—scattered pieces of Swabian[5] peasantry—from Oberufer near Pressburg. We find in *Esther*—as we do in the popular Adam and Eve plays, in the Christmas plays and so forth—that unique mixture of biblical topics and coarse folk culture, in which the respective "modern" peasants with their local dialects plop into the Bible, where they consequently deal in a highly peculiar and drastic manner with all necessary anachronisms.

In this respect, our performance is full of style, and when it doesn't quite hit the mark, it certainly means to do so. N. Fried's[6] direction effectively stresses the peasant humor and superbly solves the staging problem by using three static backgrounds for the biblical scenes and reserving the foreground for the peasant characters and actions. The costumes are colorful and amusing enough; the Esther scenes are especially charming. Dance and music supplement the pleasant impression: the pretty dances were managed by Camilla Rosenbaum[7] and Traute Gach,[8] the music by Dr. Karl Reiner.[9] The very talented dancer B. Kunc[10] deserves special praise.

K. Reiner's music is surprising in that it mimics and captures the character of old Czech folk music with such precision that the listener is completely fooled by the copy. Reiner composed in an old-style Bohemian manner in the best sense and adapted—very realistically—to its peasant style all the way down to the primitive sound of his small ensemble.

On the stage there was earthy, fresh, and humorous acting and singing, although we gladly close one ear when one of the commendable participants sings in a little more peasant-like manner than was originally intended [images 156–158].

Esther

Das alt-čechische Bauernspiel ist nur ein Geschwister aus einer sehr zahlreichen Familie.Was den Esther-Stoff betrifft,so muss er sozusagen auf jedem Jahrmarkt,sei er Airmes oder "Pout" gewesen,gespielt worden sein,denn nicht zufällig bringt ihn auch Goethe in seinem "Jahrmarkt von Plundersweilern"in deutsche Knittel-verse."Esther"gehört in die Kategorie jener Bauernspiele,die bib-lische Stoffe urwüchsiger Art bearbeiteten und zu echter Volks-kunst geworden sind.Man fand und sammelte sie grade in den letzten Jahren des vorigen Jahrhunderts,wie z.B.K.J.Schröer die Bauernspie-le aus Oberufer bei Pressburg,versprengte Stücke schwäbischen Bauerntums.In "Esther"finden wir,wie auch in den beliebten Adam und Eva-Spielen,in den Weihnachts-Spielen u.s.f.,jene einzigartige Mischung von biblischem Stoffgebiet und derber Volkstümlichkeit, wobei die jeweilig "modernen" Bauern samt ihrem Dialekt gleichsam in die Bibel hineinplumpsen und sich nun höchst sonderbar und dras-tisch mit all den nun notwendigen Anachronismen auseinandersetzen.

Unsere Aufführung ist in diesem Sinne durchaus stilvoll und wenn sie nicht immer das Richtige trifft,so meint sie es doch. N.Frieds Regie arbeitet wirksam das bäurisch Humorvolle heraus und löst mit den drei statischen Schauplätzen des Hinter-grunds für die biblischen und die Reservierung des Vordergrunds für die bäurischen Gestalten und Aktionen das Problem der Inscenie-rung vortrefflich.Die Kostüme sind bunt und lustig genug,reizvoll sind insbesondere die Esther-Scenen.Tanz und Musik ergänzen den angenehmen Eindruck,wobei die hübschen Tänze von Camilla Rosenbaum und Traute Gach,die Musik von Dr.Karl Reiner betreut wurde.Ein Sonderlob gebührt dem sehr begabten Tänzer B.Kunc.

Die Musik K.Reiners ist insoferne eine Überraschung,als der Ton alt-čechischer Volksweisen so treu nachgeahmt und getroffen erscheint,dass die Kopie den Hörer vollkommen täuscht und er der liebenswürdigen Fälschung erliegt.Reiner hat im besten Sinne alt-böhmisch komponiert,sich bis in den primitiven Klang seines kleinen Instrumentalkörpers hinein dem Bauernstil sehr realistisch ange-passt.

Auf der Scene wurde urwüchsig,frisch und humorvoll gespielt und gesungen,wobei wir gerne ein Ohr zudrücken,wenn einer der verdienstvollen Mitwirkenden bäurischer singt,als ursprünglich beabsichtigt war.

Viktor Ullmann

157. Viktor Ullmann's original manuscript of Critique 13. 1 page. NIOD.

Annotations

1 *Esther*. A play about the Biblical Queen Esther and the Purim story. Before the war, a modern version of the play had been intended for production in E. F. Burian's avante-garde Theatre D. Norbert Fried, a director and playwright in Theatre D, carried a copy of the text on his transport to Terezín.

2 *Pout*. Czech for pilgrimage or town fair.

3 *"Das Jahrmarkts-Fest zu Plundersweilern"* ("The Town Fair of Plundersweilern") is Goethe's 1769 marionette play about a medieval town fair.

4 **Karl Julius Schröer** (1825–1900). Noted scholar and writer on Goethe. A professor of literature at the Technical College of Vienna, Schröer was an authority on Goethe and Schiller. Rudolf Steiner, founder of the anthroposophical movement, was one of his pupils, and Ullmann was a follower of Steiner [Critique 13.]

5 **Swabia**. A cultural and linguistic region of southwest Germany.

6 **Norbert Fried** (post-war changed to Nora Frýd) (1913–1976) (**Transport Dh** from Prague on July 8, 1943) (**Transport Ek** to Auschwitz on September 28, 1944). In the mid-1930s, Fried was a scriptwriter and lyricist for MGM and RKO Films in Czechoslovakia. In Terezín he wrote children's plays and lectures examining literature, theater, film, and music. He was liberated in Allach. After the War, he was a journalist, writer, and diplomat, serving as a delegate for UNESCO [Critique 13].

7 **Camilla Rosenbaum** [Critiques 12, 13].

8 **Traute Amálie Gach(ová)**. (1919–1944, Auschwitz) (**No. 727 on Transport Ae** from Brno to Terezín on March 29, 1942) (**No. 1411 on Transport En** from Terezín to Auschwitz October 4, 1944) [Critique 13].

9 **Dr. Karl Reiner** [Critiques 1, 9, 10, 13].

10 **B. Kunc** (dates unknown). Performed the role of Kuchař (Czech: the Cook) in *Esther* [Critique 13].

158. Poster. *O míči, který šel jen do nepřátelské branky* ("About a Ball that Just Went into the Enemy Goal"). HCPT #4297. *This children's play was written by Nora Fried before the war. The poster states there is "playing, singing and teaching." Lilly Grossová directed the performances given in the Youth Home L410/16.*

ERÖFFNUNG

DES GEMEINSCHAFTSRAUMES WESTGASSE 3.

AM 30. APRIL 1944

1 BEETHOVEN:
THEMA AUS DER NEUNTEN SYMPHONIE

2 ANSPRACHE DES JUDENÄLTESTEN

3 ZWEI HORRA-SÄTZE FÜR GEMISCHTEN CHOR
SATZ VON GIDEON KLEIN

4 GEORG WOLKER:
BALADE O OČÍCH TOPIČOVÝCH
GESPROCHEN VON KARL KAVAN

5 DVOŘÁK:
SERENADE FÜR STREICHORCHESTER NO 3

STREICHORCHESTER: LEITUNG KARL ANČERL
CHOR: LEITUNG RAFAEL SCHÄCHTER

159. Poster. *Eröffnung des Gemeinschaftsraumes Westgasse 3* ("Opening of the Common Room in the Sokol House") on April 30, 1944. Unknown. HCPT #3956.

Critique 14
CONCERT OF THE ANČERL ORCHESTRA
September 13, 1944, Stage Hall

Karl Ančerl[1] is a conductor of remarkable stature and abilities; the fact that he has hero- ically welded together and trained such an ensemble is proof of both his qualities and superhuman patience. Ančerl reminds one of a type of conductor like Talich[2] or Hermann Scherchen[3]; like the latter, he also was and is a pioneer of new music, and hence his very beautiful and impressive premiere of Pavel Haas's "Study for String Orchestra"[4] succeeds.

A virtuosic, polyrhythmically interesting introduction leads into an artful, energetic fugue exposition—whose distinctive theme together with its hiatus proves memora- ble—and which allows a slim *fugato*[5] to arise, followed by a lively, folk-like *scherzando*. After a point of repose that takes the place of a slow movement—we do distinguish two themes—there follows an abridged recapitulation of the *fugato* and a captivating motoric coda as the finale. The Study is crafted entirely from the essence of the string orchestra and it sounds good; it is less revolutionary than pieces Haas created here earlier. On the whole, the piece shows the hand of a musician who knows what he wants and is capable of achieving it. The orchestra's achievement was—setting aside the shortage of double basses[6]—perfectly satisfying. Haas, Ančerl, and his orchestra were celebrated with gratitude.

Suk's "Meditation (On an Old Czech Chorale)"[7] receives a new, peculiar, epic choral arrangement. It is a deeply serious piece, intensifying with passionate ecstasy, that al- lows all the forces of the string orchestra to unfold and does not deny the characteristic harmonies and melodies of the great late-Romantic composer.

Antonín Dvořák's famous Serenade[8] takes the hearts of the listeners by storm here as it does everywhere else. It is an exemplary model of musical ingenuity—Dvořák is one of the few masters to whom a constant stream of vivid brilliant ideas flow, never drying up…otherwise found only in Bach,[9] Mozart,[10] and Schubert.[11] The technically easier and tuneful work was well suited to our orchestra and was the best performance of the evening [images 159–162].

II.Konzert des Ancerl-Orchesters

13.September 44 Bühnensaal

Karl Ančerl ist ein Dirigent von Format und bedeutendem
Können;dass er in heroischer Arbeit sich diesen Klangki-
körper zusammengeschweisst und erzogen hat,ist ein
Beweis seiner Qualitäten,aber auch seiner übermenschli-
chen Geduld.Ančerl erinnert im Dirigententypus an Talich
und Hermann Scherchen;wie dieser war und ist auch er ein
Pionier neuer Musik und so gelingt ihm eine sehr schöne
und achtunggebietende Uraufführung:Pavl Haas' Studie für
Streichorchester.

 Eine virtuose,polyrhythmisch interessante Einlei-
tung führt zu einer kunstreichen,energischen Fugen-Exposi-
tion,deren markantes Thema mit seinem Hiatus sich als
einprägsam erweist und ein schlankes Fugato erstehen
lässt,dem ein lebhaftes,folkloristisch getöntes Scherzan-
do folgt;nach einem Ruhepunkt,der die Stelle eines lang-
samen Satzes einnimmt, ..wir unterschieden auch tatsäch-
lich zwei Themen, ..folgt eine verkürzte Reprise des Fu-
gatos und eine fesselnde,motorische Coda als Finale.Die
Studie ist ganz aus dem Wesen des Streichorchesters geht-
holt und klingt gut;sie ist weniger revolutionär als Haas
früher hier entworfene Werke.Im Ganzen zeigt sie die sind
Hand eines Musikers,der weiss,was er will und es auch ka
kann.Die Leistung des Orchesters war _bis auf den Mangel
an Contrabässen_durchus befriedigend.Haas,Ančerl und sein
Orchester wurden dankbar gefeiert.

 Suks Meditation (über einen alten Choral) findet

eine neue, eigenartige , epische Choral-Bearbeitung.Sie
ist ein tief ernstes,bis zu leidenschaftlicher Extase
gesteigertes Stück, das alle Kräfte des Streichorchesters
sich entfalten lässt und die charakteristische Harmonik
und Melodik des grossen Spätromantikers nicht verleugnet.

 Anton Dvořaks berühmte Serenade eroberte sich
hier wie überall im Sturme die Herzen der Hörer.Sie ist
ein Prachtexemplar musikantischer Genialität,wie denn
Dvořák überhaupt einer der wenigen Meister ist, denen ~~st~~
stets eine nie versiegende Fülle plastischer, leuchtender
Gedanken zuströmt...ausser ihm gibt es das nur noch bei
Bach,Mozart und Schubert.Das technisch leichtere und
klangselige Werk kommt unserem Orchester entgegen und
war in der Wiedergabe am besten.

 Viktor Ullmann
Viktor Ullmann

160. Viktor Ullmann's original manuscript of Critique 14. 2 pages. NIOD.

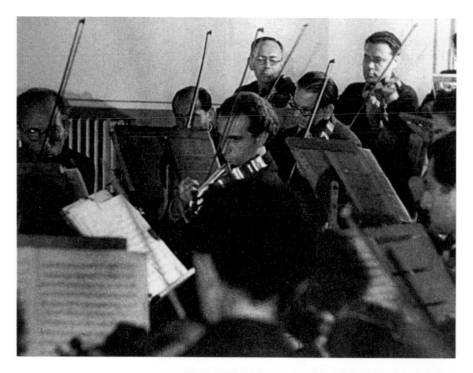

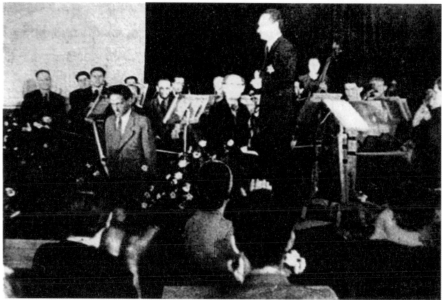

161. Still from the Nazi propaganda film, "*Theresienstadt, A Documentary Film from the Jewish Settlement Area.*" Terezín, 1944. ZM. *The image shows musicians (violinists Egon Ledeč, front left, and Pavel Kling, front right) performing the Pavel Haas Studie for String Chamber Orchestra conducted by Karel Ančerl (1943).*

162. Still from the Nazi propaganda film, "*Theresienstadt, A Documentary Film from the Jewish Settlement Area.*" Terezín, 1944. ZM. *The image shows conductor Karel Ančerl, composer Pavel Haas, and Terezín musicians acknowledging applause after a performance of the Pavel Haas Studie for String Chamber Orchestra (1943).*

Annotations

1 **Karel Ančerl:** After World War II, Ančerl wrote of his orchestra, "There were twelve first violins, ten second violins, eight violas, eight violin cellos and one doublebass. Today, twenty years later, it is hardly possible to imagine the quality of the orchestra…It was not only the members of the orchestra who were captured by our music, there were many who would come and sit quietly in a corner during every rehearsal. Our public awaited our first concert with great excitement." (*Terezín 1941–1945: Council of Jewish Communities in the Czech Lands.* František Ehrmann, Otta Heitlinger, Rudolf Iltis, editors. Prague: Selbstverlag, 1965) [Critiques 8, 14].

2 **Václav Talich** (1883–1961). Czech conductor. Talich studied violin with Otakar Ševčík at the Prague Conservatory from 1897 to 1903. At the Leipzig Conservatory, Talich's teachers included Max Reger and Hans Sitt in composition and Arthur Nikisch (a former music director of the Boston Symphony Orchestra) in conducting. From 1919 until his retirement in 1954, Talich was music director of the Czech Philharmonic, the National Theater in Prague, and the Slovak Philharmonic. Conductor Karel Ančerl studied with Talich and Scherchen [Critique 14].

3 **Hermann Scherchen** (1891–1966). German conductor noted for championing many important contemporary symphonic works. Fleeing the Nazis in 1933, he sought exile in Switzerland [Critique 14].

4 **Study for String Orchestra.** Portions of a Terezín performance of this work by Haas appeared in the Nazi propaganda film produced in Terezín. The film's narrator states, "In Theresienstadt, the music of a Jewish composer is performed." At the conclusion of the segment, Haas appears with Ančerl to take a bow [Critiques 8, 14, 15].

5 *Fugato/fugue.* A contrapuntal work with at least two voices in which a subject (the primary melody or theme) is introduced and imitated by one or more voices on lower or higher pitches.

6 There was only one bass player.

7 **Josef Suk's "Meditation on the Old Czech Chorale, 'Saint Wenceslas'" op. 35** (1914) recalls St. Wenceslas, beloved patron saint of Czech lands. His countrymen have believed for generations that he will protect and save the Czech nation in times of great danger, suffering, or injustice. The thirteenth-century chorale pleads, "St. Wenceslas, Ruler of the Czech Lands, don't let us die or our successors perish." It has been quoted by many Czech composers, including Vítězslav Novák, and Haas [Critiques 1, 7, 14, 24].

8 **Serenade for Strings in E Major op. 22** [Critiques 6, 9, 14, 15].

9 **Johann Sebastian Bach** [Critiques 5, 7, 10, 14, 18, 19, 22].

10 **Wolfgang Amadeus Mozart** [Critiques 4, 9, 10, 14, 16, 17, 21, 22, 25].

11 **Franz Schubert** [Critique 14].

KONCERTNÍ SÍŇ V RADNICI
22. ČERVNA 1944.

PÍSŇOVÝ KONCERT

K. BERMANN —— bas
R. SCHÄCHTER — klavír

PROGRAM

H. WOLF:
3 PÍSNĚ NA TEXTY MICHELANGELOVY

L. van BEETHOVEN:
VZDÁLENÉ MILÉ

P. HAAS:
4 PÍSNĚ NA SLOVA ČÍNSKÉ POESIE (MATHESIUS)
PRVNÍ PROVEDENÍ

A. DVOŘÁK:
CIGÁNSKÉ MELODIE

163. Poster. *Písňový Koncert.* HCPT #4288. *Karl Bermann song recital with Karl Bermann accompanied by Rafael Schächter on piano. The performance took place in Terezín Town Hall on June 22, 1944. Karl Bermann drew himself singing.*

Critique 15
KARL BERMANN *LIEDER* EVENING

The honest, courageous, and very multi-talented artist, singer, composer, and conductor Karl Bermann[1] was an apprentice until this day—now he has presented his masterwork.[2] And if one has to begin by thanking him for his exemplary, distinguished, and well-chosen program, one's next duty is to joyfully thank Pavel Haas[3] for his beautiful gift: his "Four Songs from Chinese Poetry,"[4] which premiered this evening.

Many may ask: Why new music? Aren't there already enough old masterpieces to delight music lovers? But a secret law forces the productive person to create; "in no case may it rest"[5]—that wonderful fabric of occidental musical development. Future generations will also want to have their music—theirs, not ours. "The appeal to posterity arises from the pure, vivid sensation that something immortal exists … and ultimately it will receive the applause of the majority" (Goethe).[6] Haas's songs are full of life and relevance; once heard, one can no longer do without them and wants to live on more intimate terms with them. It is only in this manner that over time new art catches on; it becomes "house music" and an indispensable friend, just like a good book, just like everything one earns by practicing. One especially successful piece is the graceful, lighthearted, and rhythmically vibrant second song of the Chinese cycle; which later appears again in the fourth song as a coda to the whole cycle and ends it. But the serious, homesick songs—of which the first and third are interrelated by a four-note *idée-fixe* that recurs as an *ostinato*[7] or *cantus firmus*[8] in manifold metamorphoses—are also impressive ideas, natural and yet progressive. Stylistically the Haas songs are too personal to be described as part of the Janáček school; however, the physiognomy of the mighty lion[9] flashes in the distance. The harmonies are not expressionistic, although multiple sonorities predominate that are nonetheless subordinated to a latent tonal center. Bermann recreated the cycle in an extremely musical way and with fine sensitivity for its peculiar tonal language and vocal expressiveness, [and] Rafael Schächter[10] was a loving and sympathetic interpreter at the piano.

As a prelude, we heard three splendid "Michelangelo Songs" by Hugo Wolf,[11] the third of which is among the tonal poet's master songs. Then followed Beethoven's rarely performed *Liederkreis für eine ferne Geliebte* (poetry by Jeitteles[12]) (*Song Cycle for a Beloved Far Away*),[13] a pinnacle for the master and an anticipation of Schubert. In the end, master Dvořák[14] triumphed with his ingenious "Seven Gypsy Melodies."

Bermann's voice is not so much sensually captivating or especially big, but it is resonant and controlled with taste and culture. The lower range is fairly sonorous, the *mezza voce* of the middle register is excellent, the higher notes are not yet quite balanced but are full of potential. First and foremost, every note is filled with the spirit of a musical personality. Bermann is a true artist with higher pretensions than external transitory successes.

To conclude, the thanks of Art should be offered to the initiator and superb accompanist of this beautiful evening: Rafael Schächter [images 163–166].

Liederabend Karl Bermann

Der redliche, mutige und so vielseitig begabte Künstler,
Sänger, Komponist, Kapellmeister Karl Bermann war bis zu diesem Tage
Gezelle-nun hat er sein Meisterstück geliefert. Muss man ihm gleich
zu Anfang Dank sagen für das vorbildlich vornehme und gut gewählte
Programm, so ist es die nächste Pflicht, auch Paul Haas freudigen
Dank zu sagen für sein schönes Geschenk: für seine 4 Lieder nach
chinesischen Dichtungen, deren Uraufführung dieser Abend brachte.
 Viele mögen fragen: Wozu neue Musik? Gibt es nicht genug
alte Meisterwerke, zur Ergötzung der Musikliebhaber? Doch ein gehei-
mes Gesetz zwingt den produktiven Menschen, zu schaffen; "in keinem
Falle darf es ruhn", das wundervolle Gewebe der abendländischen
Musik-Entwicklung. Die kommenden Generationen wollen auch ihre
Musik haben-ihre, nicht unsere. "Der Appell an die Nachwelt entspring
aus dem reinen, lebendigen Gefühl, dass es ein Unvergängliches gäbe..
das zuletzt des Beifalles der Majorität sich werde zu erfreuen
haben." (Goethe) Haas' lebensvolle, gegenwartsnahe Lieder möchte
man, wenn man sie einmal gehört hat, nicht mehr missen und in ver-
trauterem Umgang mit ihnen leben. Denn nur so setzt sich ja neue
Kunst im Laufe der Zeit durch: Sie wird zur Hausmusik und und zum
unentbehrlichen Freunde, wie ein gutes Buch, wie alles, was man überd
erarbeitet. Ein besonders glücklicher Wurf ist das graziöse, heiter
und rhythmisch beschwingte zweite Lied des chinesischen Zyklus,
das später im 4. als Coda des Ganzen nochmals auftaucht und den
Beschluss macht. Aber auch die ernsten, heimatsehnsüchtigen Lieder-
von welchen das erste und dritte durch eine idée fixe von 4 Tönen
miteinander verbunden sind, die als ostinato oder cantus firmus in
mannigfachen Metamorphosen wiederkehrt-, sind eindrucksvolle, natür-
liche und doch fortschrittliche Eingebung. Stilistisch sind die
Haas-Lieder zu persönlich, um noch als Schule Janáčeks angesprochen
werden; immerhin wetterleuchtet die Physiognomie des gewaltigen
alten Löwen in der Ferne. Die Harmonik ist nicht expressionistisch,
wiewohl Mehrklänge vorherrschen, die sich aber einem latenten tona-
len Zentrum unterordnen. Bermann hat den Zyklus äusserst musikalisch
und mit feinem Gefühl für die eigenartige Tonsprache wie auch
stimmlich ausdrucksvoll kreiert, Rafael Schächter war ein liebe-und
verständnisvoller Ausdeuter am Klavier.
 Als Vorspiel hörten wir drei herrliche Michelangelo-
der von Hugo Wolf, deren drittes zu den Meisterliedern des
Tondichters gehört. Dann folgte Beethovens selten aufgeführter
Liederkreis "an die ferne Geliebte" (Dichtung von Jeiteles), ein
Höhepunkt des Meisters und eine Vorwegnahme des ganzen Schubert.
Zuletzt behauptete sich als Lieger Meister Dvořák mit den genia-
len "7 Zigeunermelodieen."
 Bermanns Stimme ist nicht sowohl sinnlich bezaubernd
oder besonders gross, als tragend und mit Geschmack und Kultur
beherrscht. Die tiefere Lage klingt durchaus sonor, das mezza voce
der Mittellage ausgezeichnet, die Höhe ist noch nicht ganz angegli-
chen, aber entwicklungsfähig. Vor allem ist jeder Ton beseelt durch
eine Musiker-Persönlichkeit. Bermann ist ein echter Künstler mit
höheren Prätentionen als äusserlichen Augenblickserfolgen.
 Zum Ausklang sei der Dank der Kunst dem Initiator und vortreff-
lichen Begleiter des schönen Abends dargebracht: Rafael Schächter.

 Viktor Ullmann

164. Viktor Ullmann's original manuscript of Critique 15. 1 page. NIOD.

Annotations

1 **Karel Berman** [Critiques 9, 10, 15, 16, 18].

2 **Masterwork.** [German: *Meisterstück*.] A piece one presents to attain the status of master, as in the old German guilds. There is a nuanced distinction between this and the English "masterpiece."

3 **Pavel Haas** [Critiques 8, 14, 15].

4 **"Four Songs from Chinese Poetry"** is one of three surviving works Pavel Haas composed during his incarceration in Terezín. Haas's transport to Terezín separated him from his wife and daughter. The song cycle poignantly expresses his nostalgia and longing for home and family. Once again, Haas returned to Chinese poetry from the Tang Dynasty as a source of inspiration. He selected four poems: "I Heard the Wild Geese" (Wei Ying-wu), "In a Bamboo Grove" (Wang Wei), "The Moon is Far from Home" (Chang Tiou-lin), and "Sleepless Night" (Chan I). The work was dedicated to the baritone and fellow Terezín prisoner Karel Berman, who preserved the manuscript. In an interview (November 1991 with Mark Ludwig in Prague), Berman shared Karel Ančerl's testimony of Haas's last moments in Auschwitz. Upon their arrival, Haas and Ančerl stood in line for the selections. Ančerl was convinced he was spared the gas chambers when Haas had a coughing fit [Critique 15].

5 From Goethe's poem "Eins und Alles" ("The One and All").

6 This is an aphorism of Goethe's published in *Aphorismen and Aufzeichnungen* Vol. 4.2 (1823): "*Der Appell an die Nachwelt entspringt aus dem reinen lebendigen Gefühl, daß es ein Unvergängliches gebe, und, wenn auch nicht gleich anerkannt, doch zuletzt aus der Minorität sich der Majorität werde zu erfreuen haben.*" [Eng: "The appeal to posterity arises from the pure, vivid sensation that something immortal exists, and, even if it is not recognized immediately, ultimately the work of the minority must be enjoyed by the majority."] Ullmann quoted this from memory; while he begins accurately, he deviates in the second half of the quote.

7 *Ostinato,* from the Italian for "obstinate." An *ostinato* is a musical phrase that is stated repeatedly. The *ostinato* provides a foundation for each of the variations in a passacaglia. A *passacaglia* consists of a set of variations constructed on a continuously repeated harmony or melody appearing predominantly in the bass line.

8 *Cantus firmus.* [Latin: fixed melody] is a melody used as the basis for a polyphonic composition. Polyphonic or contrapuntal music consists of several independent melodic voices.

9 **"The mighty lion."** Haas studied composition with Janáček ("the mighty lion"). Ullmann notes his influence while praising Haas's individuality and artistry [Critiques 1, 7, 8, 15].

10 **Rafael Schächter** [Critiques 10, 15–18].

11 **Hugo Wolf** (1860–1903) was a master of German *lieder* in the tradition of Schubert and Schumann. His songs were set to the texts of several poets including Goethe and Eichendorff. His tempestuous nature caused many difficulties and setbacks throughout his career. As a music critic for the *Wiener Salonblatt*, he was known for his harsh criticism of Brahms and support of Wagner and Bruckner [Critique 15].

12 **Alois Isidor Jeitteles** (1794–1858). A doctor, writer, and translator.

13 *Song Cycle for a Beloved Far Away.* [German: **An Die Ferne Geliebte** (Literally, "to the distant beloved")] by the German poet Alois Isidor Jeitteles (1794–1858).

14 **Antonín Dvořák** [Critiques 6, 14, 15].

Progam 22.6.1943 - L 203

Sestavil a řídí - Karel Bermann

1.	Dvořák	Arie Vodníka z Rusalky	K. Bermann
2.	Dvořák	Na podzim v ořeší Z Jakobína	J. Klinke
3.	Glinka Halévy	Arie ze Živct za cara Arie ze Židovky	K. Polák
4.	Smetana	Arie ze Dvou vdov	J. Klinke
5.	Dvořák Blodek	Arie Purkrabího z Jakobína Arie Janka ze Studně	K. Bermann
6.	Smetana Dvořák	Kdybych se cos Měsíčku na nebi	J. Klinke
7.	Smetana Smetana	Arie krále Vladislava z Dalibora Arie Kaliny z Tajemství	F. Stránský

Klavírní doprovod:

č. 2,3,6,7 - K.Bermann
č. 5 - J.Klinke
č. 7 - K.Polák

165. Program for concert of arias directed by Karl Bermann (Czech name: Karel Berman).
June 22, 1943 in L203. HCPT #3952.

C III/260 . 28.října 1943 .

K O N C E R T .

Pásmo arií a písní sestavil a řídí : Karel Bermann

1./ B.Smetana: Předehra k prodané nevěstě	solo hraje:K.Bermann
2./ A.Dvořák : 2 Biblické písně	bas solo : W.Borges
3./ V.Blodek :Arie Věruny ze ,,Sutdně,,	alt solo:Heda Grábová-Kernmayerová
4./ B.Smetana :Arie Vladislava z ,,Dalibora,,	baryton solo:F.Stránsky
5./ Písně :Teče voda / Šel sedlák	sopran solo:J.Klinkeová
6./ B.Smetana:Arie Mumlala ze ,,Dvou vdov,,	bas solo K.Polák
7./ B.Smetana: Arie Karoliny ze ,,Dvou vdov,,	sopran solo:M.Tamara-Zuckerová
8./ A.Dvořák:Arie prince z ,,Rusalky,,	tenor solo:F.Weissenstein
9./ Písně : Umřem / Tancovala	alt solo: H.Grábová-Kernmayerová
10./A.Dvořák:Jen ve zpěvu z ,,Jakobína,,	dueto baryton:F.Stránský mezzosopran :H.Grábová-Kernmayerová

P ř e s t á v k a .

11./B.Smetana:Pátá písen večerní	bas solo: K.Polak
12./B.Smetana:Arie Blaženky z ,,Tajemství,,	sopran solo:M.Tamara -Zuckerová
13./B.Smetana:Arie Kaliny z ,,Tajemství,,	baryton solo:F.Stránský
14./B.Smetana:Arie Mařenky z ,,Prodané nevěsty,,	sopran solo:J.Klinkeová
15./B.Smetana: Arie Jeníka z ,,Prodané nevěsty,,	tenor solo:J.Weissenstein

P ř e s t á v k a .

16./B.Smetana:Duetto Kecala a Jeníka z ,,Prodané nevěsty,,	tenor:F.Weissenstein bas : K.Bermann

Doprovod : čís. 1 - 15 K.Bermann
 čís.16 J.Klinkeová

166. Program for a recital of vocal works by Czech composers Smetana and Dvořák directed by Karl Bermann (Czech name: Karel Berman) on October 28, 1943. HCPT #3972. *The date and repertoire suggest this concert commemorated the twenty-fifth anniversary of the founding of the first Czech Republic.*

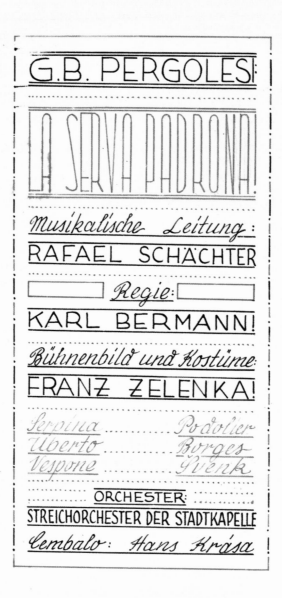

167. Poster. G. B. Pergolesi—*La Serva Padrona!* HCPT #3932. *Announcement for the Pergolesi opera under the shared direction of Karl Bermann and Rafael Schächter with set and costume design by František Zelenka.*

Critique 16

LA SERVA PADRONA

Commedia dell'arte, the Pantaloon[1] comedy, is the progenitor of the comic opera and its younger sister, the operetta. Originally, scenes from the *commedia* were used as *intermezzi* to fill the intermissions between the acts of the *opera seria*—as can be seen in the Pulcinella[2] scenes of Molière's *Le malade imaginaire* [*The Imaginary Invalid*][3]—until those intermezzi gradually emancipated themselves. (Hofmannsthal/Strauss's *Ariadne* allows the commedia into the *opera seria*[4] itself).

Pergolesi[5] is a great master, but his *opera buffa* is not his masterpiece. The first act, or more precisely the first *intermezzo*, suffers from excessively long and boring arias that hardly ever escape the brittle 4/4 meter. It is only in the little opera's second act that the cramped music loosens and rises to a height of timeless weightlessness, mainly in the grand bass aria and the "Happy End" duet—here there are premonitions of Mozart.[6] The archetypes of the libretto are of course Columbine, Pantaloon, and Harlequin, who also appears disguised as Brighella (Captain Storm Wind) and as the mute person standing between the two singers.

Rafael Schächter gave the little work a satisfying performance featuring two talented singers, an excellent comedian and a small string orchestra. With delight, we noticed Hans Krása[7] on the harpsichord. Mrs. Podolier,[8] dressed in a costume that seems a little too magnificent for the Serva, looks very pretty, plays gracefully and skillfully, and sings that way too, although the *bel canto*[9] suits her better than the *soubrette-staccato*.[10] Mr. Borges[11] is a positive surprise: He convinces less by the fullness of his voice than by his authentic *basso-buffo* acting. Švenk,[12] who has the stuff it takes to be a Grock,[13] presents a masterful performance, especially in that unforgettable moment when he involuntarily reveals his identity through "his master's voice." Bermann's[14] direction is vivid, and this high-quality musician seems to have enough theatre in his blood to prove himself as a director as well, even if he still lacks the experience. The costumes by architect Zelenka[15] were all very colorful, pretty, and funny. We don't dare pass judgement on how well the scenic problem was resolved and will leave that to more competent observers.

However, we would like to recommend shortening the arias and revising the all-too-frequent and unprompted exits and entrances [images 167–170].

La serva padrona

Die Comedia dell'arte, die Hanswurstkomödie, ist die
Ahnfrau der komischen Oper und ihrer jüngeren Schwester, der
Operette.Ursprünglich waren ihre Bilder als "Intermezzi" zur
Ausfüllung der Pausen zwischen die Akte der opera seria ein-
schaltet worden,wie es auch Molières "le malade imaginaire"
in den Polichinell-Scenen zeigt,bis sich allmählich die
Intermezzi emanzipieren.(Hoffmannsthal-Strauss' "Ariadne"
lässt dann die Comedia in die opera seria selbst eindringen)

Pergolese ist ein grosser Meister,aber seine opera
buffa ist nicht sein Meisterwerk.Der erste Akt,vielmehr das
erste Intermezzo leidet an übermässig langen und -weiligen
Arien,die aus einem spröden Viervierteltakt nicht herauskommen.
Erst der zweite Teil des Opernchens löst die Verkrampfung und
zeigt die Musik auf der Höhe zeitloser Schwerelosigkeit,
vornehmlich in der grossen Bass-Arie und im Happy-end-Duett,
hier sind Vorahnungen Mozarts.Die Urbilder des Librettos sind
natürlich Colombine,Pantalone und Harlekin,der auch als
Brighella (Hauptmann "Sturmwind")verkleidet auftritt und als
stumme Person zwischen den beiden Sängern steht.

Rafael Schächter hat das Werkchen mit zwei talentierten
Sängern,einem ausgezeichneten Komiker und mit einem kleinen
Streichorchester sehr befriedigend herausgebracht.Am Cembalo
bemerkte man mit Vergnügen Hans Krása.Frau Podolier in einem
für die serva wohl gar zu prächtigen Kostüm sieht sehr hübsch
aus und spielt graziös und gewandt,singt auch so,wenngleich
der Bel-canto ihr besser liegt als das Soubretten-Staccato.
Eine Ueberraschung ist Herr Borges,der weniger durch Fülle der
Stimme als durch echtes Bass-buffo Spiel überzeugt.Svenk,der
das Zeug zu einem Grock in sich trägt,bietet eine Meisterleist

stung, insbesondere den unvergesslichen Augenblick, wo er sich
in der Verkleidung auf "his masters voice" wider Willen verrät.
Bermanns Regie ist lebendig und der gediegene Musiker hat
entschieden Theaterblut genug, um sich auch als Regisseur zu
bewähren, mag auch die Routine noch fehlen. Die Kostüme Architekt
Zelenkas sind alle sehr bunt, hübsch und lustig. Ueber die
Lösung des scenischen Problems wagen wir ein Urteil nicht
abzugeben und überlassen dies Kompetenteren.
Empfohlen seien jedoch Kürzungen der Arien und
Revision der allzu häufigen unmotivierten Abgänge und Auftritte.

Viktor Ullmann

168. Viktor Ullmann's original manuscript of Critique 16. 2 pages. NIOD.

Annotations

1 **Pantaloon** was the elderly merchant in *commedia dell'arte* productions. His tight-fitting Turkish apparel highlighted his questionable and foolish actions and his vain attempt to attract much younger women [Critiques 2, 16].

2 **Pulcinella.** Clown in *commedia dell'arte*.

3 **Molière** (1622–1673). French comic playwright. Like Shakespeare, he wore the hats of actor, director, and playwright. Best known among Molière's satires of human vices and hypocrisies are *Tartuffe*, *Le Misanthrope*, and *Le Bourgeois gentilhomme*. *Le Bourgeouis gentilhomme* and *Le Malade imaginaire* are examples of *comédie-ballet*, a genre of French music theatre.

4 **Hofmannsthal/Strauss's *Ariadne*.** Austrian poet and playwright Hugo von Hofmannsthal (1874–1929) wrote the libretti for four Strauss operas: *Elektra*, *Der Rosenkavalier*, *Ariade auf Naxos*, and *Arabella*. *Opera seria*, with its serious style and three-act structure, was a popular form of Italian musical theater in the eighteenth century. It replaced *opera buffa*, a comic-opera genre that was inspired by the *commedia dell'arte* and had a two-act format. After the eighteenth century, many composers, including Mozart and Verdi, employed *opera buffa* and *seria* in their operas [Critique 16].

5 **Giovanni Battista Pergolesi** (1710–1736). Italian baroque composer. His most noted works are *La serva padrona*, *Salve Regina* in C Minor, and *Stabat Mater* in F Minor [Critique 16].

6 **Wolfgang Amadeus Mozart** [Critiques 4, 9, 10, 14, 16, 17, 21, 22, 25].

7 **Hans Krása** [Critiques 3, 16, 17].

8 **Marion (Hildegarda) Podolier(ová)** (1906–unknown) (**Transport Bg** from Prague to Terezín on September 12, 1942). Soprano. Podolierová sang roles of Mařenka in *The Bartered Bride*, Pamina in *The Magic Flute*, and Serpina in *La serva padrona*, conducted by Schächter, and performed the role of the girl in Ullmann's *Der Kaiser von Atlantis*. She sang Schubert *lieder* recitals with Edith Steiner-Kraus and Karel Berman, and was soprano soloist with mezzo Hilde Aronson-Lindt, tenor David Grünfeld, and basso Karel Berman in performances of the Verdi *Requiem*. Liberated in Terezín [Critiques 16–18].

9 *Bel canto* (Italian: beautiful singing) is a musical term referring to the art and vocal technique that originated in Italy during the late sixteenth century. The golden age of *bel canto* arrived with the early nineteenth-century operas of Bellini, Donizetti, and Rossini. Mozart and Verdi later gravitated towards this method of singing.

10 *Soubrette-staccato.* A style of singing. A *soubrette* is a coquettish soprano in comic operas and operettas, such as Adele in Strauss's *Die Fledermaus* and Susanna in Mozart's *The Marriage of Figaro*. *Staccato*, noted with a dot over a musical note, is a short, often fast repeating articulation in vocal and instrumental performance; in Italian it means "separated" or "detached" [Critique 16].

11 **Bedřich Borges** (1909–1992) (**Transport J** from Prague to Terezín on December 4, 1941) (**Transport Ek** to Auschwitz on September 28, 1944). Amateur basso and engineer by profession. In Terezín, he sang the role of Uberto in *La serva pedrona*, and he performed the basso solo in Haydn's *The Creation*, the role of Kecal in Smetana's *The Bartered Bride*, and, in a private performance for the Council of Elders, in Franz Eugen Klein's opera *The Glass Mountain* (*Der gläserne Berg*). Liberated in Blechhammer [Critique 16].

12 **Karel Švenk** [Critiques 12, 16].

13 **Grock** is **Karl Adrien "Grock" Wettach** (1880–1959), known as Grock the Clown. In Europe, he was acclaimed as the King of Clowns. He incorporated his gift for music (playing twenty-four instruments) and languages into his comic routines [Critique 16].

14 **Karel Berman** [Critiques 9, 10, 15, 16, 18].

15 **František (Franz) Zelenka** (1904–1944, Auschwitz) (**No. 21 on Transport Di** from Prague

on July 20, 1943) (**No. 1155 on Transport Es** to Auschwitz on October 19, 1944). Czech architect and designer of sets for the National Theatre and Prague's avant-garde Liberated Theatre. During the Nazi occupation, he worked in the Prague Jewish Community, and in 1942, he was assigned to register and organize Jewish cultural and religious objects confiscated from Jewish communities plundered and liquidated by the Nazis and destined for a planned Museum of an Extinct [Jewish] Race (*Museum einer ausgestorbenen Rasse*). In Terezín, Zelenka was head of the *Freizeitgestaltung* theatre section. He designed sets for *La serva padrona, Carmen, Bastien and Bastienne*, and *Brundibár*. He mounted plays of Gogol, Molière, and Shakespeare; cabaret shows by Karel Švenk and Kurt Gerron; and Ullmann's *Der Kaiser von Atlantis*. Zelenka lectured on Molière, Japanese and Western theater, and architecture. He refused to take part in the 1944 Nazi propaganda film. With his eight-year-old son, Martin, and his wife, Anna, Zelenka was sent directly to the gas chambers of Auschwitz [Critique 16].

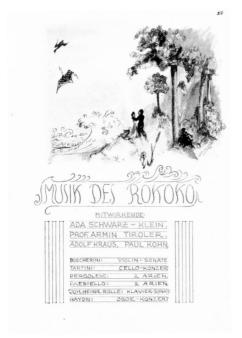

169. Poster. "Music of the Rococo." H. Alexander. 1944. HCPT #4210

170. Drawing. Self-portrait by František Zelenka. HCPT #3767.

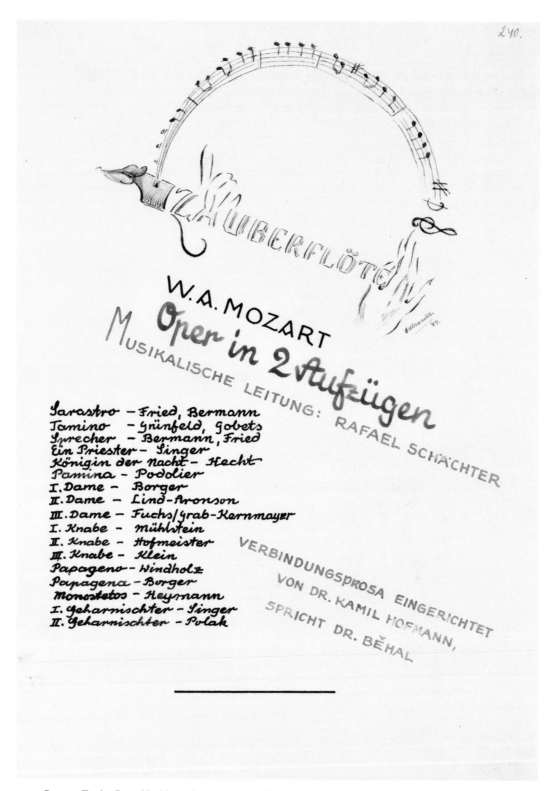

171. Poster. *Zauberflöte*. H. Alexander. 1944. HCPT #3929. *Announcement for Mozart's* The Magic Flute *directed by Rafael Schächter.*

Critique 17

THE MAGIC FLUTE

In the spring of 1791, Schikaneder[1] visits Mozart and commissions a "hit opera"[2] for his wood-shack of a playhouse in the Starhembergsches Freihaus auf der Wieden, because he needs success at the box office as he is threatened by competition from the Leopold-stadt stage.[3] Mozart has his doubts: "If we have a misfortune, I can't be held responsible, because I've never composed a magical opera before."

Schikaneder writes to Mozart: "Dear Wolfgang! Meanwhile I'm sending you back your Pa-pa-pa, that I like well enough—it just might do ... " Premiere on the thirtieth of September, 1791. After the overture: icy silence. Then the composer Schenk,[4] who is listening in the orchestra pit, sneaks up to the conductor's podium and kisses Mozart's hand ... The teacher of Beethoven pays homage to Mozart. The first act is a failure; a worried and pale Mozart appears on the stage and when, after the second act, the usual cheers and polite applause occur, he refuses to acknowledge it ... Two months and five days later he enters the "better land"—Schikaneder, who strains unscrupulously in order to create an "effect," combines two completely heterogeneous elements in his text: the remains of old Free Mason rituals and the pre–March Revolutionary,[5] Bengali-tinged magical extravaganza with singing, which Raimund[6] later elevated to the level of high art. Mozart's ingenious naiveté immediately finds an adequate musical expression—he, too, unites two opposing elements. He becomes simultaneously "classicist" and folklorist. By making the work seem archaic, he allows himself to be inspired by his admiration for Händel,[7] whom he knows very well due to his own arrangements of a number of works by his great predecessor. One notices it: the master tries to turn his back on the "Welsh" style—one notices it in the overture, which was deleted in our performance; furthermore, in the unprecedented new simplicity of Mozart's largely three-part vocal writing, indeed in the writing over all, in the lack of ornamentation and polyphony, in the predominant use of the middle register for the voices and the orchestra, the strange "bass-lessness." ... This time there is not an "enormous amounts of notes,"[8] but a minimum. The childishness of the text, whose prose parts were replaced by a tasteful narration written by Dr. Kamill Hoffmann[9] and unobtrusively spoken by F. Lerner[10]—the peculiar childlike quality of the music corresponds to the Viennese suburbs; it can't be found in any of Mozart's other works, it reminds me of Paul Klee's[11] paintings and drawings, and it characterizes almost all of the Papageno scenes.[12] ... Here, the Austrian folk songs ... no, the popular street songs of the time resound. Thus, Mozart transforms the duality of the text and ennobles it to humor, satire, irony and above all to a deeper meaning ...

We have listened to and treasured *The Magic Flute* since childhood. Some still have Mahler in their ear, others Richard Strauss, Schalk, Walter, or Zemlinsky;[13] we have heard the best Mozart singers on earth, seen the set designs of great artists, and cherished the memory of the melting, incomparable sound of the accompanying orchestra. Can

Die Zauberflöte

Schikaneder kommt im Frühjahr 1791 zu Mozart und bestellt für seine Bretterbude im Starhembergschen Freihause auf der Wieden eine "Zugoper;er braucht volle Kassen,weil ihn die Konkurrenz der Leopoldstätter Bühne bedroht.Mozart zweifelt:"Wenn wir ein Malheur haben,so kann ich nichts dazu,denn eine Zauberoper habe ich noch nicht komponiert." Schikaneder an Mozart:"Lieber Wolfgang!Lerweilen schicke ich dir dein Papa zurück,das mir ziemlich recht ist,es wirds schon thun.." Uraufführung 30.September 1791.Nach der Ouverture eisiges Schweigen.Da kriecht der Komponist Schenk,der im Orchesterraum zuhört,zum Dirigentenpult hin und küsst Mozarts Hand ...der Lehrer Beethovens huldigt Mozart.Der erste Akt füllt durch;Mozart kommt konsterniert und blass auf die Bühne und als es nach dem zweiten Akte den üblichen Achtungserfolg und Schlussbeifall gibt, weigert er sich,sich zu bedenken...Zwei Monate und fünf Tage später ist er ins "bessere Land" gegangen.-Schikaneder,der in skrupelloser Weise "Effekt" schinden will,bindet ex-läm zwei völlig heterogene Elemente: die Reste alter Geheimbund-Riten und die vormärzliche,bengalisch beleuchtete Zauberposse mit Gesang,die ein Raimund später zum Range hoher Kunst erheben sollte.Mozarts geniale Naivität findet sofort den musikalisch adäquaten Ausdruck,auch er vereinigt zwei gegensätzliche Elemente.Er wird "klassizistisch" und volkstümlich zugleich.Indem er archaisiert,lässt er sich von seiner Bewunderung Händels inspirieren,den er ja aus den Bearbeitungen die er selbst mehreren Werken des grossen Vorgängers zuteil werden liess, sehr genau kennt.Man merkt es:Der Meister sucht die Abkehr vom "welschen" Stil,markt es schon in der bei uns gestrichenen Ouverture,denn in der bei Mozart neuen unerhörten Einfachheit des meist dreistimmigen Vokal-Satzes, ja des Satzes überhaupt,an dem Verzicht auf Ornamentik und Polyphonie, an der vorherrschenden Mittellage in Gesang und Orchester,an der merkwürdigen "Basslosigkeit" ...Diesmal sind es nicht "Gewaltig viel Noten",sondern das Minimum.Der Infantilität des Textes,dessen Prosa durch eine von Dr. Kamill Hoffmann geschmackvoll ausgeführte und von F.Lerner dezent gesprochene Conference ersetzt wurde-,der Wiener Vorstadt entspricht jener seltsame Infantilismus dieser Musik,der in keinem anderen Werke Mozarts zu finden ist,der mich an Paul Klees Bilder und Zeichnungen erinnert und der fast alle Papageno-Szenen charakterisiert...hier klingt das österreichische Volkslied..nein,der Gassenhauer jener Zeiten mit.So verwandelt Mozart die Zwiespältigkeit des Textes,veredelt sie zu Scherz,Satire,Ironie und vor Allem zu tieferer Bedeutung...

Wir haben die "Zauberflöte" von Kindheit an gehört und geliebt. Manche haben noch Mahler im Ohre,andere Richard Strauss,Schalk,Walter,Zemlinsky;wir hörten die ersten Mozart-Sänger der Welt,sahen die Bühnenbilder grosser Künstler und behielten die Erinnerung an den schmelzenden,unvergleichlichen Klang des zart begleitenden Orchesters.Kann man,darf man über eine Aufführung kritisch berichten,die sich zu diesen Erinnerungen verhält wie eine zweite Bühnenprobe zu einer Generalprobe?Über eine Aufführung,die der Dirigent nicht einmal dirigieren darf -warum übrigens - und die er auf einem "mehr als fragwürdigen Klavier begleiten muss,indem er seine liebe Not hat mit den Einsätzen und den schwirigen Ensembles,die doch einen Dirigenten brauchen..Und lässt er das Klavier los und dirigiert,denn hören wir wieder nur einen Bruchteil der begleitenden Musik..Kurz ich kann nicht verstehen,warum sich der verdienstvolle Dirigent Rafael Schächter nicht einen unserer ausgezeichneten Pianisten zum Klavier setzt,um zuerst einmal die Hände für das Wichtigste frei zu bekommen,für das Dirigieren."Die Zauberflöte"gehört zu den schwierigsten und anspruchsvollsten Opern der Weltliteratur,sie erfordert rund 18 Solisten von höchstem Range und neben dem gemischten einen hervorragenden Männerchor.Es sind Bedingungen,die die Theresienstadt unmöglich erfüllen kann.Wohl gab es vollgültige Leistungen,die hinter en Forderungen kaum zurückblieben-Podolier,Fried,Windholz,es gab opferbereite,vorzügliche Sänger,die Partien sangen,die nicht in ihr Fach fallen, auszuhelfen,wie Hecht,Grünfeld,die demgemäss mit der Materie etwas zu kämpfen hatten.Es gab aber auch Notbesetzungen wie Heymann-der sich noch

t und die 3 Damen Borm, L und Fischer

endgiltig für Sopran entscheiden sollte—,wie Pollak,Singer,wie die drei
Knaben....ja,die drei Knaben!Hoffentlich wird der weckere,begabte kleine
Mühlstein doch endlich mutieren,bevor er unsere Ohren gänzlich zerschnitten
hat.Die herrlich-süssen Gesänge der drei Knaben sind nicht für die spröden
Stimmen von Kindern;die Protagonisten aus Krásas liebenswerter "Brundibar"
gehören nicht in die Zauberflöte, denn dort wurde für Kinderstimmen geschrie-
ben und sie können sich in der ihnen gemässen Mittellage halten,hier ist das
unmöglich.Die Kinder singen mit einer Präzision,die ihrer Musikalität und
Schüchtere Studier-Energie alle Ehre macht,aber sie singen wie Automaten,
seelenlos und mechanisch..Wie sich dieser Klang und dieser Vortrag mit
Paminas warmen,beseelten Tönen mixt,haben wir schaudernd erfahren.
 Rafael Schächter hat eine Dienerarbeit geleistet,die ohne
Vorbehalt gewürdigt wird.Aber—solange Gustav Mahler in der Provinz sass,
hielt er sein Gelübde:Mozart und Wagner dort nicht aufzuführen!Zudem ist
Schächter nicht grade der geborene Mozart-Dirigent.Es ist Vieles zu hastig,
es mangelt die Elastizität der Zeitmasse und des Vortrags,es ist noch
zuviel Drill herauszuhören..Zum Exempel sind etwa die beiden Geharnischten
ein durchaus gemessenes,feierliches Stück,das wohl um die Hälfte langsamer
genommen werden sollte,auch dem Priestermarsche fehlt die feierliche
Ruhe,die Münsch...treiben ebenso wie die Kinder durch die hohe Lage...etc.
Es war unnütig,noch die an allen Grossstadtbühnen gestrichenen Partien zu öff-
nen.So liesse sich noch Manches sagen,was hiermit zusammengefasst sei in
die Warnung:sich im Repertoire unseren Möglichkeiten und Mitteln anzupassen.
Schächter hat sehr gute Qualitäten,aber zu hohe Ambitionen für ein Provinz—
Theater..und das sind wir doch!Sind wir aber ein Grossstadttheater,so irre ic
mich und will nichts gesagt haben..Also kein Wettstreit mit der Mailänder
Scala und der Wiener Staatsoper,der von vornherein aussichtslos sein muss..Es
Dagegen haben wir sehr wohl die Möglichkeit,unsere Ansprüche auf künstlerisch
Qualität zu steigern und dafür Werke zu wählen,die wir durchaus einwandfrei
besetzen und sogar scenisch aufführen können—Smetanas "Kuss",jawohl,und
Nicolais "die lustigen Weiber von Windsor",Donizettis "Don Pasquale" —ein
chorloses Meisterwerk,Lortzings "Wildschütz",Glucks "betrogenen Cadi",
Haydns "Apotheker",Offenbachs "Briganten" und von Mozart höchstens:
Bastien und Bastienne.

172. Viktor Ullmann's original manuscript of Critique 17. 2 pages. NIOD.

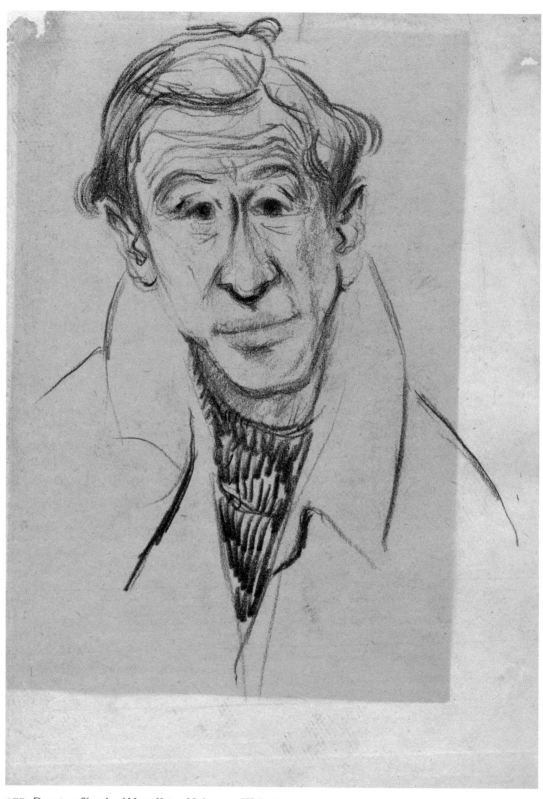

173. Drawing. Sketch of Hans Krása. Unknown. PT #14154.

one, may one report critically about a performance which compares to those memories as a second rehearsal does to a final dress rehearsal? About a performance in which the conductor is not allowed to conduct—why is that?—and which he had to accompany on a more than questionable piano, thereby having difficulty with the cues for the difficult ensemble entrances, which simply need a conductor. And if he takes his hands off the piano and conducts, then we hear only a fragment of the accompanying music. In short, I cannot understand why our commendable conductor Rafael Schächter[14] doesn't ask one of our excellent pianists to sit at the piano, so that he could have his hands free for the most important thing: conducting. *The Magic Flute* is one of the most difficult and demanding operas in world literature, it requires about ten soloists of the highest level and besides the mixed choir an outstanding men's chorus. These are requirements that are impossible to meet in Theresienstadt. There were, however, valid performances that were almost up to those requirements—Podolier,[15] Fried,[16] Windholz,[17] and the three ladies Borger,[18] Lindt,[19] Fuchs[20]—there were excellent singers like Hecht[21] and Grünfeld,[22] who were willing to help out by singing parts that don't suit their voice-genre and therefore had to struggle a bit with the material. There was also some emergency casting, such as Heymann[23]—who should finally decide he is a soprano—such as Pollak,[24] Singer,[25] and the three boys … yes, the three boys! Hopefully the valiant, talented little Mühlstein[26] will mutate soon, before he completely pierces our ears. The glorious, sweet songs of the three boys are not meant to be sung by the brittle voices of children; the protagonists of Krasá's charming *Brundibár*[27] don't belong in *The Magic Flute*, since in the former the parts were written for children's voices, and they can remain comfortably in the appropriate middle range, which is impossible here. The children sing with a precision that honors their musicality and Schächter's energetic coaching, yet they sang like automatons, soulless and mechanical. Shuddering, we experienced how this sound and expression mixed with Pamina's[28] warm, soulful singing.

Rafael Schächter accomplished an enormous undertaking that deserves unconditional praise. However—as long as Gustav Mahler was stuck in the provinces he kept his vow never to perform Mozart and Wagner there! Also, Schächter is not exactly a born Mozart conductor. Many passages are too hasty, they lack elasticity in the tempi and the presentation, there is still too much drill to be heard … For example, "The Two Knights" is a balanced, solemn piece that should have been taken twice as slow; the march of the priests, too, was lacking a solemn pace—the men's chorus rushed through the high notes, as did the children … etc.

It was unnecessary to include the parts that are deleted from all metropolitan productions. There would be a number of other things to mention that can be summarized in this warning: The repertoire should be suited to our potentials and means.[29] Schächter has very good qualities, but his ambitions are too high for a provincial theater … and isn't that what we are? If, however, we are a metropolitan theater, then I was wrong and I take it all back … So, no competition with La Scala in Milan and the State Opera

in Vienna,[30] which would be senseless from the start. On the other hand we absolutely do have the possibility to increase our demand for artistic quality and to choose works that we can appropriately cast and even perform on stage—Smetana's *The Kiss*[31] and Nicolai's *The Merry Wives of Windsor*,[32] Donizetti's *Don Pasquale*[33]—a masterpiece without chorus—Lortzing's *Wildschütz*,[34] Gluck's *Cheated Cadi*,[35] Haydn's *Pharmacist*,[36] Offenbach's *Brigadiers*,[37] and at most Mozart's *Bastien and Bastienne*[38] [images 171–176].

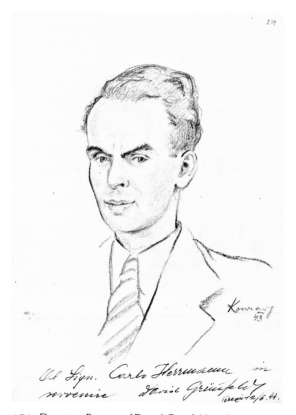

174. Drawing. Portrait of David Grünfeld, with autograph of D. Gruenfeld. Konrad. HCPT #4059.

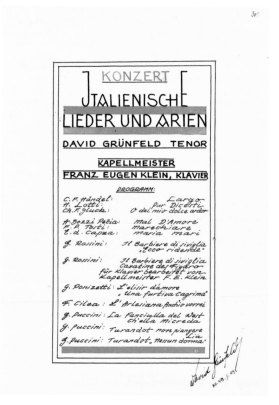

175. Poster, signed. *Italienische Lieder und Arien.* HCPT #3947. Announcement for concert of Italian songs and arias sung by David Grünfeld accompanied by Franz Eugen Klein on the piano. Signed "David Grünfeld XII.43–I.44."

176. Painting. Portrait of Hans Krása. Otto Ungar. PT #16. © Eva Odstrčilová, Pavel Weisz, and Tomáš Weisz.

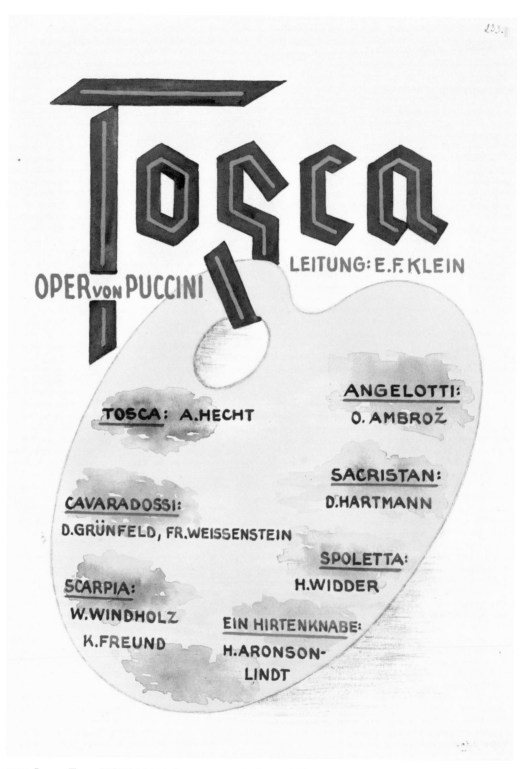

177. Poster. *Tosca.* HCPT #3925. *Announcement for Puccini's Tosca directed by Franz Eugen Klein. The artist cleverly placed the roles and names of the singers on a palette, a reference to one of the opera's lead tenor roles, the painter Mario Caravadossi.*

OPERAS IN TEREZÍN

The following images are a sampling of the impressive range of operas, operettas, oratorios, and vocal recitals performed from the classical repertoire.

Rafael Schächter and Franz Eugen Klein conducted the majority of these Terezín productions [images 177–184]:

Georges Bizet's *Carmen*
Vilém František Blodek's *In the Well*
Franz Joseph Haydn's *The Creation*
Hans Krása's *Brundibár*
Pietro Mascagni's *Cavalleria rusticana*
Felix Mendelssohn's *Elijah*
Wolfgang Amadeus Mozart's *Bastien and Bastienne*
Wolfgang Amadeus Mozart's *Magic Flute*
Wolfgang Amadeus Mozart's *Marriage of Figaro*
Wolfgang Amadeus Mozart's *The Abduction from the Seraglio*
Jacques Offenbach's *The Tales of Hoffmann*
Giovanni Battista Pergolesi's *La serva padrona*
Giacomo Puccini's *La Boheme*
Giacomo Puccini's *Tosca*
Bedřich Smetana's *The Kiss*
Bedřich Smetana's *The Bartered Bride*
Johann Strauss' *Die Fledermaus*
Giuseppe Verdi's *Aida*
Giuseppe Verdi's *Requiem*
Giuseppe Verdi's *Rigoletto*

Most performances were in concert version formats substituting piano reductions for the originally scored opera orchestras. Costumes and sets were made from the scant reusable materials available—often burlap, paper, rags, and scraps of materials—for the few staged performances produced. Scores, including instrumental and vocal parts, were largely brought into the camp by the prisoners

178.

Opernfragmente

Erster Abend

R I G O L E T T O

Oper in drei Akten nach dem Italienischen
des F.M.Piave

Musik von
Guiseppe V E R D I

Musikalische Leitung:
Kapellmeister Franz Eugen K l e i n

Künstlerische Leitung: Kurt Weisz

Personen:

Der Herzog von Mantua _____ Herr Grünfeld

Rigoletto, sein Hofnarr _____ Herr Windholz

Gilda, seine Tochter _____ Frau Tamara-
 Zucker

Sparafucile, ein Bandit _____ Herr Freund

Maddalena, seine Schwester _____ Frau Grab-
 Kernmayer

Graf von Monterone _____ Herr Hartmann

Giovanna _____ Frau Perner

179.

178. Title sheet. *Opern*. Heinrich Bähr. HCPT #4056.
*Artists made such images for Heřman at his request; he used
them to separate his collection into sections by artist, sport,
musical genre, and the like. This one is for the section of
documents relating to operas.*

179. Program for Verdi's *Rigoletto* under the direction
of Franz Eugen Klein. HCPT #3923.

180. Poster. *Hubička* ("The Kiss"). HCPT #3926. *The
premiere of Smetana's opera was July 20, 1943 in the
Dresden barracks.*

181. Poster. *Prodaná nevěsta* ("The Bartered Bride").
HCPT #4295. *The figure with the umbrella is Kecal, the
marriage broker (bass role) in Smetana's opera. 1943–44.*

180.

181.

182. Poster. *Hubička* ("The Kiss"). Possibly Dr. P. Fanti. HCPT #4294.

222

Annotations

1 **Johannes Joseph Schikaneder** (1751–1812) was a Viennese actor, singer, theatre director and playwright of more than one hundred plays and libretti. He wrote the libretto to *The Magic Flute*, which premiered September 30, 1791 in Schikaneder's theater, the Freihaus-Theater auf der Wieden. Schikaneder sang the role of Papageno with Mozart conducting [Critique 17].

2 *The Magic Flute.* This final opera and masterpiece by Mozart is a delightful mixture of *Singspiel* and Viennese Theatre of the period. Filled with elements of Freemasonry, it has been dubbed the "Freemason Opera." No surprise, as both Mozart and the librettist Schikaneder were Freemasons. **Mozart** [Critiques 4, 9, 10, 14, 16, 17, 22, 25].

3 **Leopoldstadt stage** was the **Leopoldstädter Theater,** a rival theatre formed by Karl von Marinelli in 1781.

4 **Johann Schenk** (1753–1836). Austrian composer. He composed *singspiels* for Viennese theaters, including Schikaneder's Freihaus Theater auf der Wieden. Schenk's most famous pupil in counterpoint and composition was Beethoven [Critique 17].

5 Ullmann writes in German, *vormärzliche,* referring to the "*Vormärz,*" a historical period pre-dating the **German revolutions of 1848–49** (also called the **March Revolution** or in German: *Märzrevolution*), which was marked by protests and rebellions within states of the German Confederation.

6 **Ferdinand Raimund** (1790–1836). Famous Viennese actor who starred in burlesque and comedy productions in the Freihaus-Theater an der Wien [Critique 17].

7 **George Friedric Händel** [Critiques 10, 17].

8 "**Enormous amounts of notes**" is a reference to a remark by Emperor Joseph II [Critique 4, annotation 15].

9 **Dr. Kamill Hoffmann** (1878–1944, Auschwitz) (**No. 4 on Transport Am** from Prague to Terezín on April 24, 1942) (**No. 1583 on Transport Ev** from Terezín to Auschwitz on October 28, 1944). Diplomat, writer, and translator, he gave a lecture in Terezín titled "Czech Poetry in the German Language" [Critique 17].

10 **Bedřich ("Fritz") Lerner.** (1906–1945, Buchenwald) (**No. 132 on Transport Cb** from Tábor to Terezín on November 11, 1942) (**No. 1889 on Transport Ek** from Terezín to Auschwitz on September 28,1944). Actor and dramatist [Critique 17].

11 **Paul Klee** (1879–1940) was a member of Der Blaue Reiter (The Blue Rider), a group of expressionist artists who were a major influence in the development of twentieth-century abstract art. He was on the faculty of the Bauhaus school from 1920 to 1931. Labeled a degenerate by the Nazis, he was dismissed from his teaching post at the Dusseldorf Academy in 1933. Exhibiting the influences of surrealism, cubism, and primitivism, his art resists simple classification. Klee's colorful, almost child-like fantasy world of abstract images is an apt visual parallel to the "this peculiar childlike quality of the music [of Mozart], characteriz[ing] almost all of the Papageno scenes," as Ullmann puts it.

12 **Papageno scenes.** Papageno, the bird catcher, is a character (baritone role) in Mozart's *The Magic Flute.*

13 **Gustav Mahler, Richard Strauss, Franz Schalk, Bruno Walter** and **Alexander Zemlinsky** were acknowledged as great conductors and interpreters of the opera and symphonic repertoire. Ullmann combines love for *The Magic Flute* with memories of performances led by these artists [Critiques 4, 7, 10, 17, 20, 26].

14 **Rafael Schächter** [Critiques 10, 15–18].

15 **Marion (Hildegarde) Podolier(ová)** [Critiques 16–18].

16 **J. Fried**. (Transport unknown). Basso who performed role of Sarastro in *The Magic Flute* and Colas, the magician, in *Bastien and Bastienne* [Critique 17].

17 **Walter Windholz** [Critiques 10, 17, 26].

18 **Gertrude (Truda) Borger** [Critiques 10, 17, 26].

19 **Hilde Aronson-Lindt** [Critiques 10, 17, 18, 26].

20 **Rita Fuchs (Fuchsová)** [Critiques 9, 17].

21 **Ada Chudes Hecht** (1896–1944, Auschwitz) (**No. 666 on Transport IV–10** from Vienna to Terezín on September 10, 1942) (**No. 956 on Transport Ev** from Terezín to Auschwitz on October 28, 1944). *Coloratura* in the Vienna Volksoper before the war. In Terezín, she sang in *The Magic Flute* (in interview with Mark Ludwig, Karel Berman mentioned her possible role as the Queen of the Night), Tosca in Puccini's *Tosca,* and Micaëla in *Carmen* [Critiques 17, 26].

22 **David Grünfeld** (post-war changed to David Garen) (1914–1963) (**Transport Ck** from Prague to Terezín on December 22, 1942) (**Transport Ev** from Terezín to Auschwitz on October 28,1944). Tenor. In addition to his role as Tamino in *The Magic Flute,* in Terezín performances he also sang Don José in *Carmen,* Cavaradossi in *Tosca,* Pierrot in *Der Kaiser von Atlantis,* and the tenor solo in Verdi's *Requiem,* and he performed in several vocal recitals. Schul arranged Grünfeld's melody for "In the Shadow of Your Wings." After his liberation in Litoměřice, Grünfeld emigrated to the United States and resumed his career of solo performances with a position at the NBC Opera Theatre, and he later became a cantor. His many solo engagements with orchestras include two with the Boston Symphony Orchestra [Critiques 17, 18].

23 **Heymann** sang the lyric tenor role of Monostatos. Ullmann is likely referring to Harry Hambo Heymann [Critiques 2, 17].

24 **Karel Pollak (Polák)** (1918–1945, Kauffering) (**No. 432 on Transport G** from Brno to Terezín on December 2, 1941) (**No. 86 on Transport Ek** from Terezín to Auschwitz on September 28, 1944) (**Transport** from Auschwitz to Dachau on October 10, 1944). Amateur singer. He sang the role of one of the two Armoured Men in *The Magic Flute.* He also sang Matouš in Smetana's *The Kiss* (*Hubička*), Colas in *Bastien and Bastienne,* and the Le Dancaïre in *Carmen* [Critiques 9, 17, 26].

25 **Singer.** (Transport unknown). Possibly Alexander Singer, tenor from Romania who lived in Prague before his transport to Terezín. After the war, he sang in the Grand Opera Praha and later emigrated to Johannesburg, South Africa, where he became a cantor [Critique 17].

26 **Pinta Mühlstein** (1929–1944, Auschwitz). Child performer in Terezín. He was one of the Three Child-Spirits in *The Magic Flute,* Pepíček in *Brundibár,* and The Bear in *The Bartered Bride.* [Critique 17].

27 *Brundibár* [Critiques 3, 17].

28 **Pamina (soprano)** is the daughter of the Queen of the Night (soprano-*coloratura*) in *The Magic Flute.*

29 **"Potentials and means"** is an allusion to artistic and logistical possibilities limited by the deprivation and stress in Terezín.

30 **La Scala** (Teatro alla Scala, built in Milan in 1778) and the **Vienna State Opera** (1869) are among the great opera houses of the world.

31 *The Kiss.* Bedřich Smetana's opera (*Hubička,* 1876) [Critiques 10, 11, 17].

32 *The Merry Wives of Windsor* is a comic opera by Otto Nicolai (1810–1849). The libretto by German playwright Salomon Hermann Mosenthal (1821–1877) was an adaptation of Shakespeare's comedy [Critique 17].

33 *Don Pasquale* is the *opera buffa* masterpiece by Gaetano Donizetti (1797–1847) [Critique 17].

34 *Wildschütz* (*The Poacher*). Gustav Albert Lortzing (1801–1851) composed this light comic opera in 1842.

35 *The Cheated Cadi* (*Le Cadi dupe*) is a comic opera by German composer Christoph Willibald Gluck (1714–1787).

36 *The Pharmacist*, Hob. 28/3 (1768). Comic opera by Franz Joseph Haydn [Critiques 10, 17, 19].

37 *Les Brigants* (1869). Ullmann most likely means Jacques Offenbach's operetta [Critiques 2, 17].

38 **Mozart's Bastien and Bastienne**, K. 46b (1768) [Critiques 4, 9, 10, 14, 16, 17, 22, 25].

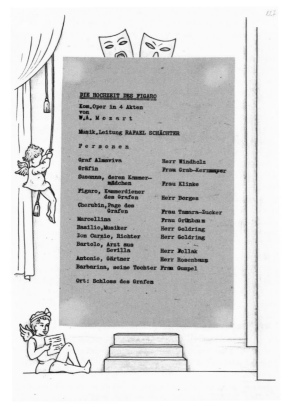

183. Program for Mozart's *The Marriage of Figaro* directed by Rafael Schächter. Heinrich Bähr. HCPT #3922.

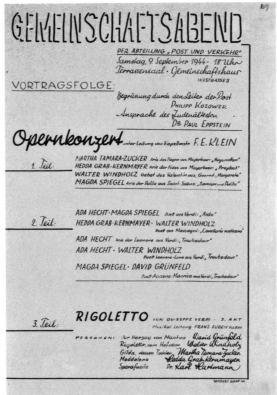

184. Poster for a program of opera arias. Herbert Graff. 1944. HCPT #3946.

185. Poster. G. Verdi: *Requiem, Dirigent: Rafael Schächter.* HCPT #4296.

Critique 18
BELATED COMMENTS ON VERDI'S *REQUIEM*

Bach,[1] the Lutheran, wrote his *Hohe Messe;*[2] Beethoven, the free thinker, his *Missa Solemnis;*[3] and Verdi, the master of the opera, his *Requiem,*[4] and with that one of his most beautiful operas. There can be no doubt that the old liturgical text undergoes a metamorphosis into the theatrical, and that this *missa defunctorum*[5] enchants more than it grips. What inexpressible glory of melodic invention, what an inexhaustible richness of styles, ensemble writing, masterfully set choruses, dramatically suspenseful moments, intelligently placed climaxes—all those qualities that Verdi used in his operas and developed to the point of highest mastery. The harmonic language of this late work clearly reveals the change of style, as evidenced in the difference between *Aida* and *Othello,*[6] that reflects his ambivalent experience with the congenial Wagner—that miracle of regeneration of an old man, who after organizing the first Italian performance of the *Walküre*[7] in Milan, finds the words, "How petty everything I've written seems to me compared to this music ... " and then, in the last decade of his lauded life, he re-learns and writes his greatest works, among them the *Requiem* ... Still: he stays in the theatre, stays true to himself. In this combination of baroque sensuousness with late-Romantic sweet melodies and harmonies, even death loses its horrors, and who wouldn't recognize the genuine theatrical gesture in this *"rex tremendae majestatis,"*[8] or even in the stubborn idea to place—against all liturgical tradition—a graceful, lively fugue at a point where all other composers of the *missa* become mystical: the *"Sanctus."*[9] It is only towards the end of the magnificent work that the master finds mystical tones: " ... *et lux perpetua luceat eis."*[10]

Yesterday's performance was one of many reprises, so nothing more should be said about technical details. In this case, however, it seems justified to emphasize once again that Rafael Schächter,[11] to whom the musical life of Theresienstadt owes so many stimuli and artistic achievements, managed to put together a performance at the level of a metropolitan standard. Rising above the technical, Schächter shapes the spirit of the work, described above, with economical yet evocative gestures. The choir is not only precise but also dynamically impeccable. The soloists stand loyally by their conductor's side, and the brilliant (especially in the higher register) soprano of Podolier,[12] the warm velvety voice of Lindt-Aronson,[13] the blooming tenor of Grünfeld,[14] and the dark, beautiful and profound bass of Bermann[15] unite to create an impression of *bel canto* singing that enraptured the audience. And who was capable of writing for the human voice, if not Verdi? Why does everything of Verdi sound good, while innumerable other masters can't make the human singing voice resound, but rather leave it sounding instead like a fish gasping on a dry beach—while the rhythmic articulation of syllables hacks the most beautiful melody to bits ... ?[16]

We'll remember this glorious production with Gideon Klein[17] at the piano with gratitude, and we hope to hear Verdi's actual bequest on the opera stage, the incomparable *Falstaff*, who proclaims as wisdom's final conclusion in the master's last and most successful fugue: "The whole world is but a joke"[18] [images 185–188].

Annotations

1 **Johann Sebastian Bach** [Critiques 5, 7, 10, 14, 18, 20, 22].

2 *Hohe Messe*, B-Minor Mass, BWV 232. Ullmann refers to three of classical music's monumental Masses. Palestrina, Haydn, Mozart, Fauré, Dvořák, Brahms, Bruckner, and Britten are also important classical composers who set the Latin Mass to music.

3 *Missa Solemnis* (Latin: solemn Mass) in D Major op. 123, completed in 1823 [Critiques 5, 6, 10, 11, 18, 20–22, 25, 26].

4 A **requiem** is traditionally a musical setting of the Roman Catholic Mass for the Dead. Verdi's *Requiem* was inspired by the passing of his idol, Italian poet and novelist Alessandro Manzoni [Critiques 4, 18].

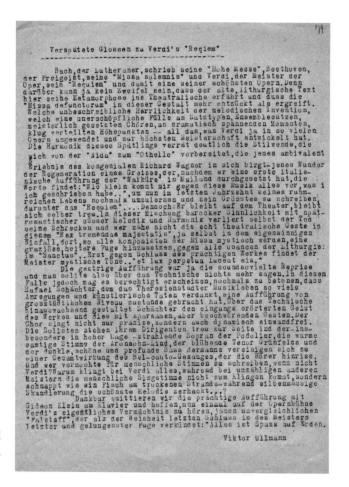

186. Viktor Ullmann's original manuscript of Critique 18. 1 page. NIOD.

5 *Missa defunctorum.* (Latin: "Mass of the dead.")

6 *Aida* (premiere 1871) and ***Othello*** (premiere 1887) are among Verdi's great dramatic operas.

7 *Walküre*. *Die Walküre* (*The Valkyrie*) is second in Richard Wagner's four-opera cycle, *Der Ring des Nibelungen* (*The Ring of the Nibelung*). Composed between 1848 and 1874, the four operas of the *The Ring* are *Das Rheingold* (*The Rhinegold*), *Die Walküre* (*The Valkyrie*), *Siegfried* and *Götter-dämmerung* (*Twilight of the Gods*), a sweeping epic about a race of Gods who fall from power and the subsequent rise of man [Critiques 12, 17, 26].

8 "*Rex tremendae majestatis.*" (Latin: "king of dreadful majesty.")

9 *Sanctus.* (Latin: holy) *Sanctus* is a musical setting to a hymn of praise. It is the fourth movement of the ordinary Catholic Mass.

10 "*Et lux perpetua luceat eis.*" (Latin: "and perpetual light shine upon them.")

11 **Rafael Schächter** [Critiques 10, 15–18].

12 **Marion (Hildegarde) Podolier(ová)** [Critiques 16–18].

13 **Hilde Lindt-Aronson** (Hilde Aronson-Lindt) [Critiques 10, 17, 18, 26].

14 **David Grünfeld** [Critiques 17, 18].

15 **Karel Berman** [Critiques 9, 10, 15, 16, 18].

16 **Terezín Verdi *Requiem* performances:** From 1991 to 2015, Mark Ludwig presented more than one hundred education programs in the United States and the Czech Republic with Terezín survivor Edgar Krasa, who sang in the chorus of these Verdi *Requiem* performances. The following is excerpted from a transcript of Edgar recounting these experiences to students: "Schächter and I shared a bunk together. He told me of his plans to perform the grand Verdi *Requiem*. Imagine Jews in a concentration camp singing a Roman Catholic Mass in Latin! The Council of Elders had mixed feelings about this undertaking. I was part of the first 150-member chorus that rehearsed the *Requiem* at the end of each day. Each night we gathered in the cellar. There were no parts, only the score he brought with him on the transport. He taught each group—sopranos, tenors, altos, and basses—the Latin text and the music section by section. We learned this from memory. After six weeks of rehearsals, news spread through the camp that there would be a major transport to the east on September 6. Against Rafi's initial wishes, he relented to the demands of the singers to give a performance for family members. Shortly afterwards, over half the choir was lost to the transport. Schächter recruited another choir. It was again decimated by transports. In January 1944, we gave the official premiere of the *Requiem*. We sang the *Requiem* fifteen more times. On June 23, 1944, Schächter was ordered by Rahm [SS Commandant in Terezín] to give a performance of the *Requiem* for the visiting Red Cross Committee. Even SS officers came from Berlin and Prague. Schächter wanted to make a musical protest to the Nazis sitting in the audience when we sang the *Dies Irae*—the day of wrath and judgement. Especially when we cried out, 'when the wicked have been confounded.' But the Germans felt we were all singing our *Requiem*."

17 Gideon Klein and Tella Polák(ová) shared duties as the pianist for the *Requiem* rehearsals and performances. Before the war, Tella was a music teacher in the Zionist youth movement *Macabi HaTzair* in Prague. Tella (1911–1971) (**Transport V** from Prague to Terezín on January 30, 1942) (**Transport Et** from Terezín to Auschwitz on October 23, 1944) was liberated in Auschwitz. Poláková was one of the counselors in Room 28 of the Girls Home. She directed a Girls Choir in the cellar of L410 and often played harmonium in Terezín programs. In the absence of the large orchestra and off-stage brass bands required, Klein and Poláková were challenged with the virtuosic and artistic undertaking of condensing Verdi's immense and dramatically charged score. **Gideon Klein** [Critiques 3, 7, 18, 21].

18 **"The whole world is a joke"** ("*Tutto nel mondo e burla*") is from the concluding fugue of Verdi's last opera, *Falstaff*, based on Shakespeare's plays *The Merry Wives of Windsor* and *Henry IV* Parts 1 and 2.

187. Drawing. Portrait of Edgar Krasa. Leo Haas. Collection of Edgar and Hana Krasa.

188. Drawing. Portrait of Rafael Schächter. František Petr Kien. ZM #174.305.

189. Poster. *Die Schöpfung—Oratorium von Joseph Haydn.* HCPT #3913. *Announcement for Haydn's oratorio "The Creation" directed by Karl Fischer. Renée Gärtner-Geiringer performed the orchestral piano reduction.*

Critique 19

THE CREATION BY HAYDN[1]

It lies in the nature of our time and our experiences that we are able to distance ourselves from the existential lie of the nineteenth century and therefore from some of the cultural values our grandparents considered sacrosanct. As true as it is that Joseph Haydn is an ingenious and at present unjustly neglected master composer—for his 120 symphonies and his operas have been forgotten—it is also true that his *Creation* is a vastly overestimated work. Imagine Michelangelo's fresco in the Sistine chapel painted by Watteau or Fragonard[2] and then you have Haydn's *Creation*. With few exceptions, this music has about as much to do with Genesis—with its sublime images and symbols, with its majesty and mystery—as a cute little rococo cottage has to do with the Cheops pyramids. It is self-evident that from Haydn's spirit pours a wealth of splendid and well-formed melodies on top of the mostly very silly, pastoral, and idyllic sweetness of the text. Yet he only achieves climaxes when he becomes Gothic, therefore polyphonic, especially in the two double fugues *"Alles lobe seinen Namen"*[3] and *"Des Herren Ruhm"*[4] in the finale.

Hence, the choruses were the best part and purest joy of our Theresienstadt performance, thanks to Karl Fischer,[5] an excellent choral conductor, who controlled his youthfully fresh and enthusiastic choir. The soloists, too, did their best, starting with Mrs. Kohn-Schlesskow,[6] whose experience as an oratory singer shows and whose fine *coloratura*[7] voice was nicely featured in the aria *"Auf starkem Fittig."*[8] Mr. Goldring[9] gave his debut as oratory singer and familiarized himself with the style astonishingly quickly; his supple tenor voice gives him every advantage and the aria *"Mit Würd' und Hoheit angetan"*[10] succeeded excellently. Mr. K. Freund still needs a voice teacher for his beautiful material, but on the whole he proved himself capable of tackling his difficult assignment. Mrs. Gärtner-Geiringer[11] allows us to forget the missing orchestral accompaniment.

Lastly, let me propose a revision of the text, in which all-too-embarrassing passages would be re-written. (There should be a "Bible—protection"!) Here are some samples: "He made the stars likewise … "[12] "And the angels touched their heavenly harps … "[13] "In fair grace the swaying hills lay yonder … "[14] Actually, everything is immediately ready to go: the lion "roaring with joy," the cattle are "divided into herds," and on the bosom of the newly created Adam—without any unnecessary time spent on Adam's sleep and his rib—nestles his "wife, fair and full of grace." And behold! It was a lady in crinoline with a powdered wig … *Eritis sicut deus ex machina* … [15] [images 189, 190].

Die Schöpfung" von Haydn

　　　　　Es liegt im Wesen unserer Zeit und unserer Erlebnisse,dass
wir Abstand gewinnen zur Lebenslüge des XIX.Jahrhunderts und damit
auch zu manchen unseren Grosseltern unantastbaren Kulturgütern.So
wahr es ist,dass Josef Haydn ein heute zu Unrecht vernachlässigter
genialer Meister ist,-denn seine 120 Symphonien und seine Opern
sind verschollen-,so wahr ist es,dass seine "Schöpfung" ein weit
überschätztes Werk ist.Man denke sich Michelangelos Deckengemälde
in der sixtinischen Kapelle gemalt von Watteau oder Fragonard-und man
hat Haydns "Schöpfung".Diese Musik hat-mit wenigen Ausnahmen- mit der
Genesis,ihren erhabenen Bildern und Symbolen,mit ihrer Majestät und
ihrem Mysterium etwa soviel zu tun wie die Cheops-Pyramide mit einem
niedlichen Rokoko-Häuschen.Es ist selbstverständlich,dass Haydn
über die meist sehr alberne,schäferhafte und idyllische Lieblichkeit
des Textes eine Fülle herrlicher und wohlgeformter Melodieen von sei-
nem Geiste ausgiesst.Dennoch erreicht er Höhepunkte nur dort,wo er
gotisch,also polyphon wird,besonders in den beiden Doppelfugen
"Alles lobe seinen Namen.." und "Des Herren Ruhm",in der Schlussfuge.
　　　　　Die Chöre waren denn auch das Beste und die reinste
Freude unserer Theresienstädter Aufführung,ein Verdienst Karl
Fischers,der als vorzüglicher Chormeister seinen jugendfrischen und
singbegeisterten Chor fest in der Hand hat.Auch die Solisten gaben
ihr Bestes,voran Frau Kohn-Schliesskov,der man die bewährte Oratorien-
sängerin anmerkt und deren feine Koloraturstimme in der Arie "Auf star-
kem Fittig" schön zur Geltung kam.Herr Goaring debütierte als Orato-
riensänger und hat sich erstaunlich schnell in den Stil hineinge-
funden;sein schmiegsamer Tenor bietet ihm hierfür auch alle Vorteile
und die Arie "Mit Würd' und Hoheit angetan.."gelang vorzüglich.Herr
K.Freund braucht für sein schönes Material noch einen Stimmbildner,
zeigte sich aber im Ganzen seiner schweren Aufgabe gewachsen.Frau
Gärtner-Geiringer lässt uns die fehlende Orchesterbegleitung nicht
vermissen.
　　　　　Zuletzt sei eine Textrevision angeregt,die allzu peinliche
Stellen einer Bearbeitung unterzieht.(Es sollte einen "Bibel-Schutz"
geben!)Einige Proben:"Er machte die Sterne gleichfalls..""und die
Engel rührten ihre unsterblichen Harfen..""In holder Anmuth stehen
die wogigten Hügel da.."Überhaupt steht alles gleich fix und fertig
da,der Löwe "vor Freude brüllend",die Rinder sind gleich "in
Herden abgeteilt"und an den Busen des eben erst geschaffenen Adam
schmiegt sich sogleich,ohne unnötigen Aufenthalt mit Adams Schlaf
und der Rippe,die "Gattin hold und anmuthsvoll" und siehe,es war
eine Dame in Krinoline und Puderperrücke...
　　　　　Eritis sicut deus ex machina........

190.　Viktor Ullmann's original manuscript of Critique 19. 1 page. NIOD.

Annotations

1 **Franz Joseph Haydn** (1732–1809). After attending a Händel Festival at Westminster Abbey in 1791, where he heard several Händel oratorios, including *The Messiah, Israel in Egypt,* and *Judas Maccabaeus,* Haydn received a copy of a libretto titled *The Creation of the World.* The text was taken from the King James version of Genesis, Milton's *Paradise Lost,* and The Book of Psalms, and was originally intended for Händel Translated to German by Baron Gottfried van Swieten, it would become the text for the first of two Haydn oratorios: *The Creation* (1798) and *The Seasons* (1801) [Critiques 10, 19].

2 **Jean-Antoine Watteau** (1684–1721) and **Jean-Honoré Fragonard** (1732–1806). French painters. Watteau and Fragonard were masters of the French Rococo, a popular style favored by the eighteenth-century French aristocracy and the King Louis XIV court. Their highly detailed, decorative paintings are characterized by frivolous scenes of the upper class enjoying a lifestyle of gaiety and privilege; Ullmann is noting their superficiality in contrast to the sublime artistry of Michelangelo's Sistine Ceiling [Critique 19].

3 *"Alles lobe seinen Namen"* ("Let us all praise his name") appears in the choral part of Part II, No. 28, declaring the completion of God's creations upon the conclusion of the sixth day.

4 *"Des Herren Ruhm"* from Part III, No. 34, Day 7 of *The Creation.* *"Singt dem Herren alle Stimmen!"* ("Sing the Lord, ye voices all!"). *The Creation* concludes in a double fugue with the words *"Des Herren Ruhm, er bleibt in Ewigkeit. Amen"* ("The praise of the Lord will endure forever. Amen.") [Critiques 19].

5 **Karl Fischer** [Critiques 10, 19, 26].

6 **Mrs. Lotte Kohn-Schlesskov** [Critiques 10, 19].

7 The *coloratura* **voice** generally sings rapid, ornate passages filled with embellishing runs and trills, and demands great suppleness and agility. Major *coloratura* roles include Queen of the Night in Mozart's *The Magic Flute* and Sofie in Richard Strauss' *Der Rosenkavalier.*

8 *"Auf starkem Fittig"* is from Gabriel's soprano aria from Part II, No. 15, Day 5 of *The Creation.* *"Auf starkem Fittige schwinget sich der Adler stolz"* ("On mighty wings uplifted soars the proud eagle aloft"), celebrating God's creation of birds.

9 **Jakob Goldring** [Critiques 8, 19].

10 *"Mit Würd' und Hoheit angetan"* ("Clad in dignity and grandeur") is the beginning of Uriel's tenor aria (Part II, No. 24, Day 6 of *The Creation*) following his recitative declaring the creation of man in the image of God.

11 **Renée Gärtner-Geiringer** [Critiques 2, 19, 22].

12 **"He also made the stars…"** is at the conclusion of Uriel's (tenor) recitative in Part I, No. 12. Day 4 of *The Creation, "Er machte die sterne gleichfalls."*

13 **"And the angels touched their heavenly harps…"** from Raphael, the bass recitative in Part II, No. 17, Day 5 of *The Creation, "Und die Engel rührten ihr' unsterblichen Harfen…"*

14 **"In fair grace the swaying hills lay yonder…"** is sung by Gabriel in the beginning of the trio for Gabriel, Uriel, and Raphael with Chorus. Part II, No. 18, Day 5 of *The Creation, "In holder Anmut stehn, mit jungem Grün geschmückt, die wogigten Hügel da…"*

15 *"Eritis sicut deus ex macina"* ("You shall be as God from a machine"): The *deus ex machina* is a dramatic character, event, or force that miraculously saves the day. Ullmann playfully uses the term in his call for "Bible—protection" in the libretto of Haydn's oratorio.

191. Dedication sheet. *Prof. Bernard Kaff.* Possibly Heinrich Bähr. HCPT #4290. *This collection marker commissioned by Heřman is signed and dated July 13, 1944 by pianist Bernard Kaff, with the dedication, "To the genial and—with lots of respect!—appreciator of art Mr. Karl Herrmann with sincere affection! Bernard Kaff. 7.13.44."*

Critique 20
BERNARD KAFF[1] PLAYS BEETHOVEN

If music is really "a higher wisdom than all of philosophy and religion," as Beethoven once said, then his music must pass that test whenever it is interpreted in the spirit of its creator. Here, two great antipodes meet, since Goethe, too, sees art as "the revelation of the secret laws of nature, which would have remained forever concealed if not for art." Music is a wordless art; its secrets are deciphered by the pulsating blood, the feeling, beating heart and not the reasoning mind. And yet one senses in the later styles of great masters of music—Bach,[2] Bruckner, Mahler—a demand for interpretation. In many late works the spirit breaks through the boundaries of form, just as the escaping entelechy breaks the physical, and through the gaps and cracks in the musical substance the masters' lofty biographical spirit emerges, towering above their works—"The works are transitory," says Gustav Mahler, " ... what stays is the human."

And yet there was never purer music than this last sonata of Beethoven (op. 111), which Kaff places at the middle of his program. This already becomes clear in the first movement, whose main theme—not coincidentally—adopts the traits of Schubert's "wretched Atlas,"[3] who must carry the burden of the entire world and grow into the greatness of the task imposed upon him, and who then in the immortal *Arietta angelica*, which Kaff plays with incomparable spirituality, surpassing himself ... "I dissolve in tones, circling, weaving, filled with bottomless gratitude and unnamed praise, surrendering myself to the great breath ... " (Stefan George). That could be the motto of this movement, and therefore Kaff plays "only a droning echo of the holy voice."[4]

Preceding this is a sonata that is also unpopular, although it is tenderly playful, cheerfully austere: Sonata in F# Major op. 78. This charming, compact, bright work stands in effective contrast to the last sonata which also consists of two movements. While the former is practically without a finale, the latter is without an adagio. The unconventionality of this slim piece, comparable to a letter to the "immortal beloved,"[5] was shown by the reaction of the audience, which did not even notice when Kaff had come to the end; and since he simply remained seated, nobody stirred ... (Afterwards someone asked me: "Why did Kaff leave out one sonata ... ?") It was Beethoven's and Kaff's most beautiful success...

The evening closed with the Rembrandtian/dark[6] of the "*Apassionata*"[7] and its stormy, dark passion—"poor Beethoven, for you there is no luck ... " Actually, I would have preferred the chronological order, not because I'm pedantic, but because the "*Arietta angelica*"—as I call it—is in itself already an epilogue which can hardly tolerate another one. Kaff now stands at the height of his mature artistry. And one has the instinctive feeling that he could still develop himself further, and that is the most beautiful thing: he remains to be one who learns in spite of his mastery ...

"But he has learned—he will teach us ... "[8] [images 191–195].

Bernard Kaff spielt Beethoven

Ist Musik wirklich "höhere Weisheit als alle Philosophie und Religion", wie Beethoven einmal sagte, so müsste die seine die Probe bestehen, wenn sie im Geiste ihres Schöpfers interpretiert wird. Hier begegnen die beiden grossen Antipoden einander, denn auch Goethe sieht in der Kunst "die Offenbarung geheimer Naturgesetze, die ohne sie ewig verborgen geblieben wären." Musik ist eine begrifflose Kunst, ihr Geheimnis enträtselt sich dem pulsierenden Blute, dem fühlenden, pochenden Herzen, nicht dem sinnenden Haupte. Dennoch fühlt man im Spätstil grosser Meister der Musik – Bachs, Bruckners und Mahlers – die Forderung nach begrifflicher Deutung. In vielen Spätwerken sprengt der Geist die Form, wie die entweichende Entelechie die leibliche, und aus den Fugen und Rissen des Musikalischen strömt die erhabene biographische Geistgestalt der Meister, ihr Werk überragend... "Die Werke sind das Vergängliche" sagt Gustav Mahler, "der Mensch ist das Dauernde." Und doch gab es nie reinere Musik als in dieser letzten Sonate Beethovens /op. 111/, die Kaff in das Zentrum seines Programmes stellt, schon am I. Satze, der nicht zufällig im Hauptthema die Züge des Schubertschen "unglückseligen Atlas" annimmt, der die Last der ganzen Welt tragen muss, zur Grösse der gestellten Aufgabe heranwachsend, dann in der unsterblichen Arietta angelica, die er unvergleichlich durchgeistigt spielt, sich selbst übertreffend.. "Ich löse mich in Tönen, kreisend, webend, ungründigen Danks und unbenamten Lobes, dem grossen Atem wunschlos mich ergebend.." /George/. So könnte wohl das Motto dieses Satzes sein und so spielt Kaff "ein Dröhnen nur der heiligen Stimme."

Voran geht eine ebenfalls unpopuläre, wiewohl doch zärtlich verspielte, heiter-entsagende Sonate: die Fis-dur op.78. Das anmutige, knappe, helle Werk steht in glücklich gewähltem Kontrast zu der ebenfalls zweisätzigen letzten Sonate. Ist diese sozusagen ohne Finale, so ist jene ohne Adagio. Wie sehr unkonventionell dieses schlanke, einem Brief an die "Unsterbliche Geliebte" vergleichbare Stück ist, hat der reizvolle Zufall erwiesen, indem die Hörerschaft garnicht merkte, dass Kaff mit der Sonate zum Schlusse gekommen war und da er sitzen blieb, regte sich keine Hand... /Nachher fragte mich jemand: "Warum hat Kaff eine Sonate ausgelassen.."?/ Es war Beethovens und Kaffs schönster Erfolg....

Mit dem Rembrandt'schen Helldunkel der Apassionata und ihrer stürmischen, finsteren Leidenschaft – "armer Beethoven, für dich gibt es kein Glück.." – wird der Abend geschlossen. Eigentlich hätte ich die chronologische Reihenfolge vorgezogen, nicht aus Pedanterie, sondern weil die Arietta angelica – wie ich sie nenne – selbst schon ein Epilog ist und eigentlich keinen weiteren verträgt. Kaff steht jetzt auf der Höhe seiner reifen Künstlerschaft. Dabei hat man das instiktive Gefühl, dass er sich noch immer weiter entwickelt; und dies ist das Schönste: dass er bei aller Meisterschaft ein Lernender bleibt.." Doch dieser hat gelernt, er wird uns lehren..".

 Viktor Ullmann.

192. Viktor Ullmann's original manuscript of Critique 20. 1 page. NIOD.

Annotations

1 **Bernard Kaff** [Critiques 8, 20].

2 **Johann Sebastian Bach** [Critiques 5, 7, 10, 14, 18, 20, 22].

3 **Schubert's "Wretched Atlas."** *Lieder "Der Atlas,"* D. 957 no. 8 (1828), from *Schwanengesang,* op. posth. Text by Heinrich Heine [Critiques 1, 4, 8, 14, 15, 20, 23].

4 **Stefan George** (1868–1933). German symbolist poet. These excerpts are from George's poem "Rapture," from his collection *The Seventh Ring* (1907), which appears in the fourth and final movement of Schönberg's String Quartet no. 2 for soprano and String Quartet in F-sharp Minor op. 10 (1908). Schönberg's use of *The Seventh Ring* marks a critical point in the transition from tonal composition to Schönberg's dodecaphonal system, also referred to as twelve-tone serialism or the Second Viennese school of music. This must have been important to Ullmann, considering his studies and continued contact throughout the 1920s and 1930s with Schönberg and his disciples Josef Polnauer, Heinrich Jalowetz, Alexander Zemlinksy, and Alban Berg [Critique 20].

5 The **"immortal beloved"** (German *"Unsterbliche Geliebte"*) is the famous yet unknown addressee of a love letter from Beethoven.

6 **Rembrandtian light/dark** refers to the Dutch painter Rembrandt van Rijn's (1606–1669) mastery of *chiaroscuro,* dramatically contrasting light (*chiaro*) and dark (*oscuro*) to imbue his portraits with drama and psychological depth.

7 **"Appassionata."** Piano Sonata in F Minor op. 57 (1804).

8 **"But this one [Faust] has learned—he will teach us…"** quote from Goethe's *Faust,* Part II (lines 12082–3).

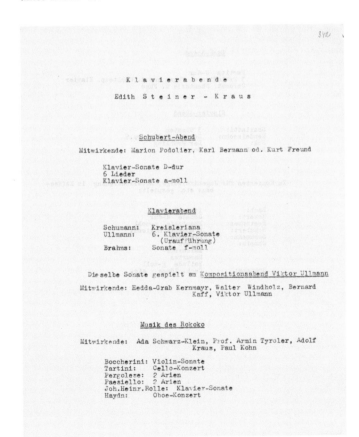

193. Program list of artists and repertoire performed by Edith Steiner-Kraus in Terezín. HCPT #3939.

194. Drawing. Portrait of Bernard Kaff. František Petr Kien. ZM #174.296

337

KONZERTE Prof. Bernhard KAFF.

I.

J. Brahms : Variationen auf ein Thema von Händel
L.v. Beethoven : Sonate Op. 109
Paul Haas : Suite
F. Chopin : Nocturno Des Dur
" " : Polonaise As Dur

II.

L. v. Beethoven : 32 Variationen C Moll
" : Eroica Variationen
" : Waldstein Sonate

III.

F. Chopin : Sonate H Moll
F. Liszt : Sonate H Moll
" : Mephisto Walzer

IV.

L. v. Beethoven : Sonate Op. 78
" : Sonate Op. 111
" : Sonate Op. 57

KONZERT FRÖHLICH - KAFF

L.v. Beethoven : Kreutzer Sonate
Cäsar Franck : Sonate A Dur

195. Program list. HCPT #3937. *This typewritten sheet documents the repertoire of four programs by Bernard Kaff. Three are solo piano recitals and one with the violinist Karl Fröhlich.*

196. Poster. *Klavier-Trio*. HCPT #4289. *Poster for a concert performance of the Gideon Klein, Paul Kling, Friedrich Mark piano trio.*

Critique 21

GIDEON KLEIN, PAUL KLING, FRIEDRICH MARK PIANO TRIO

It has been, thus far, the peculiar fate of our chamber music groups to be like meteors: they flash by promisingly and then disappear. In each new instance, there is nothing left to do but hope that this time it might be different. And this time it would be particularly disappointing if it remains merely a promise, and if that promise is not kept.

Even in its selection of pieces, the new trio introduced itself in the best possible way. Beethoven's op. 70 no. 2 is one of those seldom played and therefore especially beautiful and rich works. One notices that Beethoven is once again haunted by Mozart's[1] shadow—usually, as a result, something as wonderful as the *Andante*, this trio's second movement, comes out of it. The *Scherzo* is often reminiscent of Schubert and the Finale is a virtuoso, concerto-like, lively piece of music.

Brahms[2] was represented by a work (B-Major Trio op. 8), that was also interesting in multiple ways. Even if one didn't know that two movements, the I and III, were subjected to later revision, one would certainly notice that the *Scherzo* and the Finale bear the traits of a young Brahms, and of those early works that both he and Robert Schumann deemed worthy. The revised movements, despite all their beauty, lack the freshness and fullness of the first versions; indeed, the development in the first movement seems almost academic compared to the exposition, in which that gentle effusion, so characteristic of the themes of Brahms's youth, resounds.

The performance is remarkable due to the superb rehearsing Gideon Klein devoted to it; he masters even the difficult piano passages with energy and reliable stylistic insight. Paul Kling[3] had a very successful debut on the violin—he is on the right path and talented. Friedrich Mark[4] has often proved himself to be a superb musician. Occasionally, the two strings could have exercised a firmer, more decisive approach—here, as so often in our chamber music performances, a certain indulgent pampering of the Classical-Romantic style is noticeable in the strings, which stands out all the more in this case because of Gideon Klein's fresh, assertive playing. Apparently, our promising young musicians don't have quite the right conception of how to play the music of the old—of the "good old"—times, which they imagine as too idyllic and conventional and like the Biedermeier period[5] ... We are familiar with the phenomenon that Nietzsche, in reference to the ancient Attican style, portrayed so masterfully in *The Birth of Tragedy*: the phenomenon of the weakening and misinterpreting of older stylistic elements of art. By fearfully shrinking back from the supposed harshness of contemporary music on the one hand, and on the other hand attempting to get used to it, one is no longer able to sense the harshness in the music of the old masters ... and yet: there are seven-note chords in Brahms, and in his Symphony IV that made Hanslick despair, "as if two persons were beating each other up ... "[6] [images 196–199].

Klavier-Trio Gideon Klein, Paul Klink, Friedrich Mark

 Das merkwürdige Schicksal unserer Kammermusik-Vereini-
gungen war bisher ein meteorartiges;sie blitzten vielversprechend
auf und verschwanden.In jedem neuen Falle bleibt nichts übrig als
zu hoffen,diesmal werde es anders sein.Und es wäre auch diesmal ganz
besonders schade,wenn es bei diesem Versprechen bliebe und es nicht
gehalten würde.

 Das neue Trio führte sich schon durch die Wahl der Werke
aufs Beste ein.Beethovens op.70 Nr.2 gehört zu den selten gespielten
und somit besonders schönen und reichen Werken.Man merkt,dass Beetho-
ven wieder einmal von Mozarts Schatten bedrängt wird-und dann kommt
gewöhnlich etwas so Wunderbares heraus wie der zweite Satz,das Andante
dieses Trios.Das Scherzo lässt mannigfache Schubert-Anklänge hören
und das Finale ist ein virtuos-konzertantes,schwungvolles Stück.

 Brahms/ H-dur-Trio op.8/ war durch ein ebenfalls mehrfach
interessantes Werk vertreten.Wenn man auch nicht wüsste,dass zwei

Sätze,der I.und III.,einer späteren Bearbeitung unterworfen wurden,
müsste man merken,dass Scherzo und Finale die Physiognomie des
Jünglings Brahms tragen,jener Erstlinge,die von ihm selbst und
Robert Schumann würdig befunden wurden.Die bearbeiteteten Sätze haben
bei aller Schönheit nicht mehr die Frische und Fülle des ersten
Wurfs,ja die Durchführung des ersten Satzes will fast akademisch
wirken gegenüber der Exposition,die jene sanfte Schwärmerei aufklingen
lässt,die Brahmssche Themen aus der Jugendzeit haben.

 Die Aufführung ist bemerkenswert durch die vorzügliche
Einstudierung,die Gideon Klein ihr zuteil werden liess,der selbst
die schwierigen Klavierparte mit Elan und verlässlichem Stilgefühl
meisturt.Paul Klink debütiert an der Violine mit viel Erfolg,er
ist auf dem besten Wege und sehr begabt,Friedrich Mark hat sich
als vortrefflicher Kammermusikspieler schon oft bewährt.Gelegentlich

Klavier-Trio Oliven Klein,Paul Klein,herrlich Werk

~~wäre den beiden Streichinstrumenten ein kräftigeres,unverzagtes~~

Zupacken zu wünschen,hier wie so oft in den Darbietungen unserer

Kammermusik fällt eine gewisse Verzärtelung des klassisch-romantischen

Stils bei den Streichern auf,die in diesem Falle von Gideon Kleins
abtötet
frisch zugreifendem Spiel umsomehr auffällt.Offenbar haben unsere

jungen Musiker,die so Schönes versprechen,nicht ganz richtige Begriffe

vom Musizieren der alten,der guten-alten Zeit,die sie sich zu idyllisch

und bieder und biedermeierisch vorstellen...wir kennen das Phänomen,

das in Bezug auf den antik-attischen Stil Nietzsche in der "Geburt der

Tragödie." meisterhaft dargestellt hat,das Phänomen der Verweichlichung

und des Missverständnisses älterer Stilelemente der Kunst;denn indem

man vor den vermeintlichen Härten der zeitgenössischen Musik teils

ängstlich zurückweicht,teils sich an sie zu gewöhnen versucht,empfindet

man die Härten bei den älteren Meistern nicht mehr..und doch gibt es

Siebenklänge bei Brahms und seine IV.Symphonie brachte Hanslick zur

Verzweiflung:"als wenn zwei sich prügeln würden.."gestand der Kritiker.

<div align="center">

Viktor Ullmann

</div>

197. Viktor Ullmann's original manuscript of Critique 21. 2 pages. NIOD.

Annotations

1 **Wolfgang Amadeus Mozart** [Critiques 4, 9, 10, 14, 16, 17, 21, 22, 25].

2 **Johannes Brahms** [Critiques 1, 5–9, 21].

3 **Pavel (Paul) Kling** [Critiques 4, 8, 21].

4 **Friedrich Mark** [Critiques 4, 8, 21].

5 Ullmann refers to early twentieth-century characterizations of conservatism and conventionalism associated with the arts during the **Biedermeier period.** It was a period in Central Europe spanning the 1815 Congress of Vienna to the German revolutions of 1848–49 referenced by Ullmann in Critique 17 (see annotation 5).

6 The quote refers to Brahms and his assistant Ignatz Brüll playing a piano-four-hands arrangement of his recently completed Fourth Symphony. Eduard Hanslick, Max Kalbeck, and the conductor Hans Richter—who premiered Brahms's Third Symphony in 1883—were among those in attendance for the impromptu premiere. A similar reading for the Third Symphony was given for much the same circle. In contrast to the enthusiastic response for the Third Symphony, an uneasy silence followed the conclusion of first movement of the Fourth, only to be broken by Brahms barking: "Well, let's go on." Hanslick responded: "I feel like I've been beaten by two terribly intelligent people." (Jan Swafford. *Johannes Brahms: A Biography*. New York: Alfred A. Knopf, 1996, 514) [Critiques 10, 21].

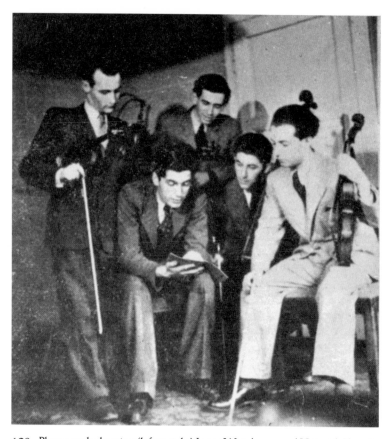

198. Photograph showing (left to right) Lenja Weinbaum and Heinrich Taussig (standing), Gideon Klein (center), Friedrich Mark, and Karl (Karel) Frölich (seated). Prague 1941. HCPT #A1984.

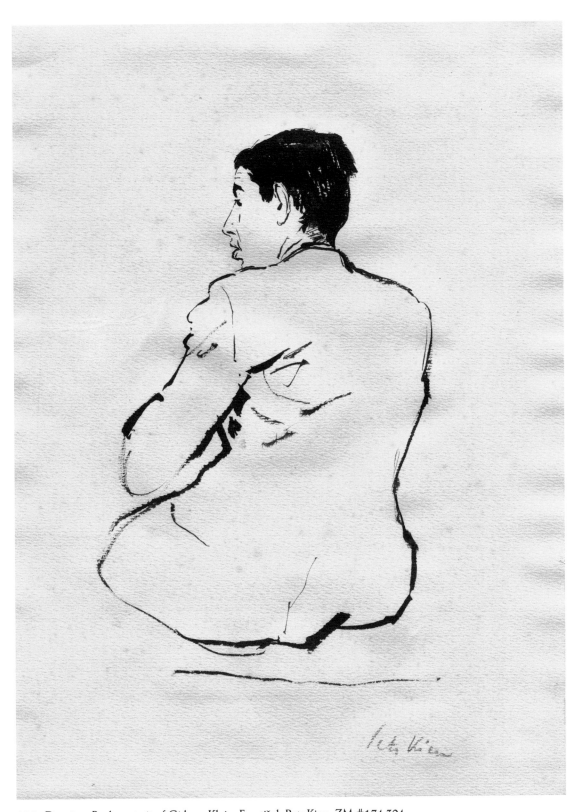

199. Drawing. Back portrait of Gideon Klein. František Petr Kien. ZM #174.304.

334

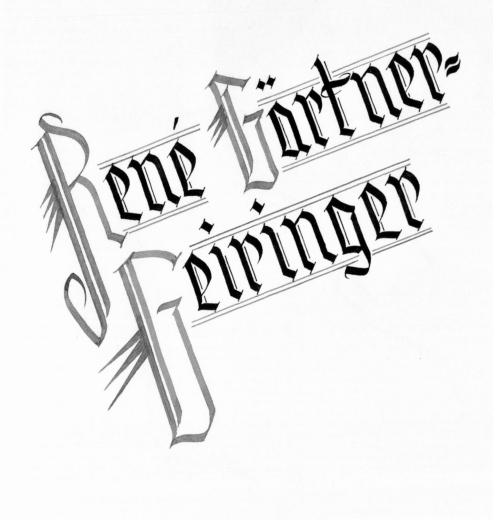

200. Dedication sheet. *René[e] Gärtner-Geiringer*. Possibly Heinrich Bähr. HCPT #4199.
Karel Heřman requested this sheet of pianist Renée Gärtner-Geiringer for his collection.

Critique 22
RENÉE GÄRTNER-GEIRINGER PIANO EVENING

The musician who has to report almost every week about a pianistic personality is faced with an all-too-difficult and responsible task. For if the artist's technique reaches a certain level, then the question of his calling can no longer be discussed. From then on, the only question to be posed is how wide the range of those traits that constitute the essence of the performer can be stretched—be the artist an actor, conductor, or pianist.

Mrs. Gärtner-Geiringer,[1] a versatile and exceptional musician, has the virtuoso technique of the genuine Viennese school. However, in regard to her personality, to the specifics of her talent, to her musical predestination, so to speak, she did not choose a very successful program this time. She is—if one can say this without being misunderstood—a harpsichordist. On that instrument her personal technique would be displayed to its best advantage. Therefore, her performance of Bach's[2] *Italian Concerto*[3] was played masterfully. I recommend using less pedal[4] for the second movement and a more moderate speed in the presto.

For the resigned melancholy of Beethoven, for his heroic intensity, his Hoffmannesque fantasies,[5] his wild passion, her playing is too objective, too cool and smooth—all of which are advantages for everything pre-Classical, for Rococo, and for the modern "objective" style. But one has to be able to bang up against Beethoven, he must hurt, as he hurt his contemporaries. "Now the fellow is ready for a mental institution," Carl Maria von Weber[6] exclaims after having listened to the Seventh Symphony for the first time. And my fellow critic from the Viennese *Freimütigen*[7] of 1806 writes about the *III. Leonore Overture*: "The most horrible, piercing modulations follow each other in a truly horrifying harmony and a few petty, insignificant ideas, which evade even the smallest glimmer of sublimity, and round out the unpleasant deafening impression … " This was Beethoven to the majority of his contemporaries. Today we play and listen to him too often. The day will come when Beethoven's music will be merely a template, a phrase. My warning comes in time. One should spare Beethoven!

Naturally, this can be applied only in general. Back to our artist. We heard the excellently performed and rarely played Prelude, Choral and Fugue by César Franck,[8] one of those peculiarly un-French composers from France who deny the famous "*esprit*" and are righteously boring—one could also say boringly righteous. Certainly, he is one of the forerunners of French impressionism. But this fugue's theme had already been borrowed from Bach by Mozart,[9] in the passage of *The Magic Flute*, where he paraphrases the somber, magnificent old chorale of the two knights …

Mrs. Gärtner-Geiringer's next program will hopefully be a harpsichord program; then we will be able to hear her at the height of her ability—a commanding and admirable ability—and simultaneously within her own and highly personal sphere [images 200–203].

Klaviersabend Renée Gärtner-Geiringer

Der Musiker,der nahezu jede Woche über eine Pianisten-
Persönlichkeit zu berichten hat,steht vor einer allzu schwierigen
und verantwortungsvollen Aufgabe.Denn wenn die Technik eines Künst-
lers eine gewisse Höhe erreicht hat,kann nicht mehr über seine
Berufung diskutiert werden.Es kann fortan nur mehr die Frage gestellt
werden,wie weit der Umkreis jener Identifikationen gespannt werden
kann,die das Wesen des reproduzierenden Künstlers ausmachen,er sei
nun Schauspieler,Dirigent oder Pianist.

Frau Gärtner-Geiringer,diese vielseitige und ausgezeichnete
Musikerin,verfügt über eine virtuose Technik der echten Wiener
Schule.Jedoch für ihre Persönlichkeit,für das Spezifische ihrer
Begabung,für ihre musikalische Prädfstination sozusagen hat sie
diesmal kein besonders glückliches Programm gewählt.Sie ist —wenn
mann so sagen darf,ohne missverstanden zu werden - eine Cembalistin.
Auf diesem Instrument müsste ihre persönliche Technik zu ganz beson-
derer Geltung kommen.So hat sie denn auch Bachs "Italienisches
Konzert"meisterlich gespielt.Im zweiten Satze empfehle ich mehr
Pedal-Losigkeit,im Presto Mässigung des rasanten Zeitmasses.

Für Beethovens resignierte Melancholie,für seine heroischen
Härten,seine hoffmanneske Phantastik,seine wilde Leidenschaft ist
ihr Spiel zu objektiv,zu kühl und zu glatt-ebensoviele Vorteile
für alles Vorklassische,für Rokoko und modernen Stil.Aber an
Beethoven muss man sich stossen können,er muss wehtun,wie er seinen
Zeitgenossen schmerzlich war."Jetzt ist der Kerl reif fürs Irren-
haus!"ruft C.M.Weber beim ersten Hören der VII.Und mein Kollege
beim Wiener Freimütigen von 1806 schreibt wörtlich über die III.
Leonoren-Ouverture:"Die grässlichsten,schneidendsten Modulationen
folgen aufeinander in wirklich schauerlicher Harmonie und ein paar

kleinliche,unbedeutende Einfälle,die auch jeden Schein von Erhaben-
heit vermeiden,vollenden den unangenehmen,betäubenden Eindruck.."
Das war Beethoven für die Mehrheit seiner Zeitgenossen.Jetzt
spielen und hören wir ihn zu oft.Es kommt der Tag,wo Beethovens
Musik für uns nur mehr Schablone,nur mehr Phrase bedeuten wird.
Ich warne beizeiten.Man schone Beethoven!

　　　　Dies gilt natürlich nur ganz allgemein.Zurück zu unserer
Künstlerin.Von seltener gespielten Werken hörten wir in vorbild-
licher Wiedergabe "Präludium,Choral und Fuge" von Cäsar Frankh,
einem jener merkwürdig unfranzösischen Komponisten Frankreichs,die
den berühmten "esprit" verleugnen und rechtschaffen langweilig
sind-man könnte auch sagen langweilig rechtschaffen.Gewiss ist
er einer der Wegbereiter des französischen Impressionismus.Aber
das Thema dieser Fuge hat schon Mozart von Bach entlehnt,dort,wo
er in der "Zauberflöte" den düster-prachtvollen alten Choral
der beiden Geharnischten umspielt..

　　　　Das nächste Programm von Frau Gärtner-Geiringer wird
hoffentlich ein "Cembalo"-Programm sein;dann werden wir sie
auf der Höhe ihres Könnens-eines souveränen und bewunderungswürdige
Könnens - und zugleich innerhalb ihrer eigenen und auf ihre Art
höchst persönlichen Sphäre ▓▓▓▓▓▓▓▓▓
HÖREN.

Viktor Ullmann

201. Viktor Ullmann's original manuscript of Critique 22. 2 pages. NIOD.

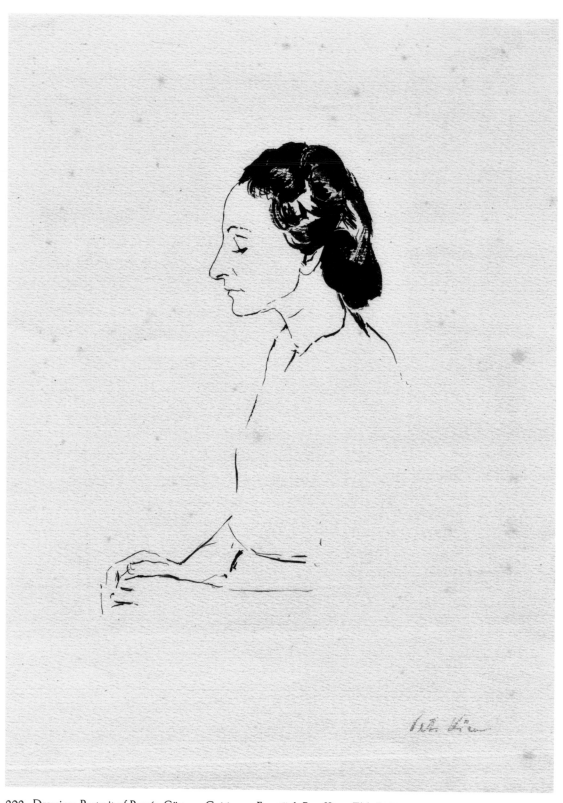

202. Drawing. Portrait of Renée Gärtner-Geiringer. František Petr Kien. ZM #174.300

Annotations

1 **Renée Gärtner-Geiringer** [Critiques 2, 19, 22].

2 **Johann Sebastian Bach** [Critiques 5, 7, 10, 14, 18, 20, 22].

3 **Bach's** *Italian Concerto* in F Major for harpsichord, BWV 971, is in the style of concertos by Vivaldi and the Italian Baroque school [Critiques 5, 7, 10, 14, 18, 20, 22].

4 Most likely Gärtner-Geiringer performed on a piano that had two or three pedals used to sustain, dampen, and color musical passages.

5 **Hoffmannesque fantasies.** Ullmann refers to the tales of the German Romantic writer and composer Ernst Theodor Amadeus Hoffmann (1776–1822). Hoffmann was famous for his fantasies, especially his story *The Nutcracker and the Mouse King*, which inspired the ballet by Tchaikovsky [Critique 22].

6 **Carl Maria von Weber** (1786–1826). Composer, conductor, and pianist, who wrote some of the first important Romantic German operas, *Der Freischütz, Euryanthe,* and *Oberon* [Critique 22].

7 *Freimütigen.* The Viennese journal *Freimütigen,* named for the *Freimütigen oder Berlinischen Zeitung für Gebildete (The Outspoken [or Candid] One, or the Berlin Paper for Educated, Objective Readers).*

8 **César Franck** (1822–1890). French composer and organist [Critique 22].

9 **Wolfgang Amadeus Mozart** [Critiques 4, 9, 10, 14, 16, 17, 21, 22, 25].

203. Program list of four solo piano recitals by Renée Gärtner-Geiringer. HCPT #3936.
The sheets include the number of performances given for each program.

KONZERT
FRITZ KÖNIGSGARTEN, TENOR
KAPELLMEISTER FRANZ E. KLEIN - KLAVIER

PROGRAMM:

SCHUBERT: JHR BILD, AN DIE MUSIK,
AM MEER, DER DOPPELGÄNGER,
DER LEIERMANN, STÄNDCHEN, DIE FORELLE.

KONZERTBEARBEITUNG VON F. E. KLEIN

MENDELSSOHN BARTHOLDY:

MORGENGRUSS, WENN SICH ZWEI HERZEN SCHEIDEN,
DER MOND, LIEBLINGSPLÄTZCHEN, WINTERLIED,
VENETIANISCHES GONDELLIED.

KLEIN: WASSERSPIELE
4 TONBILDER:

MEERGOTT U. NYMPHE, RINGELSPIELE IM WASSER,
HANDWERKER A.D. ARBEIT, DIE BLAUE GROTTE, (KLAVIER)

AUSPITZER: SCHWANENLIED, WARUM?, WAS DU MIR BIST.
(Erstaufführung)

204. Poster. *Konzert Fritz Königsgarten, Tenor.* HCPT #3955. *Poster for a concert of lieder with tenor Fritz Königsgarten accompanied by conductor Franz Eugen Klein.*

Critique 23
FRITZ KÖNIGSGARTEN *LIEDER* EVENING

It is strange: Fritz Königsgarten[1] has not yet discovered his voice. It is like gold ore in a mine shaft: Once he forgets his carefully studied *mezza voce* and allows a natural tone to resound—an uncontrolled, high tone such as in Schubert's "Doppelgänger" and its climax—then, to the astonishment of his listeners, Fritz Königsgarten's true voice emerges with violent pain. It is one of those rare, metallic voices of the Italian hero. After a couple of years of studying *bel canto* in Italy he would be heard singing Radames and Othello.[2]

Today, he presents only one half of his voice. He labors with Schubert's *lieder*, Mendelssohn's beautiful and simple melodies, some are more successful, some less, but one senses: this is not the right place for Königsgarten as singer. His *mezza voce* is shaded, muffled and after one has heard some of those glorious coincidental tones and discovered his true voice and its character, one has the feeling: why doesn't he just sing out freely, why doesn't he just use his voice, which is there, and always appears whenever he forgets to control himself? Why does he ascetically suppress this voice, which is unschooled, yet still a healthy natural gift, and why does he trouble himself with singing little *lieder* when it is clear that he is an aria singer, indeed a light, dramatic tenor? One parts with the wish: the singer should find himself and his truly beautiful voice.

The mention of Franz Eugen Klein[3] as discreet accompanist should not be omitted. [images 204–206, 220–221].

Annotations

1 **Bedřich (Fritz) Königsgarten** (1898–1944, Auschwitz) (**No. 496 on Transport G** from Brno on December 2, 1941) (**No. 1398 on Transport Es** to Auschwitz on October 19, 1944). Tenor. Königsgarten performed solo recitals in Terezín [Critique 23].

2 **Radames and Othello** are the lead tenor roles in Verdi's operas *Aida* and *Othello*.

3 **Franz Eugen Klein** (1912–1944, Auschwitz) (**No. 76 on Transport IV/13** from Vienna on October 10, 1942) (**No. 944 on Transport Er** to Auschwitz on October 16, 1944). Composer and conductor. Before his incarceration, he was a *Kappelmeister* of the Vienna State Opera and in 1938 conductor of Orchester des Wiener Jüdischen Kulturbundes (Vienna Jewish Cultural Association). In Terezín, Klein directed Bizet's *Carmen*, Puccini's *Tosca*, and Verdi's *Rigoletto*; he and Edith Steiner-Kraus performed the orchestral accompaniment on piano for *Carmen*. Klein composed the opera *The Glass Mountain* in Terezín, and he also lectured on music [Critiques 23, 26].

Liederabend Fritz Königsgarten

Es ist merkwürdig,dass Fritz Königsgarten seine Stimme noch nicht entdeckt hat.Sie ist wie Golderz in einem Schacht;wenn er an das einstudierte mezza voce vergisst und einen Naturton klingen lässt,einen unkontrollierten,hohen Ton,wie etwa in Schuberts "Doppelgänger" und dessen Höhepunkt,so dringt mit "Schmerzensgewalt" zur Ueberraschung des Hörers die wahre Stimme Fritz Königsgartens durch-es ist eine jener seltenen metallischen Stimmen des italienisch Helden.Einige Jahre Belcanto-Studium in Italien und er singt Radames und Othello.

Heute bietet er nur seine "halbe "Stimme.Er müht sich um Schuber Lieder,um Mendelssohns schöne,einfache Weisen,es gelingt eines mehr, eines weniger,aber man fühlt;dies ist nicht der Platz des Sängers Königsgarten.Sein mezza voce ist beschattet,ist belegt und man hat wenn man einige jener prächtigen Zufallstöne gehört und die wahre Stimme und ihren Charakter entdeckt hat,immer das Gefühl;warum singt er nicht drauf los,warum macht er keinen Gebrauch von seiner Stimme, die doch da ist,die immer dann kommt,wenn er vergisst,sich zu kontrol- ieren?Warum unterdrückt er asketisch,was doch,wo nicht geschult,doch gesunde Naturgabe ist und warum müht er sich,Liederchen zu singen,da er doch ganz gewiss ein Ariensänger ist,ja ein leicht-dramatischer Tenor?Und man scheidet mit dem Wunsche;dass der Sänger zu sich selber und seiner in Wahrheit schönen Stimme komme.
 Franz Eugen Klein darf als diskreter Begleiter nicht vergessen werden.

Viktor Ullmann

205. Viktor Ullmann's original manuscript of Critique 23. 1 page. NIOD.

256

206. Drawing. Ferdinand Bloch. ZM #176.334. *The piano rests on sawhorses.*

207. Dedication sheet. *Steiner-Kraus.* Possibly Heinrich Bähr. HCPT #4201. *Commemorating an Edith Steiner-Kraus concert. Steiner-Kraus's signed dedication reads, "To the genial chronicler of cultural life in Theresienstadt, Karel Herrmann."*

Critique 24
EDITH STEINER-KRAUS[1] PIANO EVENING

"Well, you must have been dreaming of a goblin or a dragon! That went over hill and dale!" Zelter[2] says jokingly to twelve-year-old Felix Mendelssohn,[3] who has just finished improvising on a theme given to him by his teacher. It is the eighth of November 1821 in Weimar. It is that memorable evening, described by Rellstab,[4] on which Goethe[5]—more than 72 years old—prophesies a great future for the ingenious child. "He spoke of it with full, warm belief." (Rellstab) From now on Felix has to play every afternoon and each time he receives a kiss from Goethe. The glorious E-flat Sonata op. 6, with which Edith Steiner-Kraus presented us this time, stems from a time not much later than this: one magnificent thing after the other bubbles up out of it; in form, invention, style, and movement, it is of incomprehensible maturity.

The qualities that Rellstab praises in Mendelssohn's playing—the lightness of hand, the accuracy, roundness, and clarity of the passages; fire and imagination—these are qualities that are also applicable to the interpreter Edith Steiner-Kraus. One can hardly imagine this sonata performed more beautifully by the youthful Mendelssohn himself.

The prelude to this original program was three sonatas by the young Scarlatti,[6] to whom we owe several significant formal innovations in the classical sonata form. Here there were three such nascent sonata form first movements ... lovable, occasionally pianistically brittle early Rococo; the third sonata is especially interesting and innovative. I wish their tempo had been a touch more moderate, because, as is generally known, the present day's virtuosic tempi were impossible to perform on the harpsichord. However, our new concert grand piano[7] celebrated triumphs of beautiful tone—except for in the Mendelssohn—in the pieces by more recent masters that followed.

Admittedly, Suk's *Frühling* ("Spring") is not really by Suk yet ... Liszt's dangerous influence is palpable; there are little May breezes and amorous whispers. It is only in the fourth piece—three asterisks as a title serve as an omen—that the lion's claw leaves the traces of a scratch, for which we are grateful as it gives us a premonition of the ingenious *Asrael*.[8] Ravel's *Sonatine*[9] proves that the polychrome harmony of the French impressionists is no substitute for the relinquished linearity—whether thematic development or imitative style—unless composed by a personality with powerful individuality. More Debussy's[10] scraps than Ravel's innovations, except for the minuet. Admittedly, even that piece is not the work of the mature master Ravel, the master of *Gaspar de la nuit, Les sortilèges, L'Heure espagnole, La valse*, etc. But even these works were once judged by Arnold Schönberg as he spoke to a circle of musicians: "Ravel always preludes, but nothing follows ... " [images 193, 207–210].

Klavier-Abend Edith Steiner-Kraus

"Na,du hast ja wohl vom Kobold oder Drachen geträumt!Das
ging ja über Stock und Block!"ruft Zelter scherzend dem zwölfjäh-
rigen Knaben Felix Mendelssohn zu,der eben über ein von seinem
Lehrer gegebenes Thema improvisiert hat.Wir schreiben den 8.November
1821 in Weimar.Es ist jener denkwürdige Abend,den Rellstab beschreibt,
an dem Goethe,über 72,dem genialen Kinde die grosse Zukunft weis-
sagt."Er sprach mit vollem,warmem Glauben davon zu mir"(Rellstab).
Nun muss Felix jeden Nachmittag vorspielen und jedesmal bekommt er
einen Kuss von Goethe.Die prachtvolle E-dur-Sonate op.6,mit der
uns Edith Steiner-Kraus diesmal beschenkte,mag aus nicht viel
späterer Zeit stammen;sie sprudelt eine um die andere Herrlichkeit
aus sich heraus,sie ist in Form,Invention,Stil und Satz von unbe-
greiflicher Reife.
 Was Rellstab an Mendelssohns Spiel rühmt:Leichtigkeit
der Hand,Sicherheit,Rundung und Klarheit der Passagen,Feuer und
Phantasie-es sind Eigenschaften,die auch für die Interpretin,für
Edith Steiner-Kraus gelten können.Man kann sich diese Sonate,vom
jugendlichen Mendelssohn vorgetragen,kaum schöner denken.
 Das Präludium des originellen Programms bildeten drei
Sonaten des jüngeren Scarlatti,dem wir entscheidende formplasti-
sche Anregungen für den klassischen ersten Satz-Typus der Sonate
verdanken.Um drei solche werdende erste Sonatensätze handelt es
sich hier..liebenswerter und stellenweise pianistisch spröder
Frührokoko;interessant und einfallsreich ist besonders die dritte
"Sonate".Ich würde sie um eine kleine Nuance mässiger im Zeit-
masse wünschen,da bekanntlich auf dem Cembalo solch virtuose
Tempi von heute nicht ausführbar waren.Dafür feierte unser neuer
Konzertflügel Triumphe der Klangschönheit-ausser im Mendelssohn-
in den nun folgenden Stücken neuerer Meister.
 Freilich,Suks "Frühling"ist noch nicht recht von Suk...
der gefährliche Einfluss Liszts wird fühlbar,es gibt Maienlüft-
chen und Liebessäuseln,nur im 4.Stück,dessen Omen drei Sterne
als Titel sind,hinterlässt die Löwenklaue eine Tatzenspur,für
die wir als Vorahnung des genialen "Asrael" dankbar sind.Dass
die polychrome Harmonik der französischen Impressionisten für
die preisgegebene Linearität-sei sie thematische Entwicklung oder
imitierender Stil-keinen Ersatz zu bieten vermag,wenn nicht eine
Persönlichkeit kraftvoller Eigenart dahinter steht,bewies Ravels
Sonatine..Mehr Abfälle Debussys als Einfälle Ravels,das Menuett
ausgenommen.Freilich ist auch das noch nicht der reife,der Meister
Ravel,der Meister des "Gaspard de la nuit",La sortilège,L' Heure
espagnol,la valse u.s.f.Aber selbst über diese Werke gab Arnold
Schönberg in einem Kreise von Musikern das Urteil:"Ravel prälu-
diert immer,aber es kommt nichts..."

 Viktor Ullmann

208. Viktor Ullmann's original manuscript of Critique 24. 1 page. NIOD.

Annotations

1 **Edith Steiner-Kraus** (1913–2013) (**Transport Ba** from Prague to Terezín on August 10, 1942). Pianist. Steiner-Kraus was a student of pianist Arthur Schnabel at the Berliner Hochschule für Musik. In Terezín, she performed an orchestral reduction of *Carmen* for two pianos with Franz Eugen Klein. She gave solo piano recitals of Bach, Chopin, Mozart, Schubert, and Smetana; performed with chamber ensembles; and accompanied Karel Berman and Marion Podolier in *lieder* recitals. She premiered Ullmann's Sonata No. 6 op. 49 in Terezín. Following her liberation in Terezín, she became an Israeli citizen and taught at the Rubin Academy in Tel Aviv. Steiner-Kraus recorded the first four piano sonatas of Ullmann (EDA Records 005-2) [Critique 24].

2 **Carl Friedrich Zelter** (1758–1832). Pianist and composer, composition teacher of Mendelssohn and Giacomo Meyerbeer. Zelter and Goethe are credited with introducing Mendelssohn to the works of J. S. Bach; Mendelssohn later spearheaded a revival of Bach's music [Critique 24].

3 **Felix Mendelssohn** [Critiques 10, 11, 23, 24].

4 **Heinrich Friedrich Rellstab** (1799–1860). German music critic and poet. Schubert set ten of Rellstab's poems to music, and seven of them appear in *Schwanengesang*, D. 957. As a music critic, Rellstab championed the works of Mendelssohn [Critique 24].

5 **Johann Wolfgang von Goethe** [Critiques 4, 13, 15, 20, 24].

6 **Giuseppe Domenico Scarlatti** (1685–1757). Italian Baroque–early Classical period composer and harpsichordist. He composed more than 500 sonatas for keyboard (piano and harpsichord) [Critique 24].

7 Ullmann's mention of "our new concert grand piano" likely places this performance among his later Critiques. In several conversations and interviews with Mark Ludwig, Zuzana Růžičková and George Horner recalled instruments which the Nazis brought into Terezín during the first half of 1944 in preparation for that summer's production of the propaganda film and visit by the International Red Cross Committee. This time frame may also be supported by Ullmann's comments in Critique 10, "A Musical Panorama (III.): Mid-August 1944": "The summer months have seen an increase rather than a decrease of interest in musical productions and therefore we have more performances once again." As noted in the introductory essay, the Nuremberg Racial Laws forbade ownership of musical instruments by Jews in Nazi Germany and occupied lands. Prague would have been the most probable source of musical instruments making their way into Terezín considering that over twenty-three thousand instruments had been relinquished in that city alone.

8 *Asrael.* Symphony by Josef Suk [Critiques 1, 7, 14, 24].

9 **Maurice Ravel** (1875–1937). French Impressionist composer. The *Sonatine*, a Neo-classical work for solo piano, was premiered March 10, 1906 by Madame Paule de Lestang. Ravel recorded this composition on a reproducing piano roll that has since been transferred to LP and CD formats [Critique 24].

10 **Claude Debussy** [Critiques 7, 8, 24–26].

209. Drawing. Portrait of Edith Steiner-Kraus. František Petr Kien. ZM #174294

KLAVIERABEND

Edith STEINER – KRAUS

Programm

BACH Toccata und Fuge D – dur

MOZART Sonate B – dur

CHOPIN Nocturne cis moll
 Ballade as moll

 5 Capricii u. Intermezzi

BRAHMS 2 Konzert Polkas

SMETANA

210. Program for a piano evening with Edith Steiner-Kraus. HCPT #4202. *The profiles drawn by the unknown artist may represent two of the composers whose works she performed.*

211. Dedication sheet. *Sommer-Herz.* Possibly Heinrich Bähr. HCPT #4204. *The pianist Alice Herz-Sommer's signed dedication reads: "To the very talented Mr. Herrmann with deep admiration as a remembrance of the cultural life in Theresienstadt."*

Critique 25

TWENTY-FOUR CHOPIN ÉTUDES PLAYED BY ALICE HERZ-SOMMER[1]

George Sand[2] recounts Chopin's[3] working habits: He locks himself in a room, plays, writes, crosses out, runs back and forth, starts anew, discards again—a constantly repeated process, an often desperate struggle with musical thought, and Chopin is not always the winner; he often rips up the manuscript and starts over again the next morning. That is how this iridescent sound world between *brio* and melancholy is born, in classicist eyes often a monstrous discrepancy between substance and attribute: lavish ornament often entwines a single melodic idea, almost crushing it—inconceivable with Mozart,[4] rarely found in Schumann,[5] whose writing for piano is well balanced between the *melos*[6] and the harmonic ornament. In spite of that—or because of that—Chopin remains the favorite of pianists and of a broader crowd of music lovers. The former can present their virtuosic dexterity, the latter can enjoy the shimmering arabesque-like surface, of the capricious and brilliant ornaments which play around and conquer an often primitive, often wonderful basic idea. In that sense, Chopin is probably the opposite of the old as well as the New Objectivity. His fantastical, sensitive, morbid nature, his restless French-Polish blood, his feminine masculinity, and not least his career as a virtuoso: all of this determines the style and destiny of these much loved and often-criticized works. *Mazurkas, polonaises, études, waltzes, ballads, preludes,*[7] etc.—what a playground for pianistic ambition! No wonder our artists compete to shine with Frédéric Chopin's works.

To play all of the twenty-four études in one evening was a physical but also an aesthetic risk. They are after all études, thus practice pieces, designed to develop the Romantic piano technique. It is correct that they are also performance pieces—just like Debussy's études. However, that is no justification for performing them in one evening, as if they were a single work of art consisting of connected and interrelated pieces. It became evident to the attentive observer that each individual étude is unrelated to the ones around it because of the change made to their original order: it is possible to play two, three, six, twelve or all Chopin's études one after the other or from the last to first—there is no interconnection. Even with the cleverest order, monotony is inevitable. Add to that the unspeakable technical difficulty, which demands physical tension, even hypertension, whose consequence unfortunately manifested itself in the A-flat Étude.

Although Alice Herz-Sommer, this great *petit* artist and justly admired pianist, gave a phenomenal performance of certain études—I am thinking of the two études in C-minor, of the E flat-minor, of the C#-minor, to pick a few at random—on the whole this program should be rejected. If Lamond[8] played Beethoven for several evenings, he still didn't play Beethoven études; and Chopin's études are and remain—despite the enraptured and therefore jazzed E-major played by Alice Herz, who re-endowed it with all its delicate, original magic—exactly as their name describes them: études, namely pianistic training [images 211–215].

- 24 Chopin-Etuden, gespielt von Alice Herz-Sommer

George Sand erzählt von Chopins Schaffen:Er schliesst sich im
Zimmer ein,spielt,schreibt,streicht durch,rennt auf und nieder,beginnt
von Neuem,verwirft wieder-ein immer wiederholter Vorgang,ein oft verzwei-
feltes Ringen mit dem musikalischen Gedanken und nicht immer bleibt
Chopin Sieger,oft zerreisst er das Manuskript,um am nächsten Morgen neu
anzufangen.So entsteht diese zwischen Brio und Melancholie schillernde
Klangwelt,in klassizistischen Augen ein oft ungeheuerliches Missver-
hältnis zwischen Substanz und Attribut:um einen einfachen,melodischen
Gedanken ranken sich üppige Ornamente,die ihn fast erdrücken-undenkbar
für Mozart,kaum bei Schumann anzutreffen,dessen Klaviersatz ausgeglichen
ist zwischen Melos und harmonischem Ornament.Dennoch-oder deswegen-
bleibt Chopin der Liebling der Pianisten und der breiteren Masse der
Musikfreunde.Jene können ihre ganze Virtuosen-Kunstfertigkeit präsentie-
ren,diese erfreut sich an der glitzernden Oberfläche des Arabeskenhaften,
an den kapriziösen und bravourösen Ornamenten,die eine oft primitive,
oft wundervolle Grundidee umspielen und besiegen.So ist Chopin wohl das
Gegenteil der alten wie der neuen Sachlichkeit.Sein phantastisches,
reizbares,morbides Wesen,sein unruhiges,französisch-polnisches Blut,
seine feminine Mannesnatur,nicht zuletzt seine Virtuosenlaufbahn:dies
Alles bestimmt den Stil und das Schicksal dieser vielgeliebten,vielgescho l-
tenen Werke.Mazurken,Polonaisen,Etuden,Walzer,Balladen,Preludes u.s.w.-
welch ein Tummelplatz pianistischen Ehrgeizes!Es ist kein Wunder,dass auch
unsere Künstler wetteifern,mit Frédéric Chopins Werken zu glänzen.

Alle 24 Etuden an einem Abend zu spielen war ein physisches,
aber auch ein aesthetisches Wagnis.Es sind eben doch schliesslich
Etuden,also Uebungsstücke,bestimmt zur Ausbildung der romantischen Klavier-
technik.Dass sie zugleich wie Debussy's Etuden Vortragsstücke sind,ist
richtig;doch ergibt sich daraus keine Berechtigung,sie an einem Abend,
gleichsam als zusammenhängendes Kunstwerk und mit Beziehung auf einander
aufzuführen.Dass die einzelnen Uebungsstücke beziehungslos nebeneinander
stehen,ergab sich dem aufmerksamen Beobachter aus der Aenderung der
ursprünglichen Reihenfolge;man kann eben zwei,drei,sechs,zwölf oder alle
Chopin-Etuden hintereinander oder von hinten nach vorne spielen:ein
Zusammenhang ergibt sich nicht.Monotonie ist bei jeder noch so geschick-
ten Anordnung unausbleiblich.Dazu kommt die unsägliche technische
Schwierigkeit,die eine physische Anspannung,ja Ueberspannung fordert,
deren Folgen sich in der As-dur leider manifestierten.

So phänomenal also auch gewisse Etuden von Alice Herz-
Sommer,dieser grossen kleinen Künstlerin und mit Recht bewunderten
Pianistin,gespielt wurden-ich denke da an die beiden Etuden in c-moll,
an die es-moll,an die cis-moll,um beliebig einige herauszugreifen-so
ist dieses Programm doch im Ganzen abzulehnen.Spielte Lamond einige
Abende lang Beethoven,so waren es eben keine Etuden Beethovens;und Chopins
Etuden sind und bleiben-trotz der schwärmerischen und daher verjazzten
E dur,der Alice Herz all ihren zarten,ursprünglichen Zauber wieder verlieh-
letzten Endes,was ihr Name sagt:Etuden,nämlich pianistischer Training.

Viktor Ullmann

212. Viktor Ullmann's original manuscript of Critique 25. 1 page. NIOD.

Annotations

1 **Alice Herz-Sommer** [Critiques 5, 11, 25].
2 **George Sand** (1804–1876). Pseudonym of Amantine Lucile Aurore Dupin, well-known French writer. Sand shared a long romantic relationship with Chopin, and her 1842 novel, *A Winter in Majorca,* describes some of the time she spent caring for him while he suffered from tuberculosis [Critique 25].
3 **Frédéric Chopin** [Critiques 9, 11, 25].
4 **Wolfgang Amadeus Mozart** [Critiques 4, 9, 10, 14, 16, 17, 21, 22, 25].
5 **Robert Schumann** [Critiques 1, 6, 9, 11, 25].
6 *Melos.* A succession of musical tones constituting a melody.
7 The *mazurka* and *polonaise* are Polish national dances. *The Harvard Dictionary of Music* credits Chopin with making "the *polonaise* the symbol of Polish heroism and chivalry." Études are musical exercises created to help students develop technical command of their instruments. Chopin was among the first to weave technical and artistic elements into the étude, taking the form out of the practice room and into the concert hall.
8 Ullmann refers to **Frederic Archibald Lamond** (1868–1948), a Scottish classical pianist who studied with Franz Liszt and was considered a master interpreter of Beethoven's piano works.

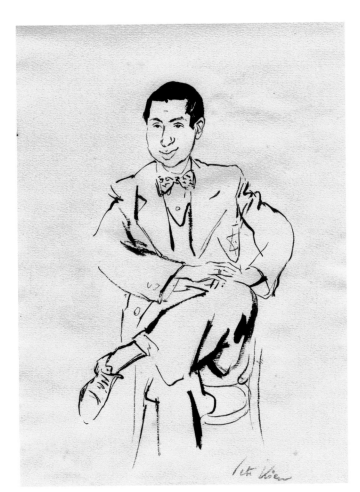

213. Drawing. Portrait of Karel Ančerl. František Petr Kien. ZM #174.301.

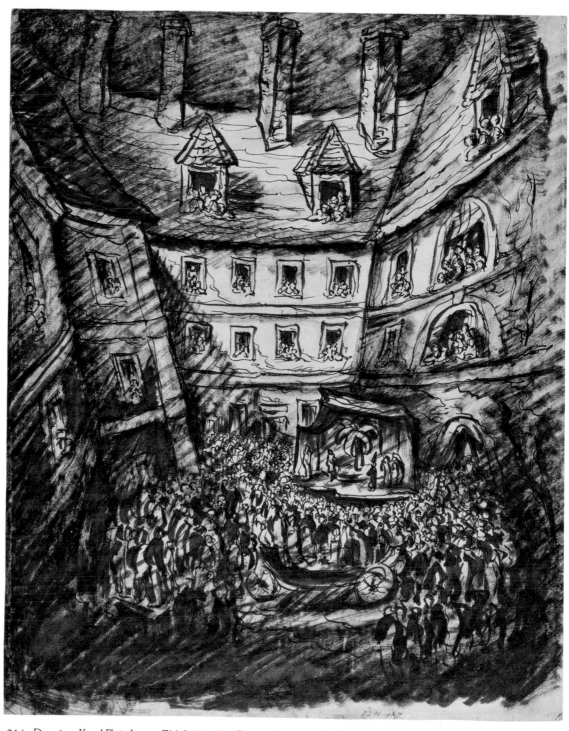

214. Drawing. Karel Fleischman. ZM #176.334. *Concert in courtyard of the Magdeburg Barracks.*

268

MUSIK und THEATER
Programm für die Zeit vom 25.9.bis 1.10.1944
Montag den 25.9.1944

Westg.3/Terrass.	15,00	Eine Stunde Musik:Lieder und Klavier-stücke von Schumann.Mitw.:L.Kohn - Schleskow,M.Schiller.
Westg.3/Terrass.	18,15	Klavierkonzert Alice Sommer-Herz /Chopin:Etüden/ /KG/
Bahnhofst.3/Bod.	18,30	Lindenbaum-John-Gruppe /Karten/
Westg.3/Bühnens.	19,00	"La Serva Padrona" von Pergolesi,Leit. R.Schächter,Ausstatt.F.Zelenka,Regie: K.Bermann /KG/

Dienstag den 26.9.1944

Westg.3/Terrass.	15,00	Eine Stunde Musik: Lieder,Violin- und Klavierwerke von Beethoven.Mitw.: M. Spiegel,A.Schächter,G.v.Gizycki-Rosenthal

Donnerstag den 28.9.1944

Hauptst.2/541	18,15	Ledeč-Quartett /Haydn,Schul,Borodin/KG/
Parkstr.14	18,15	Liederabend Helly Eisenschimmel - Dr. Erich Klapp /Mussorgsky,H.Wolf/ /KG/
Hauptstr.22/Bod.	18,00	"Spiel im Schloss" von Molnár, Regie: B.Spanier,Ausstatt.Arn.Reimann /KG/
Westg.3/Terrass.	18,30	Vikt.Ullmann:"Cornet Rilke",gesprochen von E.Lerner und "Pierrots Lieder und Tänze". Leit.H.Schächter /KG/
Bahnhofstr.3/Bod.	18,30	Strauss-Brettl /Karten/

Freitag den 29.9.1944

Westg.3/Terrass.	15,00	Eine Stunde Musik: Violinsonaten und Klavierwerke von Haydn.Mitw.J.Grauer, James Simon.
Westg.3/Bühn.	17,00	"Carmen",Leit.F.E.Klein,Ausstatt.Fr. Zelenka/KG/
Hauptstr.22/Bod.	18,00	"Spiel im Schloss",Regie:B.Spanier, Ausstatt.Arn.Reimann /KG/
Parkstr.14	18,15	Klavier-Trio /Beethoven-Brahms/ Mitw. Gideon Klein,P.Kling,F.Mark/ /KG/
Bauhof/Heal	18,00	Strauss-Brettl

Samstag den 30.9.1944

Parkstr.14	18,15	Studio für neue Musik IV /Reger,Mahler, Schönberg,Hába/,Mitw.Al.Sommer-Herz, H.Grab-Kernmayer,Vikt.Ullmann /KG/
Westg.3/Bühnens.	17,30 19,00	Streichorchesterkonzert der Stadtkapel-le.Leit.Kapellm.K.Ančerl /Suk,P.Haas, Dvořák/ /KG/
Hauptstr.22/...	18,00	"Fledermaus",Regie Hans Hofer,musik. Leit.Wolfg.Lederer,Ausstatt.Arn.Reimann /AZ-Arb.Betr.- KG/
Bahnhofstr.3/Bod.	18,30	Lindenbaum-John-Gruppe /Karten/

Sonntag den 1.10.1944

Westg.3/Bühnens.	17,30	Mendelssohn "Elias",Leit.Karl Fischer/KG/
Hauptst.22/Bod.	18,00	"Fledermaus",Regie:Hans Hofer,musik. Leitung:Wolfg.Lederer,Ausst.Arn.Reimann/K...
Parkstr.14	18,15	Jazz-Konzert Martin Roman mit seinem Swing-Orchester /KG/
Bahnhofstr.3/Bod.	18,30	Strauss-Brettl /Karten/

215. A listing of music and theatre programs for the week of September 25 to October 1, 1944. HCPT #3940. PT: A7599. ZM. *For many of these artists, the performances during these six days would be their last, as the final eleven transports to Auschwitz in September and October 1944 effectively liquidated the cultural core of Terezín. On September 25, Alice Herz-Sommer performed a recital of Chopin études. She appeared four evenings later in Ullmann's Studio for New Music chamber series. This sheet includes a good number of the artists and repertoire critiqued by Ullmann at an earlier period [Critiques 1, 2, 11, 12, 14, 16, 19, 21, 25, 26].*

237

CARMEN

Oper in 4 Akten * von =

GEORGES BIZET

Leitung: Kapellmeister Franz Eug. Klein

Don José, Sergeant	Gobets / Grünfeld
Escamillo, Stierkämpfer	Windhola / Freund
Remendado, Schmuggler	Karl Fischer / Goldring
Dancairo, Schmuggler	Pollak / Pollak
Zuniga, Leutnant	Hartmann / Bermann
Morales, Sergeant	Löwy / Löwy
Carmen, Zigeunermädchen	Grab-Kernmayer / Schwarz-Klein
Micaela, Bauernmädchen	Ada Hecht / Borger
Frasquita, Zigeunermädchen	Borger / Kohn-Schleskov
Mercedes, Zigeunermädchen	Lind-Aronson / Wirth

Soldaten, Stierkämpfer, Schmuggler, Zigarettenarbeiterinnen, Strassenjungen, Zigeuner, Volk, Damenchor, Herrenchor, Kinderchor.

Ort der Handlung: Sevilla

1. Akt: Platz in Sevilla, 2. Akt: Schenke b. Lillas Pastia,
3. Akt: Wilde Gebirgsgegend, 4. Akt: Platz vor der Arena.

Einstudierung d. Kinderchores: R. Freudenfeld
Assistenz am Flügel: Stern
Inspizient: Polák.

216. Poster. *Carmen—Oper in 4 Akten.* HCPT #3927. *Poster for production of Bizet's* Carmen *listing soloists, conductor Franz Eugen Klein, and choir director Rudolf Freudenfeld.*

270

Critique 26
CARMEN[1]

If Nietzsche[2] enthusiastically embraced Bizet[3] in order to pull himself away from Wagner[4]—who had previously seemed to him the mightiest educator of European humanity next to Schopenhauer—then today we may say from an appropriate distance: Wagner should return to raise doubts about *Carmen*. That is the mission of all these great destroyers, rebels, and futurists, the decadent and independent ones: to create a *tabula rasa*.[5] Nothing seems more important to the *Weltgeist*[6] than overcoming inertia, the law of lethargy. Even if the path leads through mediocrity's indignant resistance—it is, after all, a path and not a swamp—"tradition is sloppiness" (Mahler).[7] Even Bizet unwittingly serves progress, not so much through his often more charmingly written than ingeniously inspired music, but rather through the thoroughly revolutionary idea of this first naturalistic libretto, which precedes the *verismo*[8] by decades ... Lulu[9] enters the stage instead of Euridice,[10] Alceste,[11] and Leonore,[12] and as primitively as the libretto was adapted from Merimée's ingenious novella,[13] his only thought remains that "love stems from the gypsies"—thus, in combination with the music, it is still an important step toward a new era, now an era gone past; we can feel the air of Decadence,[14] the "faces are paling into the dark"[15] and those faces are of Baudelaire and Verlaine,[16] of Toulouse-Lautrec and Van Gogh, of Matisse[17] and Debussy ... [18] The outward gesture of this music is admittedly reactionary—well, it still seemed too Spanish to the contemporary French, and the Spaniards thought it far too French—it is music for the body, sensual music, and so its best moments lie in its rhythmic domain and in its—in our case necessarily silenced—exquisite and sparkling clean score.[19]

The vocal parts of our performance are absolutely worthy of praise. Grab-Kernmayr,[20] Gobets,[21] and Windholz[22] offered us splendid voices and vivacious achievements; the tightly rehearsed ensemble pieces stuck out pleasantly, among the smugglers especially Karl Fischer[23] [sic!] together with the ladies Borger[24] and Lindt.[25] Ms. Hecht,[26] the ever-ready artist, sings everything remotely soprano-like, and her [!] versatility is admirable.[27] The choral passages are as difficult as ever and sounded, despite their much-rehearsed precision, a little labored and not always pleasant.

On the whole, the performance is an important achievement of the talented conductor F. E. Klein.[28] There are problems only with the production. If it works half way, it should work in its entirety. As long as it remains at the stage of a dress-rehearsal, one can't really enjoy it, especially if one is reminded all too often of Frittas's punchy caricatures[29] ... but then I am once again missing Escamillo's umbrella.[30]

The climax of our production was without doubt the third act, in which Bizet, too, tied the dramatic knot with a master's hand. Here, Frasquita and Mercedes (Truda Borger and Aronson-Lindt) sing their charming duet; here, Micaela (Ada Hecht) beautifully sings her aria; here, Hedda Grab-Kernmayer and Mr. Gobets unfold their voluminous and juicy voices; here even the choruses rise to a satisfactory volume level [images 216–228].

Carmen

Wenn Nietzsche sich begeistert Bizet an die Brust
warf,um ihn gegen Wagner auszuspielen,-der ihm doch zuvor
neben Schopenhauer der gewaltigste Erzieher europäischer
Menschheit gewesen,-so können wir heute aus angemessener
Distanz sagen:Wagner musste kommen,um Carmen-fragwürdig
zu machen.Das ist ja die Mission all dieser grossen
Zerstörer,der Rebellen und Futuristen,der Dekadenten und
Unabhängigen:tabula rasa zu machen.An Nichts scheint dem
Weltgeiste mehr zu liegen als an der Überwindung des
Beharrungsvermögens,des Trägheitsgesetzes.Geht der Weg
auch über den empörten Aufstand der Mediokrität-es ist
doch eben ein Weg und kein Sumpf--"Tradition ist Schlampe-
rei"(Mahler).Auch Bizet dient unbewusst der Entwicklung,
weniger in seiner meist mehr liebenswürdig gekonnten als
genial inspirierten Musik,als in dem durchaus revolutio-
nären Idee dieses ersten naturalistischen Textbuches,das
um Jahrzehnte dem Verismo voraneilt...Lulu betritt die
Opernbühne an Stelle der Euridices,Alkesten und Leonoren
und so primitiv das aus Merimées genialer Novelle zurecht
gezimmerte Textbuch ist-sein einziger Gedanke bleibt,dass
die Liebe von Zigeunern stammet"...so ist es in Verbindung
mit der Musik doch eine wichtige Etappe zum damals kommen-
den,heute vergangenen Zeitalter,wir fühlen Luft der Deca-
dence,schon "blassen in dem Dunkel die Gesichter und es
sind die der Baudelaire und Verlaine,der Toulouse-Lautrec
und Van Gogh,der Matisse und Debussy...Die äussere Geste
dieser Musik ist freilich reaktionär-nun,sie kam den
damaligen Franzosen trotzdem spanisch vor,den Spaniern
wieder allzu französisch-es ist Musik der Glieder,Sinnenmu-
sik und so liegt ihr Bestes im Rhythmischen und in der
bei uns notwendigerweise verschwiegenen köstlichen und
blitzsauberen Partitur.
 Das Gesangliche unserer Aufführung ist durchaus
lobenswert.Grab-Kernmayr,Gobets und Windholz bieten
prächtige Stimmen und temperamentvolle Leistungen;die
straff studierten Ensemblesätze fallen angenehm auf,unter
den Schmugglern besonders Karl Fischer (sic!) und Pollak
mit den Damen Borger und Lindt.Frau Hecht,die immer einsatz
bereite Künstlerin,singt nun wirklich schon alles Sopran-
artige und ist in ihrer Vielseitigkeit bewundernswert
Bewunderungswert.Die Chöre sind noch immer so schwer wie
früher und bei aller gut studierten Präzision klangen sie
doch etwas mühsam und nicht immer erfreulich.
 Im Ganzen ist die Vorstellung eine bedeutende Leistung
des begabten Dirigenten F.E.Klein.Problematisch bleibt nur
die Inszenierung*.Geht es halb,so geht es auch ganz.Bleibt
die Sache im Stadium einer Stellprobe,kann man nicht zum
rechten Genusse kommen,zumal,wenn mann allzusehr an Frittas
schwungvolle Karikaturen erinnert wird..Dann aber fehlt
mit wieder Escamillos Regenschirm...

*fortschreitenden
fortschreitenden

272

CARMEN 2

Den Höhepunkt unserer Aufführung bildet zweifellos der
III.Akt,in dem ja auch Bizet den dramatischen Knoten mit
Meisterhand geschürzt hat.Hier singen Frasouita und Mer-
cedes (Burger und Lindt)ihr reizvolles Duett,hier lässt
Micaela (Hecht)ihre wunderschön gesungene Arie hören,hier
entfalten Hedda Grab und Herr Gobets ihre voluminösen und
saftigen Stimmen,hier wachsen sogar die Chöre zu einer
befriedigenden Klangfülle heran.

217. Viktor Ullmann's original manuscript of Critique 26. 2 pages. NIOD.

273

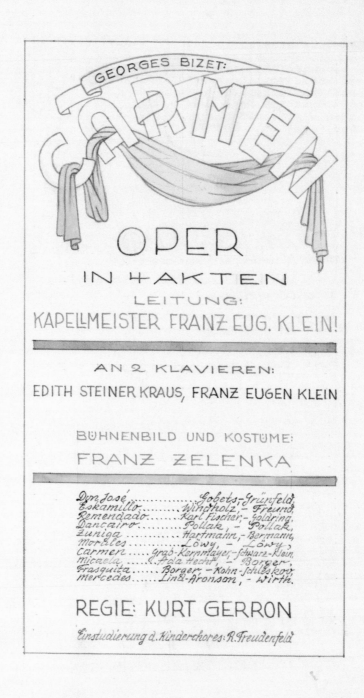

218. Poster. *Georges Bizet: Carmen. HCPT #3928. Edith Steiner-Kraus and Franz Eugen Klein are listed as the pianists substituting for the opera orchestra. Set and costume design was by František Zelenka with stage direction by Kurt Gerron.*

Annotations

1 *Carmen*. Opera by George Bizet. *Carmen* was premiered in the Théâtre National de l'Opéra-Comique, Paris, on March 3, 1875. The libretto was based on Mérimée's novella about a seductive Spanish Gypsy who weaves a web of amorous intrigue and deception that ultimately leads to her murder.

2 **Friedrich Wilhelm Nietzsche** (1844–1900). German philosopher and poet. [Critiques 21, 26].

3 **Georges Bizet** (1838–1875). French composer noted for his masterful opera *Carmen* and the *L'Arlésienne* suites [Critique 26].

4 **Richard Wagner** [Critiques 12, 17, 26].

5 *Tabula rasa.* (Latin: clean slate.)

6 *Weltgeist.* (German: world spirit.) A term for the force of history coined by German philosopher Georg Wilhelm Friedrich Hegel (1770–1831).

7 **"Tradition is slovenliness"** (*"Tradition ist Schlamperei"*) was Mahler's credo against the stagnating forces of traditional approaches to performance in operas and symphonies [Critiques 4, 7, 10, 17, 20, 26].

8 *Verismo.* (Italian: realism.) A style of Italian opera. Until the late nineteenth century, history and mythology were the inspiration for most operatic plots. *Verismo* appeared with Mascagni's *Cavalleria rusticana*, Leoncavallo's *I Pagliacci,* and Puccini's *La Boheme,* and expressed the dark side of life among the lower rungs of society.

9 **Lulu.** Heroine of an unfinished opera by Alban Berg (1885–1935), a student of Arnold Schönberg who was among the major influences on the Second Viennese school of music. *Lulu* is a tragedy with an erotic plot filled with deception, intrigue, and murder. Ullmann contrasts Lulu with Euridice, Alceste, and Leonore (see below).

10 **Euridice.** In Greek mythology, the wife of Orpheus who dies from a serpent's bite. Orpheus mourns her with music, and his songs persuade Hades and Persephone to release her from the Underworld. There is one stipulation: as they depart, Orpheus may not look back. But he does, and Eurydice vanishes into the Underworld.

11 **Alceste.** In Greek mythology, Alcestis is a heroine who sacrifices her life for her husband, Admetus the King of Pherae. Heracles rescues her from the clutches of Hades.

12 **Leonore** (soprano) is the female protagonist in Beethoven's two-act opera, *Fidelio.* Florestan, her husband, is held captive and sentenced to death as a political prisoner. Disguised as a prison guard, she rescues him. **Beethoven** [Critiques 5, 6, 10, 11, 18, 20–22, 25, 26].

13 **Merimée's ingenious novel.** Prosper Mérimée (1803–1870) was a French novelist, essayist, and archaeologist. The "ingenious novel" is *Carmen.*

14 **Decadence.** Ullmann is referring to The Decadents, a group of nineteenth-century European writers who believed that art must challenge the influence of societal moralities and conventions [Critique 26, annotation 16].

15 **"Faces grow pale in the dark."** A quote from *"Entrückung"* ("Transport") by nineteenth-century German poet Stefan George, from his collection *Der siebente Ring (The Seventh Ring),* famously set by Schönberg to the String Quartet no. 2 in F-sharp Minor op. 10 for Soprano and String Quartet [Critique 26].

16 **Baudelaire and Verlaine.** French poets Charles Baudelaire (1832–1867) and Paul Verlaine (1844–1896), along with poet Stéphane Mallarmé, labeled themselves "The Decadents"; their morose, ghoulish, and often erotic imagery laid the foundations for the decadent and symbolist movements and paved the way towards experimental techniques in poetry such as free verse [Critique 26].

17 **Henri de Toulouse-Lautrec** (1864–1901). French artist renowned for his scenes of late nineteenth-century Parisian nightlife, particularly the performers at the Moulin Rouge. **Vincent**

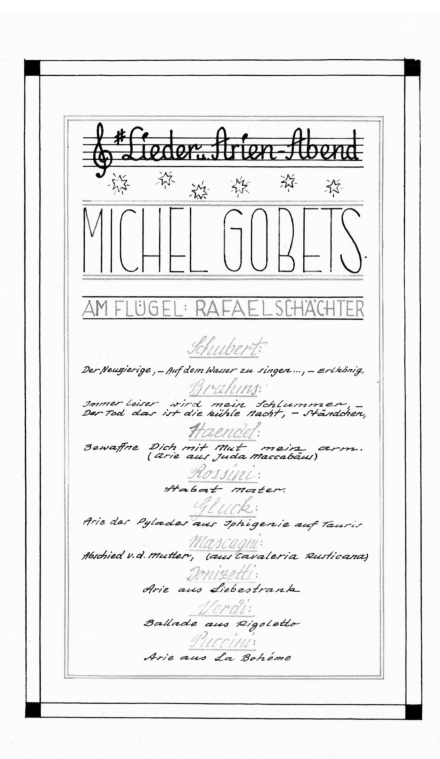

219. Poster. Lieder u. Arien-Abend—Michel (Michael, Macheil) Gobets. HCPT #3954. An evening of arias and lieder with Michel Gobets accompanied by Rafael Schächter at the grand piano.

Van Gogh (1853–1890): Iconic post-impressionist painter. **Henri Matisse** (1869–1954): French impressionist painter and sculptor considered the leader of the fauvist movement [Critique 26].

18 **Claude Debussy** [Critiques 7, 8, 24–26].

19 **"In our case inevitably silenced…"** refers to the absence of an opera orchestra in the Terezín production of *Carmen*. The two pianists, Edith Steiner-Kraus and Franz Eugen Klein, performed the piano reduction of the score. Klein conducted from the keyboard [Critique 26].

20 **Hedda Grab-Kernmayer** [Critiques 1, 26].

21 **Machiel Gobets** [Critiques 10, 26].

22 **Walter Windholz** [Critiques 10, 17, 26].

23 **Karl Fischer** [Critiques 10, 19, 26].

24 **Gertrude (Truda) Borger** [Critiques 10, 17, 26].

25 **Hilde Aronson-Lindt** [Critiques 10, 17, 26].

26 **Ada Hecht** [Critiques 17, 26].

27 **"The ever-ready artist…admirable."** In a rather back-handed complement, Ullmann is critical of Hecht's voice while saluting her willingness to step into a variety of roles at a moment's notice. His bracketed exclamation mark adds further emphasis and appreciation for her "versatility."

28 **Franz Eugen Klein** [Critiques 23, 26].

29 **"Fritta"** is Fritz Taussig (1906–1944, Auschwitz) (**Transport J** from Prague to Terezín on December 4, 1941) (**Transport Ev** from Terezín to Auschwitz on October 28, 1944). Taussig was a member of the *Aufbaukommando* (Building Battalion), the construction battalion assembled and commanded to convert Terezín from a garrison town to a concentration camp. In Terezín he was Director of the Technical Department, the central organization for visual artists. He belonged to a circle of painters who secretly produced a number of studies and paintings chronicling the people and conditions in Terezín. The publication of their smuggled works abroad led to the arrest of these artists and their families on July 17, 1944. They were sent to the *Kleine Festung* (Terezín's Small Fortress) and sentenced for creating and distributing "horror propaganda" [Critique 26].

30 **Escamillo:** The bullfighter in *Carmen*.

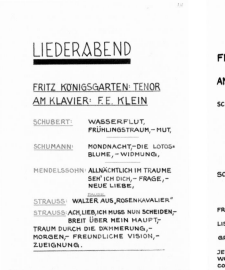
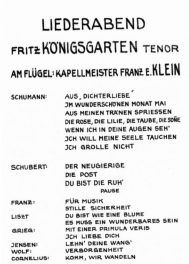

220/221. Program lists for *lieder* recital #I and #II with tenor Fritz Königsgarten accompanied by Franz Eugen Klein. HCPT #4221 and #4222.

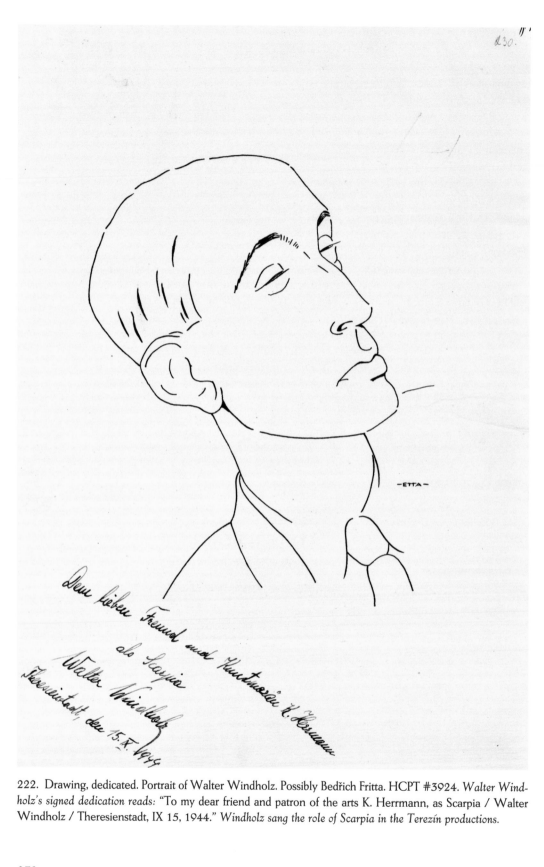

222. Drawing, dedicated. Portrait of Walter Windholz. Possibly Bedřich Fritta. HCPT #3924. *Walter Wind-holz's signed dedication reads:* "To my dear friend and patron of the arts K. Herrmann, as Scarpia / Walter Windholz / Theresienstadt, IX 15, 1944." *Windholz sang the role of Scarpia in the Terezín productions.*

278

223. Drawing. Caricature of the Dutch singer Machiel Gobets by Dr. Hugo Kurzbauer (Kurzbaum?) dated June 16, 1944. HCPT #4180. *The artist adds a caption in Yiddish, "Oy is this a chazen [cantor]! And with that noodle and needle [prick]!" The exaggerated features of Gobets and the silliness of the Yiddish caption is likely a reference to one of the roles he performed in Terezín cabaret productions.*

224. Poster. *Liederabend.* "Evening of *lieder* with Walter Windholz." HCPT #4220.

Kavalier Kaserne . 3.Mai 1942

Ghetto - Wiegenlied .

von Carlo Taube im Rahmen seiner Ghetto-Suite
für Orchester und 1 Altstimme .

Raum 219 . 5.Juni 1942

H e r z l - F e i e r .

Aus der Bibel Magda Weisz

An Herzl J.Altberger

2 Psalme von Dvořák Hedda Grab-Kernmayer

II.Hof der Hamburger Kaserne . 11.Juni 1942 .

I. Gesangs - Konzert .

Gerta Harpmann, Jakob Goldring, Emmy Zeckendorf,
Anka Dub, Hedda Grab-Kernmayer.

Arien von Puccini - Meyerbeer - Bizet - Smetana -
Dvořák - und Jiddische Lieder .

Ohne Begleitungsinstrument .

25.Juni 1942 Wiederholung im Magdeburger Saal, diesmal
mit Harmonika Begleitug von Wolfi Lederer .

225. Program sheet for three performances (May 3, 1942; June 5, 1942; and June 11, 1942). HCPT #4217. *Hedda Grab-Kernmayer performed in the second and third of these programs in the Cavalier and Hamburg barracks.*

226. Poster. *Arien-Abend.* HCPT #4224. *An evening of arias with Ada Hecht and Walter Windholz.*

1.Juli 1942 Im Rahmen des Thorn-Kabaretts
 Arie der Dalila und Carmen .

23.September 1942 in Magdeburg .
Kompositionen Franta Domažlický "Sterne"
ein a capella Stück für Männerquartett und 1 Altsolo
gewidmet vom Komponisten der Sängerin Hedda Grab-
Kernmayer und von ihr dortselbst uraufgeführt.

22.Jänner 1943 .
I.Konzert von Liedern und Arien auf L 417 .
Mitwirkenden : Hedda Grab-Kernmayer, Franta Weissenstein,
Brahms-Schumann-Dvořák-Křička-Verdi-Beethoven .

7.Feber 1943 Magdeburg-Arbeiter Betreuung .
Reise d. Land der Musik
2 Slow.Volkslieder
Donizetti: Arie aus der "Favoritin"

Unzählige Block-Veranstaltungen .

Caffeehaus - Arien Matinées .

30. Oktober 1943
Kompositions-Abend Viktor Ullmann
2 Lieder auf Texte von Hans Günther Adler für
Hedda Grab-Kernmayer in Theresienstadt komponiert.
1./Immer inmitten .
2./Von der Ewigkeit .
Uraufführung .

19.Feber 1944 - Rathaus .
Lieder-Abend tschechischer Komponisten .
V. Novák: Melancholische Liebeslieder
K.B.Jirák: Cyklus 7 Lieder:Vergängliches Glück
J.Suk : 2 Lieder
L.Janáček : Mährische Volkspoesie
V.Novák : Slovakische Volkslieder
Begleitung : Dr-Karl Reiner

Opern :
Prodaná nevěsta : Ludmila - Háta
Figaros Hochzeit : Gräfin
Rigoletto : Maddalena
Hubička : Martinka
Chor u.Solo Konzert Fischer :
Aida : Amneris
Cavalleria Rusticana: Santuzza
Zauberflöte : 3.Dame
Carmen : Carmen
Requiem : Mezzosopranpartie

227. List of musical events from July 1, 1942 to February 19, 1944 in the Magdeburg barracks, the Coffeehouse, and Town Hall. HCPT #4218. *Hedda Grab-Kernmayer performed in several of the listed programs. On October 30, 1943, she performed two lieder, "Immer inmitten" ("Always in the Midst") and "Von der Ewigkeit" ("From Eternity"), set to text by H. G. and composed in Terezín by Viktor Ullmann.*

Darbietungen

DER FREIZEITGESTALTUNG

für die Zeit vom 21.bis 27.4.1945

	Uhr	
Samstag 21.4.1945		
Westg.3/Terrassens.	19.15	O p e r n a b e n d. Orchester unter Leitung von Leo Pappenheim: Solisten: Fr.Attler, Willy Rhoden, Méry
Westg.3/Bühnensaal	19.15	A b e n d j ü d i s c h e r K u l t u r Lithurgische Musik und jiddische Volkslieder.
Parkstr. 14	19.15	Konzert Karl Blum (Geige) Dr. Ernst Latzko (Klavier) (Schubert, Schumann, Brahms).
Hauptstr.2/241	20.00	"Herodes und Mariamne" Tragödie von Friedrich Hebbel
Sonntag 22.4.1945		
Westg.3/Bühnensaal	15.30	"G l ü h w ü r m c h e n", Kindersingspiel.
Westg.3/Bühnensaal	19.15	"Hoffmanns Erzählungen", Szenen aus der Oper von J. Offenbach
Westg.3/Terrassens.	19.15	S o l i s t e n a b e n d. Mitw. Hilde Aronson-Lind,Alice Sommer-Herz, Edith Steiner-Kraus, Else Schiller, Prof.Leidensdorff, Willy Rhoden
Hauptstr.2/241	19.15	"D e r K a m m e r s ä n g e r" Tragikomödie von Wedekind.
Montag 23.4.1945		
Westg.3/Terrassens.	15.30	"D i e W i n t e r r e i s e" von Schubert, gesungen von Hilde Lind - Aronson (für die Fürsorge)
Westg.3/Terrassens.	19.15	Konzert Alice Sommer-Herz (Klavier) Paul Herz (Violine) (Smetana, Chopin, Dvorak)
Westg.3/Bühnensaal	19.15	"V a r i e t é" Mitw.Jazz-Orchester unt.Leitung von Hans Feith, Anny Blechschmidt,Anny Frey, Gisa Wurzel, Josef Kraus, Karl Schostal u.a.
Dienstag 24.4.1945		
Hauptstr.2/241	15.30	"Die Abenteuer des Bären Pu" von J Milne, ein Kinderspiel, bearbeitet von Vlasta Schön.
Westg.3/Terrassens.	19.15	Klavierkonzert Beatrice Pimentel (Bach, Haydn, Schubert, Debussy)
Westg.3/Bühnensaal	19.15	"Hoffmanns Erzählungen", Auszug aus der Oper von J. Offenbach
Parkstr. 14	19.15	B r a h m s - K o n z e r t Mitw.Hilde Lind-Aronson,Edith Steiner-Kraus, Prof. Hermann Leidensdorff, Rom. Süssmann.

.*/.

	Uhr	
Mittwoch 25.4.1945		
Westg.3/Terrassensaal	19.15	Konzert Ada Schwarz-Klein (Alt), Alice Sommer-Herz (Klavier) (Beethoven, Schumann, Dvorak)
Westg.3/Bühnensaal	19.00	"G l ü h w ü r m c h e n", Kindersing-spiel
Hauptstr.2/241	19.15	"D e r K a m m e r s ä n g e r" Tragikomödie von Wedekind
Donnerstag 26.4.45		
Westg.3/Terrassensaal	19.15	Klavierkonzert Alice Sommer - Herz (Schubert, Schumann)
Westg.3/Bühnensaal	19.15	"Hoffmanns Erzählungen" von J. Of-fenbach
Hauptstr.2/241	19.15	"Herodes und Mariamne" Tragödie von Friedrich Hebbel
Parkstr. 14	19.15	Klavierkonzert an 2 Klavieren : Edith Steiner-Kraus, am 2. Flügel Else Schiller (Mozart,Beethoven)
Freitag 27.4.1945		
Westg.3/Terrassensaal	15.30	O p e r n k o n z e r t. Orchester unter Leitung von Leo Pappenheim. Solist: Hans Grünwald (für die Fürsorge)
Westg.3/Bühnensaal	19.15	J a z z - K o n z e r t, unt.Leit.von Hans Feith unter Mitw. von Gertie Guth.
Hauptstr.2/241	15.30	"Die Abenteuer des Bären Pu" von J. Milne, ein Kinderspiel, bearbeitet von lasta Schön
Hauptstr.2/241	19.15	S a b b a t h - F e i e r s t u n d e

V O R T R Ä G E

Montag 23.4.1945		
Wallstr. 8/16	19.00	Dr. Leo Löwenstein: "Die geistigen Quellen technischen Schaffens".
Dienstag 24.4.1945		
Hauptstr.2/241	19.15	Prof.Dr. Utitz: "Meister der Wortkunst" mit Rezitationsbeispielen. Mitw. Käthe Goldschmidt

S P O R T

Sonntag 22.4.1945		
Hauptstr. 22	13.30	Fussball Liga Merkur - Terezin
	14.50	Handball Frauen
	15.30	Fussball Liga Linden - Bohemia
	17.00	Fussball Liga Hungaria- Sparta

K A F F E E H A U S

täglich	17.30	P r o g r a m m
Montag,Mittwoch,Samstag	19.30	Programm für Arbeitende

228. Program of cultural events from April 21 to 27, 1945 (front and back). PT A7599. *The pianists Edith Steiner-Kraus and Alice Herz-Sommer are among the last remaining central figures of the Terezín cultural community. Gone are Ullmann, Klein, Krása, Haas, and the many other gifted artists appearing in the critiques and artwork of the Heřman collection.*

VIKTOR ULLMANN: ADDITIONAL TEREZÍN WRITINGS
Mark Ludwig

Along with his concert critiques, there survived three additional works from Terezín: two short pieces titled "Goethe and Ghetto"[1] and "Sigmund Schul," and a poem, "While Looking Upon Schul's Coffin."[2] It seems only right to include them here as a tribute to Ullmann and a deeper introduction to his intellect and humanity. Along with his Third String Quartet, I find them to be his most revealing and touching expressions of grief and reflection on his experiences in Terezín.

The paean to Sigmund Schul is a testament to their special bond. In Terezín, Ullmann was a father-like mentor, friend, and colleague to Schul. He expresses the deep respect and hopes he held for Schul, who died of tuberculosis on June 20, 1944 at the age of twenty-eight. As a father, I sense that Ullmann's grief was heightened by the earlier death of his two-year-old son, Paul, also from tuberculosis.[3]

As stated earlier, the title of this book is taken from "Goethe and Ghetto." There is an air of defiance when Ullmann states:

I would only like to emphasize that my musical work was fostered and not inhibited by Theresienstadt, and that we in no way merely sat around lamenting by the banks of Babylon's rivers, and that our will for culture was equal to our will to live.

It is a personal manifesto declaring his determination to create in the face of the deprivation and death surrounding him. This is echoed in his poem memorializing Schul:

The core is freedom, the goal is love,
the purpose is beauty—transform desires!

who in the future will understand our sounds?

These same feelings of defiance and pain can be heard in Ullmann's Third String Quartet op. 46. The fugue in the third movement is filled with a dark, lifeless despair followed much later by the two violins screaming the quartet's main musical motif in the coda of the *Rondo Finale* movement. Ullmann completed the quartet in late January 1943, the month his son Paul died. My colleagues in the Hawthorne Quartet and I truly immersed ourselves in this quartet, recording it twice and performing it well over three hundred times. Like his writings, this work provides a window into the inner anguish and creative determination of Ullmann and his fellow prisoners [images 229–233].

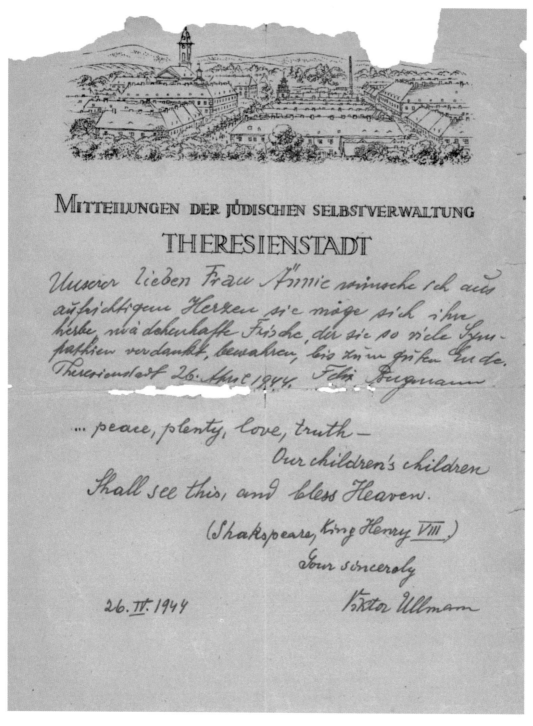

MITTEILUNGEN DER JÜDISCHEN SELBSTVERWALTUNG

THERESIENSTADT

Unserer lieben Frau Ännie wünsche ich aus aufrichtigem Herzen sie möge sich ihre herbe, mädchenhafte Frische, der sie so viele Sympathien verdankt, bewahren, bis zum guten Ende. Theresienstadt 26. April 1944. Felix Bugmann

... peace, plenty, love, truth —

Our children's children

Shall see this, and bless Heaven.

(Shakspeare, King Henry VIII.)

Your sincerely

Viktor Ullmann

26. IV. 1944

229. Handwritten document on letterhead with the heading "Notifications of the Jewish Self Government." ZM #327. Viktor Ullmann's dedication to Anna Witrofská reads, "To our dear Mrs. Anna I most sincerely hope that she will preserve her tart, girlish freshness, which has earned her so many sympathies, until a good end. Theresienstadt 26. April 1944," and includes the English verse form Shakespeare's Henry VIII. Anna Witrofská wrote a collection of poems in Terezín. She was liberated in Terezín.

288

GOETHE AND GHETTO[4]

Meaningful models shape the "habitus"—one's way of being in the world, the character of life—for generations to follow. It seems to me that for the past 150 years Goethe has determined the mindset of the educated European in everything that constitutes language, worldview, the human relationship to life and art, to work and pleasure. One symptom of this is that everyone likes to reference Goethe, even when their ideologies may be as dialectically opposed as possible. (The second great influence—to a certain extent the first's antithesis, its countercurrent—stems from Darwin and Nietzsche.)

Thus it has always seemed to me that Goethe's maxim "Live in the moment, live in eternity" entirely revealed the mysterious meaning of art. Painting—as in the still life, for example—snatches the ephemeral, transient thing or the quickly wilting flower, the landscape, the human face and figure, or the significant historical moment of transient-ness. Music does the same for everything pertaining to the soul, for human emotions and passions, for the "libido" in its broadest sense, for Eros and Thanatos. It is from this position that "form"—as it is understood by Goethe and Schiller—is able to surmount "substance."

For me, Theresienstadt was and is a school of form. Previously, in times when one didn't feel the force and burden of material life because comfort—that magic of civilization—suppressed it, it was easy to create a beautiful form. Here, where one has to overcome substance through form in one's daily life, where everything artistic is in complete contrast to the surroundings: Here is the true master class, if one finds, as Schiller did, that the secret of the work of art lies in eradicating substance through form—and presumably that is the human mission in general, the mission not only of aesthetic but also of ethical humans.

I have written quite a lot of new music in Theresienstadt, mostly to fulfill the needs and wishes of conductors, directors, pianists, singers and therefore the ghetto's need for leisure-time activities. To list them seems to me as pointless as emphasizing that as long as there were no instruments, one could not play the piano in Theresienstadt. The severe shortage of staff paper will probably also be uninteresting to future generations.[5] I would only like to emphasize that my musical work was fostered and not inhibited by Theresienstadt, and that we in no way merely sat around lamenting by the banks of Babylon's rivers, and that our desire for culture was equal to our will to live. And I am convinced that all those who have endeavored in both life and art to wrest form from resisting substance would agree with me.

Goethe und Ghetto

von Viktor Ullmann

Bedeutende Vorbilder prägen den folgenden Generationen ihren "Habitus", ihren Lebensduktus auf. So scheint es mir, dass die Haltung des gebildeten Europäers seit 150 Jahren von Goethe bestimmt wird in allem, was Sprache, Weltanschauung, Verhältnis des Menschen zum Leben und zur Kunst, zu Arbeit und Genuss ist.
Ein Symptom dafür ist, dass sich jeder gerne auf Goethe beruft, sei die dialektische Ideologie noch so verschieden.(Der zweite grosse Einfluss, gewissermassen die Antithese, die Gegenströmung, kommt von Darwin und Nietzsche.)
So schien mir Goethes Maxime:"Lebe im Augenblick, lebe in der Ewigkeit"immer den rätselhaften Sinn der Kunst ganz zu enthüllen.Malerei entreisst,wie im Stilleben das ephemere, vergängliche Ding oder die rasch welkende Blume,so auch Landschaft,Menschenantlitz und Gestalt oder den bedeutenden geschichtlichen Augenblick der Vergänglichkeit,Musik vollzieht dasselbe für alles Seelische,für die Gefühle und Leidenschaften des Menschen,für die "libido" im weitesten Sinne,für Eros und Thanatos.Von hier aus wird die "Form",wie sie Goethe und Schiller verstehen,zur Überwinderin des "Stoffes".
Theresienstadt war und ist für mich Schule der Form.Früher,wo man Wucht und Last des stofflichen Lebens nicht fühlte,weil der Komfort,diese Magie der Zivilisation,sie verdrängte,war es leicht,die schöne Form zu schaffen.Hier,wo man auch im täglichen Leben den Stoff durch die Form zu überwinden hat,wo alles Musische in vollem Gegensatz zur Umwelt steht:Hier ist die wahre Meisterschule,wenn man mit Schiller das Geheimnis

des Kunstwerks darin sieht:den Stoff durch die Form zu vertilgen-was ja vermutlich die Mission des Menschen überhaupt ist,
nicht nur des aesthetischen,sondern auch des ethischen Menschen.

 Ich habe in Theresienstadt ziemlich viel neue
Musik geschrieben,meist um den Bedürfnissen und Wünschen von
Dirigenten,Regisseuren,Pianisten,Sängern und damit den Bedürfnissen der Freizeitgestaltung des Ghettos zu genügen.Sie aufzuzählen scheint mir ebenso müssig wie etwa zu betonen,dass man
in Theresienstadt nicht Klavier spielen konnte,solange es
keine Instrumente gab.Auch der empfindliche Mangel an Notenpapier dürfte für kommende Geschlechter ininteressant sein.
Zu betonen ist nur,dass ich in meiner musikalischen Arbeit
durch Theresienstadt g e f ö r d e r t und nicht etwa
gehemmt worden bin,dass wir keineswegs bloss klagend an Babylons Flüssen sassen und dass unser Kulturwille unserem Lebenswillen adäquat war;und ich bin überzeugt davon,dass alle,die
bestrebt waren,in Leben und Kunst die St Form dem widerstrebende
Stoffe abzuringen,mir Recht geben werden.

230. Viktor Ullmann's original manuscript "Goethe and Ghetto." 2 pages. NIOD.

WHILE LOOKING UPON SCHUL'S COFFIN[11]

Your life, it was but a brief *stretto* …
we accompany you to the border of the ghetto.
Do we want to trade and haggle with fate?
Faced by the furrows, the traces, the God-raked
in the fields of death, plowed by angels,
preserve reverence! Lives were enough!
The core is freedom, the goal is love,
the purpose is beauty—transform desires!

In the place where you are, we dwell daily.
We reach it in sleep, but it remains indescribable.
We return from the threshold of the ghetto—
Fate's boundary, it ends your *stretto*!
O, short are the arts and long are lives
and meagre is the harvest, as hard as we strive.
What do the sounds want, what makes me so afraid?
We search for the songs of forgotten angels.

Already shrill demons hiss at us,
the grail's shrine remains closed to us,
and games and dignity and melancholy and horror
vanish in the face of mocking, hellish whims …
They carry the coffins … hear children's screams!
A wagon pulls up and already it's gone—
Isn't that the little one, the little boy—O look!—
who in the future will understand our sounds?

And if you plucked the harp of the resonant sun
and lived in word and in wind and in wonder
and if you created witnesses through searing sounds—
as we go on without you, they will appease.
You did your work, your life was undone—
you will strive for the stars that resound.
But if one day you return to us from Saturn—
you will praise the luck of past fortune.

Bei Betrachtung von Schuls Sarg

Dein Leben, es war nur ein kurzes Stretto...
wir geleiten dich bis an die Marken des Ghetto.
Wollen mit Schickung wir feilschen und markten?
Vor den Furchen, den Spuren, den Gott-geharkten
im Acker des Todes, von Engeln gepflügten,
bewahret die Ehrfurcht! Die Leben genügten!
Das Mark ist die Freiheit, das Ziel ist die Liebe,
der Zweck ist die Schönheit-verwandelt die Triebe!

Und dort, wo du bist, verweilen wir täglich.
Wir erreichens im Schlafe, nur bleibt es unsäglich.
Wir kehren zurück von der Schwelle des Ghetto-
Des Schicksals Gemarkung, sie endet dein Stretto!
Ach, kurz sind die Künste und lang sind die Leben,
und karg ist die Ernte, so viel wir auch streben.
Was wollen die Töne, was wird mir so bang?
Wir suchen vergessener Engel Gesang.

Schon zischen uns schrille Dämonen hinein,
verschlossen nun bleibt uns des Grales Schrein
und Spiele und Würde und Wehmut und Grausen
zerrinnen vor höhnischen, höllischen Flausen...
Sie tragen die Särge...hört Kindergeschrei!
Ein Wagen fährt vor und schon ist er vorbei-
ist das nicht der Kleine, das Knäblein-o seht!-
das künftig die Töne, die unsern, versteht?

Und schlugst du die Harfe der tönenden Sonne
und lebtest im Wort und im Wind und in Wonne
und schufst du dir Zeugen in sehrenden Tönen-
sie werden, wenn wir dich entbehren, versöhnen.
Du wirktest die Werke, verwirktest dein Leben-
du wirst nach den Sternen, den tönenden, streben.
Doch kehrest du-einst vom Saturn uns zurück-
du rühmest vergangnen Geschickes Glück.

231. Viktor Ullmann's original manuscript "While Looking Upon Schul's Coffin" (poem). 1 page. NIOD.

SIGMUND SCHUL[6]

The composer Sigmund Schul has died at twenty-eight after a long lingering illness in Theresienstadt. One of those talents commonly called "great hopes" has left us. But Schul was more than a hope. Despite his youth, he possessed an astonishingly mature conception of music, and he created—in anticipation of forfeiting his blooming life all-too-soon—a series of works that we can confidently call fulfillments.[7]

Schul was a student of Hindemith and Hába; during the last few years, he also liked to talk with me about all kinds of problems pertaining to contemporary and classical music, about questions of form, of tonality and its deformation and subversion, about style, aesthetics, *Weltanschauung*,[8] and about many details of his works then in progress. He kept me informed during every phase of his new works and consulted with me by playing them for me as he was creating them. Thus I gained insight into the evolution of this absolutely rare personality whose true calling was for musical composition.

Schul was obviously still a "seeker," not a "priest" (in Weininger's sense).[9] How could it be otherwise when great masters remained seekers throughout the years of their maturest mastery, even throughout their high old age. Schul was initially close to the Expressionists; his ideal would probably be best described by the name Alban Berg. The initiated will know what that means. Alban Berg means the highest degree of responsibility toward the values of older music and the achievements of newer music, means strict self-discipline, the preservation of the soulful warmth and passion that has flowed into music since—and because of—the Romantic era, but it also means balancing that out with polyphonic-constructive work, a symmetry between musical feeling and thought. There are works in which Schul truly approaches this ideal; although it is not as if Schul resolved these problematic issues that still burden Berg's work...he was much too young for that. But he wrote works whose value is not diminished when they are evaluated according to the strict measure I have suggested here ... and that is huge!

Schul was doubly talented. He was also a poet, and here, too, a significant aptitude was exhibited by his rich, intensely lived nature. In his "*Gesänge an Gott*" ["Songs to God"]—which premiered in Prague—his musical and poetic poles are revealed in a beautiful symbiosis. These songs as well as his piano sonatas are most likely the closest to Expressionistic harmonies. Soon it became evident that he was striving to loosen and regain a more tender music oriented toward those poles, that is, music that is tonal in a new way, music that doesn't renounce consonant sounds—Alban Berg was also on the verge of making that change, as *Lulu* proves. (In *Wozzeck*, too, all the lyrical parts are oriented toward the tonal.) This loosening is shown in the flute sonatas, for example. He often said to me that my music kept the feeling for the problematic

Sigmund Schul

Der Komponist Sigmund Schul ist achtundzwanzigjährig nach langem Siechtum in Theresienstadt gestorben.Damit ist eine jener Begabungen von uns gegangen,die man gewöhnlich "grosse Hoffnungen" nennt.Schul war aber mehr als eine Hoffnung.Er war trotz seiner Jugend von einer erstaunlichen Reife der musikalischen Konzeption und er hat - sein allzubald verwirktes,blühendes Leben antizipierend- eine Reihe von Werken geschaffen,die wir getrost als Erfüllungen ansehen können.

Schul war Schüler Hindemiths und Hábas,er hat sich in den letzten Jahren auch gerne mit mir über alle Probleme der neuzeitlichen und klassischen Musik,über die Fragen der Formen, der Tonalität und ihrer Deformation und Ersetzung,über Stil, Aesthetik,Weltanschauung und viele Einzelheiten seiner eben im Entstehen begriffenen Werke unterhalten.Er pflegte mich auf dem Laufenden zu halten über alle Phasen seiner neuen Werke und sich mit mir zu beraten,indem er sie mir schon während der Entstehung vorspielte.So gewann ich Einsicht in das Werden dieser durchaus seltenen,zum musikalischen Schaffen berufenen Persönlichkeit.

Selbstverständlich war Schul noch ein "Sucher",kein "Priester" (im Sinne Weiningers).Wie sollte es auch anders sein,da grosse Meister es bis in die Jahre reifster Meisterschaft,ja bis in ihr hohes Alter blieben.Schul stand zunächst dem Expressionismus nahe,sein Ideal dürfte am besten mit dem Namen Alban Berg bezeichnet werden.Der Eingeweihte weiss,was das bedeutet.Alban Berg heisst höchste Verantwortung gegenüber den Werten der älteren und den Errungenschaften der neueren Musik,heisst strenge Selbstdisciplin, Bewahrung der seit und durch die Romantik in die Musik einfliessenden Seelenwärme und Leidenschaftlichkeit,aber deren Ausgleich in polyphon-konstruktiver Arbeit,Gleichmass zwischen musikalischem Fühlen und Denken.Es gibt Werke,in denen Schul diesem Ideal wirklich näher kommt;nicht,als ob er jene Problematik,die ja auch noch Bergs Werk belastet,gelöst hätte,..dazu war er ja viel zu jung. Aber er schrieb Werke,die vor solch strengem Masse,wie ich es angedeutet habe,ihren Wert nicht verlieren..und das ist viel!

Schul war eine Doppelbegabung.Er war auch Dichter und auch hier zeigte eine reiche,intensiv erlebende Natur bedeutende Anlagen.In seinen -in Prag uraufgeführten- "Gesängen an Gott" offenbaren sich sein musikalischer und dichterischer Pol in schöner Symbiose.Diese Lieder sowie seine Klaviersonate dürften der expressionistischen Harmonik am nächsten stehen.Bald zeigte sich ein Streben nach Auflockerung und Wiedergewinnung einer sanfteren,polar gerichteten,d.h.in neuer Weise tonalen Musik,die mindestens auf konsonante Klänge nicht Verzicht leistet-auch Alban Berg stand im Begriffe zu dieser Wendung,wie "Lulu" bezeugt.(Auch im Wozzek sind alle lyrischen Teile tonal orientiert.)Jene Auflockerung zeigt z.B.die Flötensonate.Er hat mir oft gesagt,dass meine Musik in ihm das Gefühl für die Problematik des reinen Expressionismus lebendig erhalte.Am Deutlichsten wendete sich Schul wohl zur Tonalität in seinem Theresienstädter Werke für Streichquartett, den Variationen über ein hebräisches Volkslied (Divertimento ebraico). -Wir haben an Schul eine wirkliche Persönlichkeit verloren,eine wirklich s t r e b e n d e Künstlerpersönlichkeit.Es ist nicht die Phrase eines Nachrufes,die damit gemeint ist wenn ich sage,dass er das volle Recht dazu hatte,kurz vor seinem Tode zu äussern:"Es ist schade um mich!" Es war die Wahrheit.

 Viktor Ullmann

232. Viktor Ullmann's original manuscript "Sigmund Schul." 1 page. NIOD.

295

issues of pure Expressionism alive in him. Schul probably turned most clearly toward tonality in his Theresienstadt work for string quartet, the variations on a Hebrew folk song (*Divertimento ebraico*) [image 233].

With Schul we have lost a true personality, a truly aspiring artistic personality. It is no eulogy cliché if I say that he was absolutely justified when he uttered shortly before his death: "What a pity this is what has come of me!"[10] It was the truth.

233. Poster. *Studio für neue Musik* ("Studio for New Music"). HCPT #3950. *In this second concert, Ullmann served the dual role of artistic director and critic. He selected Sigmund Schul's "Divertimento Ebraico" for a concert titled "Young Composers in Theresienstadt" as part of his Studio for New Music chamber series.*

Annotations

1 In the NOID archives the "Goethe and Ghetto" manuscript is placed between *Kritik 11: Klavier-abend Alice Sommer-Herz* (Critique 11: Alice Sommer-Herz Piano Evening) and *Kritik 12: Die Švenk-Première* (Critique 12: The Švenk Première).

2 In the NOID archives the manuscript of this poem follows Ullmann's tribute "Sigmund Schul." It is placed between *Kritik 15: Liederabend Karl Bermann* (Critique 15: Karl Bermann *Lieder* Evening) and *Kritk 16: La serva padrona* (Critique 16: *La serva padrona*).

3 **Paul Ullmann** died in Terezín on January 14, 1943.

4 In the NOID archives the "Goethe and Ghetto" manuscript is placed between *Kritik 11: Klavier-abend Alice Sommer-Herz* (Critique 11: Alice Sommer-Herz Piano Evening) and *Kritik 12: Die Švenk-Première* (Critique 12: The Švenk Première).

5 The scarcity and value of paper is highlighted by a touching story shared by survivors Eliska Kleinová and Dr. George Horner (interviews in Prague and Philadelphia with Mark Ludwig, 1990–2012). The composers Gideon Klein and Pavel Haas arrived on the early December 1941 transports to Terezín. Before his incarceration, Haas divorced his wife, who was not Jewish, to save her and their baby daughter from the transports. Understandably, Haas had little desire to participate in the musical community within the camp. In an attempt to engage and encourage Haas, the young Gideon Klein shared sheets of paper on which he had drawn musical staves.

6 In the NOID archives the manuscript is placed between *Kritik 15: Liederabend Karl Bermann* (Critique 15: Karl Bermann *Lieder* Evening) and *Kritk 16: La serva padrona* (Critique 16: *La serva padrona*).

7 His surviving Terezín works include: *Two Chassidic Dances* for viola and cello; *Tzaddik* for string quartet; *Cantata Judaica* op. 13 for Tenor and choir; "*Ki tavoa al-ha'aretz*" ("When You Will Go to the Land") for boys choir; "*Uv'tzeil K'nofecho*" ("In the Shadow of Your Wings") for string quartet; "*V' l'Yerushalayim*" for voice and string quartet; "*Schiksal*" for Alto, flute, viola, and violincello; and Duo for violin and viola.

8 *Weltanschauung* (Eng: world view) is an individual's view or philosophy of the world and life.

9 **Otto Weininger** (1880–1903). Austrian philosopher known for his book *Geschlecht und Charakter* (*Sex and Character*). Weininger committed suicide in the house where Beethoven died—he considered Beethoven the ultimate genius. His suicide launched the book's initial success. Ullmann refers to Weininger's article "*Sucher und Priester*" ("Seeker and Priest") printed in the Viennese journal *Die Fackel* in 1903. He perceived the artist as a "seeker-priest." Widely read within the Schönberg circle, Alban Berg and Anton Webern referred to Schönberg as the priest. Ironically, Weininger's works are generally considered anti-Semitic and misogynistic.

10 Schul's dying words: "*Es ist schade um mich*" literally translates "Too bad about me." As so often is the case, there is much lost in a literal translation. It would certainly not do justice to the spirit of both Schul and the poignant close to Ullmann's tribute. Schul is lamenting not so much his death at such at young age, but his lost opportunity to compose more music.

11 In the NOID archives the manuscript of this poem follows Ullmann's tribute "Sigmund Schul." It is placed between *Kritik 15: Liederabend Karl Bermann* (Critique 15: Karl Bermann *Lieder* Evening) and *Kritk 16: La serva padrona* (Critique 16: *La serva padrona*).

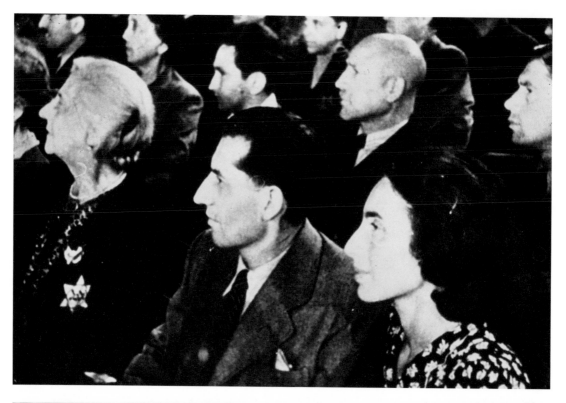

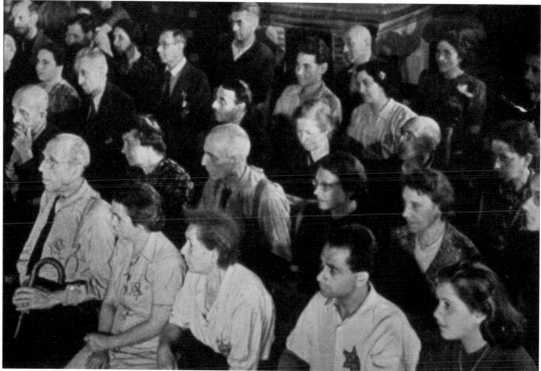

234. Two stills from the Nazi propaganda film, "*Theresienstadt, A Documentary Film from the Jewish Settlement Area.*" ZM #22077. *Prisoners listening to a performance.*

CODA
Mark Ludwig

I am haunted by the faces of the prisoners in the audience and chamber orchestra appearing in the 1944 Nazi propaganda film. The vast majority were weeks away from being sent to the gas chambers of Auschwitz. For them, these moments offered the last music they would hear or perform [images 234, 236].

In a career of both performing and attending concerts, I have often found myself watching the impact of the music on both audience members and artists. We all enter the hall filled with a multitude of emotions and concerns. Yet, on rare occasions, the music offers us moments of complete transcendence; the hall becomes a sanctuary elevating us from the weight of daily life. It is a portal into the sublime, beyond the space and time we inhabit.

I see this occurring in stills from the propaganda film. The image of the audience listening to music has resonated with me on many occasions. In October 1991, my quartet performed Gideon Klein's String Trio, his masterpiece and final work, in Terezín.[1] The foreboding second movement is based on a Moravian folksong[2] Klein's nanny sang to him in his childhood. Completed just days before his transport to Auschwitz, it would become his final creative testament. I will never forget looking out at the faces in the audience—some with their eyes closed, others in tears, moved by the music, the story it embodies, and fate of this composer.

With his critiques, Ullmann shows us how much music meant to audiences in Terezín. He also provides a sobering and chilling reminder that alongside the transcendent moments, there always lurked the awareness that artists and audiences alike would be sent to the East at any time.

It has been, thus far, the peculiar fate of our chamber music groups to be like meteors: they flash by promisingly and then disappear. In each new instance, there is nothing left to do but hope that this time it might be different. And this time it would be particularly disappointing if it [referring to the piano trio of Gideon Klein, Pavel Kling, and Friedrich Mark] remains merely a promise, and if that promise is not kept.[3]

The faces in the film show the toll of this uncertainty and the dark reality of life in the camp—even as they poignantly capture the experience of transcendence that momentarily banished the destruction all around them.

Ullmann periodically draws our attention to those artistic "meteors"—the next generation of promising talents.

Gideon Klein is without doubt a very important talent. His style is that of the new youth—cool and objective... Our youth has strong intelligent brains; hopefully they can lift the heart up into the head.[4]

Among the singers we discovered a true talent for both acting and singing: R. Fuchs. One should keep an eye out for her.[5]

It is surprising that Fritz Königsgarten hasn't yet discovered his voice. It is like a gold ore in a mineshaft.[6]

Ullmann holds great hopes for these young, gifted artists. Tragically—as attested in many of this book's annotations—most were murdered before their talents could ever be fully realized. A generation of creativity and mentorship was erased.

Through Ullmann's critiques and the Heřman collection, these gifted artists step out of the shadows of annihilation and remind us how precious and vital the arts are to our humanity. Perhaps there is one more lesson: the importance of finding one's voice, listening to those among us, and ultimately resisting efforts to suppress them.

Distinguished psychoanalyst and Auschwitz survivor Dr. Anna Ornstein wrote,

I would maintain that these activities, in addition to providing moments of experiences of pride, vigor, and aliveness, also represented resistances to cultural genocide; they helped maintain a thread of continuity of the culture of a people who were slated not only for physical but also for complete cultural and spiritual destruction.

In ghettos in particular, cultural activities provided opportunities to strengthen internalized values and ideals when the need for such values was greater than ever. The capacity to preserve deeply internalized values meant that degraded and physically and emotionally abused prisoners could retain their sense of continuity that reached into their past and could—potentially—be transmitted to future generations.[7]

235. Zuzana Růžičková at her desk in Prague, May 2012. Photograph by Mark Ludwig. TMF.

It is only fitting that two survivors who performed in Terezín close this book:

Zuzana Růžičková would often remind me, "Music kept me alive through Terezín and Auschwitz" [image 235].

Dr. George Horner, who at age ninety gave his Symphony Hall debut in Boston, playing cabaret tunes by Karel Švenk with Yo-Yo Ma, turned to me and said, "See, I made it here … I am alive because of music."

Annotations

1 The performance marked the commemoration of the fiftieth anniversary of the first transport to Terezín. President Václav Havel and Israeli President Chaim Herzog were joined by diplomats, government officials, and several hundred Terezín survivors and their descendants.

2 The Moravian folksong, *"Ta kněžzdubská vezža"* ("Kněžzdubská Tower") tells of a goose who is shot by a hunter. As she falls to earth she wonders what will happen to her goslings. Filmed interviews with Zuzana Růžičková and George Horner speaking about the folksong and recalling their memories of Gideon Klein are available at www.terezinmusic.org

3 Critique 21: "Gideon Klein, Paul Kling, Friedrich Mark Piano Trio"

4 Critique 7: "Gideon Klein Piano Evening"

5 Critique 9: "A Musical Panorama (II.)"

6 Critique 23: "Fritz Königsgarten *Lieder* Evening"

7 **Dr. Anna Ornstein** is a former Lecturer in Psychiatry at Harvard, and Professor Emerita of Child Psychology at the University of Cincinnati. From her paper titled "Artistic Creativity and the Healing Process." *Psychoanalytic Inquiry*, 26: 657–69.

236. Still from the Nazi propaganda film, *"Theresienstadt, A Documentary Film from the Jewish Settlement Area."* Terezín, 1944. ZM. *The image shows conductor Karel Ančerl, composer Pavel Haas, and Terezín musicians acknowledging applause after a performance of the Pavel Haas Studie for String Chamber Orchestra (1943).*

237. Poster. Benefit Concert for Terezín. Photograph by Mark Ludwig. *Benefit concert directed and produced by Mark Ludwig to raise funds to restore Pamatník Terezín after it was severely damaged by the historic summer floods of 2002. The concert received the patronage of President Václav Havel and Ambassador Craig R. Stapleton of the United States Embassy to the Czech Republic. The program featured works by Czech composer Josef Suk; Terezín composers Hans Krása, Gideon Klein, and Viktor Ullmann; and American composer David L. Post.*

302

ACKNOWLEDGEMENTS

This book would not have been possible without the insight and generosity of several extraordinary people I have had the great fortune to know in my life. My heartfelt thanks to Edgar Krasa, Dr. George Horner, Zuzana Růžičková, Dagmar Lieblová, and Eliska Kleinová, all Terezín survivors who were critical to the special alchemy of translating the spirit and flavor of Ullmann's writings from the original German into English.

Many additional survivors of Terezín provided invaluable testimonies for the introductory essay and annotations throughout this book, and I am indebted to them as well:

Karel Berman	Ivan Klima
Ruth Bondy	Pavel Kling
George Brady	Hana Krasa
Dr. Anita Franková	Michael Kraus
Doris Grozdonovičová	Dasha Lewin
Michael Gruenbaum	Anna Lorencová
Olga Haasová	Leopold Lowy
Akiba Hermann	Arnošt Lustig
Alice Herz-Sommer	Hana Reinerová
Lili R. Horner	Fred Terna
Helga (née Weissová) Hošková	Ela Weissberger

Sadly, this is a posthumous note of gratitude for most of these wonderful souls who so graciously shared their guidance, support, and friendship. May their memory be a blessing and this book worthy of their contributions.

I am grateful to Lisa Schumann Harries for reviewing the final draft of our translation of Viktor Ullmann's Terezín writings—her enthusiasm coupled with her knowledge of European history and classical music shows in her nuanced eye and ear for Ullmann's text.

A debt of gratitude to directors Jan Roubinek and his predecessor, the late Jan Munk of Památník Terezín; Dr. Leo Pavlat of the Jewish Museum Prague; and Professor Dr. Frank van Vree, director of the Institute for War, Holocaust and Genocide Studies in Amsterdam, Netherlands. This extends to the devoted scholars and archivists of these venerable institutions, particularly Vojtěch Blodig, Martina Šiknerová, Tomáš Fedorovič, Petra Penicková, Daniela Bartakavá, Arno Parík, and Eduard Feuereis for their assistance in the research of this book and my previous Terezín projects spanning thirty years.

Many of these cherished relationships began during my 1996 Fulbright scholarship in the Czech Republic, which afforded me the opportunity to fully immerse myself in the archives of the Jewish Museum Prague and Pamatník Terezín while experiencing the rich Czech culture that nurtured so many of the Terezín artists. My Fulbright scholarship continues to inspire my work in international cultural and educational exchange.

I would also like to thank my dear friend, the late Christopher Hogwood CBE, for his scholarly guidance and review of this book in its early stages, through our many conversations in Prague, London, and Boston.

The musical tracks in *Our Will to Live* draw us into the world of music chronicled in Ullmann's critiques. I am grateful to Yo-Yo Ma, the Hawthorne String Quartet, Dr. George Horner, Thomas Martin, Karel Berman, Vytas Baksus, Annette Miller, and members of the Boston Symphony Orchestra for sharing their artistry in the soundtracks accompanying these critiques. It was my great privilege and joy to perform this repertoire with each and every one of them around the world.

My thanks to Lisa Pemstein and Cecilia Witeveen, along with Alexis Rizzuto and Will Myers for their line and copy editing. They gracefully and adroitly navigated the vast terrain of references within Ullmann's writings, which is a landscape of Western philosophy; classical, folk, and Jewish music; and European art, politics, and history. Throughout the process, they marveled at the extraordinary scope of Ullmann's intellect while I marveled at their infectious enthusiasm and commitment to this book.

Childhood visits with my mother to the famous and unfortunately long-gone Leary's Book Store in Philadelphia planted the seeds for a love not only for the content but also the feel, design, and smell of a book. It invariably led to envisioning this project as not only a work of art but also an homage to the Terezín artists.

A book filled with the inspiring elements of art, music, and history while bearing witness and remembrance demanded a publisher outside conventional norms with unsurpassed creative skills in design and production. Thus, serendipity smiled when Bernie and Sue Pucker introduced me in March 2018 to Siegfried Schäfer and Cecilia Witteveen, founding directors of Art-Archives.net/Kunst-Archive.net. From that moment a new chapter to the book's journey was launched, its path forged as Siegfried championed the project to legendary master printer Gerhard Steidl. Siegfried has been this book's guardian angel. I can only compare my ensuing collaboration with Gerhard, Siegfried, and Holger Feroudj to performing chamber music at its highest and most sublime level. It is with great pride and joy that this book joins the celebrated pantheon of Steidl Verlag.

This endeavor would not have been possible without the support of Cynthia and Oliver Curme, Iris Fishman and Jay Fialkoff and The Omer Foundation, Penny and Claudio Pincus, Carol (in memorium) and Joe Reich, Elaine (in memorium) and Robert Baum, Terezín Music Foundation staff member Debora Ramos, and the many TMF volunteers. Their unwavering support and commitment ensured this dream took flight.

Special thanks go out as well to Stephen Falk and Paul Finnegan for their sage legal counsel and unwavering friendship over many, many years.

I close thanking my wife, Kate; our teenage daughter, Sarah; and our rambunctious five-year-old, Asher. Through the lengthy process of working on such a dark and painful period of history they were constant reminders of the blessings of family, comfort, support, and love.

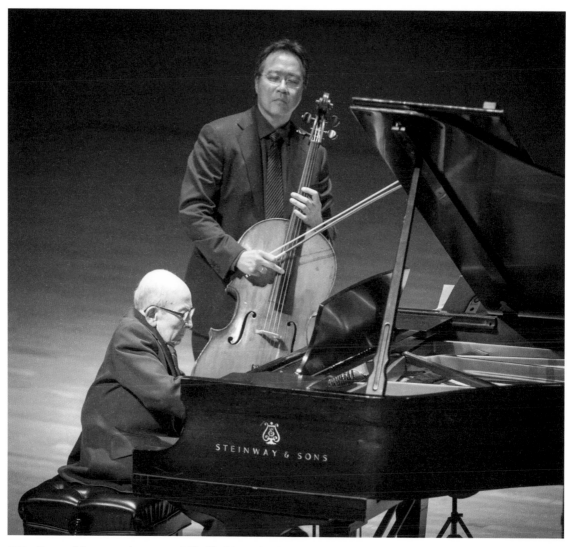

238. George Horner performing with Yo-Yo Ma at the October 22, 2013 Terezín Music Foundation Gala concert in Symphony Hall, Boston. Photograph by Michael J. Lutch. TMF.

MUSIC TRACKS

The musical tracks I have selected for *Our Will to Live* offer a companion to Viktor Ullmann's writings. They fall into two categories: those of historic significance, and those that came to hold a special place in my heart and memory. In some cases, the historic and personal are deeply intertwined.

Pavel Haas composed *Four Songs on Chinese Poetry* in 1944 for fellow prisoner and noted baritone Karel Berman. In 1991, I had the memorable experience of performing two concerts with Berman in Terezín and Prague. In these two programs commemorating the fiftieth anniversary of the first Terezín transport, Berman sang this heartbreaking song cycle by Haas. Fortunately, it was recorded by Czech Radio, as was the Piano Sonata by Gideon Klein.

While incarcerated in Terezín, George Horner performed cabaret tunes composed by Karel Švenk on piano and accordion. The tunes survived the war only in his memory. I had the great pleasure of knowing George, and, over the course of several years, I was able to convince him to notate this music and perform it in public. The first performance was in my parents' living room in Ardmore, Pennsylvania, more than sixty years after he first played the tunes as a Terezín prisoner. The second performance came a few years later, when George, at the tender age of ninety, debuted them with Yo-Yo Ma at Symphony Hall in Boston. It brought down the house [image 238].

Two soundtracks from the 1944 Nazi propaganda film produced in Terezín add a haunting dimension to the text and artwork in this book. For three minutes, several gifted children and adult artists step out from the pages of Ullmann's critiques to perform the Finale from Hans Krása's children's opera *Brundibár* and Pavel Haas's "Studie" for String Chamber Orchestra. Erwin Schulhoff's 1928 recordings offer yet another glimpse of this lost world of great artistic potential.

Hans Krása's Passacaglia and Fugue for string trio was the last work he completed before he was sent to the gas chambers of Auschwitz. The sonorous opening lamentation of the Passacaglia is arguably among the most touching moments in chamber music. Another final opus and masterpiece is Gideon Klein's String Trio. The second movement is a theme and variations on a Moravian folk song his nanny had sung to him in his childhood. I will never forget survivor Zuzana Růžičková singing the song and telling me its story of a mother goose who has been shot. As she is falls to earth, she worries over the fate of her goslings. Klein completed the score days before his transport to Auschwitz. Several of the remaining tracks were recorded in Tanglewood, Prague, and Terezín. All twenty-nine tracks represent a dimension of each composer's unique voice and gifts.
I hope that listening to this music deepens your experience and desire to further explore the music of Viktor Ullmann and his fellow Terezín composers.

MUSIC TRACKS

 This QR code brings you to the Terezín Music Foundation website page offering these tracks for listening, at www.terezinmusic.org.

1 Josef Suk, "Meditation on the Old Czech Chorale, 'Saint Wenceslas'" op. 35 [07:11]
Hawthorne String Quartet
Suggested listening for Viktor Ullmann Critiques 1, 7, 14, 23

2 Hans Krása, Passacaglia and Fugue for String Trio (Terezín, 1944) [09:37]
Si-Jing Huang, violin
Mark Ludwig, viola
Sato Knudsen, cello
Suggested listening for Viktor Ullmann Critiques 3, 16, 17

3 Hans Krása, Finale from children's opera *Brundibár* [01:40]
Excerpt from the Nazi propaganda film *"Theresienstadt. Ein Dokumentarfilm aus dem jüdischen Siedlungsgebiet"* ("Theresienstadt. A Documentary from the Jewish Settlement Area") performed by children in Terezín, 1944. Courtesy of National Center for Jewish Film at Brandeis University.
Suggested listening for Viktor Ullmann Critiques 3, 16, 17

4-5 Gideon Klein, Duo for Violin and Cello
I—Allegro con Fuoco [06:31]
II—Lento [02:36]
Si-Jing Huang, violin
Sato Knudsen, cello
Suggested listening for Viktor Ullmann Critiques 3, 7, 18, 20

6 Gideon Klein, "Fantasie and Fugue" for String Quartet (Terezín, 1943) [08:15]
"Fantasie"
"Fugue"
Hawthorne String Quartet performing in Terezín Ghetto Museum.
Suggested listening for Viktor Ullmann Critiques 3, 7, 18, 20

7-9 Gideon Klein, Piano Sonata (Terezín, 1943) [10:09]
 Movement I—Allegro con Fuoco
 Movement II—Adagio
 Movement III—Allegro Vivace
 Přemsyl Charnát, piano
 November 1991 Czech Radio broadcast of a concert featuring Terezín
 composers in the Jewish Town Hall, Prague.
 Suggested listening for Viktor Ullmann Critiques 3, 7, 18, 20

10-12 Gideon Klein, String Trio (Terezín, 1944)
 Movement I—Allegro [02:19]
 Movement II—Theme and Variations [07:17]
 Movement III—Molto Vivace [03:04]
 Ronan Lefkowitz, violin
 Mark Ludwig, viola
 Sato Knudsen, cello
 Suggested listening for Viktor Ullmann Critiques 3, 7, 18, 20

13-16 Pavel Haas, *Four Songs on Chinese Poetry* (for Karel Berman)
 (Terezín, 1944) [14:11]
 "I Heard the Cry of the Wild Geese" (Wei Ying-wu)
 "In the Bamboo Grove" (Wang Wei)
 "Far is My Home, O Moon" (Zhang Chiu-Ling)
 "A Sleepless Night" (Han Yu)
 Karel Berman, baritone
 Přemsyl Charnát, piano
 November 1991 Czech Radio broadcast of a concert featuring Terezín
 composers in the Jewish Town Hall, Prague.
 Suggested listening for Viktor Ullmann Critiques 8, 14, 15.

17 Pavel Haas, String Quartet No. 2, Op. 7 [08:47]
 Movement IV—"A Violent Night"
 Hawthorne String Quartet
 Will Hudgins, percussion
 Suggested listening for Viktor Ullmann Critiques 8, 14, 15

18 Pavel Haas, "Studie" for String Chamber Orchestra [02:01]
 Excerpt from the Nazi propaganda film *"Theresienstadt. Ein Dokumentarfilm*
 aus dem jüdischen Siedlungsgebiet" ("Theresienstadt. A Documentary from the
 Jewish Settlement Area") performed by prisoners conducted by Karel Ančerl
 in Terezín, 1944.
 Suggested listening for Viktor Ullmann Critiques 8, 14, 15

19 Sigmund Schul, "In the Shadow of Your Wings" for String Quartet
 (Terezín, 1942) [02:24]
 Hawthorne String Quartet
 Suggested listening for Viktor Ullmann Critique 10,
 Additional Terezín Writings

20 Sigmund Schul, "Chassidic Dance" (Terezín, 1942) [01:06]
 Mark Ludwig, viola
 Sato Knudsen, cello
 Suggested listening for Viktor Ullmann Critique 10,
 Additional Terezín Writings

21-24 Erwin Schulhoff, String Quartet No. 1
 Movement I—Presto con fuoco [02:28]
 Movement II—Allegretto con moto e con malinconia [04:31]
 Movement III—Allegro giocoso alla slovacca [02:56]
 Movement IV—Andante molto sostenuto [07:10]
 Hawthorne String Quartet
 Suggested listening for Viktor Ullmann Critique 11

25 Erwin Schulhoff, "Tempo di Fox a la Hawaii" (Berlin, 1928) [02:00]
 Erwin Schulhoff, piano
 Suggested listening for Viktor Ullmann Critique 11

26 Erwin Schulhoff, "Shimmy-Jazz: Jolie tambour, donne-moi ta rose"
 (Berlin, 1928) [01:04]
 Erwin Schulhoff, piano
 Suggested listening for Viktor Ullmann Critique 11

27 Viktor Ullmann, Third String Quartet (Terezín, 1943) [13:38]
 Hawthorne String Quartet
 Suggested listening for Viktor Ullmann Critique 3

28 Viktor Ullmann, *The Lay of the Love and Death of Christoph Rilke* for
 Recitation and Piano (Terezín, 1944) [29:29]
 Mark Ludwig, director
 Annette Miller, recitation
 Vytas Baksys, piano
 Suggested listening for Viktor Ullmann Critique 3

29 Karel Švenk, "Why Does the Black Man Sit at the Back of the Car?"
 (Terezín, 1943) [01:16]
 Arrangement by David L. Post
 Thomas Martin, clarinet
 Hawthorne String Quartet
 Suggested listening for Viktor Ullmann Critique 12

30 Karel Švenk, "Why Does the Black Man Sit at the Back of the Car?"
 (Terezín, 1943) [01:06]
 Performed by Terezín survivor Dr. George Horner, piano
 Suggested listening for Viktor Ullmann Critique 12

31 Karel Švenk, "Why Does the Black Man Sit at the Back of the Car?"
 (Terezín, 1943) [01:21]
 Yo-Yo Ma, cello
 Dr. George Horner, piano
 Suggested listening for Viktor Ullmann Critique 12

32 Karel Švenk, "Terezín Strut" (Terezín, 1943) [01:38]
 Yo-Yo Ma, cello
 Dr. George Horner, piano
 Suggested listening for Viktor Ullmann Critique 12

33 Karel Švenk, "Terezín March" (Terezín, 1943) [01:35]
 Yo-Yo Ma, cello
 Dr. George Horner, piano
 Suggested listening for Viktor Ullmann Critique 12

34 Karel Švenk, "Lullaby" (Terezín, 1943) [02:27]
 Yo-Yo Ma, cello
 Dr. George Horner, piano
 Suggested listening for Viktor Ullmann Critique 12

Music mastered by James Donahue.
Additional music samples, survivor testimonies, and information on the artists performing
in *Our Will to Live* recordings are available at www.terezinmusic.org.

APPENDIX

A NOTE ON TRANSLATION AND ANNOTATIONS
Mark Ludwig

The fate of Viktor Ullmann and most of the artists he wrote about adds a special dimension of responsibility to this translation. Undertaking it evolved into a collaboration with a uniquely qualified group of people: Terezín survivors Edgar Krasa, Dr. George Horner, the world-renowned harpsichordist Zuzana Růžičková, Dagmar Lieblová, and Eliska Kleinová. I reached out to them because they knew, listened to, and in some cases performed with many of the artists in the concerts Ullmann critiqued.[1]

Our process spanned several years and involved many phone calls and visits to their homes in Prague and the suburbs of Philadelphia and Boston. These were experiences I will always cherish. Quite often, our conversations would result in the recollection of precious new memories that enriched our understanding of the history of cultural activities in the camp. Many direct quotations from these survivors made their way into the introductory essay and Critique annotations.

Though we were reluctant to alter Ullmann's voice in any way, we decided that meaning at times took precedence, and applied the rare comma or semicolon as required to lend clarity to his thinking. In a few instances, we opted with great care to use a contemporary English equivalent for a word or phrase. As living links to this lost world, my colleagues were committed to preserving and conveying the flavor of Ullmann's writings for the reader in English.

There are a few instances where Ullmann writes rather lengthy and winding sentences knitting knowledge from a variety of disciplines—history, philosophy, the arts, and politics—into his observations about the music and performances in a given Critique. We elected not to simplify these by breaking them up into separate sentences. The scarcity of paper in the camp and instances where Ullmann pencils in edits make it unlikely that he had the luxury of writing preliminary drafts before a final version. More importantly, Ullmann's long sentences provide an opportunity to follow his train of thought and add a sense of immediacy to the Critiques and the performances he chose.

Wherever Ullmann notes musical works, we have accompanied titles in the original German, Czech, or other languages with English translations.

My annotations are meant to serve as a helpful companion in navigating the wealth of musical, literary, and historical references throughout Ullmann's critiques. Rather than being exiled to the back of this book, the annotations reside among the critiques and artwork to preserve a flow with these musical moments. The Nazis' dehumanizing process of assigning transport numbers to individuals stands in stark contrast to Ullmann's critiques, where he brings forth the spirit and artistry of those musicians. Edgar Krasa often noted in Holocaust education classes we conducted together, "As long as I live I will continue to mention the names of Rafael Schächter, Gideon Klein, Viktor Ullmann … There are others I will mention later. There is no tombstone or monument for Schächter, for

any of them. But saying their names aloud keeps them among us." In that spirit, I have annotated every person noted in the critiques, providing their transport information accompanied by background on their lives before and during their incarceration in Terezín.[2]

Annotations

1 Several members of this Czech-born group grew up with German as their first tongue. Dr. Horner recalled speaking only German in his parents' home as a means towards higher education and assimilation.
2 The archives of the Jewish Museum in Prague and Památník Terezín were primary sources for the artists' transport information to Terezín, Auschwitz, and other camps.

239. Stolperstein (English: stumbling block) of Viktor Ullmann. German artist Gunter Demnig began the Stolperstein project in 1992, and by 2021 had laid more than 75,000 of these brass-plated markers honoring victims of the Holocaust. Each is set into the pavement at the person's last known place of residence or work before they fell victim to the Nazis. Ullmann's Stolperstein reads: Composer/conductor. Born 1898. Deported to Theresienstadt September 8, 1942. Death in Auschwitz, October 18, 1944.

A NOTE ON DATA AND SOURCE ABBREVIATIONS

Deportation transport data
Wherever possible, annotations introducing Terezín prisoners document their registration numbers and deportation transport designations as they were sent to and from Terezín, e.g. for Hans Krása: **No. 67 on Transport Ba** from Prague to Terezín on August 10, 1942, and **No. 940 on Transport Er** from Terezín to Auschwitz on October 16, 1944.

Image identification
Captions show description or title, use, subject, artist if known, date if known, and the work's current location or source with its inventory or catalog number if assigned. Information is taken directly from its archives' catalogs. Additional notes are written by Mark Ludwig; these appear in italics. All works are on paper except as noted. Most artworks on paper in the Heřman collection measure about 20 x 30 cm (8 x 12 inches).

Source abbreviations
HCPT: Heřman Collection in Památník Terezín archives
ML: Collection of Mark Ludwig
LBI: Leo Baeck Institute
NIOD: Instituut voor Oorlogs, Holocaust en Genocide Studies,
 Amsterdam, Netherlands, archives
PT: Památník Terezín archives
TMF: Terezín Music Foundation archives
USHMM: United States Holocaust Memorial Museum
Critique(s): Viktor Ullmann critique numbers
VUF: Viktor Ullmann Foundation
ZM: Jewish Museum Prague archives
NGP The National Gallery of Prague

BIBLIOGRAPHY AND SOURCES

Adler, H. G. *Theresienstadt 1941–45: The Face of a Coerced Community*. Edited by Amy Loewenhaar-Blauweiss. Translated by Belinda Cooper. Cambridge: Cambridge University Press, 2017.

Albright, Madeleine. *Prague Winter: A Personal Story of Remembrance and War, 1937–1948*. New York: Harper Perennial, 2013.

Baker, Leonard. *Days of Sorrow and Pain: Leo Baeck and the Berlin Jews*. New York: Oxford University Press, 1978.

Bauer, Yehuda. *Rethinking the Holocaust*. New Haven: Yale University Press. 2001.

Bek, Josef. *Erwin Schulhoff: Leben und Werk*. Hamburg: Von Bockel Verlag, 1994.

Beneš, František, and Patricia Tošnerová. *Mail Service in the Ghetto, 1941–1945*. Prague: Profil Dum Filatelie, 1996.

Benz, Wolfgang. *Theresienstadt: Eine Geschichte von Täuschung und Vernichtung*. Munich: C.H. Beck, 2013.

Berkley, George E. *Hitler's Gift: The Story of Theresienstadt*. Wellesley: Braden, 2002.

Blodig, Vojtech. *Art Against Death: Permanent Exhibitions of the Terezín Memorial in the Former Magdeburg Barracks*. Prague: Publishing House Helena Osvaldová for the Terezín Museum, 2002.

Bondy, Ruth. *"Elder of the Jews": Jakob Edelstein of Theresienstadt*. New York: Grove Press, 1989.

Branson, Johanna, ed. *Seeing Through Paradise: Artists and the Terezín Concentration Camp*. Boston: Massachusetts College of Art, 1991.

Brenner, Hannelore. *The Girls of Room 28: Friendship, Hope, and Survival in Theresienstadt*. New York: Schocken Books, 2009.

Červinková, Blanka. *Hans Krása: Život a dílo skladatele*. Prague: Tempo, 2003.

Council of Jewish Communities in the Czech Lands, ed. *Terezín 1941–1945*. Prague: Selbstverlag, 1965.

Database of Victims of the Holocaust. Institute of the Terezín Initiative in cooperation with the Jewish Museum, Prague. Accessed through January 2018. www.holocaust.cz.

Davidson, Susie. *I Refused to Die: Stories of Boston-Area Holocaust Survivors and Soldiers Who Liberated the Concentration Camps of World War II*. Somerville: Ibbetson Street Press, 2005.

Davidowicz, Lucy. *The Jewish Presence*. New York: Hold, Reinhart, and Winston, 1977.

Demetz, Peter. *Prague in Black and Gold: Scenes from the Life of a European City*. New York: Hill and Wang, 1997.

Dwork, Deborah, and Robert Jan van Pelt. *Holocaust: A History*. New York: W.W. Norton, 2003.

Fantlová, Zdenka. *The Tin Ring: How I Cheated Death*. Newcastle: Northumbria University Press, 2010.

Friedlander, Albert H. *Leo Baeck: Teacher of Thereseinstadt*. New York: Holt, Rinehart, and Winston, 1968.

Friedländer, Saul. *When Memory Comes*. New York: Farrar Straus Giroux, 1979.

Gilbert, Martin. *The Holocaust: A History of the Jews of Europe during the Second World War*. New York: Henry Holt, 1985.

Goethe, Johann Wolfgang von. *Faust: A Tragedy, Part One*. Translated by Martin Greenberg. New Haven: Yale University Press, 1992.

Goldman-Rubin, Susan. *Fireflies in the Dark: The Story of Friedl Dicker-Brandeis and the Children of Terezin*. New York: Holiday House, 2000.

Gruenbaum, Michael. *Somewhere There Is Still a Sun: A Memoir of the Holocaust*. New York: Simon and Schuster, 2017.

Gruenbaum, Thelma. *Nešarim: Child Survivors of Theresienstadt*. London: Vallentine Mitchell, 2004.

Hajkova, Michaela, Hannelore Wonschick, Susan Leshnoff, Rebecca Rovit, Voitech Blodig, Sybil H.

Milton, and Moravian College Payne Gallery. *Art, Music and Education as Strategies for Survival: Theresienstadt 1941–45.* Edited by Anne D. Duttlinger. New York: Herodias, 2001.

Jelavich, Peter. *Berlin Cabaret.* Cambridge: Harvard University Press, 1993.

Kantor, Alfred. *The Book of Alfred Kantor: An Artist's Journal of the Holocaust.* New York: Schocken, 1987.

Karas, Joža. *Music in Terezín: 1941–1945.* New York: Beaufort Books, 1985.

Kater, Michael H. 1997. *The Twisted Muse: Musicians and Their Music in the Third Reich.* New York: Oxford University Press, 1999.

Kluger, Ruth. *Still Alive: A Holocaust Childhood Remembered.* New York: The Feminist Press at the City University of New York, 2001.

Kotouč, Kurt Jiří, Marie Rút Křížková, and Zdeněk Ornest. *We Are Children Just the Same: Vedem, The Secret Magazine by the Boys of Terezín.* Philadelphia: The Jewish Publication Society, 2013 (reprint edition).

Kuna, Milan. *Musik an der Grenze des Lebens.* Frankfurt am Main: Zweituasendeins, 1993.

Kutler, Laurence, editor. *The Terezín Diary of Gonda Redlich.* Lexington: The University Press of Kentucky, 1992.

Lederer, Zdenek. *Ghetto Theresienstadt.* New York: Howard Fertig, 1953.

Ludwig, Mark. "*Entartete Musik* and Music at Terezín." *Encyclopedia of Genocide and Crimes Against Humanity,* New York: Macmillan Reference USA, 2004.

——and Phyllis Goldstein. *Finding a Voice: Musicians in Terezín.* Boston: Facing History and Ourselves National Foundation, Inc. and Terezín Chamber Music Foundation (now known as the Terezín Music Foundation), 2000.

——, editor. *Liberation: New Works on Freedom from Internationally Renowned Poets.* Boston: Beacon Press, 2015.

MacDonald, Callum, and Jan Kaplan. *Prague in the Shadow of the Swastika.* Prague: Melantrich Publishers, 1995.

Makarova, Elena, and Seidman Miller, Regina. *Friedl Dicker-Brandeis: Vienna 1898 – Auschwitz 1944.* Los Angeles: Tallfellow/Every Picture Press, 2000.

——Sergei Makarov, and Victor Kuperman. *University Over the Abyss: The Story Behind 489 Lecturers and 2309 Lectures in KZ Theresienstadt, 1942–1944.* Jerusalem: Verba Publishers, 2000.

——and Ira Rabin. *Franz Peter Kien.* Prague: Publishing House Helena Osvaldová, 2009.

Müller, Melissa, and Reinhard Piechocki. *A Garden of Eden In Hell: The Life of Alice Herz-Sommer.* London: Macmillan UK, 2007.

Newman, Richard, and Karen Kirtley. *Alma Rosé: Vienna To Auschwitz.* Portland, Oregon: Amadeus Press, 2003.

Peduzzi, Lubomír. *Pavel Haas.* Brno: Českého hudeního fondu a Mezinárodního Terezínského sdružení, 1993.

Peschel, Lisa. *Performing Captivity, Performing Escape: Cabarets and Plays from the Terezín/Theresienstadt Ghetto.* London: Seagull, 2014.

—— *Theatertexte aus dem Ghetto Theresienstadt, 1941–1945.* Prague: Akropolis, 2008.

Pressburger, Chava, ed. *The Diary of Petr Ginz 1941–1942.* New York: Atlantic Monthly Press, 2004.

Rossel, Dr. Maurice. *The Theresienstadt Ghetto: Visited June 23, 1944.* Bern: International Red Cross, 1944.

Rovit, Rebecca, and Alvin Goldfarb, eds. *Theatrical Performance During the Holocaust.* Baltimore: The Johns Hopkins University Press, 1999.

Rubin, Susan Goldman, and Ela Weissberger. *The Cat with the Yellow Star: Coming of Age in Terezín.* New York: Holiday House, 2006.

Stuckenschmidt, H. H. *Arnold Schönberg: His Life, World and Work.* New York: Schirmer Books, 1977.

Slavický, Milan. *Gideon Klein: A Fragment of Life and Work.* Prague: Helvetica-Tempora Publishers, 1996.

Sontag, Susan. *Regarding the Pain of Others.* New York, NY: Picador, 2003.

Terezínská Iniciativa Kniha. *Terezínská Pamětní Kniha.* Terezín: Edice Terezínská Pamětní, 1995.

Troller, Norbert. *Theresienstadt: Hitler's Gift to the Jews.* Chapel Hill: The University of North Carolina Press, 1991.

Ullmann, Viktor. *26 Kritiken über musikalische Veranstaltungen in Theresienstadt.* Hamburg: Bockel Verlag, 1993.

Weil, Jiří, and Anita Franková, eds. *I Never Saw Another Butterfly: Children's Drawings and Poems from Terezín.* Prague: The Jewish Museum Prague, 1993.

Weissová, Helga. *Zeichne, as Du siehst.* Göttingen: Walstein Verlag, 1998.

Zadikow, Mariánka. *The Terezín Album of Mariánka Zadikow.* Annotated by Debórah Dwork. Chicago: The University of Chicago Press, 2008.

First-hand testimonies were gathered by Mark Ludwig in extensive interviews with the following Holocaust survivors, conducted from 1990 to 2017:

Karel Berman. Prague, Czech Republic

George Brady. Toronto, Canada

Dr. Anita Franková. Prague, CZ

Doris Grozdonovičová. Prague, Czech Republic

Michael Gruenbaum. Brookline, Massachusetts

Olga Haasová. Brno, Czech Republic

Dr. George Horner. Newtown Square, Pennsylvania

Helga (née Weissová) Hošková. Prague, CZ

Eliška Kleinová. Prague, Czech Republic

Ivan Klima. Prague, Czech Republic

Pavel Kling. Vancouver, Canada

Edgar Krasa. Newton, Massachusetts

Hana Krasa. Newton, Massachusetts

Dasha Lewin. Los Angeles, California

Dagmar Lieblová. Prague, Czech Republic

Anna Lorencová. Prague, Czech Republic

Leopold Lowy. Hackensack, New York

Jacob Mincer. New York, New York

Dr. Anna Ornstein. Brookline, Massachusetts

Hana Reinerová. Prague, CZ

Zuzana Růžičková. Prague, CZ

Fred Terna. Brooklyn, New York

Ela Weissberger. Tappan, New York

Documentaries:
Lanzmann, Claude. "SHOAH Interview Transcript with Maurice Rossel (1979)." Trans. Lori Eichorn. Washington, DC: United States Holocaust Memorial Museum, 2009.

Lanzmann, Claude. "The Last of the Unjust." New York: Cohen Media Group, 2013.

INDEX OF NAMES

TEREZÍN MUSIC FOUNDATION

Our Will to Live is a project of the Terezín Music Foundation, a U.S. nonprofit dedicated to honoring the Terezín artists and all voices silenced by oppression and war. Since its founding in 1991, TMF has firmly established works by the Terezín composers in the classical repertoire through research, multi-media concerts, publications, recordings, and Holocaust education programs, and has built a memorial to these artists by sponsoring more than forty new commissions by outstanding composers including André Previn, Nico Muhly, Miroslav Srnka, Sivan Eldar, David Post, Ellis Ludwig-Leone, and Pablo Ortiz. Yo-Yo Ma, Garrick Ohlsson, Dawn Upshaw, and Simone Dinnerstein are among the many celebrities who bring TMF commissions to the great stages of the world. Sir Simon Rattle, a member of TMF's Advisory Board, calls TMF "one of the most powerful indications of the unquenchability of the human spirit." TMF has published *Liberation* (Beacon Press), an anthology of works commissioned from the world's foremost poets, which provides texts for many TMF commissions. The Dalai Lama praised *Liberation* as "an inspiration."

Our Will to Live is the springboard for exhibitions and multi-media concerts that are part of TMF's ongoing Holocaust education programs, residencies, and tours around the world. For these programs as well as associated music, survivor testimony, interviews, and more, see www.terezinmusic.org.

MARK LUDWIG

Mark Ludwig is a Fulbright scholar of the Terezín composers and a leading authority on and teacher of Holocaust music. He is a member of the Terezín Memorial Museum Advisory Board and Executive Director of the Terezín Music Foundation, which he founded in 1991. Mr. Ludwig is author of the widely adopted Holocaust education curriculum *Finding A Voice: Musicians in Terezín*. Since 2001, he has been Adjunct Professor at Boston College, where he teaches "Music During the Third Reich," and he has lectured at Harvard University, the University of Virginia, Charles University in Prague, and other institutions.

Mr. Ludwig is also a violist and Boston Symphony Orchestra member emeritus who has blended his musical career with social causes promoting tolerance. He has performed on stage and CD to benefit causes in the U.S., Bosnia, Darfur, Tibet, and Central Europe's Roma communities. He performed for the Dalai Lama at the U.S. Capitol in a ceremony awarding His Holiness the Tom Lantos Human Rights Prize. For his global outreach efforts, Mr. Ludwig was nominated by U.S. Ambassador William Cabaniss as a UNESCO Artist-for-Peace and Goodwill Ambassador. He has authored essays and CD liner and program notes, and served as a consultant for numerous cultural organizations, including the Chicago, Boston, Birmingham (UK), and Philadelphia Symphony Orchestras, and he has participated as an artist, consultant, and producer of CDs on the London Decca, Koch, Naxos, and Terezín Music Foundation recording labels. Mr. Ludwig is editor of *Liberation: New Works on Freedom from Internationally Renowned Poets* (Beacon Press).

See www.markludwig.org.

Photograph by Michael J. Lutch

All of Mark Ludwig's proceeds from this book will be
contributed to Terezín Music Foundation education programs.

First edition published in 2021

Cover Art: Detail from a Terezín poster, "Entertaining Music," with the
Weiss Quintet. HCPT #3969.

Concept and production: Siegfried Schäfer
Book design: Holger Feroudj / Steidl Design, Siegfried Schäfer
Color separations by Steidl image department

Printing: Steidl, Göttingen

Steidl
Düstere Str. 4 / 37073 Göttingen, Germany
Phone +49 551 49 60 60
mail@steidl.de
steidl.de

ISBN 978-3-95829-959-7
Printed in Germany by Steidl